Penguins

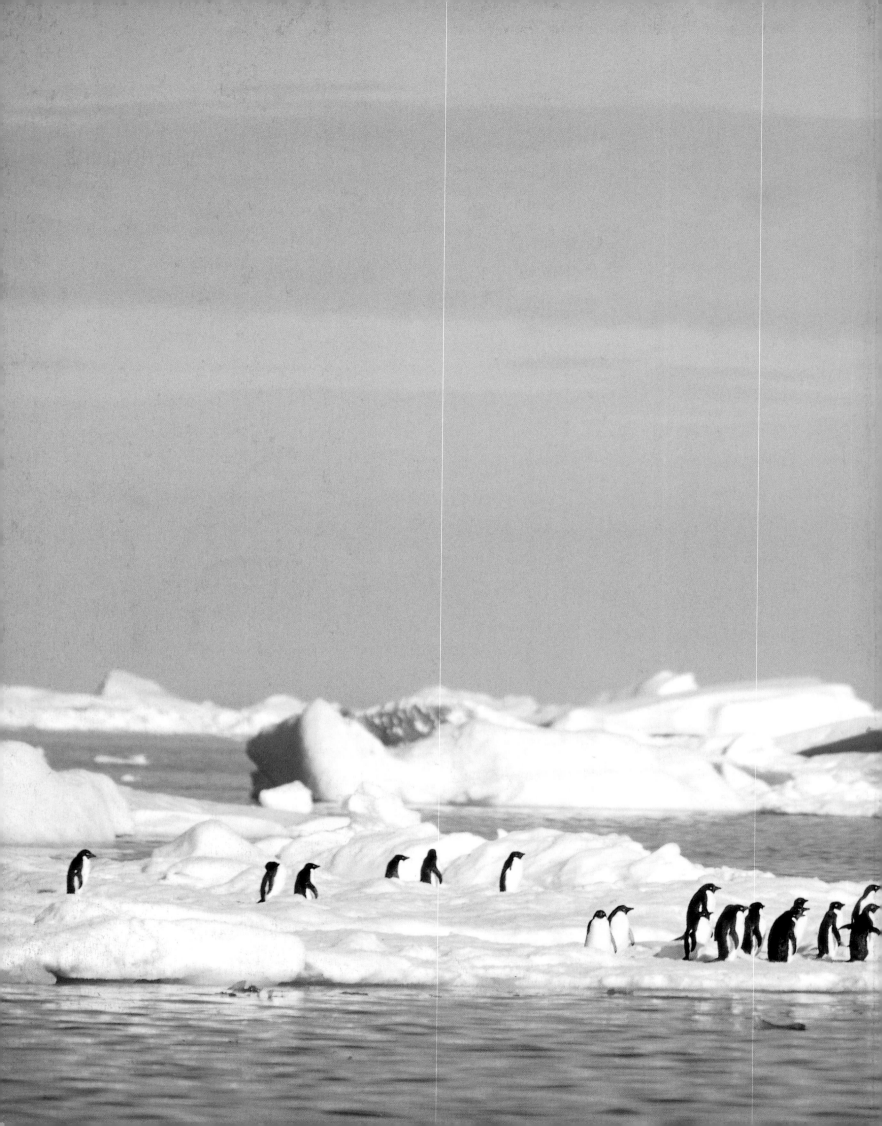

Brutus Östling

Penguins

text by Susanne Åkesson

Collins
An Imprint of HarperCollinsPublishers

We dedicate this book to our families, especially to our children,
Astrid, and Alice, Eddie, and Isak.

Originally published in Swedish as *Pingvinliv* by Norstedts

Published by agreement with Norstedts Agency

Design: Jens Andersson

HarperCollins books may be purchased for educational, business, or sales promotional use.

For information, please write:

Special Markets Department, HarperCollinsPublishers, 10 East 53rd Street, New York, NY 10022.

FIRST U.S. EDITION

ISBN-10: 0-06-119858-7

ISBN-13: 978-0-06-119858-8

06 07 08 09 / 10 9 8 7 6 5 4 3 2 1

Contents

Preface

AS YOU FIND yourself in the middle of a thousand penguins, surrounded by a strong smell of guano and unable to think because of the loud braying, it is impossible not to experience a sense of awe. A first encounter with penguins affects people in a most fundamental way. Perhaps we identify ourselves with their "human" aspect and their awkward gait on land, or perhaps it is simply their heroic determination to survive and reproduce in one of the most inhospitable places on Earth that we find so deeply moving. One thing is certain: we are touched and fascinated by penguins. A closer look at the different species reveals their remarkable and unique acclimatization to their respective environments.

We are all aware of the fact that penguins are flightless birds. Instead, they are extremely well suited to life in the water. As awkward as they are on land, they are correspondingly skillful in the sea, using their flippers to "fly" through the water. One of the largest species described in this book, the King Penguin, can dive to 1,100ft (340m) and can stay underwater for almost 15 minutes.

During the breeding season, penguins move on to land, where they congregate in large colonies. The females lay up to two eggs, and some species incubate their eggs on top of their feet for several months. The Emperor Penguin, which can survive temperatures down to –75°F (–60°C), keeps its egg warm under a flap of skin below the belly. In order to be able to incubate their egg for months at a time while waiting to be relieved by their partner, these birds build up extensive fat reserves. Other species change places more often, while King Penguins have developed an ability to store food in the gut, ensuring a sufficient food supply for the newborn chick in case the other partner should be late in returning with food.

It is hard—impossible even—not to fall in love with penguins, as photographers and scientists who have crawled around in slimy, smelly guano for weeks, and who have arrived back home a little hard of hearing, will tell you. It is also difficult to avoid seeing human traits in these tail-coated creatures, which, through a combination of dignity and their somewhat comical aspect, remind us of ourselves. Amusing as they may seem, however, they are also a source of inspiration. They almost seem to look at us sweetly and say, "Living is not always easy; you just have to make the best of it."

Susanne Åkesson and Brutus Östling

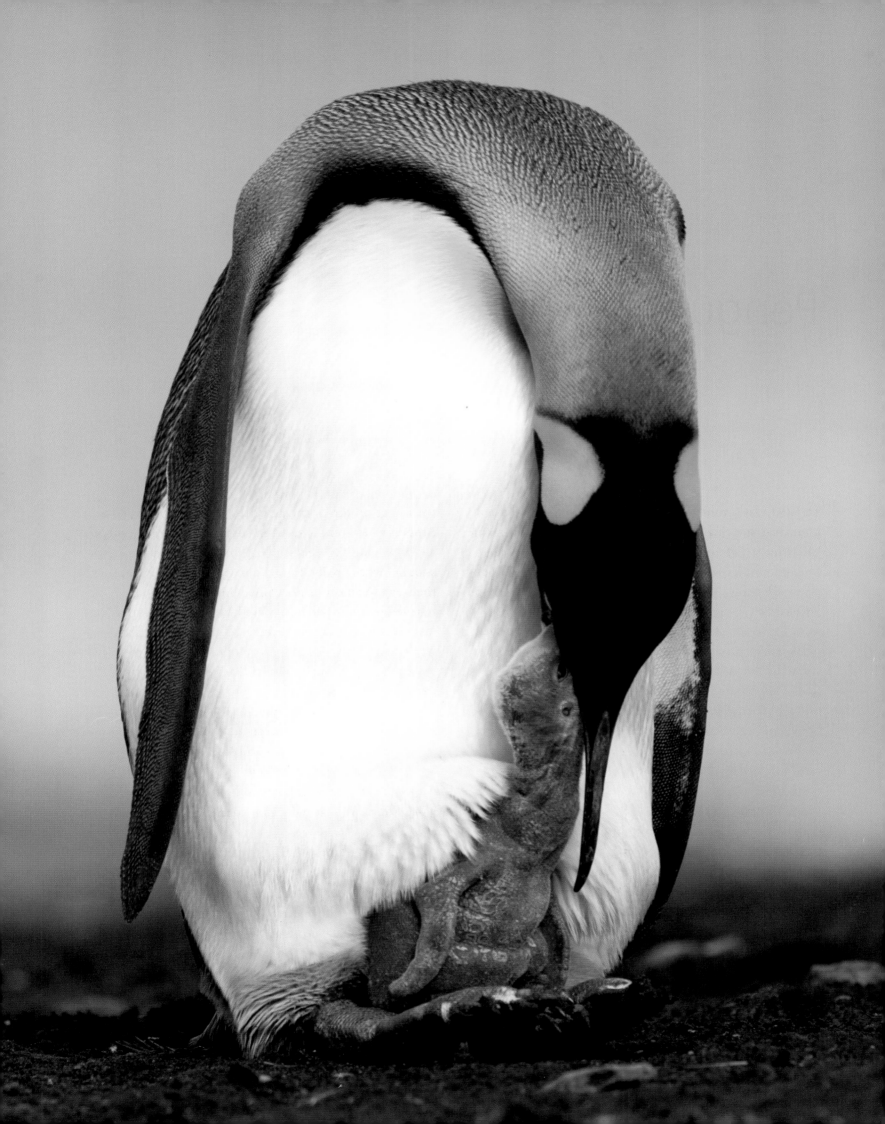

Penguin Distribution

THIRTY-TWO EXTINCT penguin species have been identified and documented with the help of fossil finds. Their identification was possible because penguins have a redundant leg joint, and the breastbone to which their powerful wing muscles are attached is uniquely shaped. Seventeen (arguably eighteen) species are currently found, and they live only in the southern hemisphere.

As is the case with many other bird species, there is some dispute as to how penguins should best be classified. This debate is intensifying as more advanced technology is being utilized to study genetic differences between species. Body structure, color pattern, and bone shape used to be the determining factors in the classification of species. Today, however, species that appear quite similar may be divided into subspecies if they are found to differ in their genetic makeup.

Many penguin species are found in isolated subantarctic islands and as far north as South Africa, Australia, and even the equator, where the Galápagos Penguin breeds on the Galápagos Islands off the coast of Ecuador. The greatest diversity is found around New Zealand, where several species of crested penguins breed on a number of islands, as well as in the South Atlantic, which is home to Gentoo, Magellanic, and King penguins, among others.

Penguins have been around for millions of years, but the Adélie Penguin did not arrive in the Antarctic until approximately 6,000 years ago. Because these birds need firm, ice-free ground for their nests, they were unable to settle there while the continent was still covered in ice. Therefore, the system by which millions of Adélie Penguins today use different geographical areas for breeding and migration is a relatively recent development. Furthermore, the various groups of Adélie Penguins that populate the Antarctic have clear distinctions in their genetic makeup, so we can be certain from this that mutations have occurred over a relatively short time period. Population sizes have probably fluctuated, causing "bottlenecks" to occur, whereby a small number of individuals have survived a harsh period and then multiplied their numbers again at a later stage. The genetic makeup of the main population is therefore dependent on the genes that these few survivors have transmitted to subsequent generations.

In 2001, a gigantic iceberg calved from a glacier in the Ross Sea. It floated out to sea, where it blocked the migration route used by many of the local Adélie Penguins. These birds were unable to return to their breeding grounds and failed to breed that year. During the Holocene epoch, some 20 icebergs are estimated to have broken off glaciers around the Ross Sea. Presumably, these also had a major impact on the migration routes of local penguin populations.

African Penguin, Boulders Beach, Simon's Town, South Africa, March.

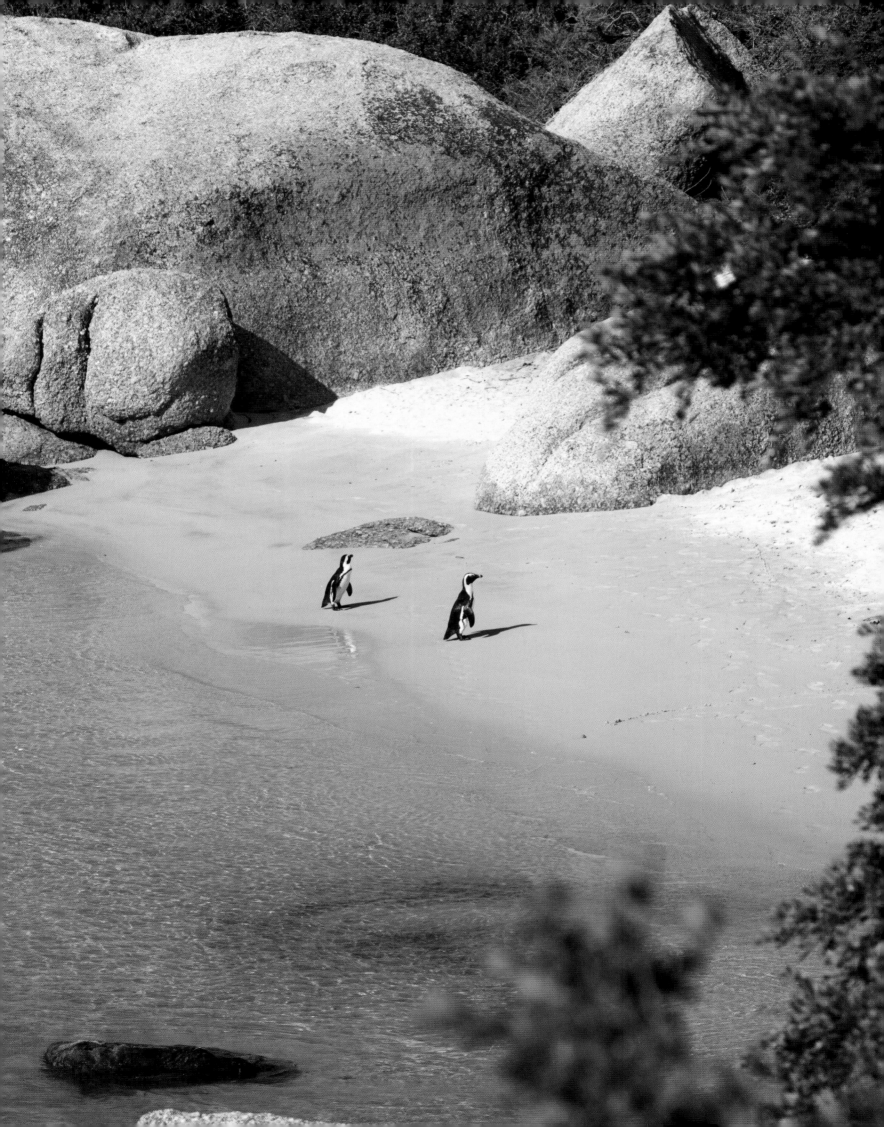

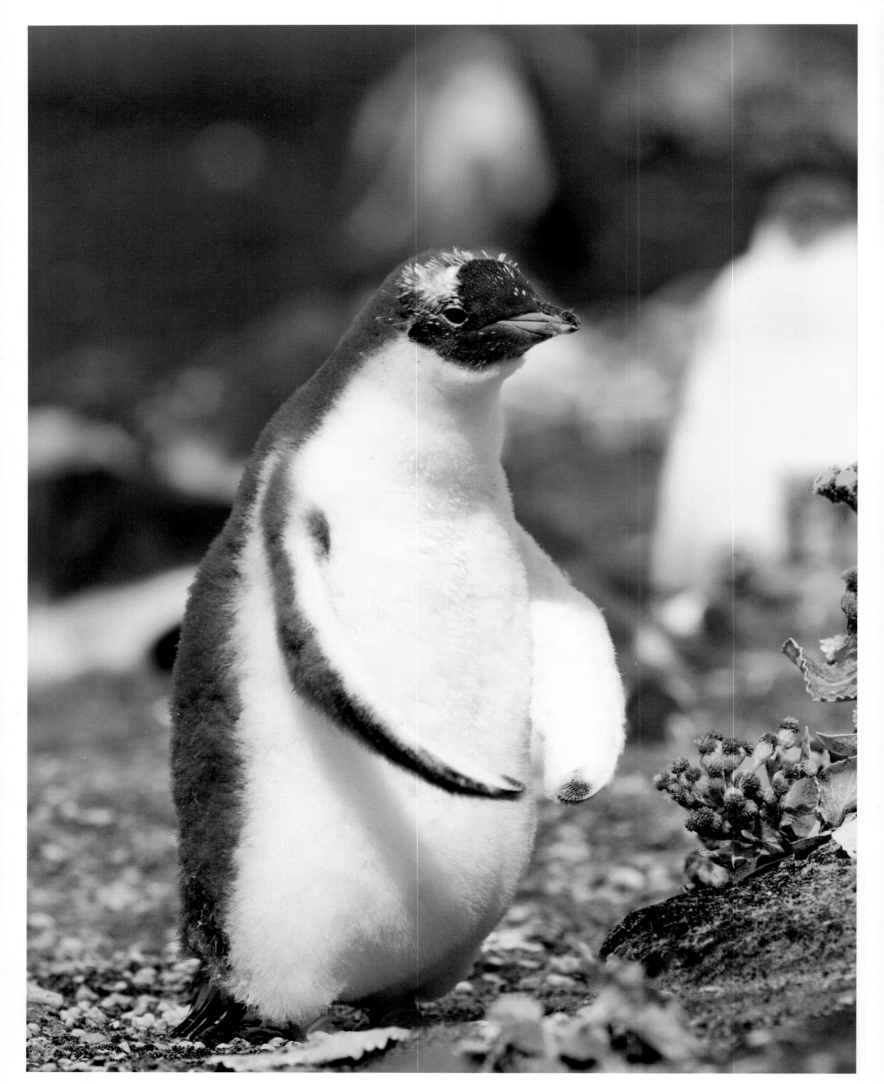

Gentoo Penguin chick, Saunders Island, Falkland Islands, January.

The smallest penguin species live near the equator—on the Galápagos Islands, for example—while larger species such as the Emperor Penguin are found in the Antarctic, nearer the South Pole. This kind of geographical range within or between animal species, known as Bergmann's Rule, is a commonplace phenomenon. In 1847, the zoologist Carl Bergmann established that individuals of a species are smaller the closer they are to the equator and that they increase in size nearer the poles. This is because warm-blooded animals with a large body volume in relation to surface area are better adapted to storing heat and conserving energy in cold climates than are small individuals. This simply means that a large animal sheds heat via a relatively small surface area compared to a small animal and thereby runs the risk of overheating in hot climates. For the same reason, large animals lose less heat in cold climates compared to smaller individuals. The zoologist Joel Asaph Allen noted in 1877 that protruding body parts such as ears, limbs and tails are also often shorter and smaller closer to the poles.

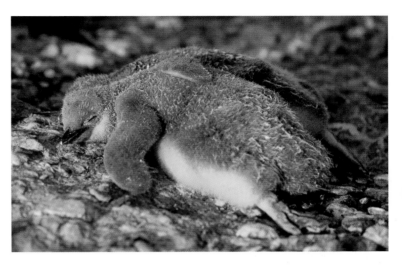

Chinstrap Penguin chick, Antarctica, January.

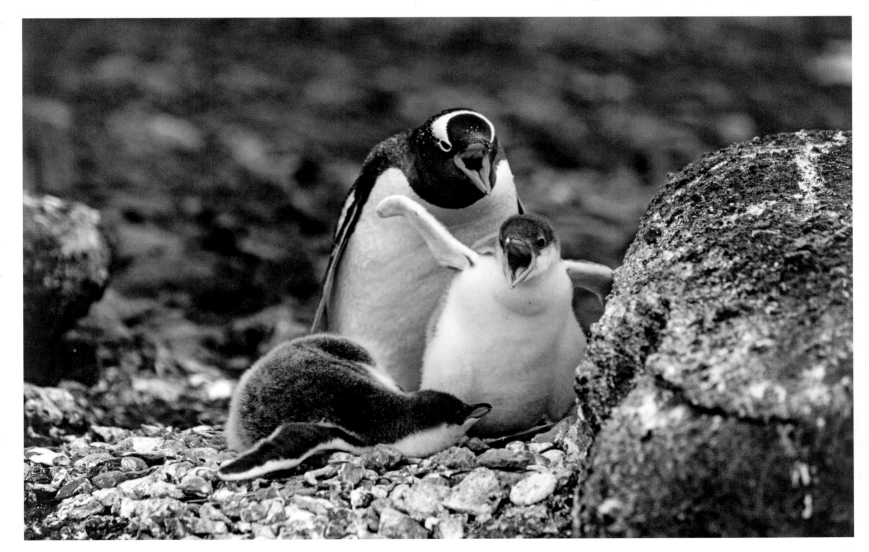

Gentoo Penguins, Antarctica, January.

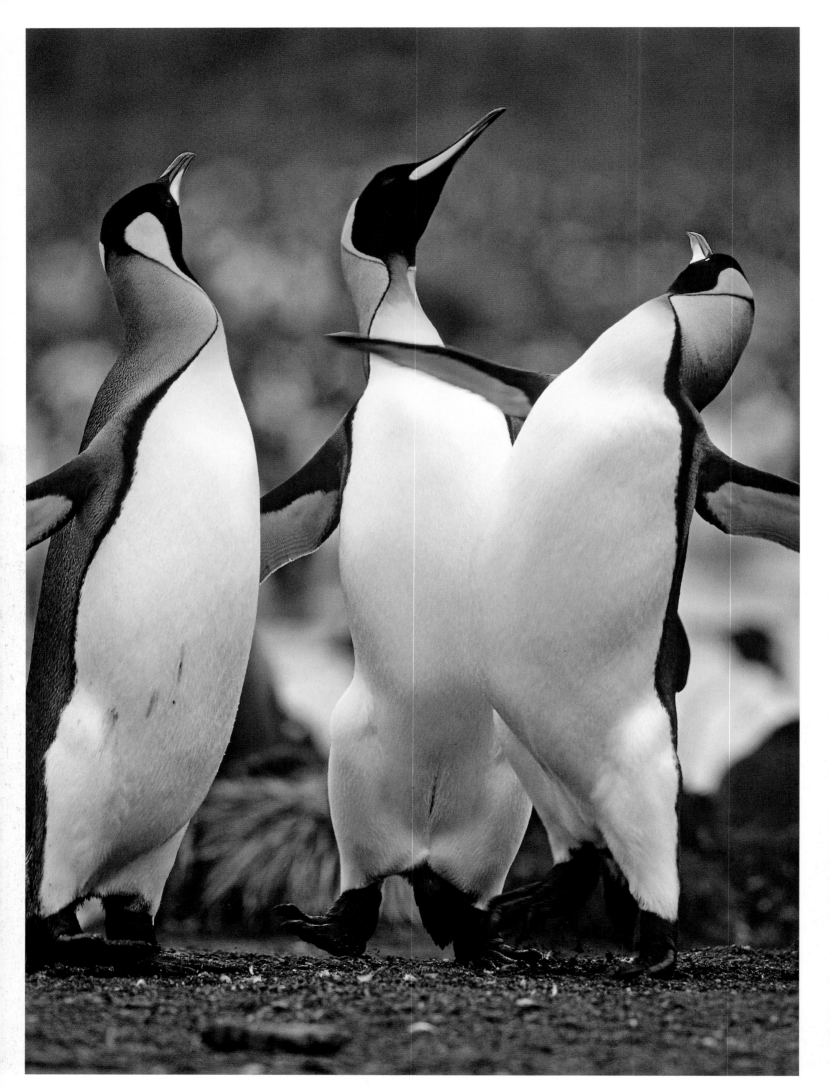

Like all other penguins, King Penguins live near a food supply. They spend the breeding and molting seasons on islands, but, because they are well adapted to long-distance swimming and deep diving, the rest of the time they remain in the sea. Where cold water from the bottom of the ocean reaches the surface along the rim of the Antarctic ice shelves, it carries nutrients to the surface, and so there is a rich food supply here. King Penguins and other ocean birds congregate in these areas, of which South Georgia is an example, because food is abundant here for long periods. Food production in the ocean can be very high in some places, so islands and other areas where penguins live can get crowded. Is there enough food for all? In one year, a million pairs of King Penguins eat approximately 745,000 tons of lanternfish and 65,000 tons of squid. This is about 1 per cent—between 70 and 130 million tons—of the total stock of lanternfish in the entire Southern Ocean. It is estimated that there are more than 70 million penguins on Earth, and together with other marine birds and mammals they naturally have a major impact on the food chains in some areas.

Overleaf It's easy to recognize an active Chinstrap Penguin colony in the exposed, barren environment of Deception Island in the Antarctic Ocean. It is, however, just as easy to spot an abandoned colony by the dark green carpet of lush vegetation that covers the previously exposed ground. The soil often remains high in nutrients for hundreds, even thousands, of years after a colony has been abandoned. While it is populated, however, not many plants are able to stand the high levels of nitrates and phosphates combined with the constant wear from penguin feet. The only green vegetation, in the form of grass, for example, is found on the outskirts of the colony, although occasionally lichen grows on rocks protruding from the ground within the colony.

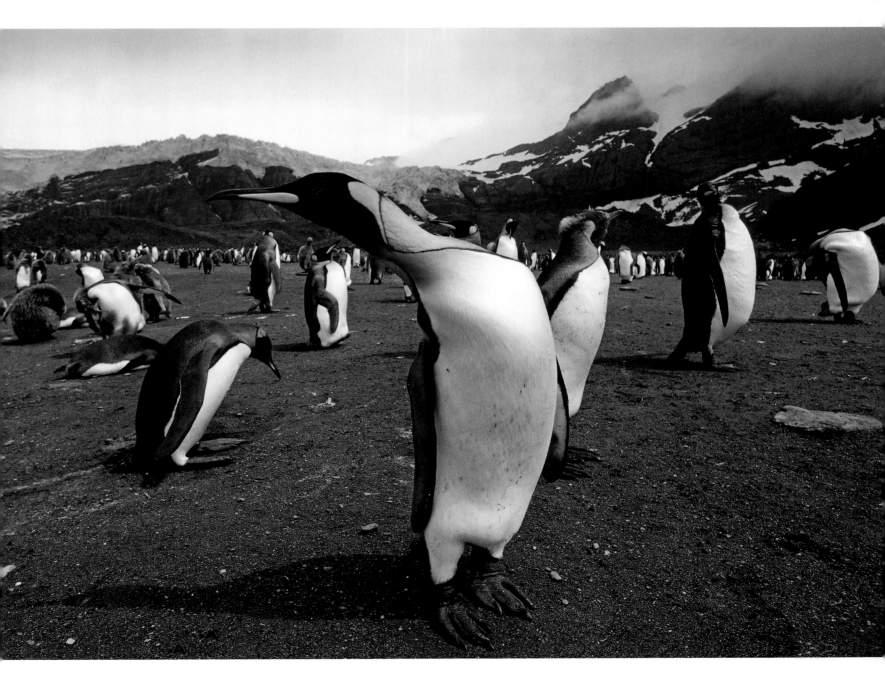

King Penguins with chicks, South Georgia, January.

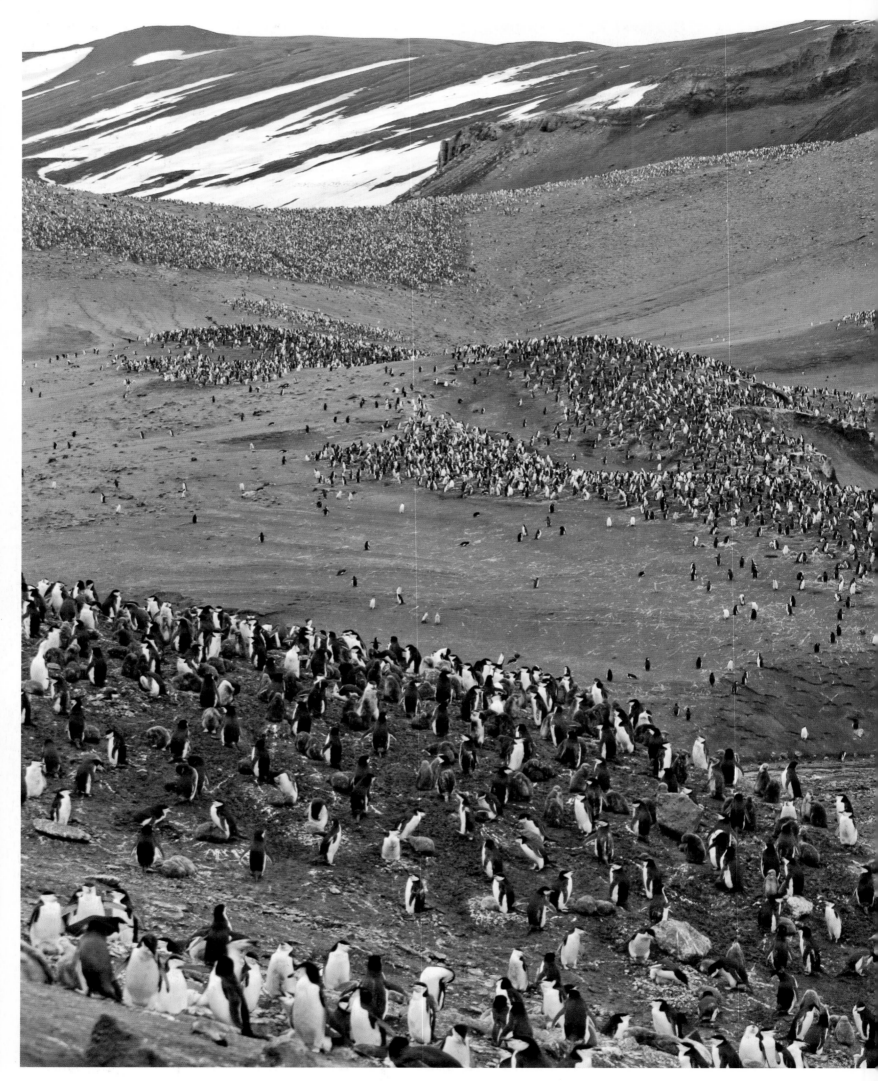

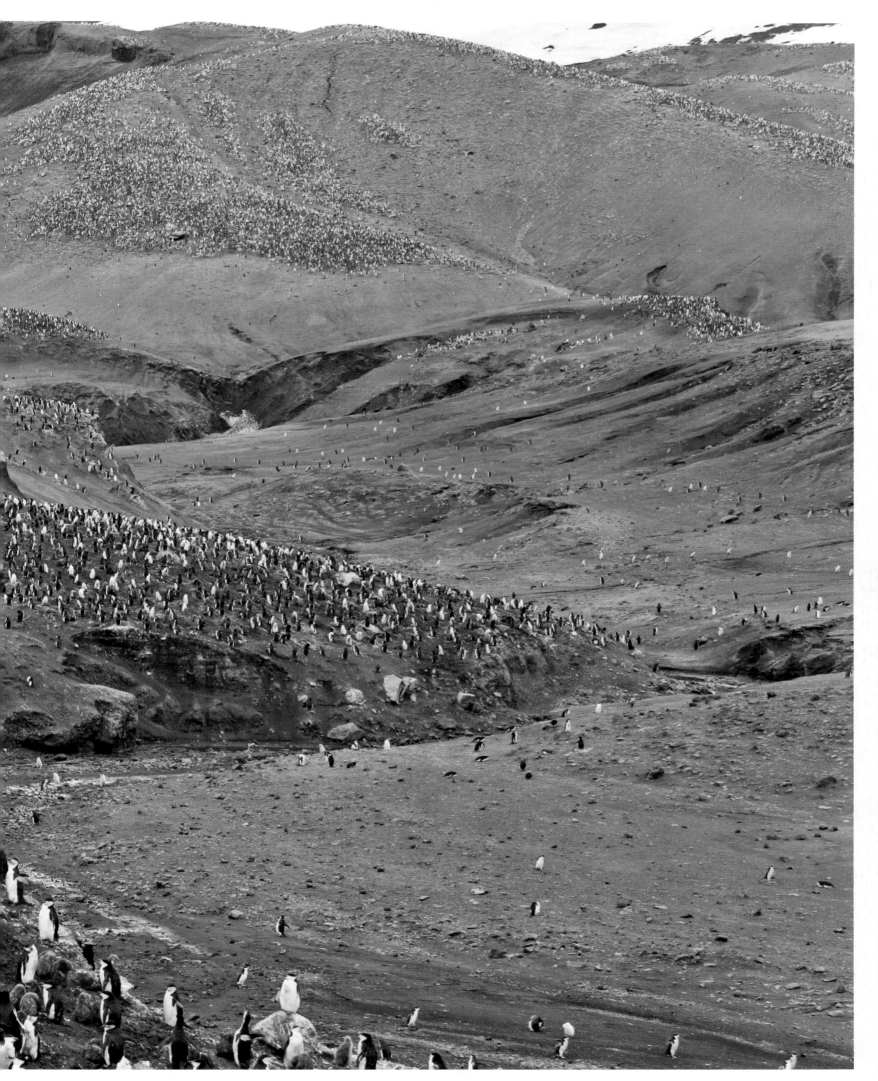

Chinstrap Penguins, Baily Head, Deception Island, Antarctica, January.

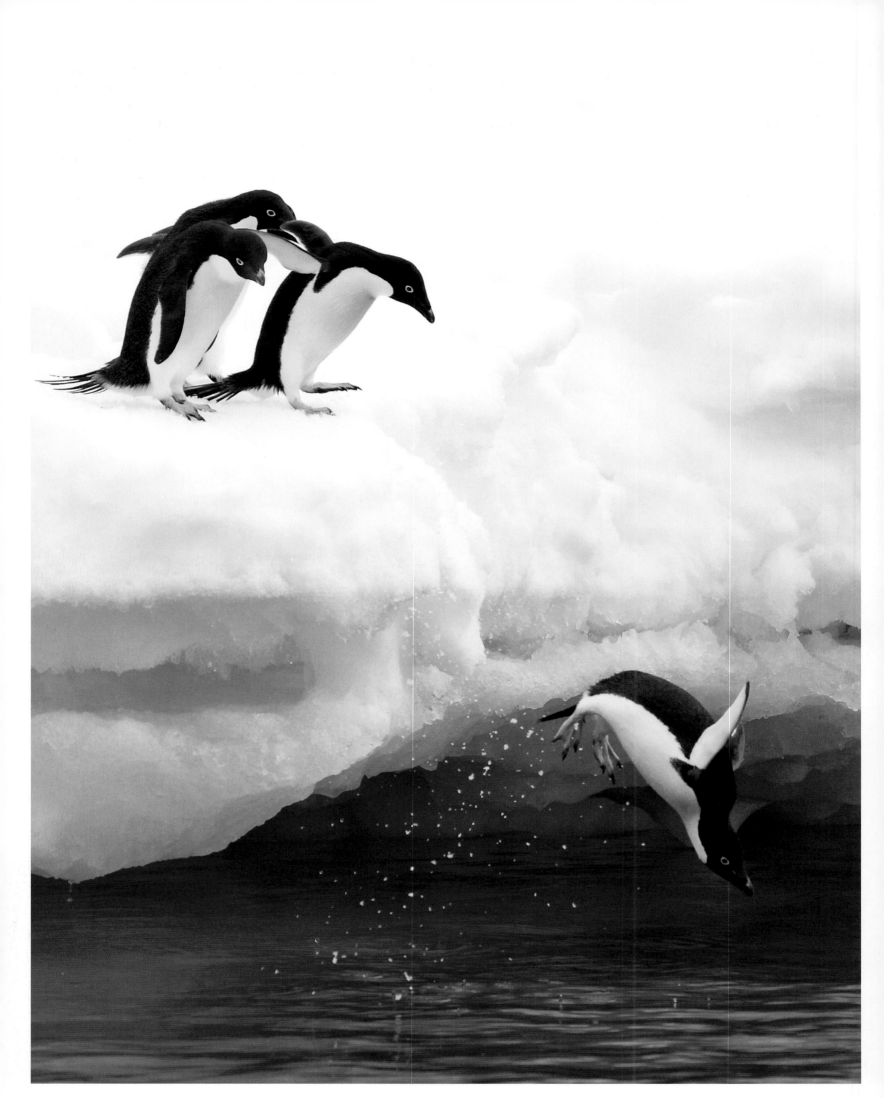

Adélie Penguins, Paulet Island, Antarctica, January.

The fact that we find synchronized diving beautiful and are drawn to it in large numbers may seem quite normal to us humans, but of course this is not the reason why Adélie Penguins dive in groups. It is a more efficient way of catching fish and krill, but it may also reduce the risk of getting caught by Leopard Seals. There are some disadvantages to diving together with other penguins, and it may not suit all individuals—some may prefer to keep diving a little longer than the rest.

The Leopard Seal hunts different prey at different times of the year in the Antarctic. In the spring, it feeds on Adélies and other penguins, as well as on fish and seals, while during the winter it lives entirely on fish. An adult Adélie Penguin accelerates from 0 to 16mph (25km/h) in less than a second as it dives off an ice flow. Its greatest enemy, the Leopard Seal, swims at an average speed of 4mph (7km/h), and so it needs to approach the penguins by stealth. It is a lot easier for the seals to catch young, inexperienced birds on their first swim.

The male Antarctic Shag does not use his blue spectacles when foraging for fish, but for finding himself a partner. The intensity of the spectacles' color reveals whether the individual has caught any diseases or parasites, or if he has a good immune system, which will make him more attractive to the opposite sex.

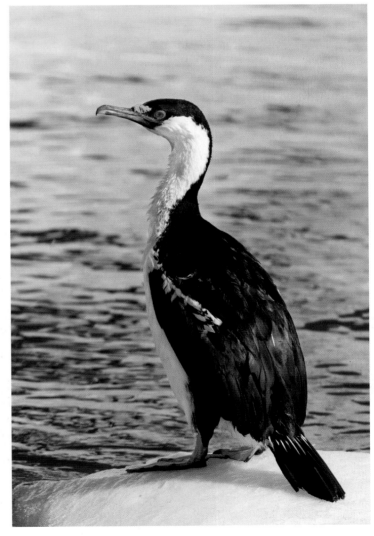

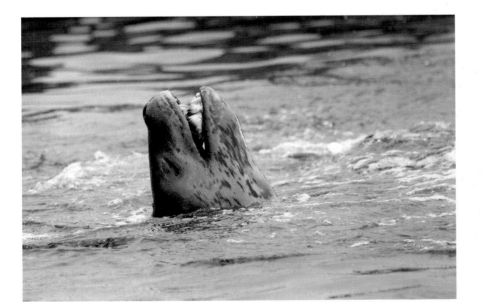

Leopard Seal, Paulet Island, Antarctica, January.

Antarctic Shag, Antarctica, January.

When it is time to breed, King Penguins start to look for a place where they can incubate their eggs and raise their young together with other penguins—this ensures that there are always other birds around to feed the young. It takes more than a year to raise a chick, molt, and eat in preparation for the next season, which is why King Penguins are able to breed in only two years out of three. Since breeding starts at different times, there is enough food in the colony practically all year round for other birds that feed on carrion or eggs and chicks. The Turkey Vulture takes advantage of this predictable food supply by nesting close by. It feeds on the remains of dead penguins and other carrion, so it prefers to stay close to large colonies. The Southern Giant Petrel, on the other hand, raids the colonies on a regular basis.

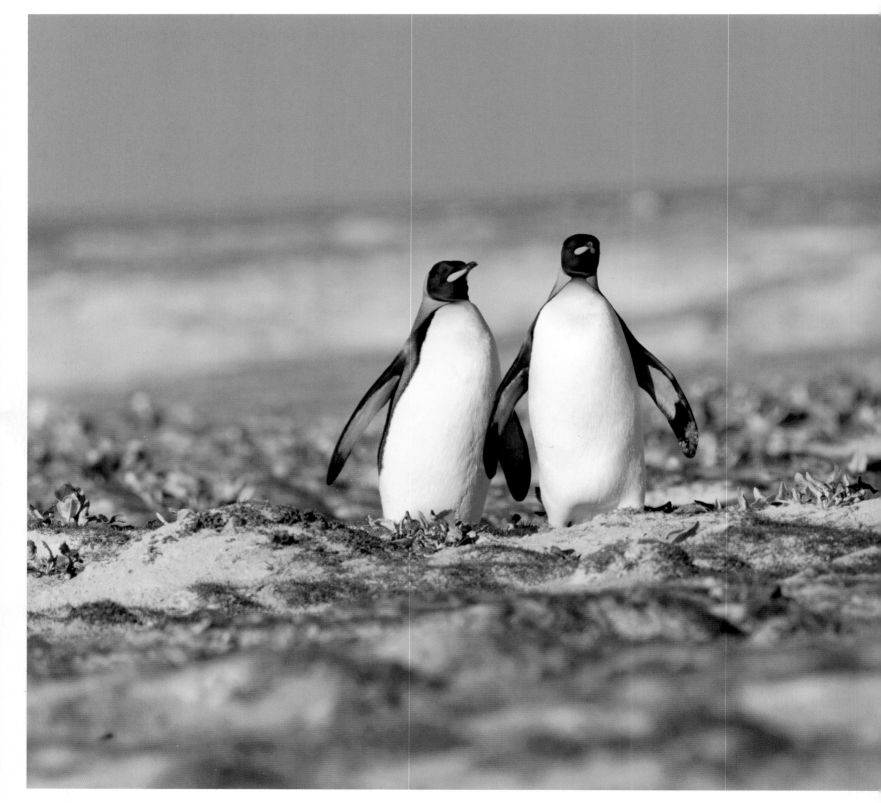

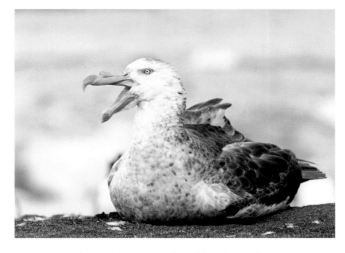

Southern Giant Petrel, Falkland Islands, January.

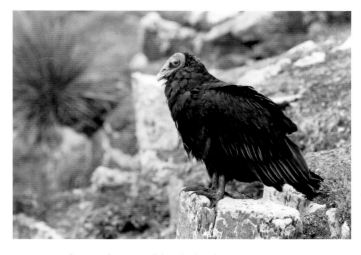

Turkey Vulture, Falkland Islands, January.

King Penguin, Volunteer Point, Falkland Islands, February.

All penguin species, including the Gentoo, are believed to have emerged somewhere near the center of the Gondwanaland continent at the point where South America, Africa, and Antarctica started to drift apart. As the distance between the new continents increased, the ocean now known as the Southern Ocean was formed. East Antarctica started to drift to the south, where it was subsequently covered in ice and where it remained as a result of the Earth's rotation. Antarctica is still linked to South America via an undersea mountain range that forms a string of islands, and the richest food source of the Southern Ocean is found around the northernmost of these islands. There is such a good supply of krill here, so this is where the largest populations of Gentoo Penguins and other marine predators are found.

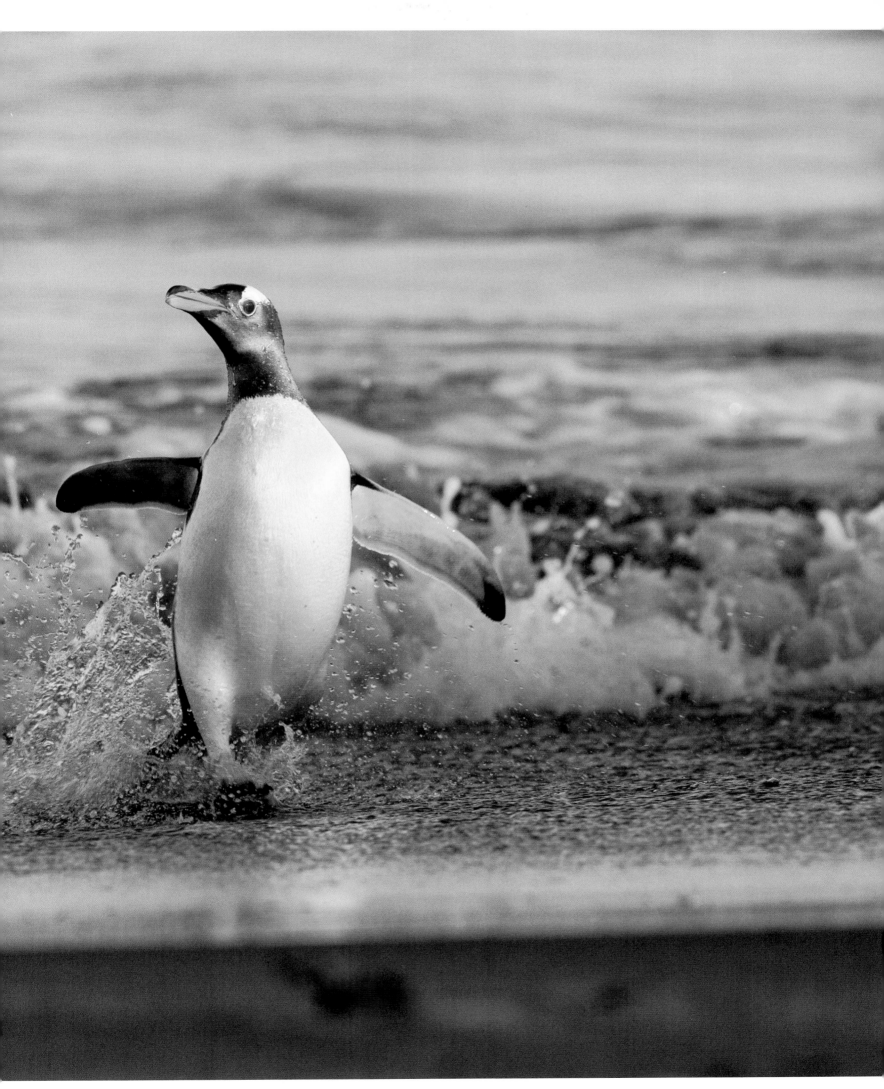

Why do many penguin species have such odd names? "Gentoo," for example, was first used in the Falklands. It is an Anglo-Indian word for the non-Muslim population of Hindustan, but no one really knows why the penguin was given this name. It has been suggested that it refers to the area of white on its head, which, with a bit of imagination, resembles a turban. Other penguin species have been named after explorers and therefore refer to people, including Sclater's Crested Penguin (now more commonly known as the Erect-crested Penguin) and the Magellanic Penguin. The Macaroni Penguin's name refers to the feathers adorning the hats of early explorers (young men wearing these hats were called Macaronis); these resemble the birds' elongated, brightly colored crown feathers. The Adélie Penguin was discovered by the French explorer Jules-Sébastien-César Dumont d'Urville when he visited the Antarctic in January 1840, and was named after his wife, Adélie.

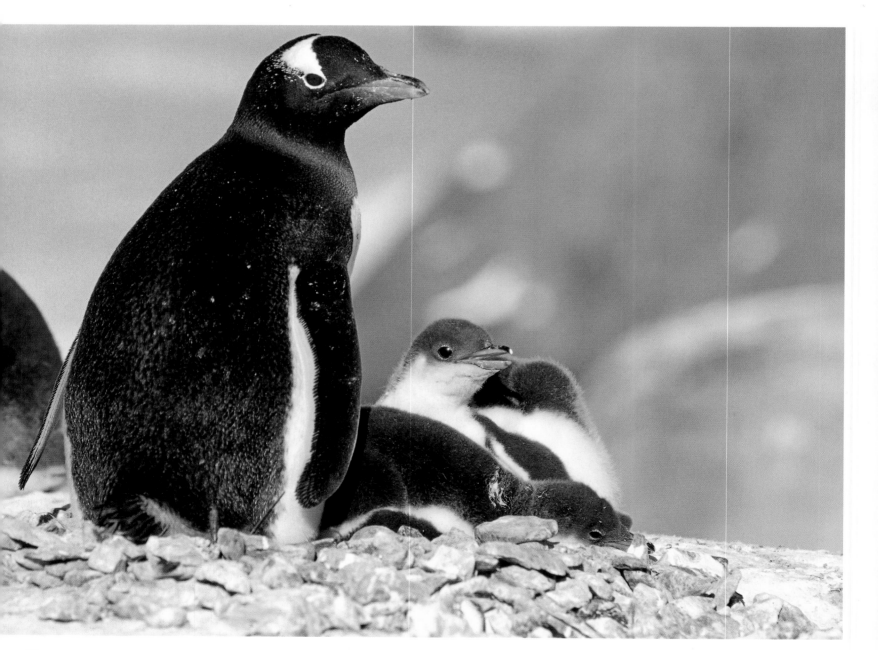

Gentoo Penguin, Petermann Island, Antarctica, January.

Magellanic Penguins, like most other penguin species, usually lay only two eggs and raise only two chicks. Often a chick from a nearby nest will also beg for food, like this one at Volunteer Point in the Falklands. The largest penguin species are able to incubate only a single egg, which they keep warm under a fold of skin on top of their feet. Magellanic Penguins, on the other hand, nest in burrows and normally incubate two eggs at a time by lying on them.

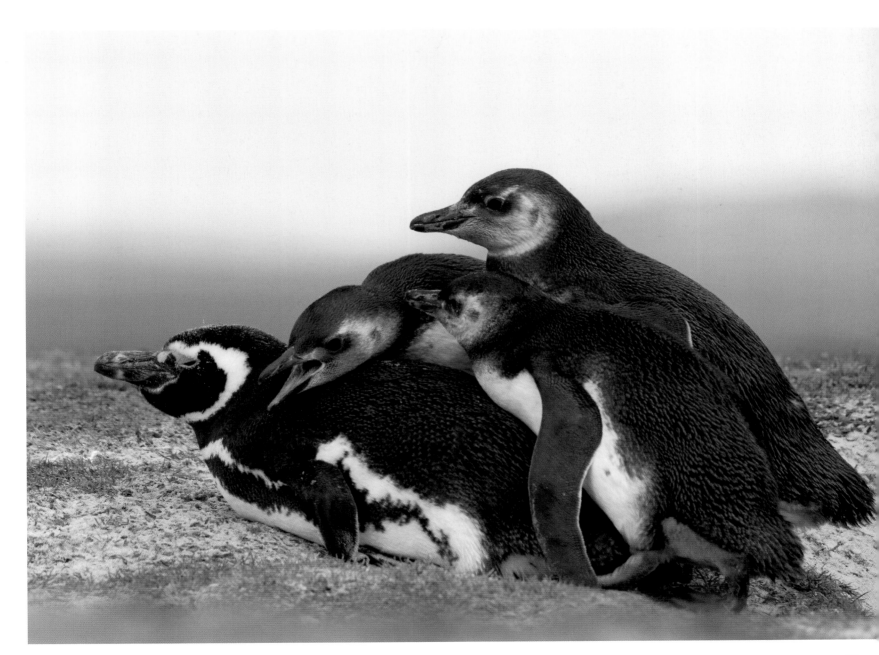

Magellanic Penguin, Volunteer Point, Falkland Islands, February.

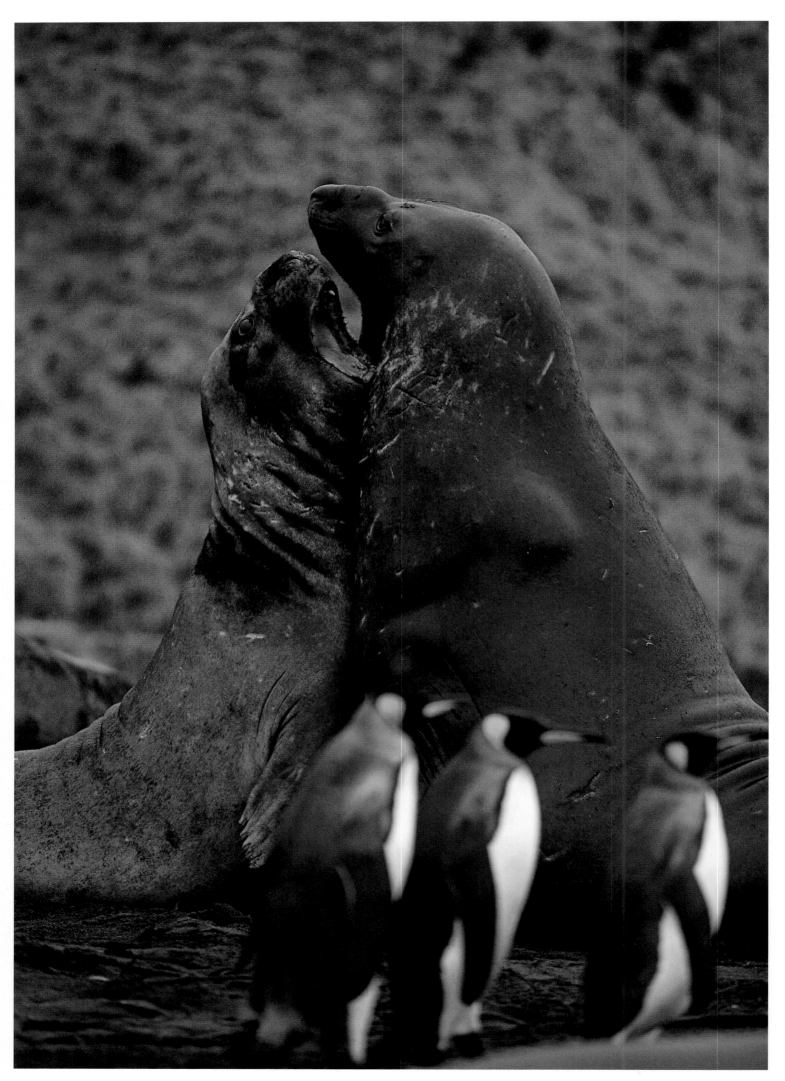

King Penguins and Southern Elephant Seals, South Georgia, January.

As the King Penguins of South Georgia wander down to the seafront they must weave their way between the hundreds of Southern Elephant Seals—each weighing several tons— that wallow around on the beach. The seals regularly catch penguins, and it must be with some trepidation that the birds encounter these gigantic beasts on land and in the water.

Even though the African Penguins of Boulders Bay, South Africa, have learned to live alongside humans, they prefer to keep their distance. If people get too close, they retreat to their burrow, hidden under a tuft of grass or a bush.

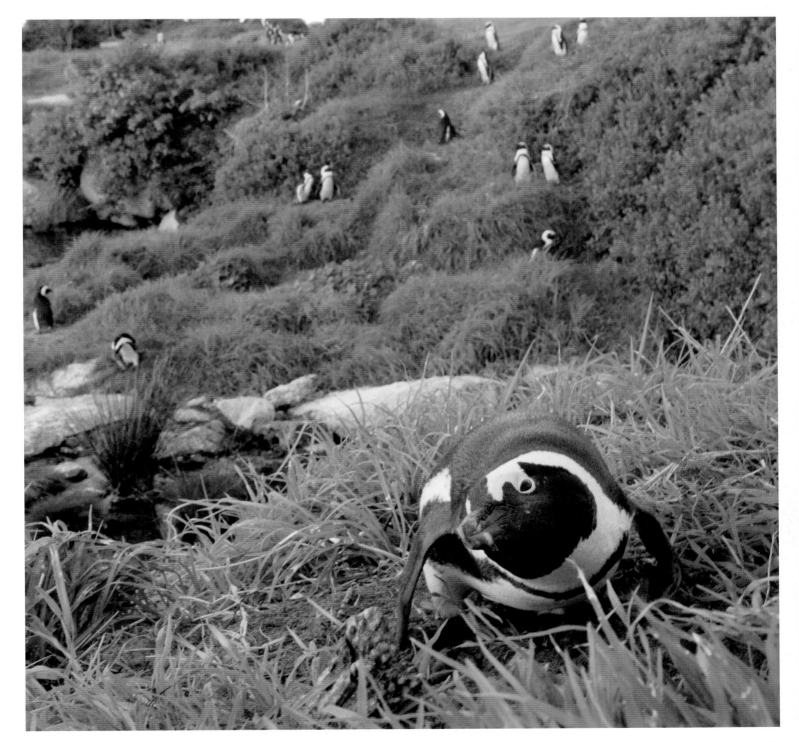

African Penguin, Simon's Town, South Africa, March.

On entering the water, penguins briefly open their bills. This may be a way of tasting the water to find out whether there are any predators nearby, or perhaps the cold water that enters their mouths triggers a process that lowers their heart rate when diving. Tasting chemical triggers in water is a way of keeping check on predators. It is not necessarily a chemical signal from the animal itself the penguins are looking for, but the taste of killed prey, torn apart underwater. Sharks are experts in sensing chemical triggers and are attracted to recently killed prey, but fish and plankton also react to similar signals from the predators that feed on them.

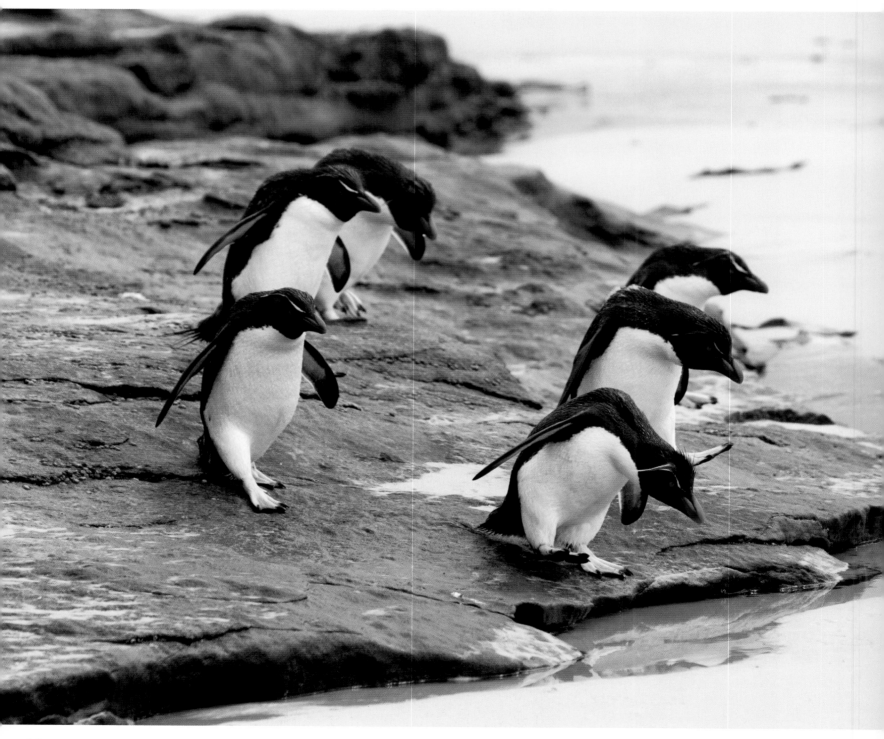

Rockhopper Penguins, Saunders Island, Falkland Islands, January.

The Macaroni Penguin's bright crown feathers and its red eyes and bill are colored by carotenoids, naturally occurring pigments that the birds ingest with food. The color intensity of an individual determines its degree of attraction to a presumptive partner. The stronger the yellow or red, the better the bird's resistance to disease and negative stress, which may in turn determine its ability to raise a new generation.

Animals that spend a lot of time holding their breath underwater are subjected to an uneven supply of oxygen, leading to what is referred to as oxidative stress. Penguins, however, have a well developed method for ridding themselves of the harmful oxygen radicals that are formed when they dive and that would otherwise lead to premature aging of their tissues: their food contains plenty of natural antioxidants. Paler feathers reveal a lack of antioxidants in a penguin's diet. The color intensity of a Macaroni Penguin's elongated feathers is thus perceived as a reliable signal to a potential mate, revealing its genetic makeup and its health status.

Overleaf Juvenile Gentoo Penguins get together at the "penguin nursery" at The Neck on Saunders Island, while their parents forage for food.

Gentoo Penguins, Saunders Island, Falkland Islands, January.

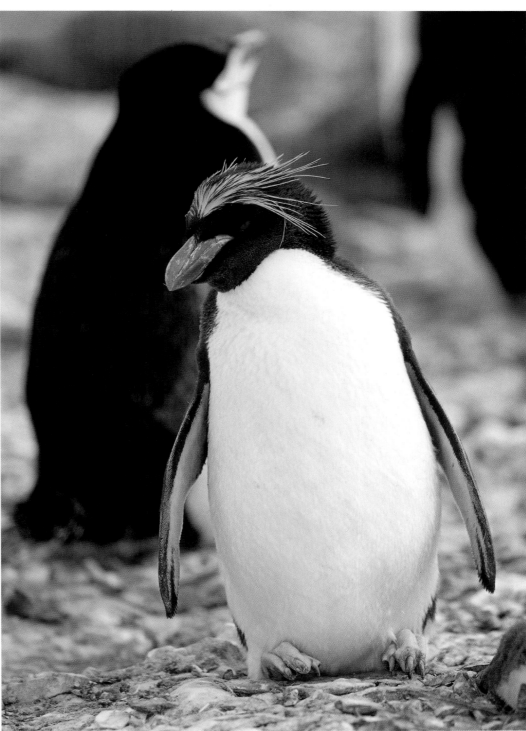

Macaroni Penguin, Hanna Point, Antarctica, January.

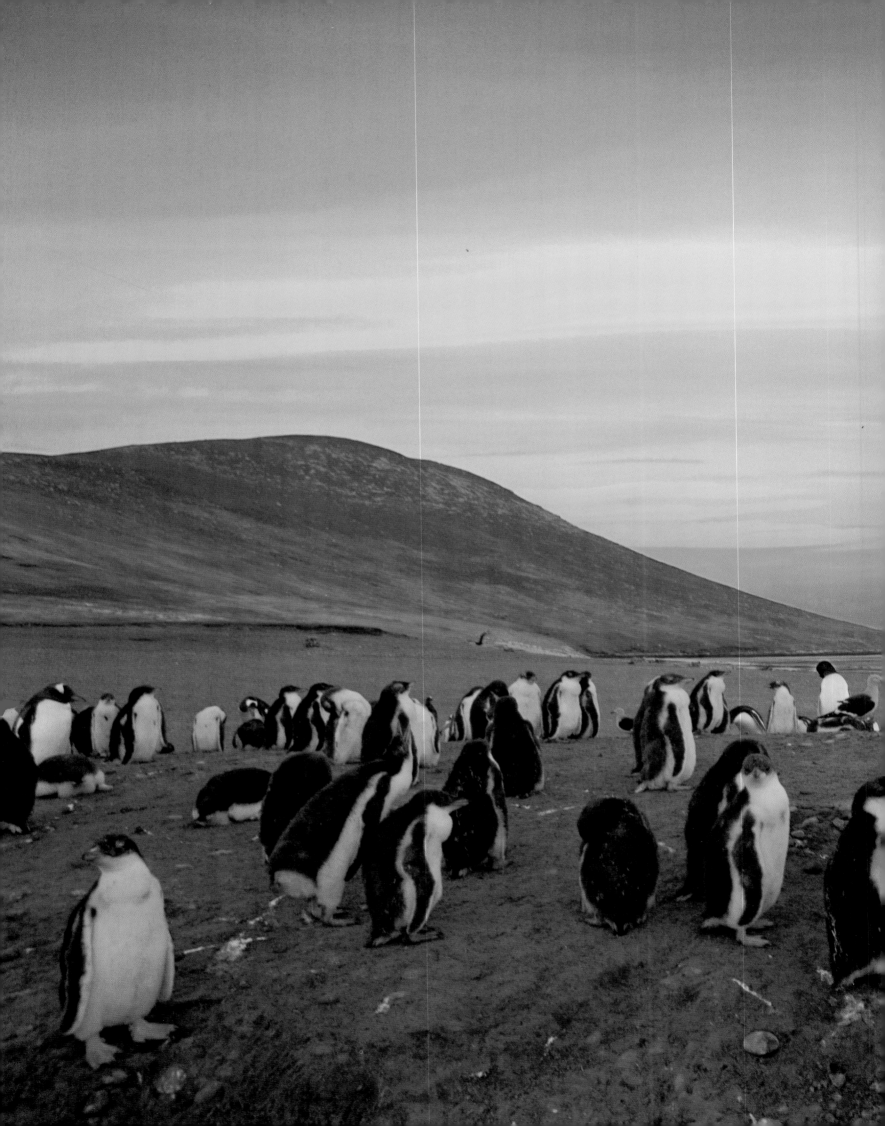

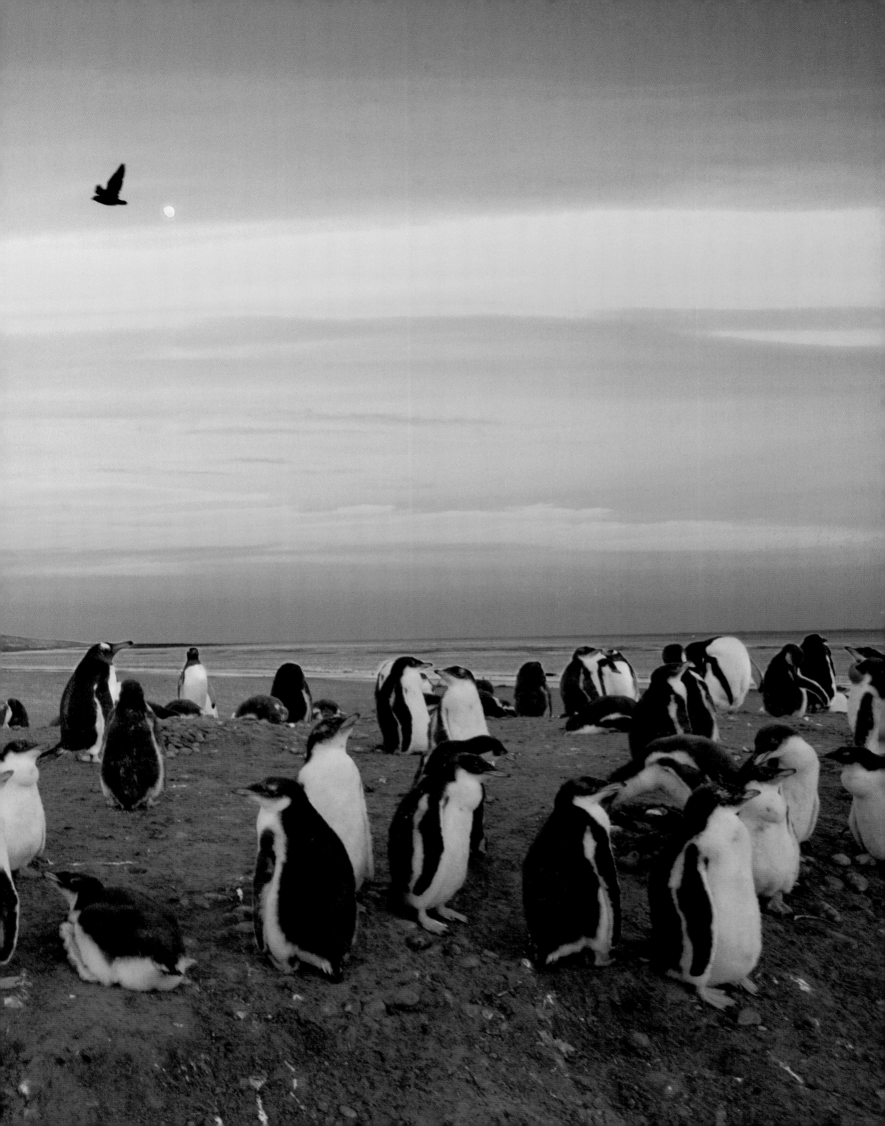

Life in the sea

PENGUINS CANNOT FLY, but you need take only one look at their spool-shaped bodies to realize they are extremely well adapted to water. In order to be able to take advantage of the immense food resources the ocean offers, penguins have also developed a way of transporting and storing food that is unparalleled among birds. They must, however, raise their young on land or on ice. This is why we tend to find millions of penguins in colonies on isolated islands and beaches, where competition between individuals has more to do with gaining access to a place in a land-based colony than to food supply.

It is not only the shape of a penguin's body and flippers that are suited to an aquatic existence. Other, less obvious, elements have also contributed to its adaptation to the environment in which it lives. The plumage's ability to maintain an insulating air pocket next to the skin is vital to keep penguins warm when they dive in icy seawater. Large fat reserves also protect the body against hypothermia, and they allow penguins to survive long periods of starvation. The birds' ability to distinguish the call of their partner and chicks among the deafening cacophony of sound in the surrounding colony is impressive, as is the way their eyes have adapted to function under water as well as on land. Not only this, but their digestive system copes with vast amounts of food that other animals find both hard to digest and poisonous. Furthermore, penguins are able to lower the temperature inside their stomachs during dives in order to slow down physiological processes that require oxygen, thereby maximizing the amount of time they are able to stay underwater—something that can also be useful during migration. Emperor Penguins are best adapted to holding their breath, and regularly stay underwater for up to 15 minutes.

It is obvious that penguins have adapted to the extreme environment in and around Antarctica, with its long periods of extreme, subzero temperatures. The limiting factor is not the cold, however, but food supply—as long as there is plenty to eat, there are always species that will adapt. The extreme climate has, however, made all "uneconomical" body features redundant, and these have been replaced with forms that are better suited to the climate. This includes good insulation, rounded shapes, and a large body volume. Penguins are an amazing example of how the lives and appearance of different species adapt to their surrounding environment.

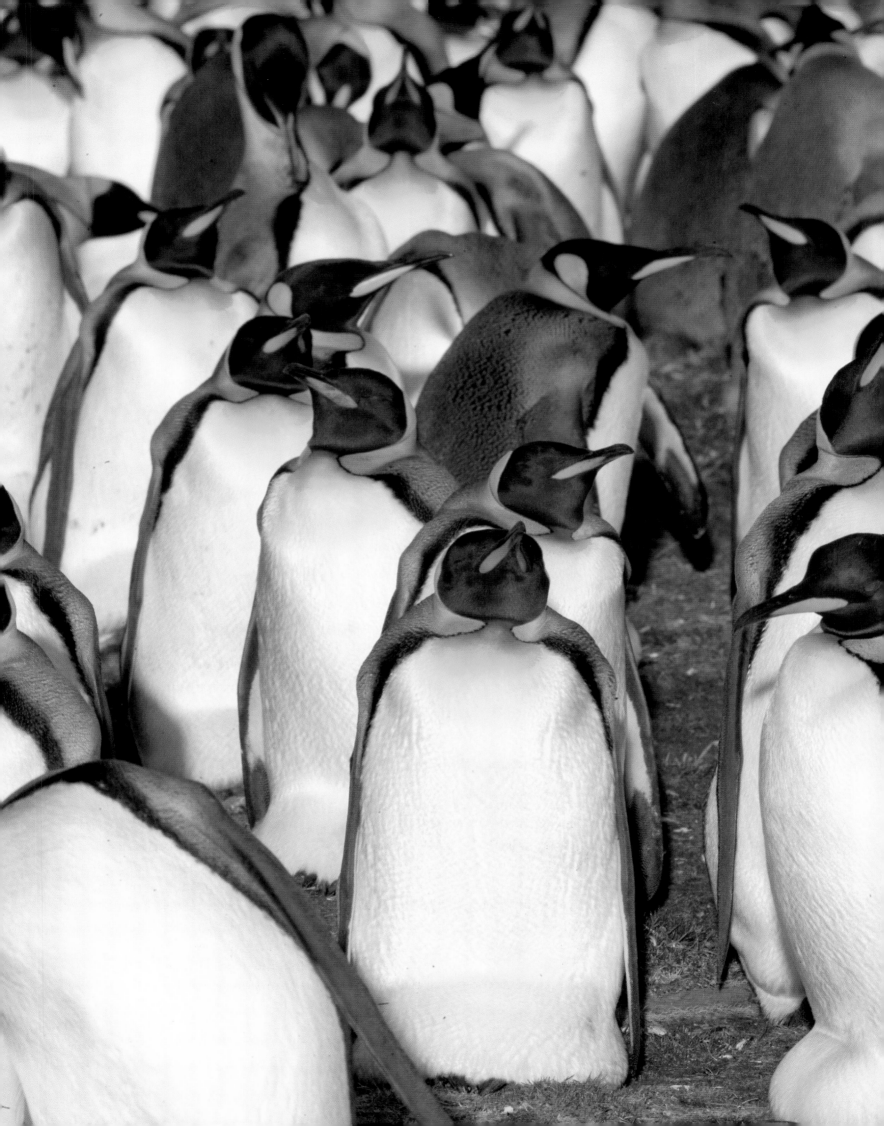

Penguins' wings, or flippers, are short and stiff and cannot be used for flying. But can the birds really not fly at all? It depends on how you look at it. They do, in fact, "fly" through the water, using their flippers for propulsion. To do this, they need powerful muscles, which are attached to the oversized breastbone. Their webbed feet and their legs are used only for steering.

Penguins live most of their lives in the water. Adélie Penguins, for example, spend less than one-fifth of their time on land. Over millions of years, penguins have adapted to their two disparate environments: the land and the sea. They have very short legs, and their characteristic waddle is all down to the fact that evolution has simply eliminated one of their leg joints. The reason for this is that articulated legs cause species that spend most of their time in the water to waste energy.

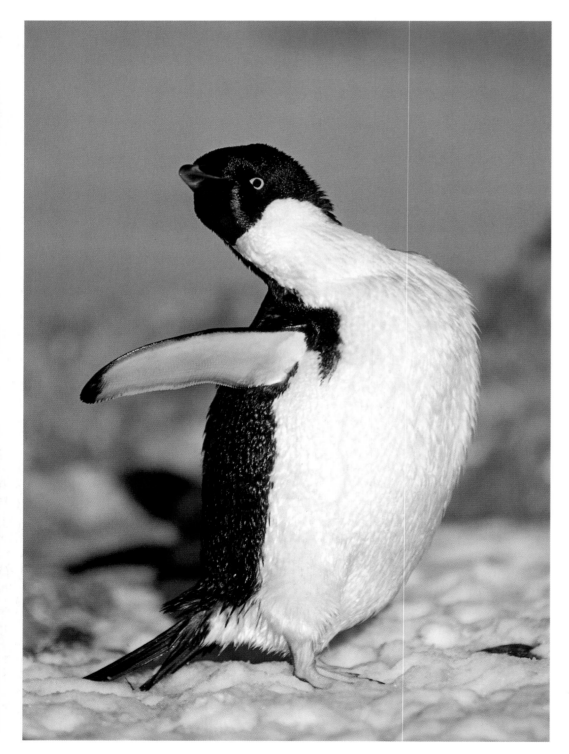

Overleaf. Although they are better adapted to an aquatic environment, Magellanic Penguins live on land during the breeding season. No bird has developed a more functional shape or is better suited to life in the water than the penguin, so Magellanic Penguins on land look somewhat out of place, especially alongside the cows and sheep with which they coexist. In the Falklands, Magellanic Penguins frequently nest in pastures, and because they burrow under ground they can live among sheep with relatively few casualties. Cattle are a different matter, because, not surprisingly, the cows' hooves often damage the penguins' burrows. It seems that Magellanic Penguins have not developed any suitable behavior to keep the cattle away. Should another Magellanic Penguin enter their territory, however, it will be immediately and ruthlessly chased away. Magellanic males call out regularly in order to attract females and to signal their presence at the nest site to other males.

Magellanic Penguin, Saunders Island, Falkland Islands, January.

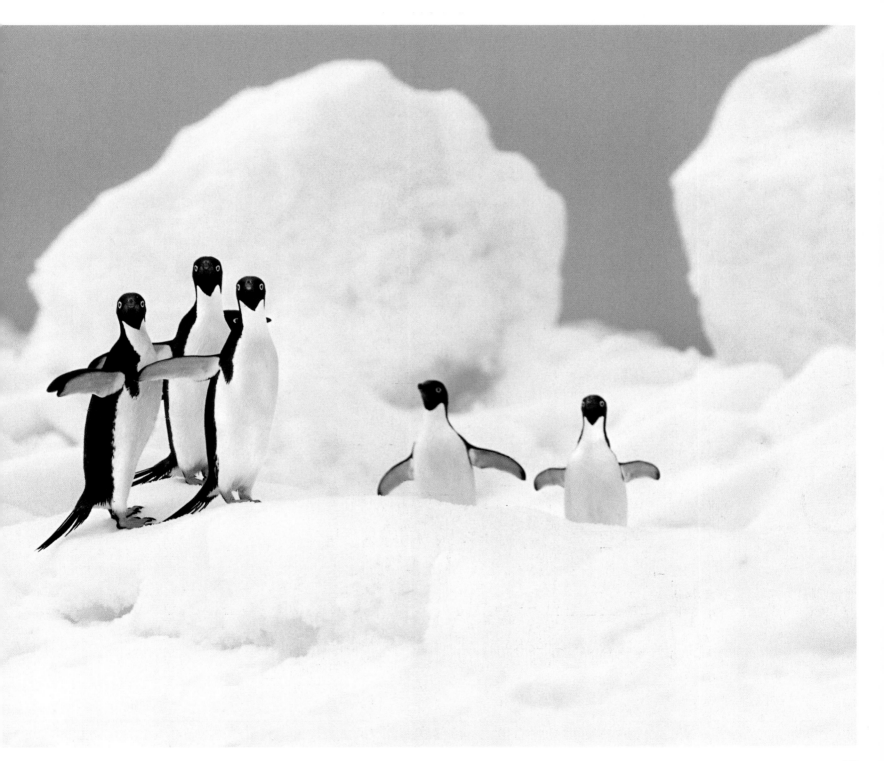

Adélie Penguins, Paulet Island, Antarctica, January.

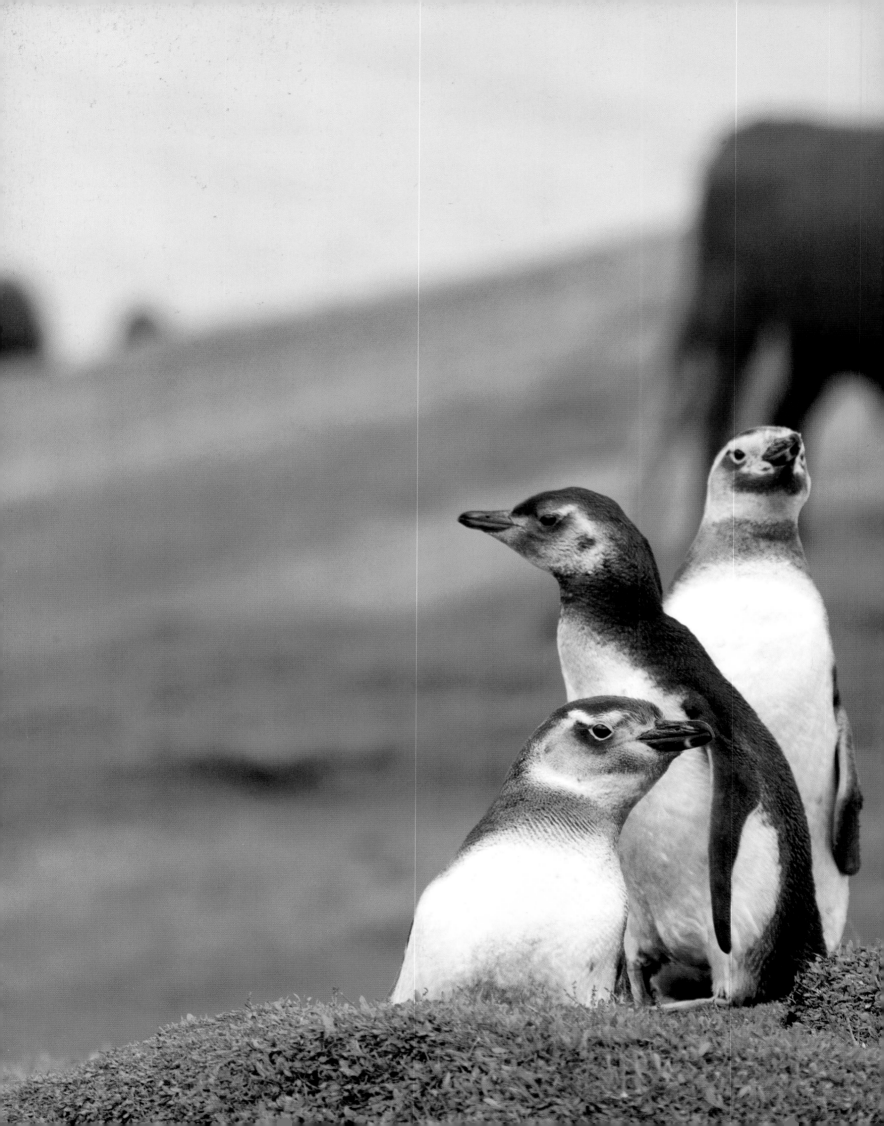

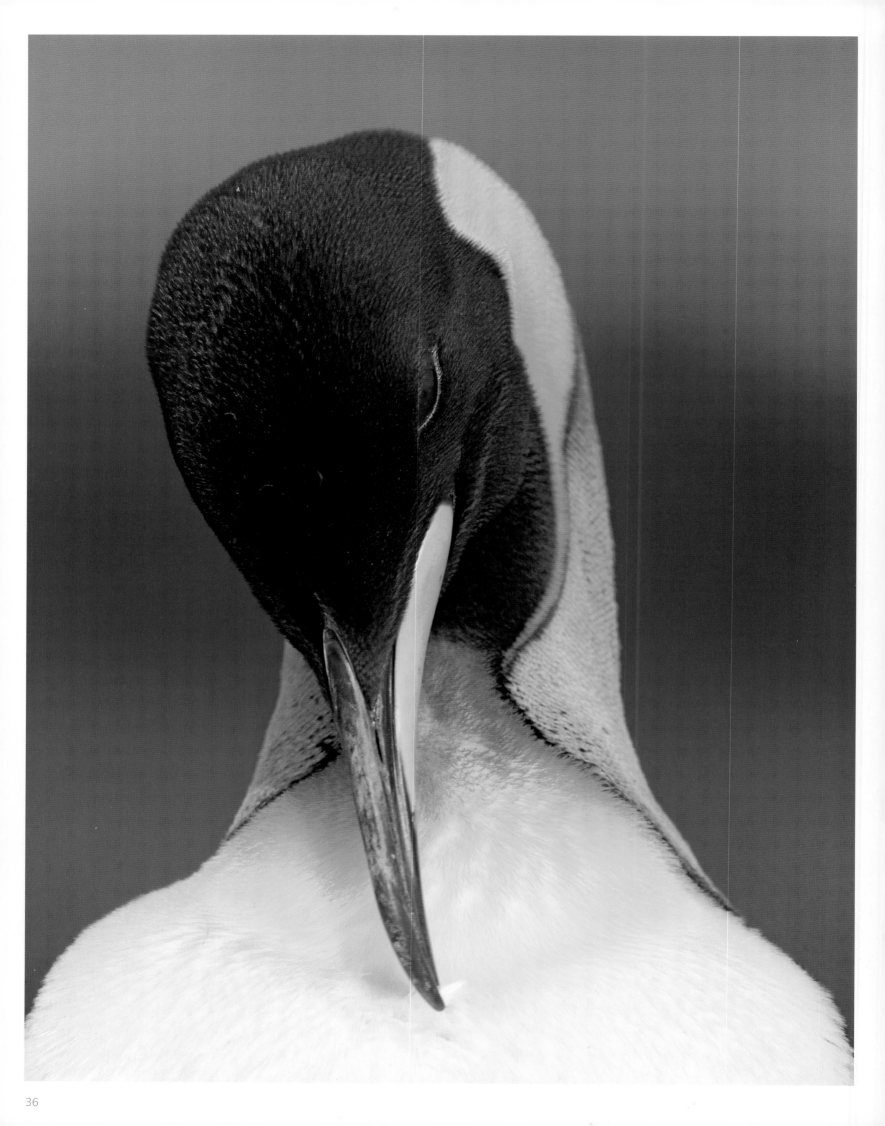

It almost looks as if King Penguins are wearing a coat of fur. In reality, their plumage is adapted to retain heat in extremely low temperatures. The feathers are hollow, and each individual feather hooks into the others, creating an air pocket nearest to the skin. Just like other birds, penguins shed and grow new feathers once a year through a process called molting. Obviously, the birds cannot walk around naked in this extreme climate, which is why they have their own special way of molting. Unlike other birds, they do not shed their old feathers as soon as the underlying feathers start to appear, but instead shed them only when the new feathers are fully developed. This is why penguins often look a little scruffy during the molting season.

Molting is so energy consuming it must be "planned" so as not to coincide with other high-energy activities during the year. Penguins cannot molt and feed their chicks simultaneously, for example. As the new feathers start to show, parts of the skin become exposed—the birds would soon start to freeze in the icy water, which is why they molt on land. The entire molting process takes between three and six weeks.

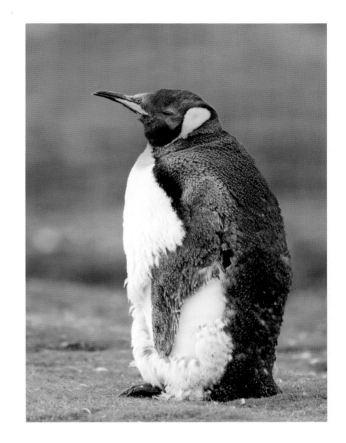

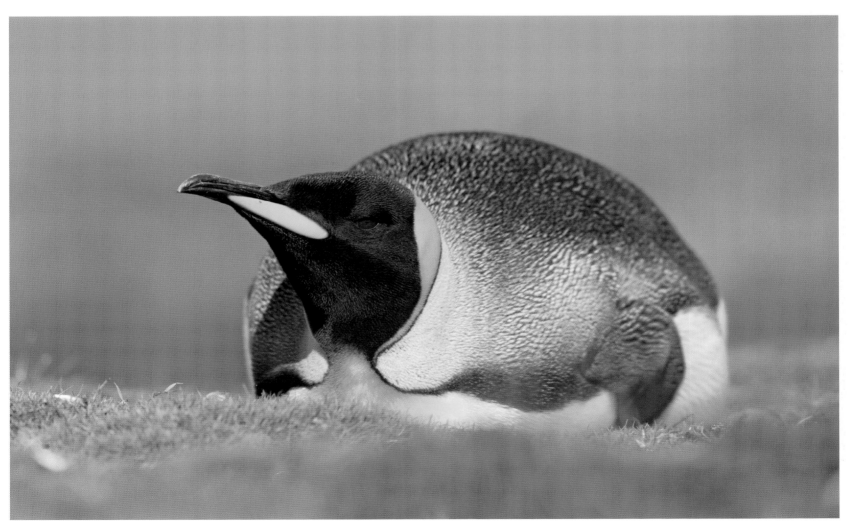

King Penguin, Volunteer Point, Falkland Islands, February.

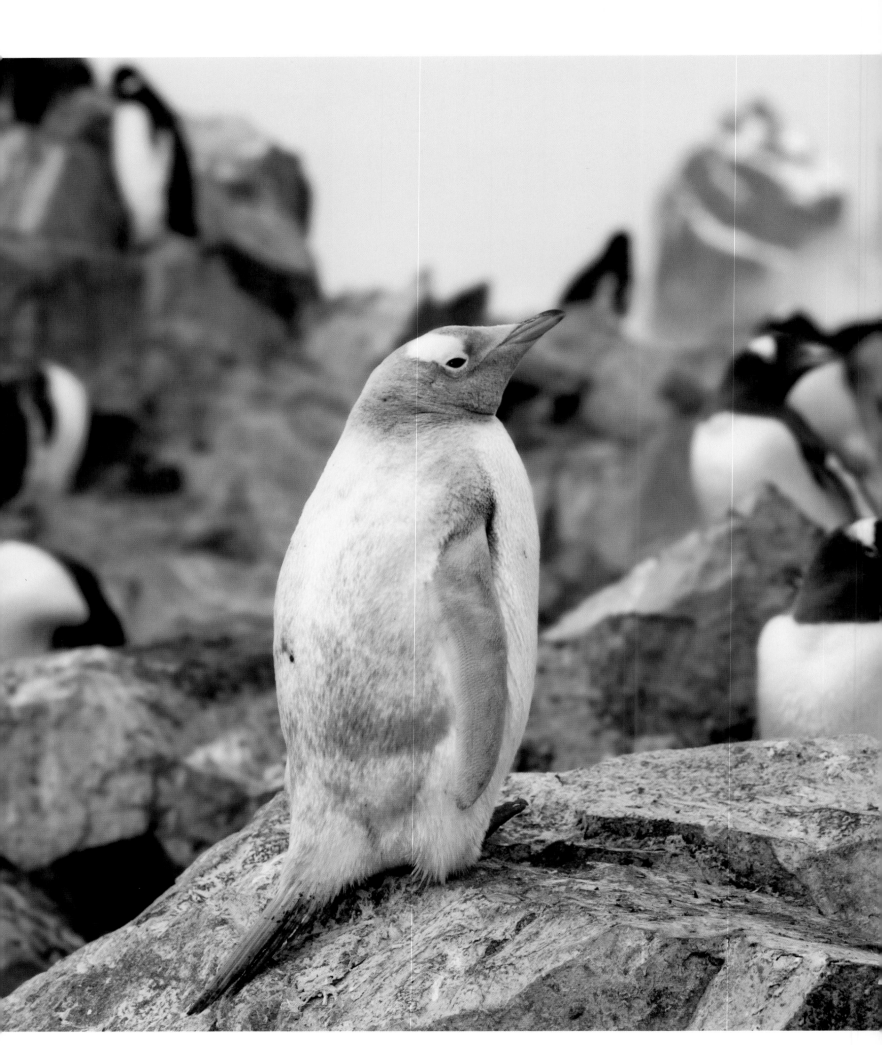

Gentoo Penguin, Antarctica, January.

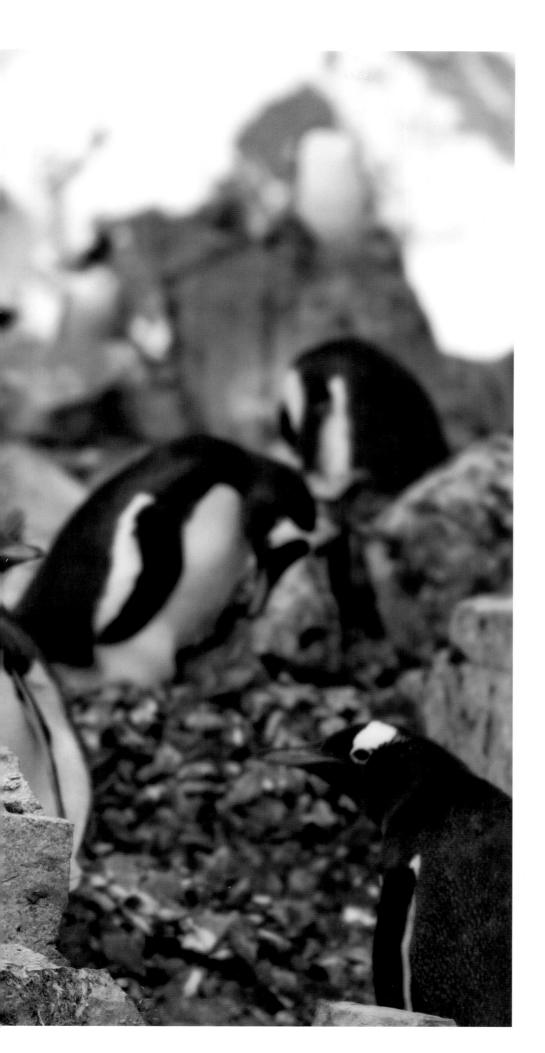

Most penguins are almost exclusively black and white, although there may be variations in pattern. Some species also have a few brightly colored feathers on their crown or a mottled bill. It is common for animals that swim in water to have a light-colored belly and a dark back. This makes them less visible to predators approaching from above and below—a pale underside is harder to see against the bright sky, while a dark back is less easily discerned against the dark bottom of the sea.

Penguins that look very different seldom find a mate, because the characteristic contrast of black and white is an important signal when choosing a partner. An albino penguin is the result of genetic mutation. Such a bird lacks melanin (brown and black pigmentation) in its feathers and other areas of the body. Other variations are also caused by mutations. Some birds are leucistic (yellowish) and isabelline (pale) plumages, which are caused by a reduction in pigmentation. The Gentoo Penguin pictured opposite, which has not yet found itself a partner, has this "washed-out" look.

Occasionally, only part of the plumage shows variations in color or pattern. Albino birds often lack pigmentation in their eyes, which leads to impaired eyesight, especially in strong daylight. Albinos face serious difficulties. Their difference in color makes them easy for predators to spot, and their poor eyesight makes them less aware of dangers. Not surprisingly, albino animals generally have a shorter lifespan than other members of their species.

Walking is one of the most energy-consuming means of getting from A to B. Despite this, a number of penguin species walk for miles across land and ice, moving between their foraging and breeding grounds. Isn't this a waste of precious energy in such extreme temperatures? The fact is that their swaying gait—a kind of oblique waddle caused by their short legs—allows Rockhoppers and other penguins to recycle one-fifth of the energy expended at each step they take on land.

Is it just as strenuous for a penguin to move in water as on land? The answer is no, because water provides buoyancy. The amount of energy required to swim depends on the weight of the penguin. Bird skeletons are generally made up of light, hollow bones, but penguin bones are dense and heavy. Because they are unable to fly, there has been no need for penguins to minimize their weight. It is more important for a penguin to be heavy—as heavy as water—in order for it to minimize energy expenditure through not having to counteract the force that would propel a lighter body toward the surface.

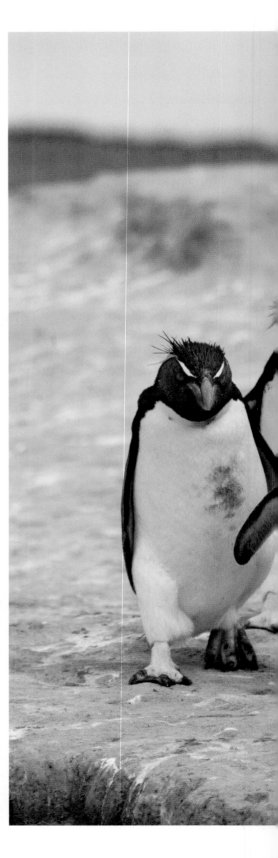

African Penguin, Simon's Town, South Africa, March.

Overleaf Penguins and marine mammals that hold their breath when diving regularly suffer from apnea, or oxygen shortage, as the gas-exchange system is closed off. Lack of oxygen is potentially harmful to the body's cells and leads to impaired muscle function, so penguins need to store oxygen in order to be able to continue swimming throughout the dive. Oxygen is stored in the muscles with the help of myoglobin—the more myoglobin a penguin has, the deeper and longer it is able to dive. King Penguin chicks are born with only a small amount of myoglobin, and this increases with age. As is the case with whales and seals, myoglobin in penguins does not reach adult levels until the juveniles start to dive, and it increases gradually as they adapt to greater depths. Adult King Penguins regularly forage for food at depths of 1,100ft (340m).

King Penguin, Volunteer Point, Falkland Islands, February.

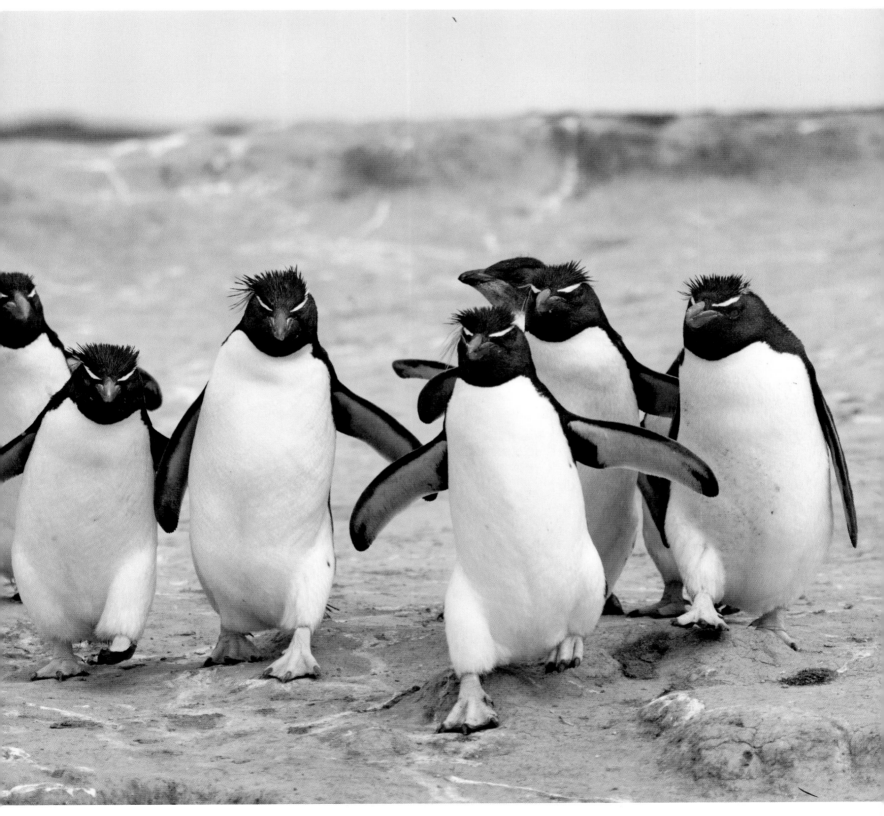

Rockhopper Penguins, Pebbles Island, Falkland Islands, February.

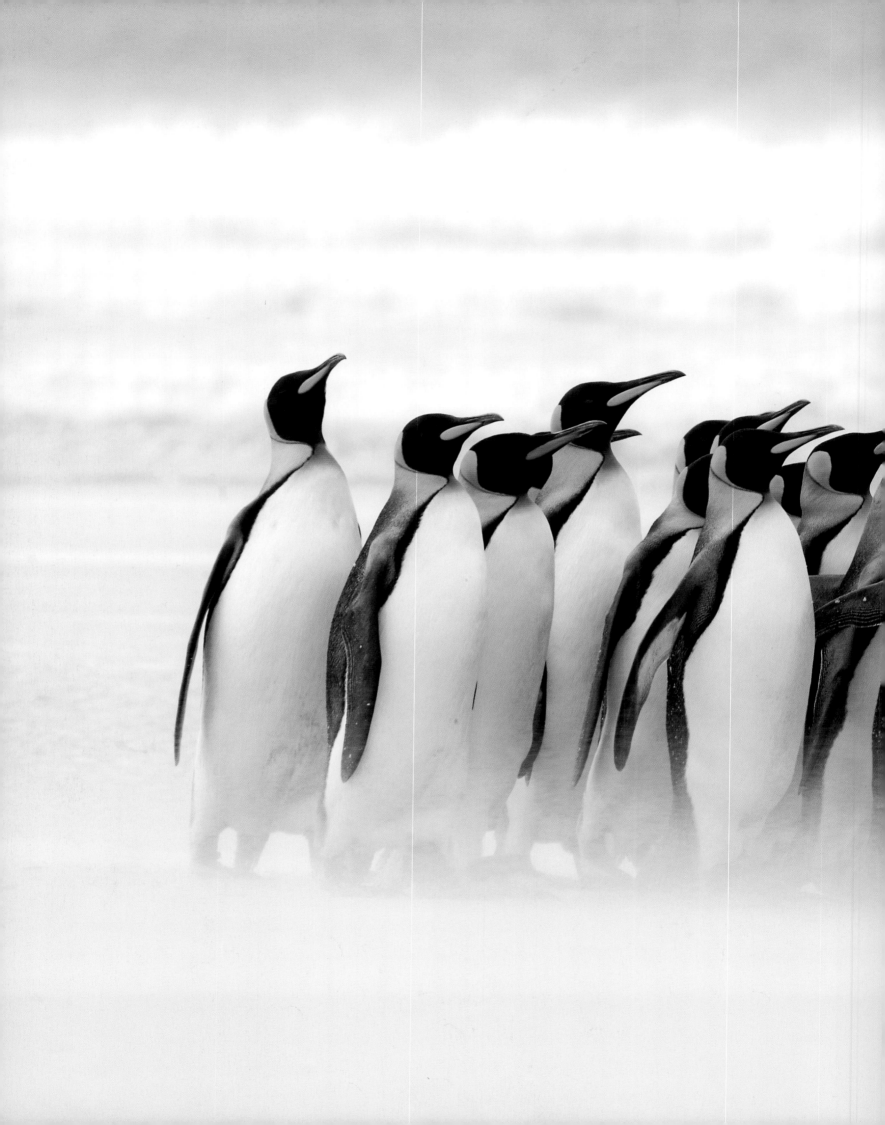

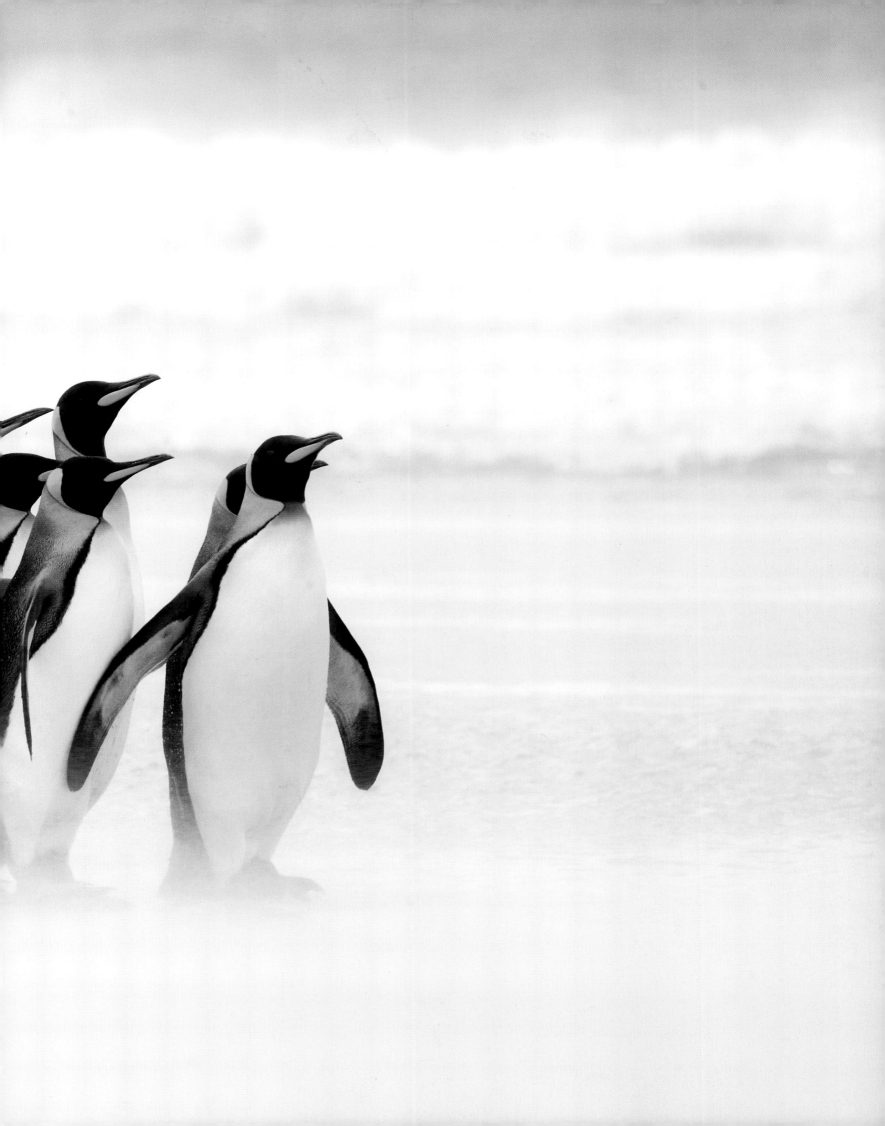

Like other species that breed in the extreme south, the Gentoo Penguin has an insulating layer of fat to help it survive low temperatures, as well as a warm pocket of air closest to the skin within the tight-fitting, heat-storing plumage. Next to the body it has a dense, fluffy layer of down, which helps it extend its outer feathers while diving. These outer feathers hook into one another with the help of an oily secretion, and lock the air in place during submersion, making them tight-fitting enough to withstand icy hurricane-force winds of up to 90mph (145km/h) on land. The secretion comes from a couple of glands at the base of the tail, and is applied during preening. No oils are used on the chicks' plumage; instead, it resembles a coat of fur. Molting occurs in patches, always ending with the head.

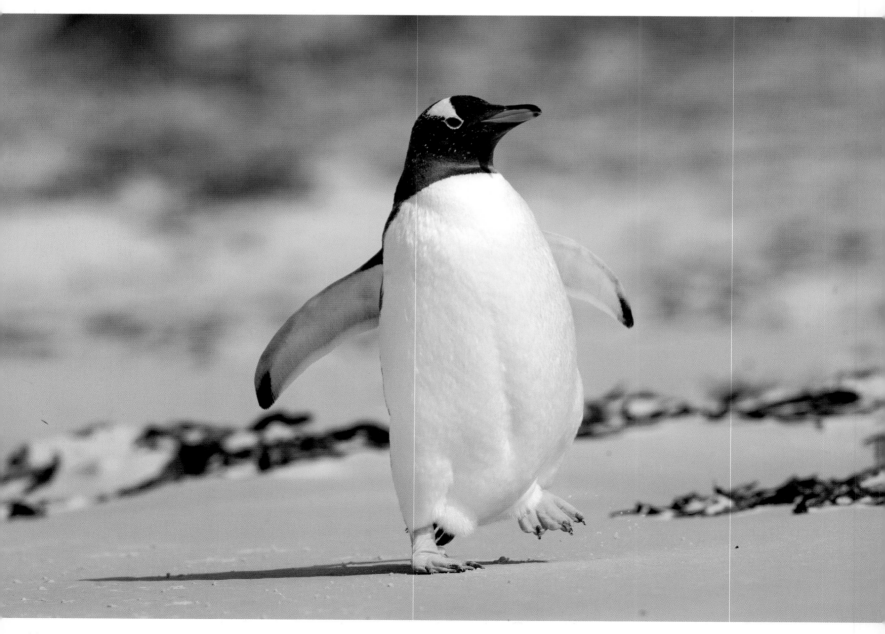

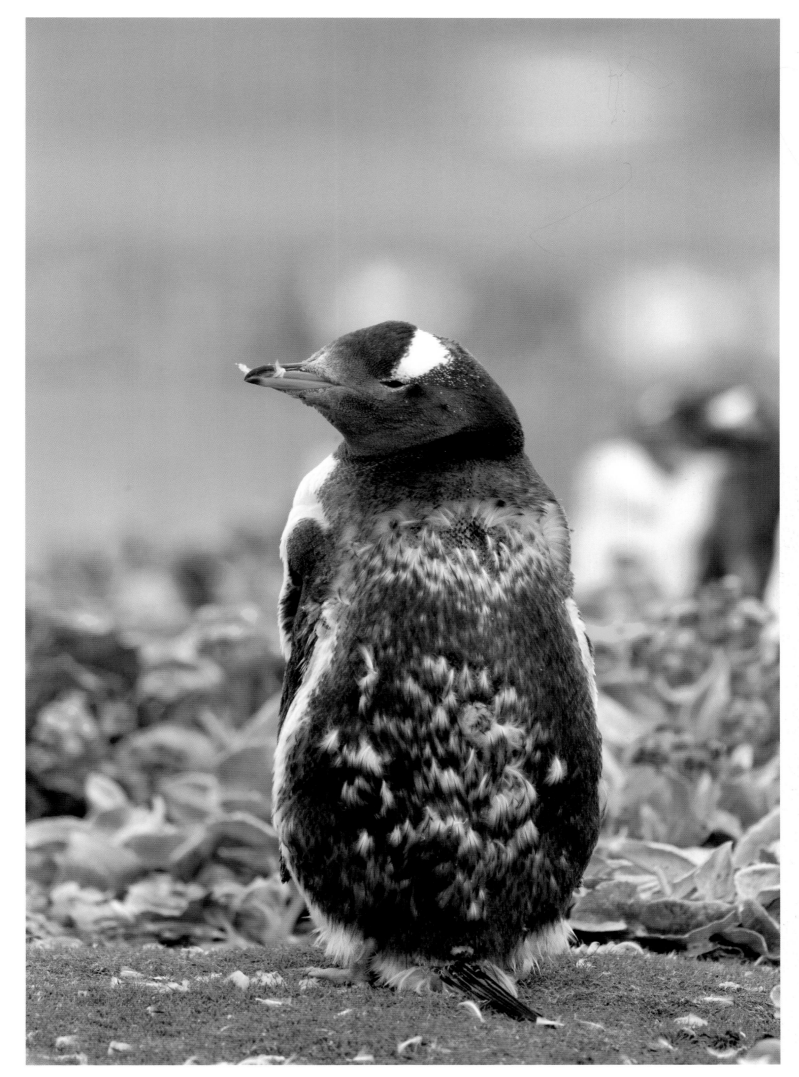

Gentoo Penguin, Pebbles Island, Falkland Islands, February.

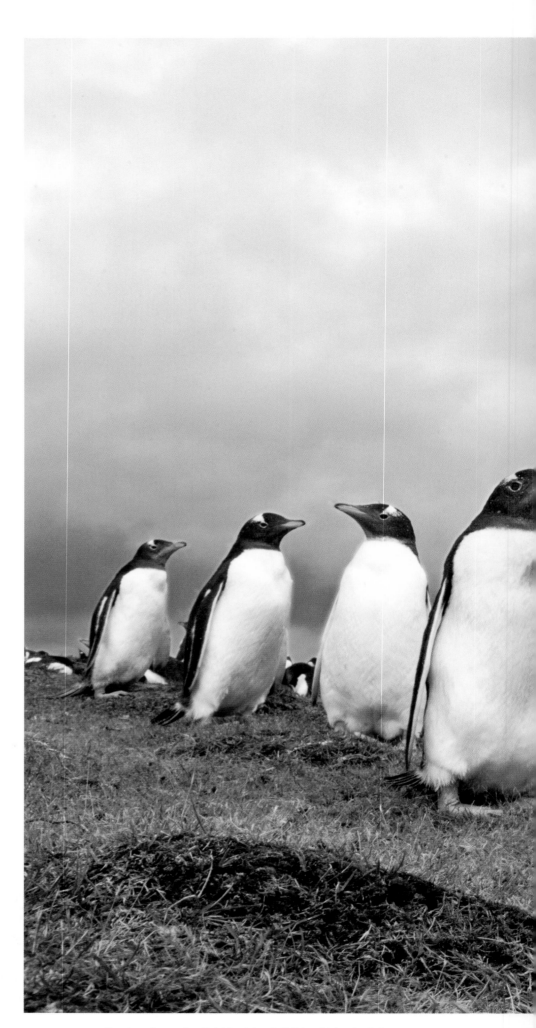

Penguins have a lower body temperature than other birds and an almost unique ability to regulate it. This allows penguins to live in temperatures ranging from −76°F (−60°C) in the Antarctic to +104°F (+40°C) near the equator, something achieved by no other bird. It is easier for penguins to adapt to life in water than to conditions on land, because variations in temperature there are smaller. In fact, they have greater difficulty in shedding excess heat and avoiding hyperthermia on land than they do coping with low water temperatures. But how do they avoid overheating? The answer is that they pant, open out their flippers, and separate their feathers to let body heat radiate from the many blood vessels on the surface of the skin. When they need to spend long periods on land, some species that live near the equator shed feathers around the bill and eyes in order to expose bare patches of skin.

In contrast, the world's southernmost penguin species, the Emperor, has extra feathers on its legs and bill to avoid hypothermia. These birds also reduce heat loss by leaning on their heels and rump, thereby minimizing their contact with the ice. In order to avoid frostbite, penguins have a kind of heat exchanger in their feet and legs. Blood vessels leading to and from the heart are placed next to each other so that the blood flowing out from the heart heats the blood flowing from the feet into the body. Even so, the temperature of an Emperor Penguin's feet can still be as low as 43°F (6°C) while the rest of its body maintains a temperature of 102°F (39°C). Gentoo Penguins are not exposed to the same extreme temperatures as some species, but they do sometimes use their flippers as cooling flanges when they feel they are getting too hot.

Gentoo Penguin, Pebbles Island, Falkland Islands, February.

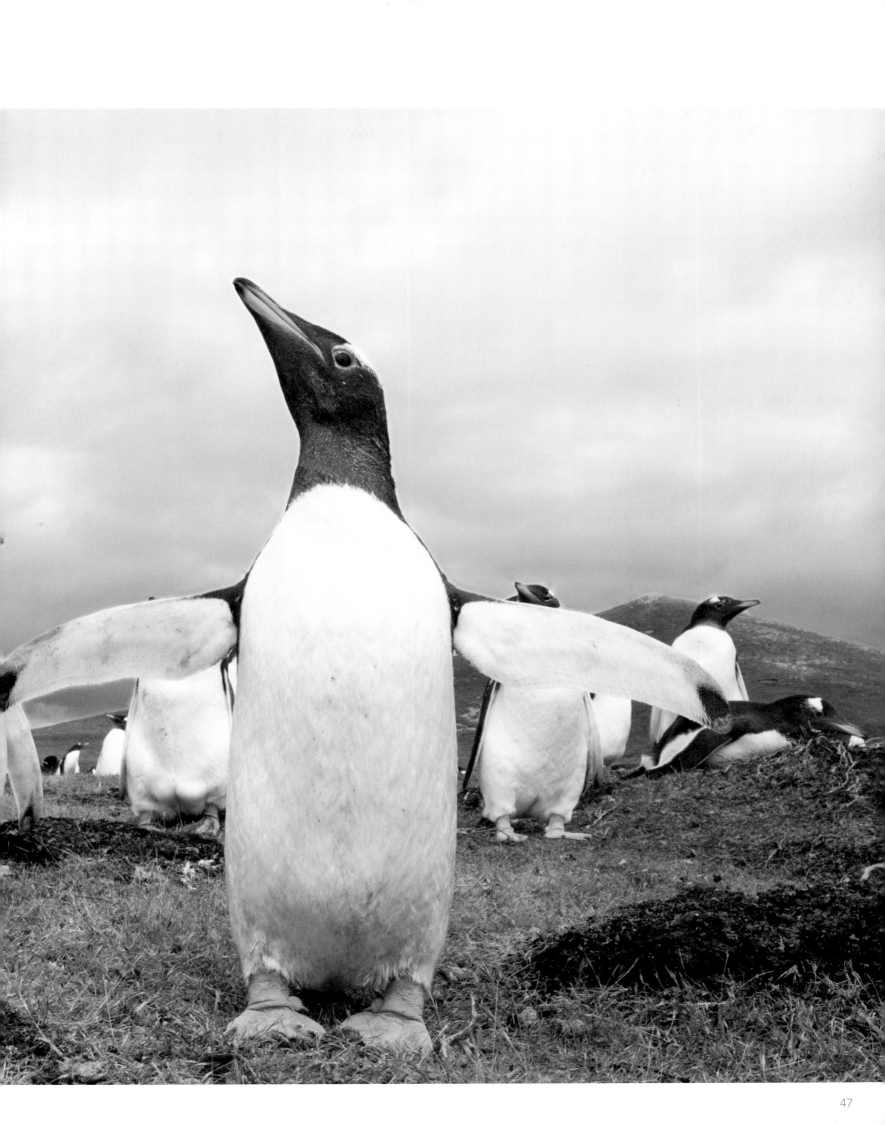

The Rockhopper Penguin got its name from the way it hops from boulder to boulder, but it is not the only penguin that does this. On land, penguins walk, hop, and slide around ("tobogganing") on their bellies. They have three ways of moving in water, too: they swim near the surface; they "fly" underwater; and they skim across the surface like dolphins. The first mode is the slowest and consumes the most energy, because the birds need to keep their heads and tails above the surface, thereby creating turbulence. Counteracting the backward pull caused by this turbulence uses up a lot of energy, so the birds tend to stay deeper unless they need to preen or rest on the surface.

"Flying" underwater using its flippers is a penguin's preferred method when diving for food, while propulsion by dolphin-like movements near the surface is used by the smaller species as the larger species cannot swim fast enough. It is not clear why the birds do this, but it is a comparatively faster means of locomotion and they probably use it to see where they are going, as well as making it easier to breathe. In addition, by regularly coming out of the water Rockhoppers can replenish the warm air pockets stored in their plumage, which thereby prevents them from getting cold.

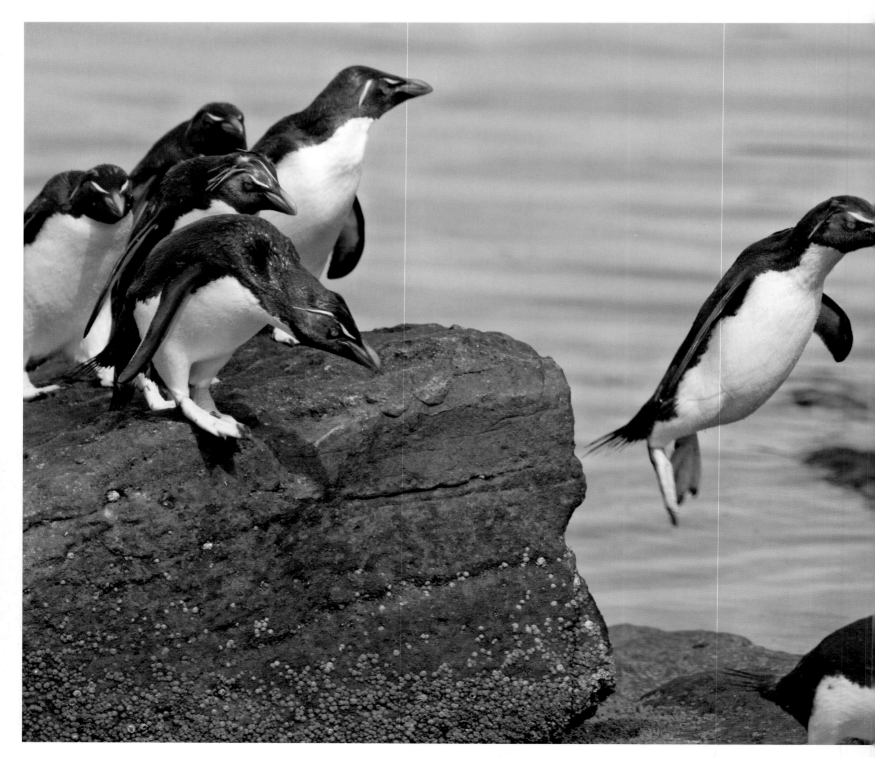

Rockhopper Penguins, West Point Island, Falkland Islands, December.

Overleaf Sleep is vital function in most animals. It is a period when the brain and nervous system are able to recover and process important information. Birds living in areas with a midnight sun also need to sleep, but this can be difficult in the constantly active penguin colonies. The King Penguins of the Falklands are at their busiest during the early hours of the morning, when many birds come and go. Birds that are trying to sleep are disturbed by passersby that try to avoid going near those that are awake, because these birds will try to protect their nests by using their sharp bills to attack any that come too close. King Penguins in large colonies therefore sleep best in the afternoon, when, if they are lucky, things are a little quieter.

King Penguin, St. Andrews Bay, South Georgia, January.

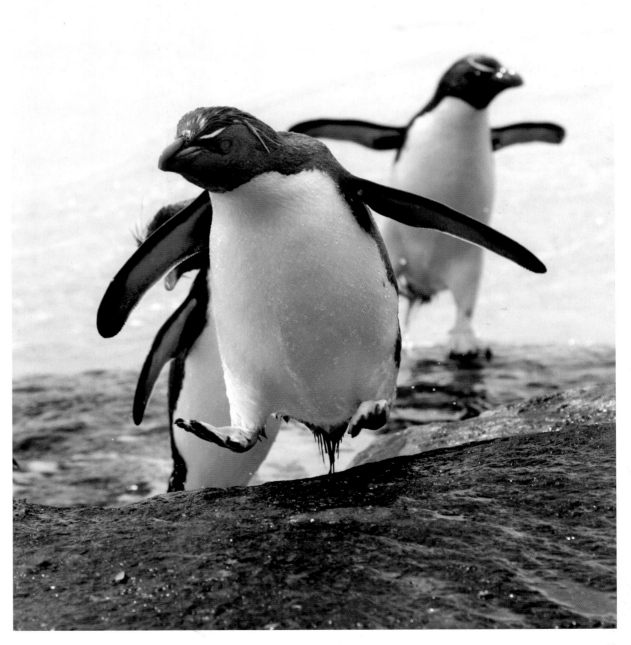

Rockhopper Penguins, Saunders Island, Falkland Islands, January.

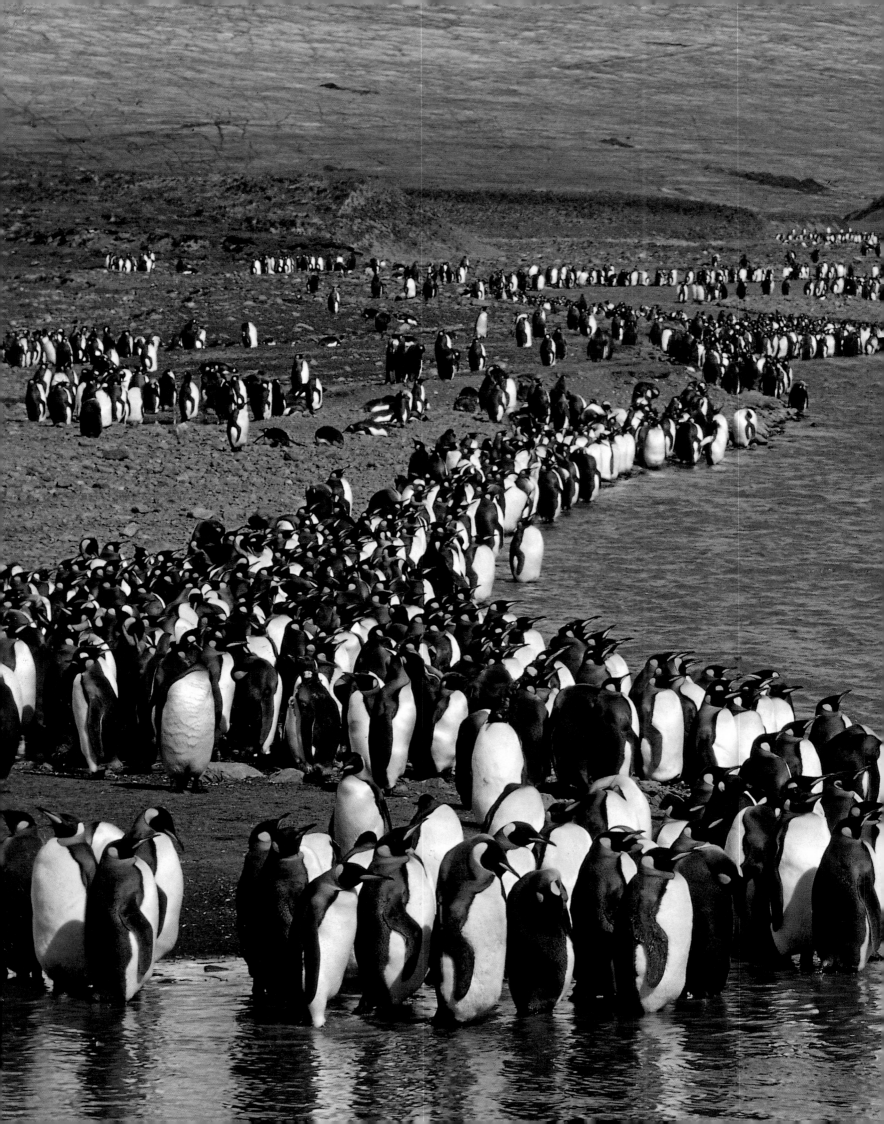

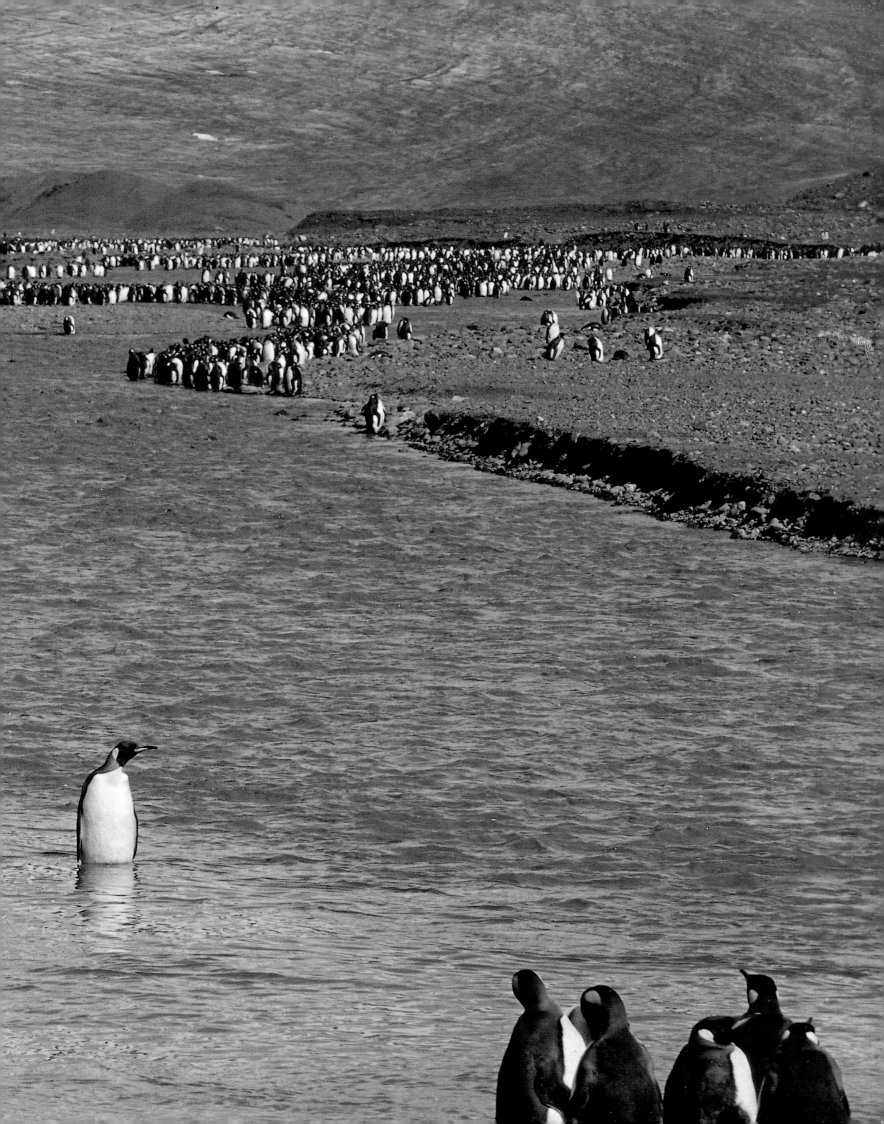

Rockhopper Penguin chicks do not have the red iris of adult birds. Instead, the iris is still dark, which protects the eye against strong sunlight. The red eye color appears as the chick matures.

In contrast to their mostly black and white plumage, penguins' bills, feet, and eyes are brightly colored. But why do Rockhoppers have red irises and are they really red? The color of the iris varies depending on how far south the birds live. A dark iris, which protects the eye, is found in penguins that are exposed to strong ultraviolet light, which is harmful to the pigmentation of the eye and may cause permanent damage. The color of the iris also changes with age and can form part of the display plumage, with the purpose of attracting a partner. It may be bright yellow, as in the Yellow-eyed Penguin, or red as in adult Humboldt and Rockhopper penguins.

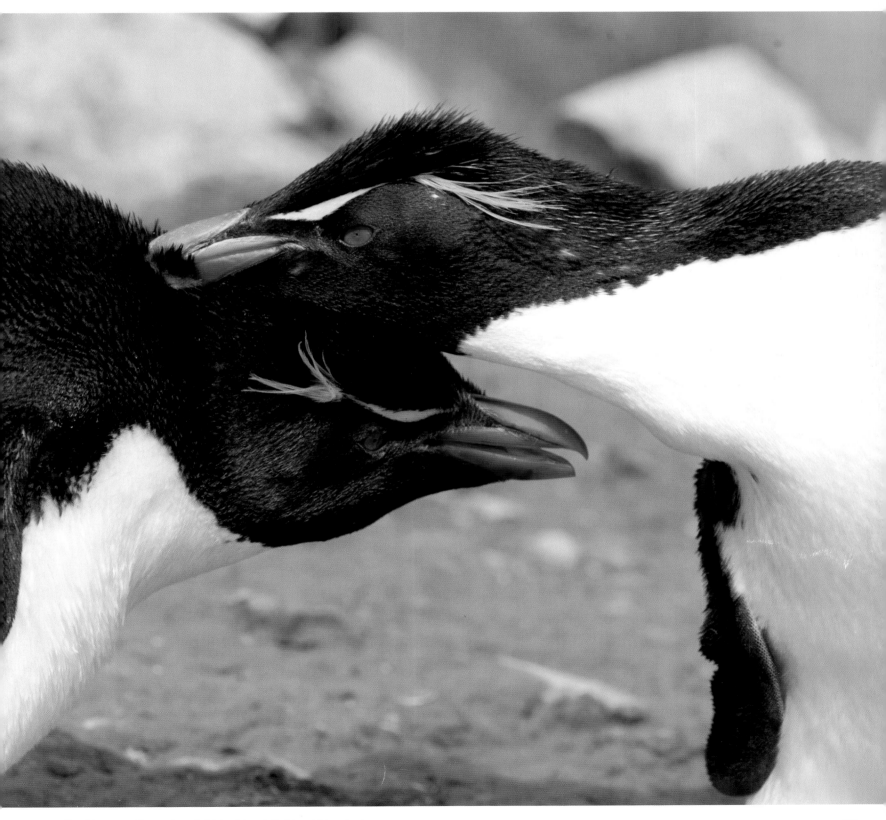

Rockhopper Penguins, Pebbles Island, Falkland Islands, January.

When a King Penguin incubates an egg, it stands for weeks at a time balancing it on top of its feet under a protective fold of skin. After the chick is born, the fold of skin, which is found in both parents, serves as a warm cover. The chick grows very quickly in just a few months, so that by winter it is nearly the size of an adult penguin and has built up more than double its weight in fat in order to survive four months on land without food. The supply of the King Penguins' marine source of food, lanternfish, varies from season to season. During the winter—normally a critical period for young animals still not used to foraging on their own—it is low. Consequently, the birds have adapted to staying on land and living off their fat reserves during this period, which uses up less energy than trying to catch fish in the sea.

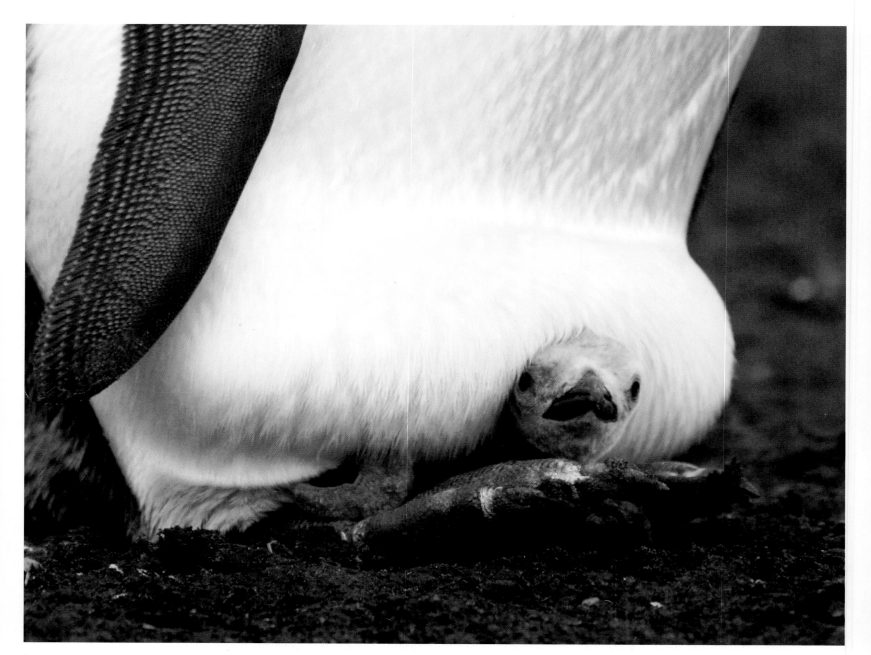

King Penguin, Saunders Island, Falkland Islands, January.

The Blue-eyed Cormorant feeds on fish it catches just off the coast of the penguin colonies where it lives. When looking for food, the bird depends on its good eyesight: its eyes are positioned to give good stereoscopic vision, which allows it to judge distances easily. Cormorants depend on fish and small animals for feeding their young, and sometimes they compete with the nearby penguins for food. Despite that, there is an advantage to living near a large colony, because the penguins may offer some protection against predators.

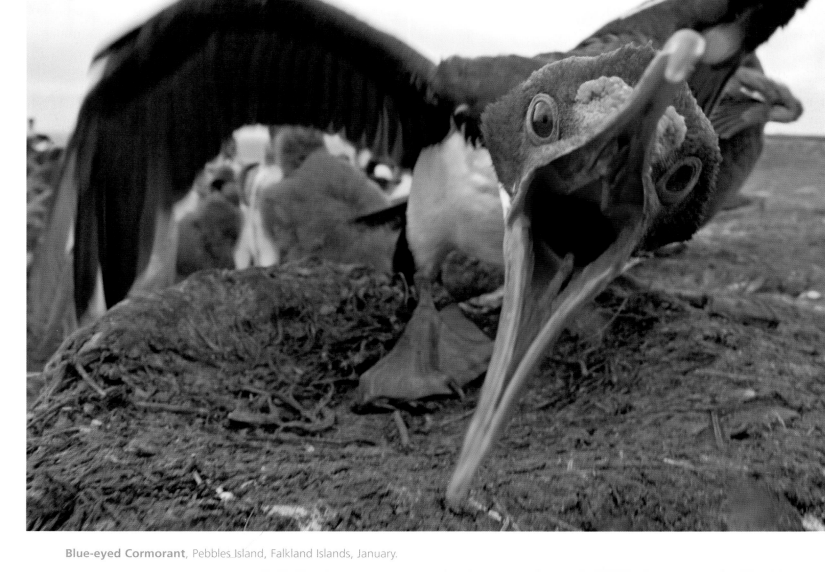

Blue-eyed Cormorant, Pebbles Island, Falkland Islands, January.

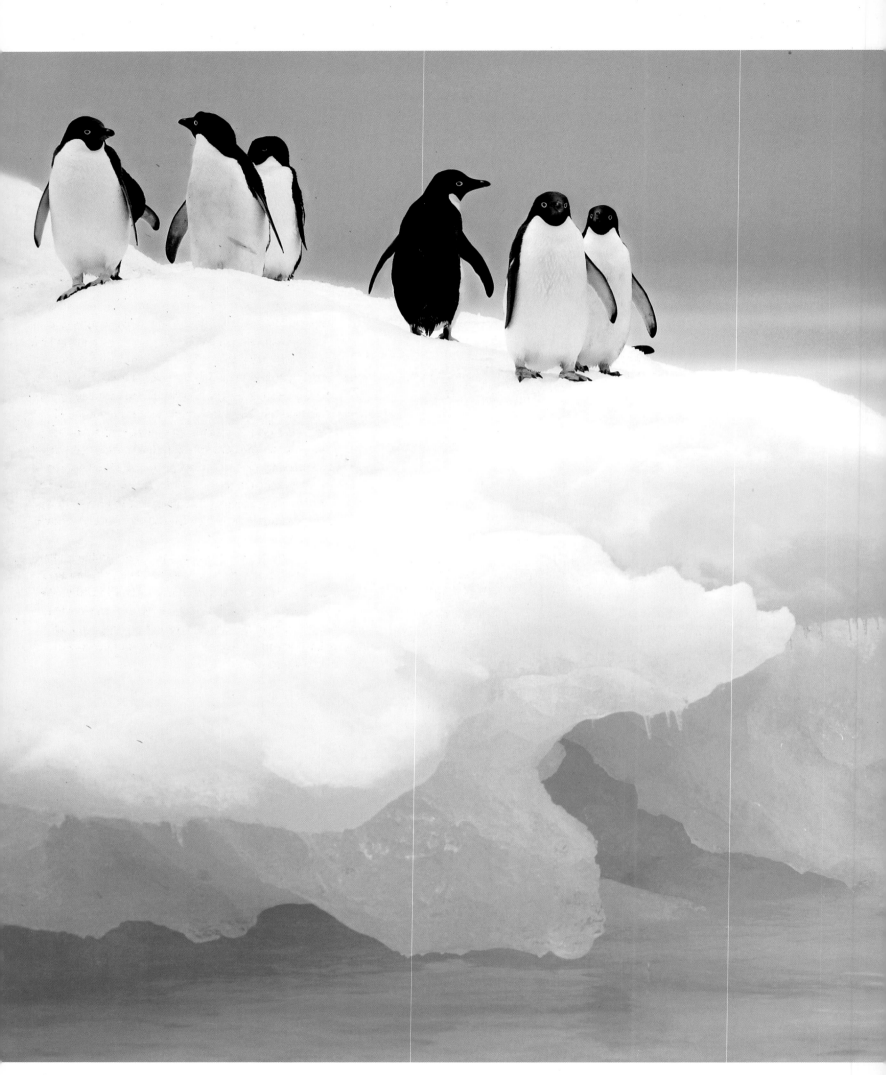

Adélie Penguins, Paulet Island, Antarctica, January.

Hormones govern several important physiological and time-regulated behaviors in birds. This applies, for example, to foraging, egg laying, fat storing, migration, and molting. Adélie Penguins live in a continuous daylight zone during the southern summer. Therefore, their hormone production does not vary over a 24-hour period in the way that it does in species living in areas with dark nights and bright days. In birds and reptiles, it is the pineal gland that regulates the diurnal rhythm by producing hormones governing activity and rest. Two such hormones, the production of which varies according to the amount of light during a 24-hour period, are prolactin and corticosterone. The levels of these are at their highest during the night, when penguins are normally at rest. In constant daylight, the normal diurnal variation of the hormone melatonin also becomes redundant, and individuals living in the same area may have completely different levels of it at the same time of day.

Penguins in continuous daylight zones have an internal clock that is not affected by external conditions. This control mechanism is usually adjusted by outside variations in light and by the number of hours of daylight, but it is turned off when there is not enough variation. It is still not known how penguins and other animals are able to cope with conditions of permanent light and how that affect their lives.

Magellanic Penguins have no teeth, at least not to chew with. Instead, they swallow their food whole or tear it apart with their bills like raptors. So how can penguins digest their food if they swallow it whole? The answer is that they use a trick they share with many other bird species—they swallow stones. The stones end up in the gizzard, the first part of their digestive system, where they grind the food to a pulp before it reaches the stomach and gut.

Penguins are apparently able to swallow quite a large quantity of stones. The zoologist Philip Lutley Sclater, who visited Antarctica in the late nineteenth century, reported that one Emperor Penguin was found to have 10lb (4.5kg) of pebbles in its stomach. It isn't only Magellanic and Emperor penguins that swallow stones, but all penguins, and if more than one individual sets its sight on the same stone it might even end in a fight. There are other advantages to swallowing stones, including the fact that they may function as ballast during diving, allowing the penguins to reach greater depths quickly and effortlessly in their pursuit of some special treat.

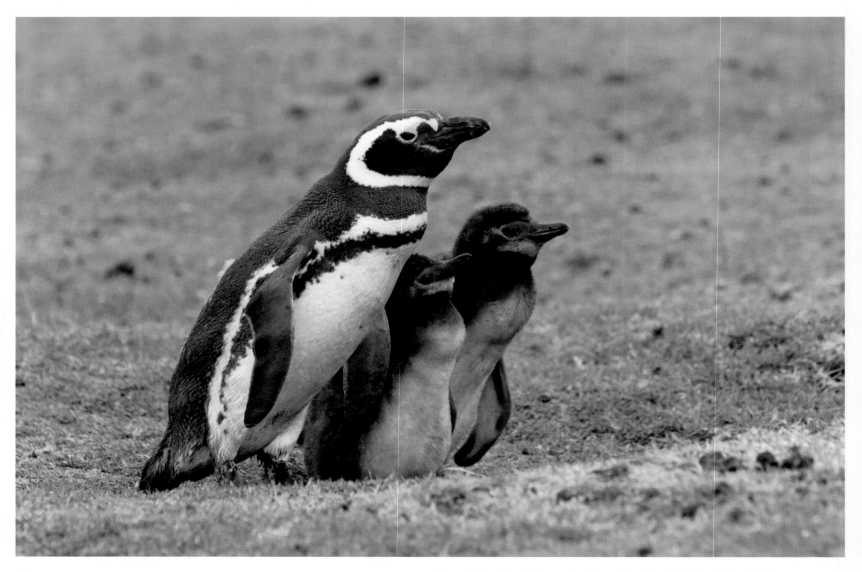

Magellanic Penguins, Saunders Island, Falkland Islands, January.

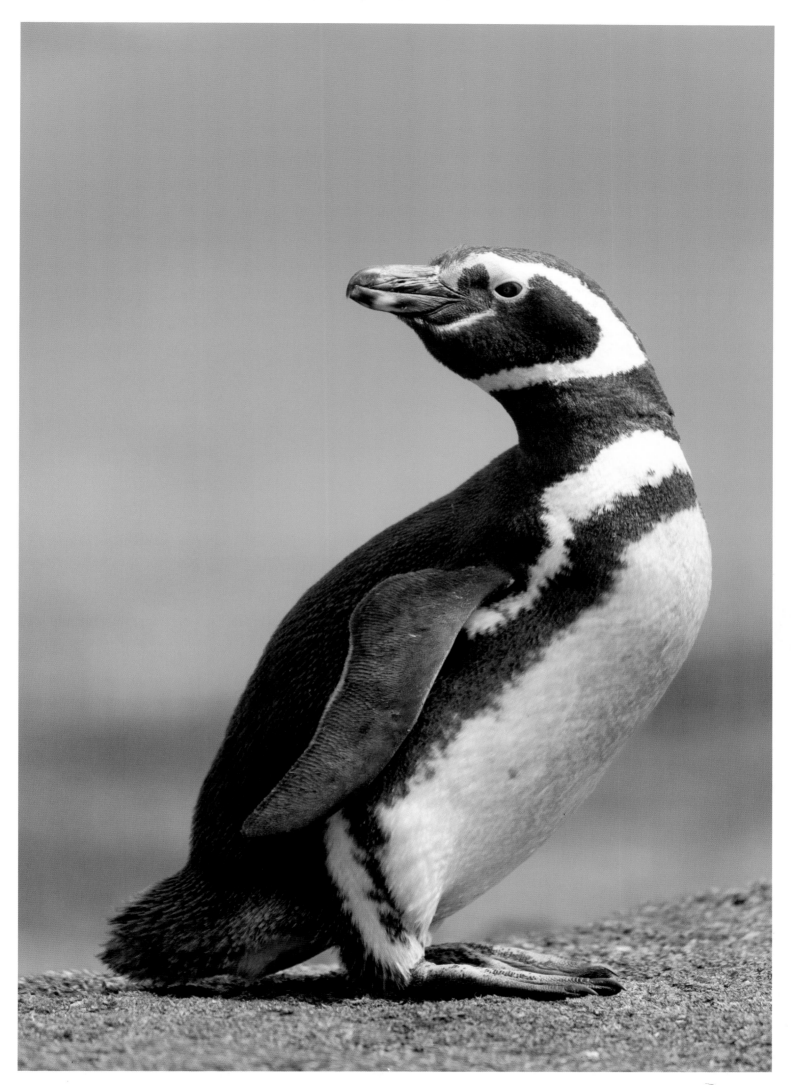

Magellanic Penguin, Carcass Island, Falkland Islands, December.

Life in the colony

A SINGLE PENGUIN colony can contain as many as several hundred thousand breeding birds. You might wonder why so many birds choose to live so close together. One of the main reasons for forming colonies is probably the limited availability of suitable seashore. Penguins have to nest on land or ice, but equally they want to have easy access to a plentiful food supply.

Another reason for huddling up together is that each individual bird becomes less exposed to predators. You sometimes even see adult penguins helping each other chase off predators. Birds forced to forage far from the colony have also developed another special form of cooperation: the older chicks stay at a "penguin nursery" while their parents are away. One or several of the adult birds watches over the chicks while the others make short foraging trips. In this way, all the parents take turns helping each other.

How can penguin chicks find their parents among a thousand, even a hundred thousand, other screeching birds? It seems that the King Penguin chick knows its parents by their voice rather than by the way they look or smell. Each parent has a unique call, and in the middle of the din it is enough for the chick to hear only part of it—it can identify a parent's signature in less than half a second. The call of adult birds also varies in strength, which helps the chicks determine the direction it is coming from.

So are there any disadvantages to life in a colony? Of course there are. For one thing, the proximity of other birds can be rather intrusive, making it difficult for penguins that are busy building nests to remain constantly alert and prepared to defend their patch. Penguins are dependent on a well preened and insulated plumage, so sanitation can also be a greater problem than you might expect. Parasites and diseases spread easily in a crowded colony where the animals are standing so close together. Finally, the more penguins there are in one place, the greater the risk that food will run out and the birds will be forced to swim farther and farther away to find new foraging grounds. Food availability in turn affects how successful the birds are at bringing up strong and competitive young, as well as their own chances of staying alive until the next season.

Adélie Penguins, Antarctica, January.

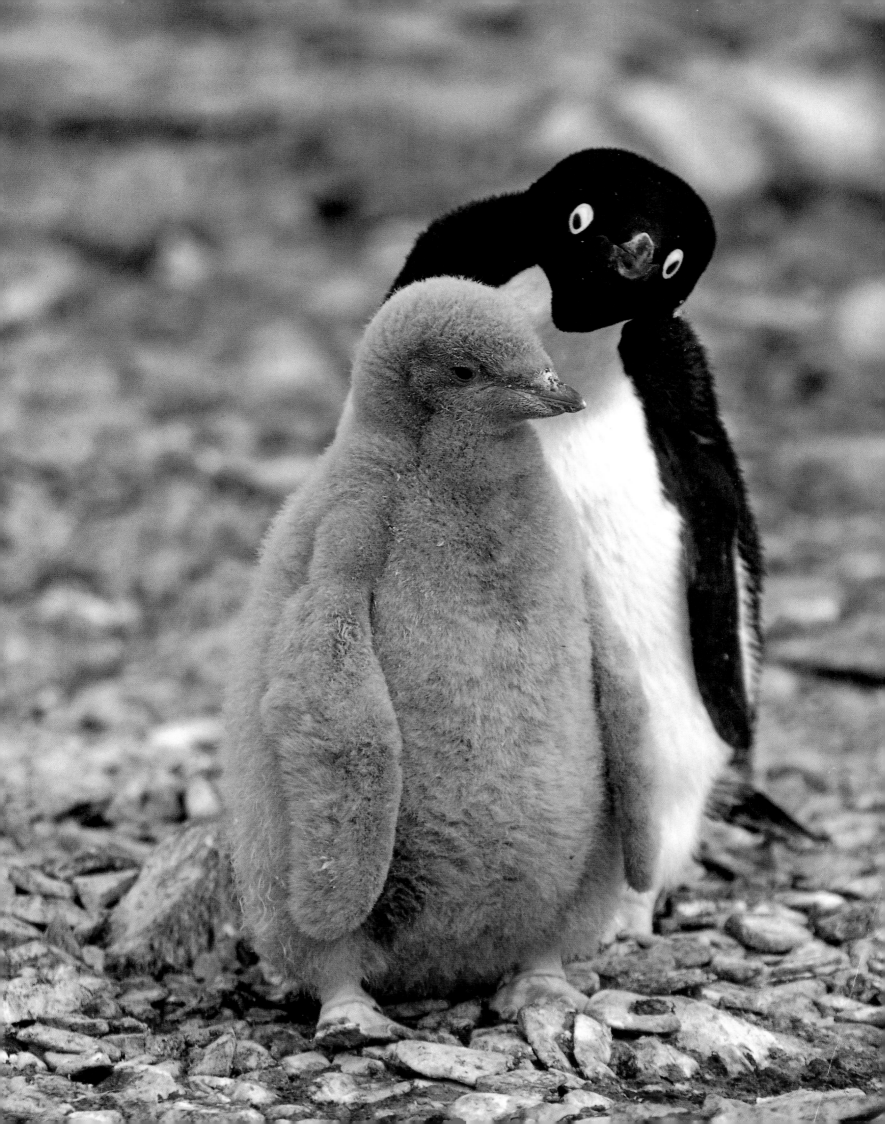

Some penguin species, such as the Magellanic Penguin, nest in burrows. Here the chicks enjoy a certain amount of protection against predators, and it is easier for them to keep warm. King Penguins claim virtually no territory, and incubate their eggs standing on the ground. Their young are not as well protected and there is a greater risk that skuas or the Southern and Northern Giant Petrels will attack them.

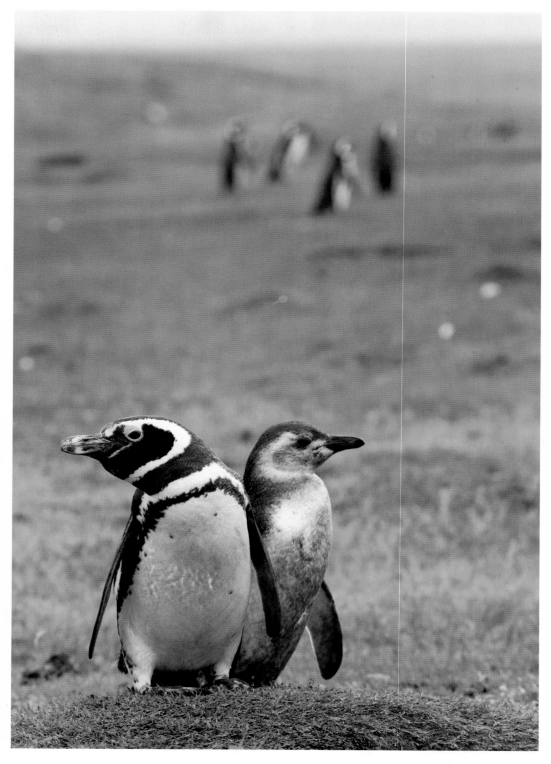

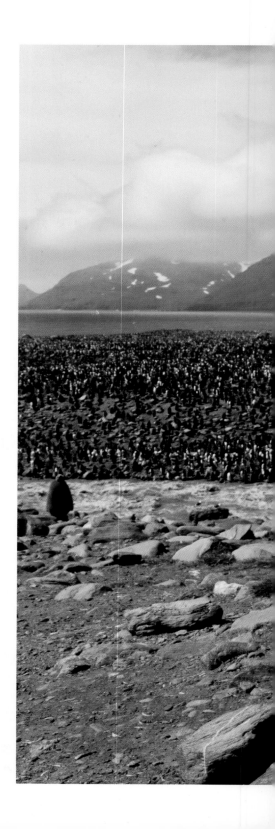

Magellanic Penguins, Saunders Island, Falkland Islands, January.

Giant petrels and skuas can easily find food near large King Penguin colonies. It is estimated that on average two-thirds of all King Penguins fail to raise their young in a normal year. In nearly half the cases the reason for this is that giant petrels or skuas kill their eggs or young. The skuas prefer eggs or young chicks, while the giant petrels capture bigger chicks and are even able to kill adult birds that are weak or ill. The giant petrel raid the colonies during the night, picking out birds, grabbing them by the neck, and killing them. Giant petrels are the single largest threat to King Penguins, and kill more of these birds than any other predator.

Overleaf As you step ashore at St. Andrews Bay or Salisbury Plain, South Georgia, you encounter one of the most spectacular scenes in the animal world, involving all the senses: the sound of hundreds of thousands of King Penguins; the smell of guano; and, wherever you look, penguins, penguins, and more penguins. The first impression is unforgettable; there are hundreds of thousands of these birds, and you soon find yourself asking why they have all decided on this particular spot. The answer is simple: the ocean here is full of food.

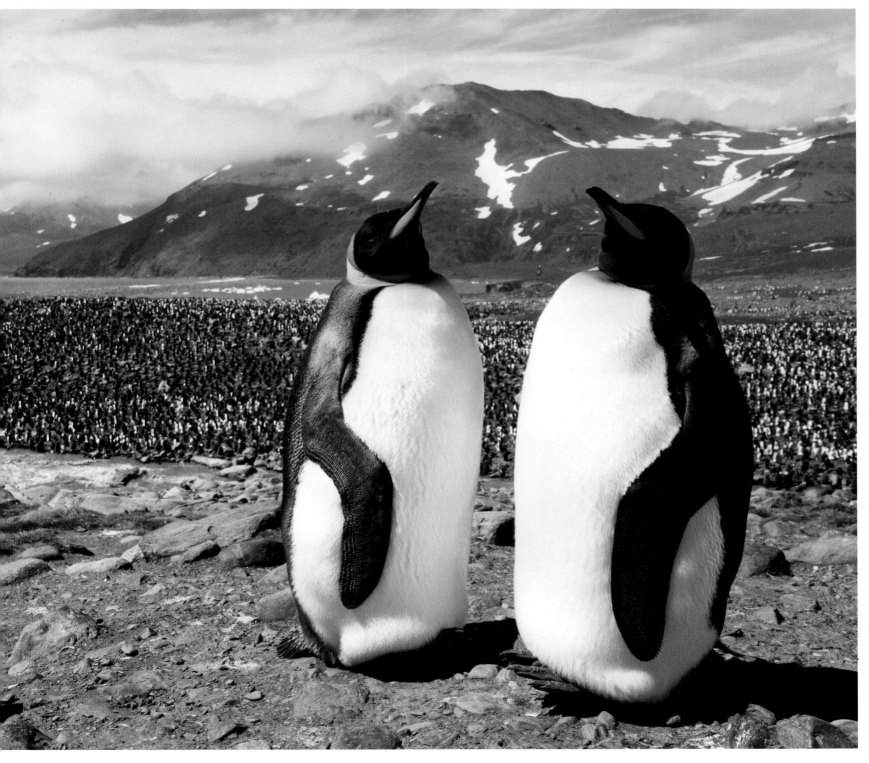

King Penguins, St. Andrews Bay, South Georgia, January.

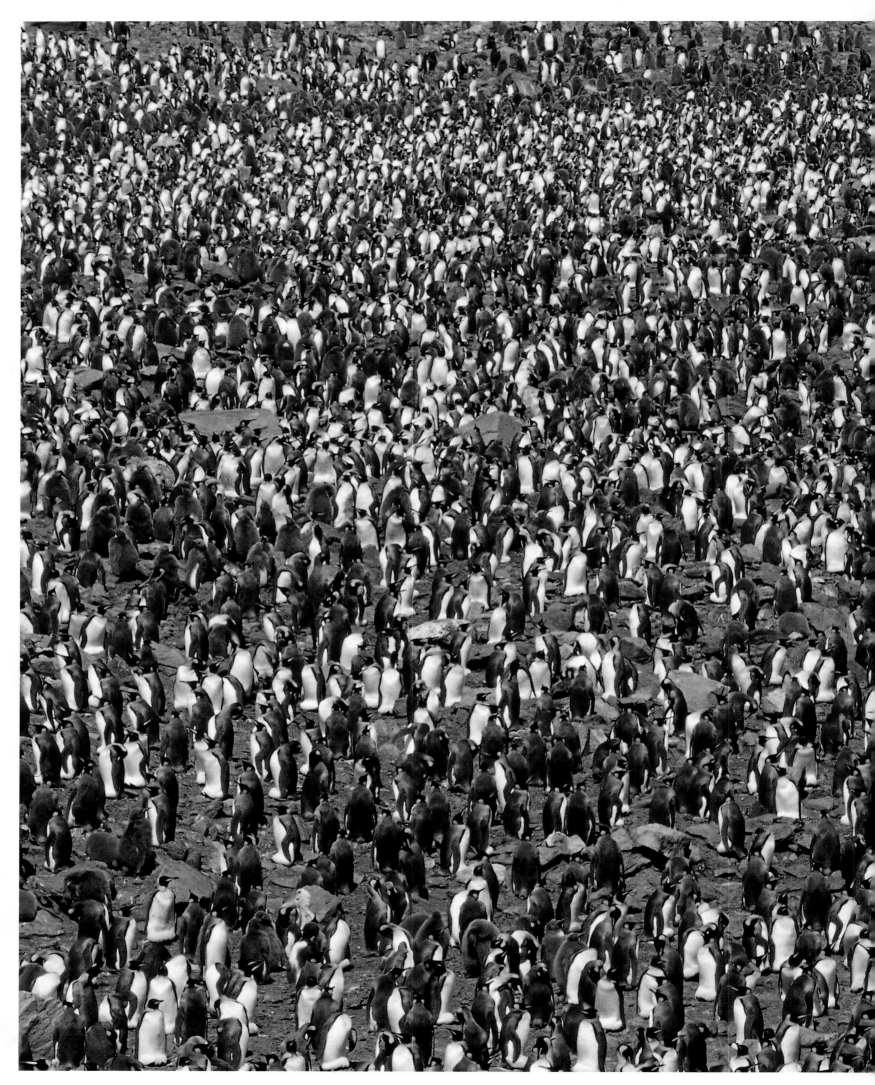

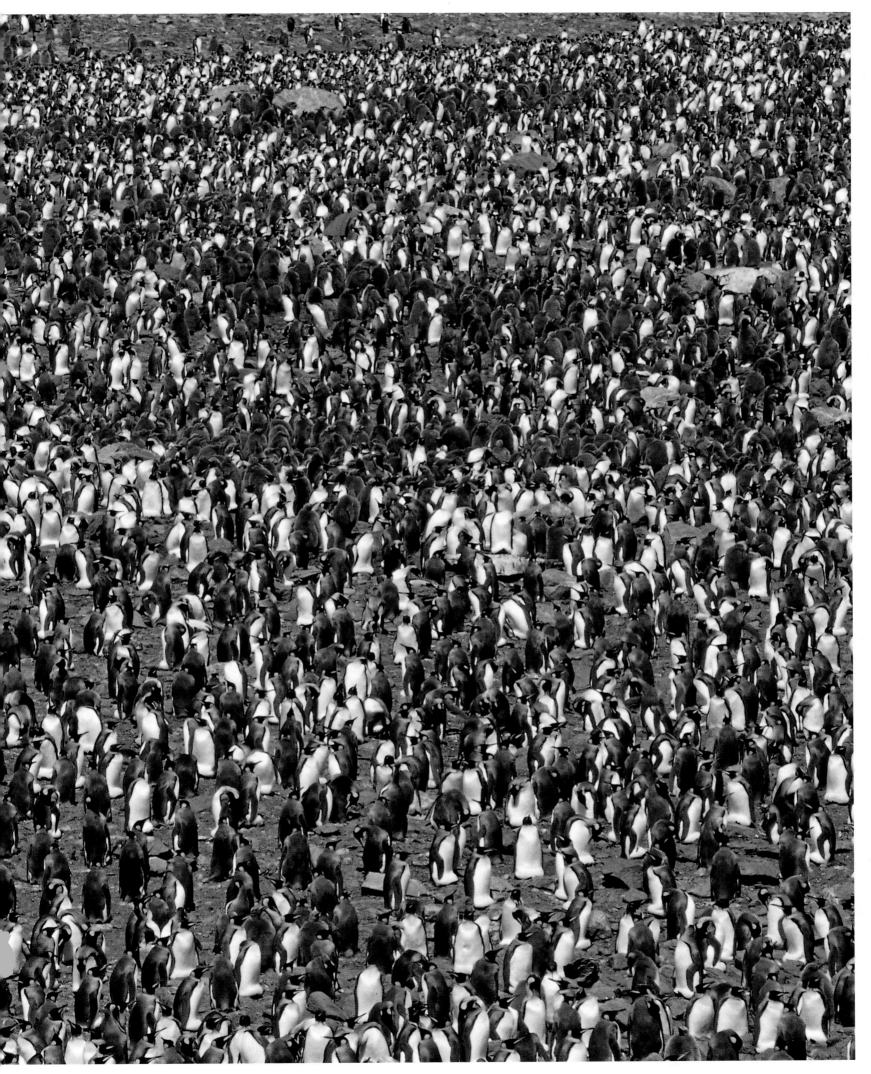

King Penguins, St. Andrews Bay, South Georgia, January.

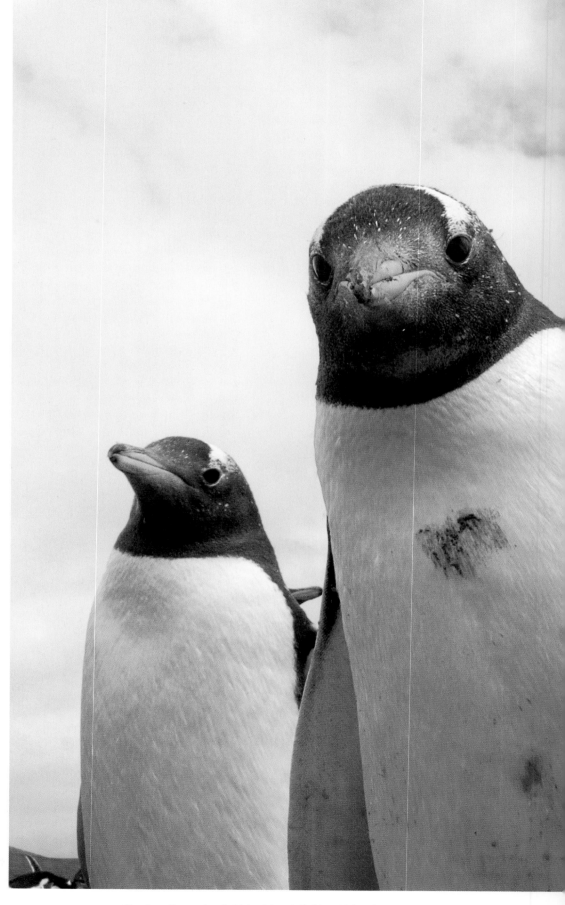

How well can penguins see on land? Because they are so highly adapted to life in water, their eyesight should be less acute on land, where light refracts differently. The Gentoo's cornea is relatively flat compared to the size of its eye. A flat cornea and lens minimize the optical effects that occur when penguins dive, helping light to be refracted in such a way that a sharp image is formed on the retina. On land, a flat cornea is less suited to refracting light passing through air, but here the birds are able to use their greater ability to accommodate (change focus) to compensate for this. It seems to work so well that they suffer no effects of myopia out of the water.

The young Gentoos look like adult birds, but have not yet acquired their cautious behavior. Here, on Pebbles Island, the Falklands, they are unreserved and come very close, peering at the photographer and his companion, Allan White, who runs the local hostel. Allan lies down on the ground, the penguins walk about and suddenly several birds are standing on top of him – an unexpected close encounter.

Gentoo Penguin, Pebbles Island, Falkland Islands, January.

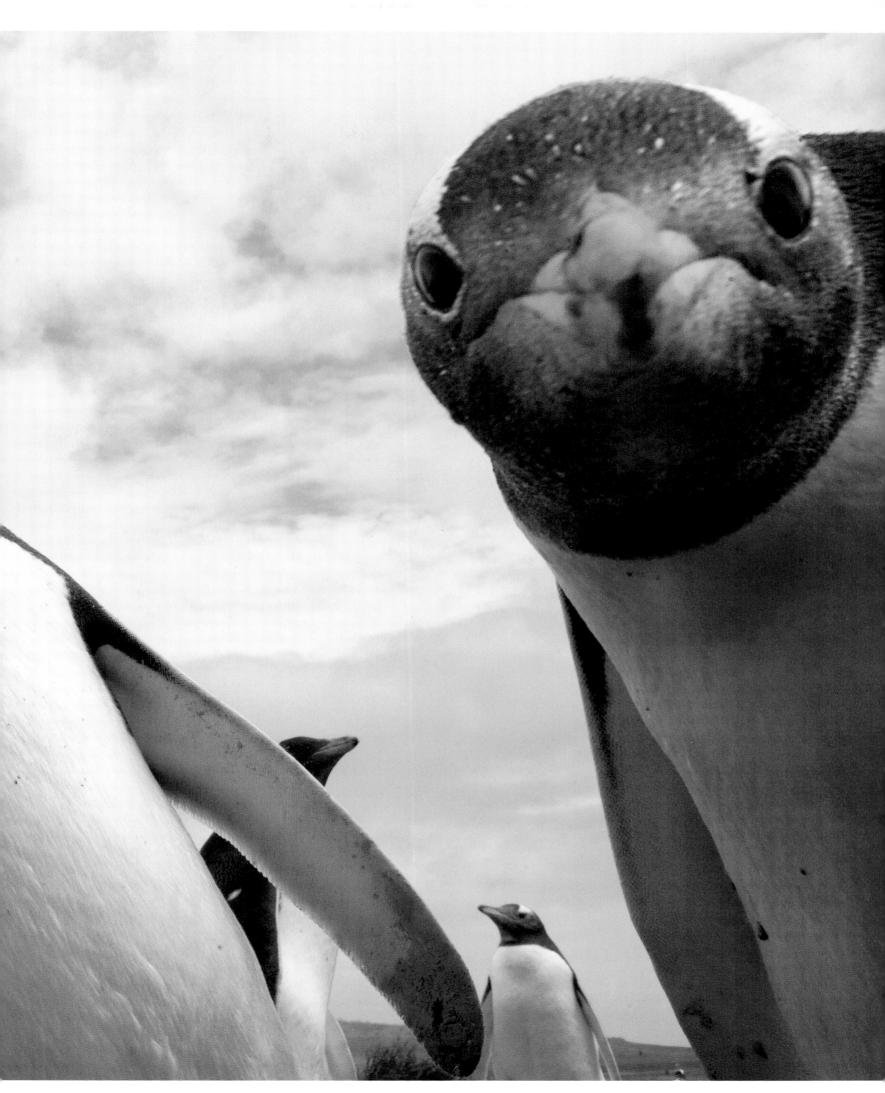

When several penguin species live together in the same place, there is a risk that they need to compete for the same food. And not only do they compete with each other, but also with other animals that feed mainly on krill, which is abundant in the waters of the Antarctic and subantarctic. Weddell Seals, for example, share their winter food source with Adélie and Emperor penguins. However, there are different ways of avoiding direct competition when you live in the same area: by eating at different hours of the day; by focusing on prey of different sizes; or by looking for food at different depths or in different areas. Young Adélies are unable to compete with adults, or with Weddell Seals, so as soon as they are able to swim independently they set out to forage farther north.

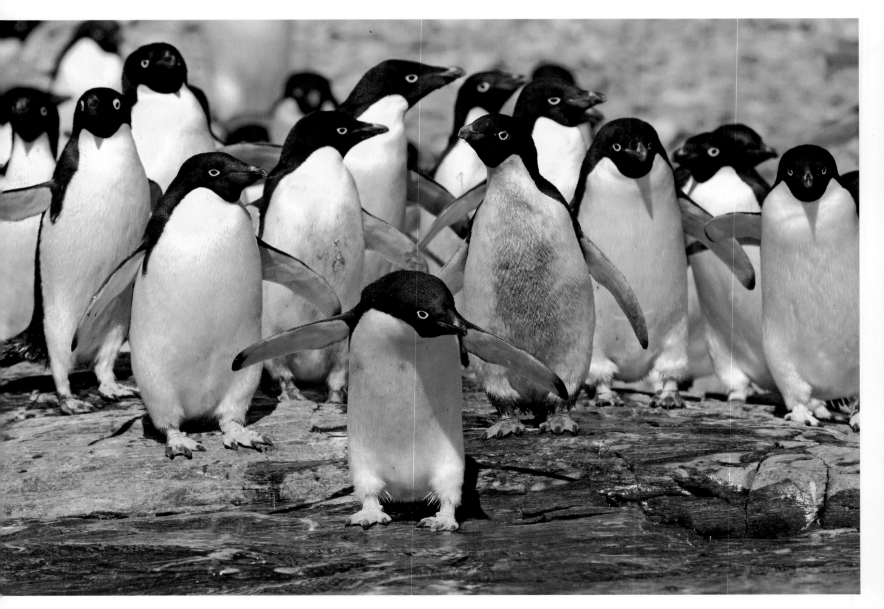

Adélie Penguins, South Orkneys, January.

Male King Penguins are no more aggressive than the females, but because they live in large colonies they have to fight hard to defend their territory. Individuals on the outskirts are often latecomers that, for one reason or another, have not started breeding in time. They have to withstand twice as many predator attacks as penguins at the center of the colony, and other penguins that are passing to and from the waterfront also harass them more often. Consequently, failure to breed is more than twice as common on the outskirts than it is at the center of the colony.

Antarctic Fur Seals on the island of South Georgia feed on krill, fish, and penguins. In some areas penguins constitute the bulk of their diet—inexperienced chicks out for their first swim are particularly easy prey. The distribution of Antarctic Fur Seals seems to coincide with that of the penguins because large numbers of seals are normally found around large colonies. The seals may be aggressive toward penguins on land, and so need to be kept well at bay by the birds.

Overleaf The soil at the South Orkneys colony is stained red with Adélie Penguin guano. This is due to their main diet, which is krill.

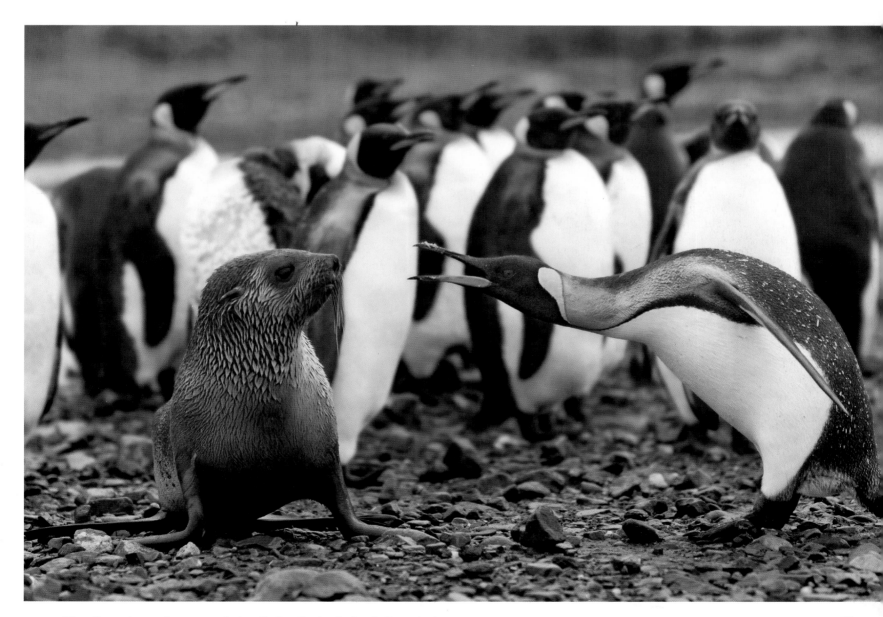

King Penguins and a young Antarctic Fur Seal cub, South Georgia, January.

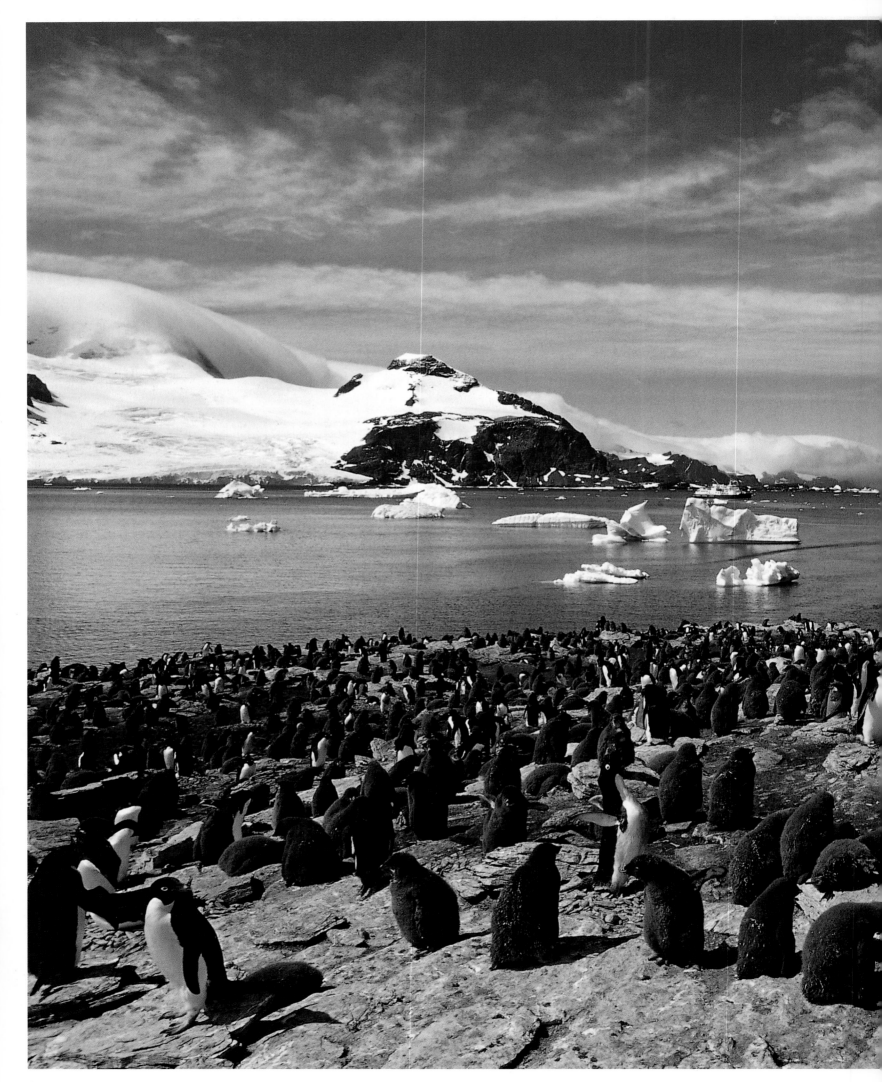

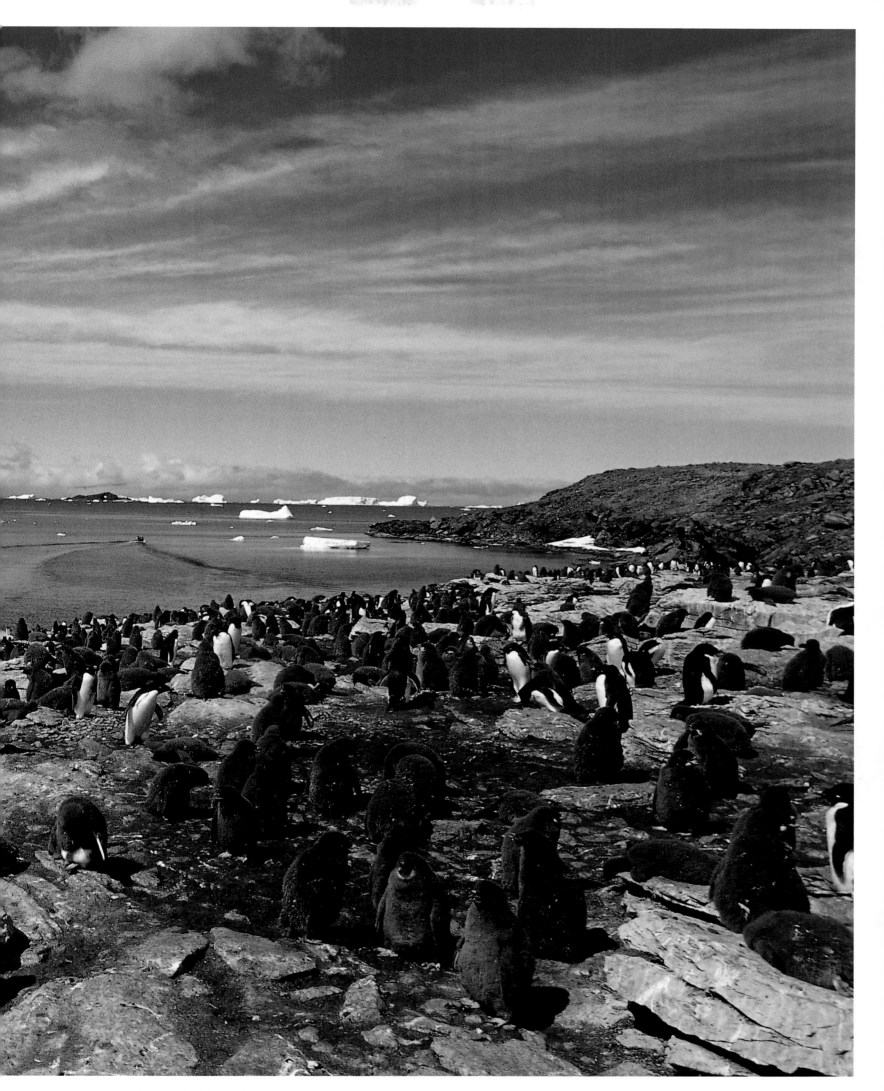

Adélie Penguins, South Orkneys, January.

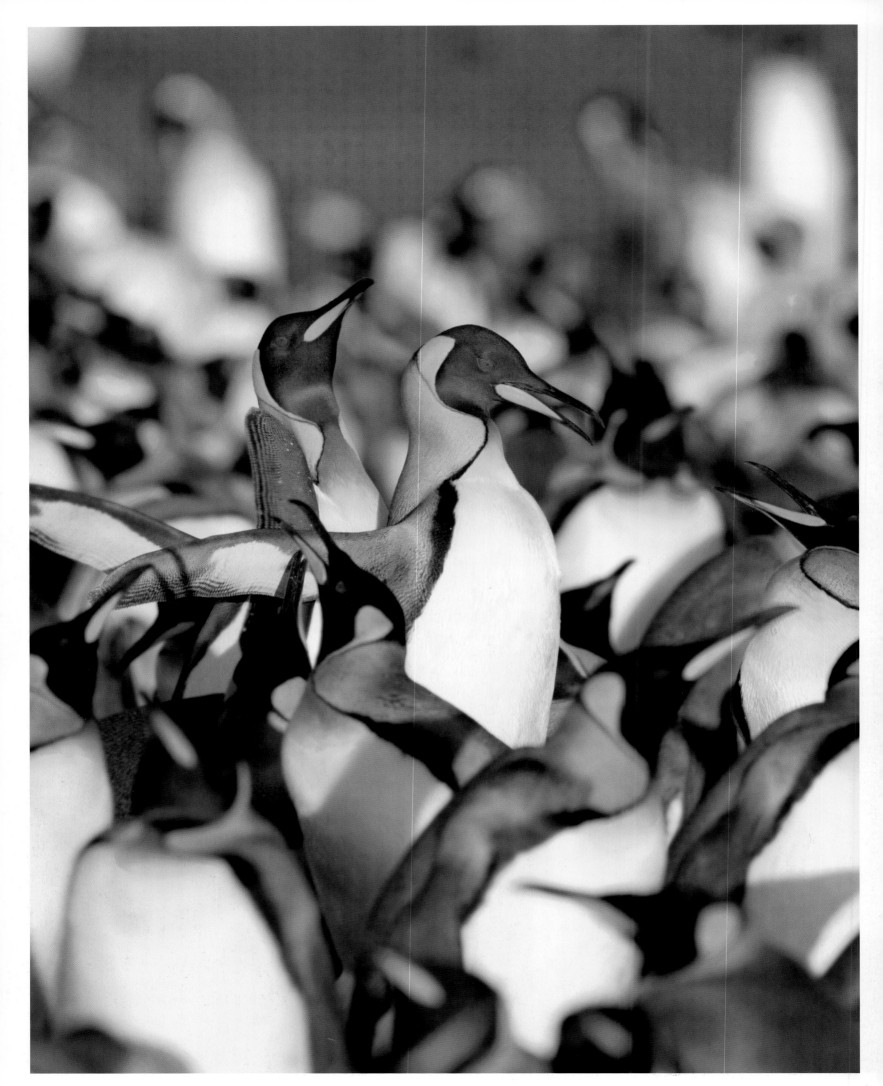

King Penguins, Volunteer Point, Falkland Islands, February.

Each time King Penguins need to go down to the sea to forage, they face a long and dangerous struggle as they try to make their way down through the colony unscathed. The tiny space a King Penguin needs to defend does not reach further than the tip of its beak, but King Penguins protect their nests by reaching out and stabbing passersby with their razor-sharp bills. The damage they inflict can be both severe and long lasting.

Rockhopper Penguins breed on higher ground and always defend their nest sites against intruders. This is why it is important for adult birds to reach a site first and then guard it against any others that should turn up and try to claim it.

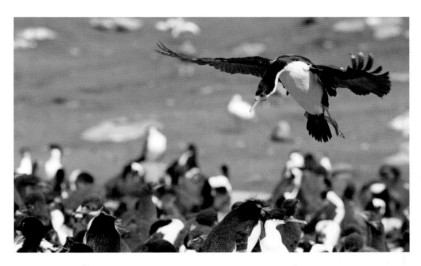

Blue-eyed Cormorant with Rockhopper Penguins, Saunders Island, Falkland Islands, January.

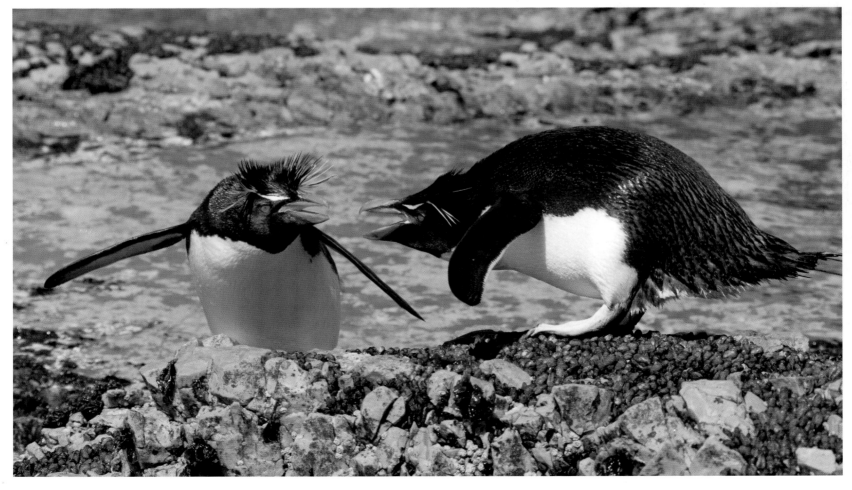

Rockhopper Penguins, Pebbles Island, Falkland Islands, February.

Magellanic chicks are well protected against the harsh, icy winds in their burrow. It is important that they conserve their energy and use it mainly for growing and minimizing heat expenditure. They generate heat by shivering—rapidly contracting their muscles—just as we do when we are feeling cold. This is an effective way of keeping their body temperature at the right level.

Gentoo Penguins prefer to place their nests on high, north-facing plateaus that offer a good supply of pebbles for building material. The reason for this is that the snow thaws in such sites earlier in the spring, while the pebble mounds they build protect the birds against being drenched by water from melting ice. The sun's radiation is also stronger on these north-facing slopes, making them slightly warmer.

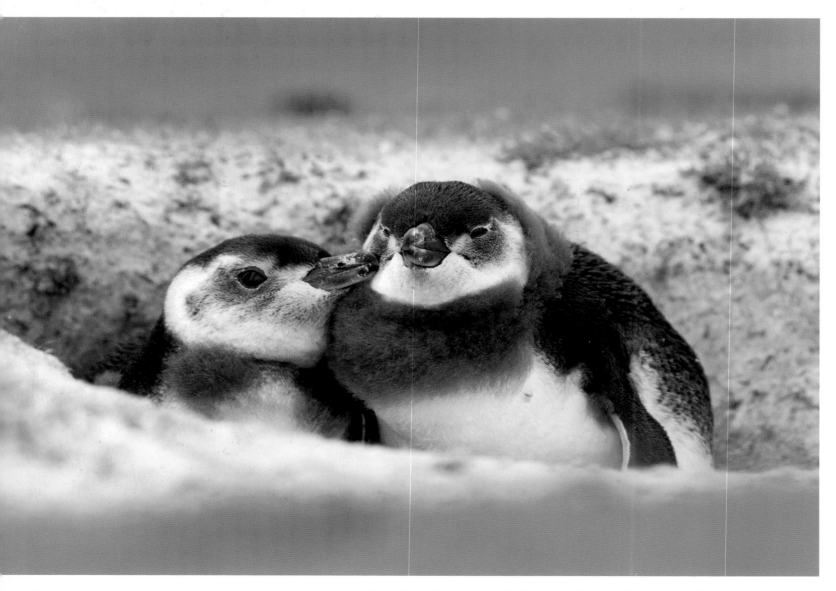

Magellanic Penguin chicks, Volunteer Point, Falkland Islands, February.

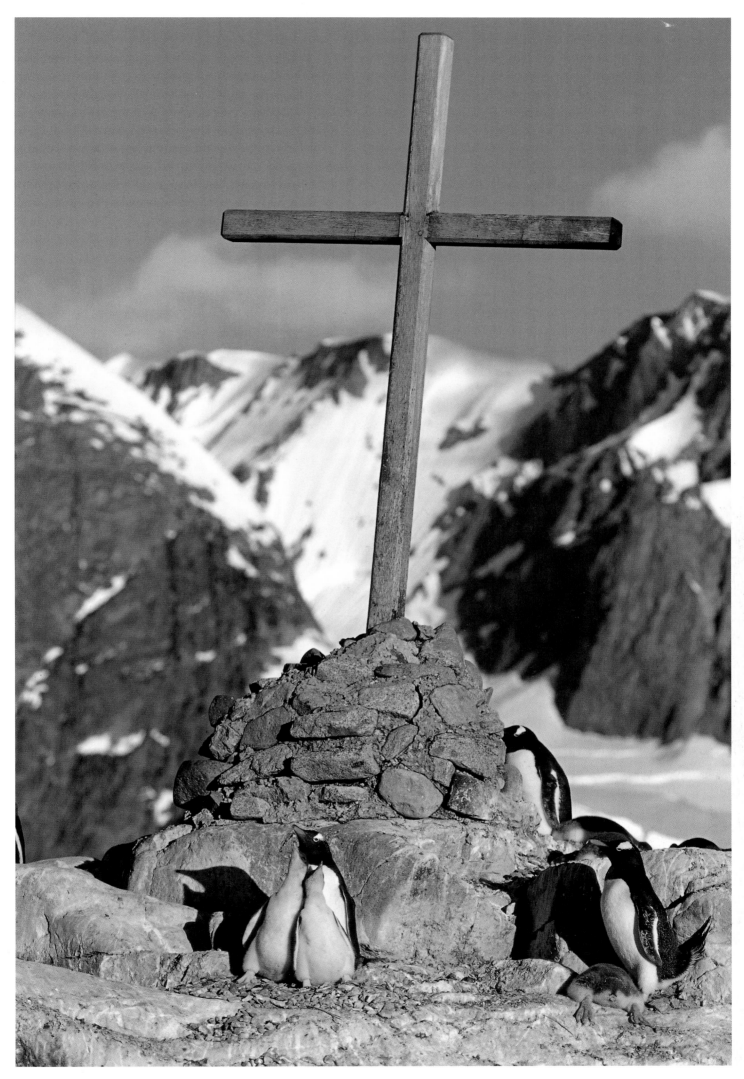

Gentoo Penguins, Antarctica, January. 75

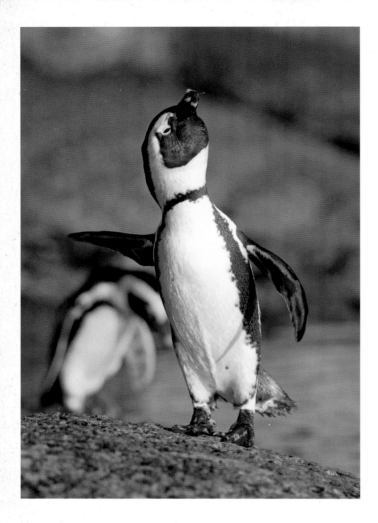

The first thing the African Penguins at Boulders Beach, South Africa, do when they wake up in the morning is go down to the beach for a swim. They are obviously in great need of a wash after passing the night in their burrows, and they spend several of the cool early morning hours on the beach. During the breeding season, which starts in January and lasts for several months, the birds stay close to the coast, where they forage for fish and crustaceans. Just like many other penguin species, African Penguins need to spend up to four months replenishing their food supply out at sea in preparation for the breeding season before they return to the colony.

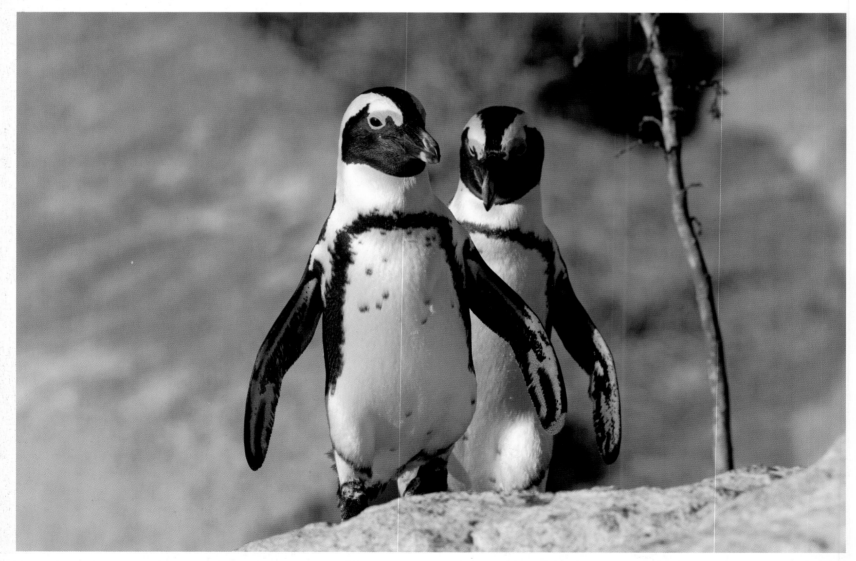

African Penguins, Boulders Beach, Simon's Town, South Africa, March.

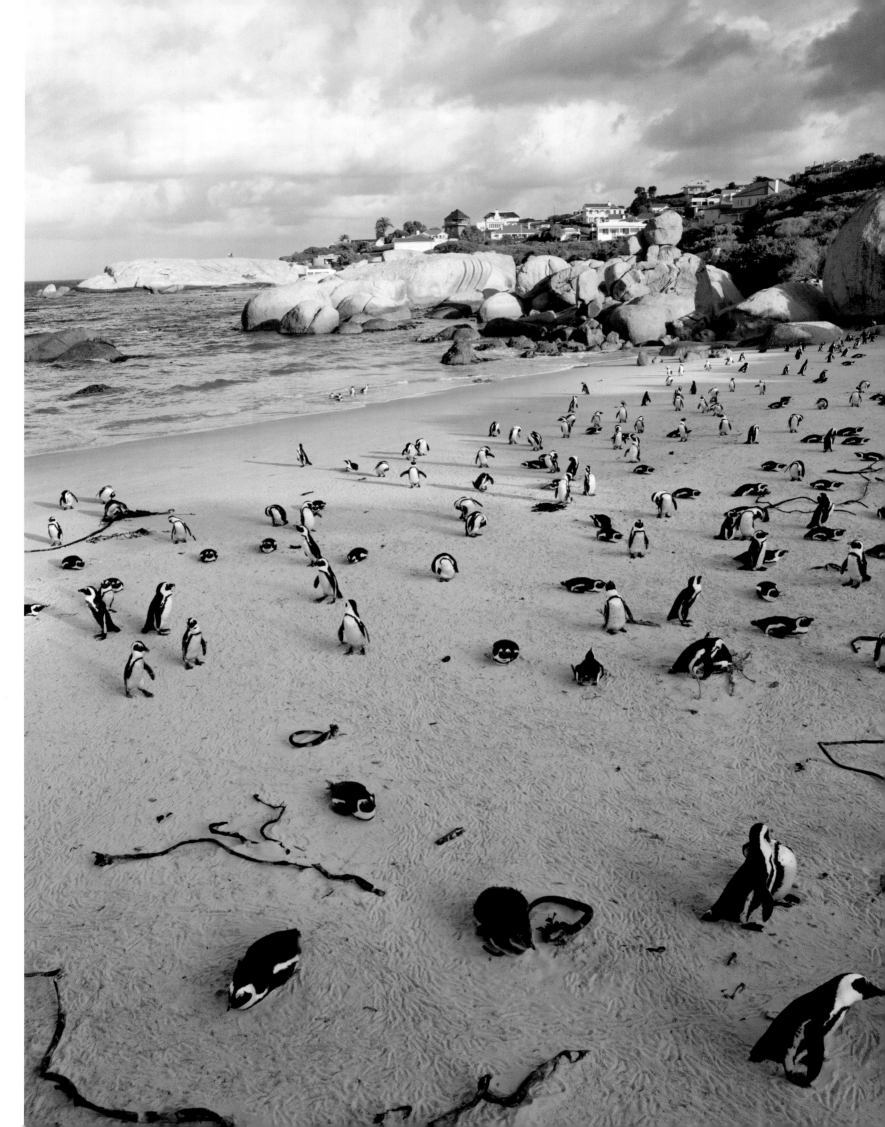

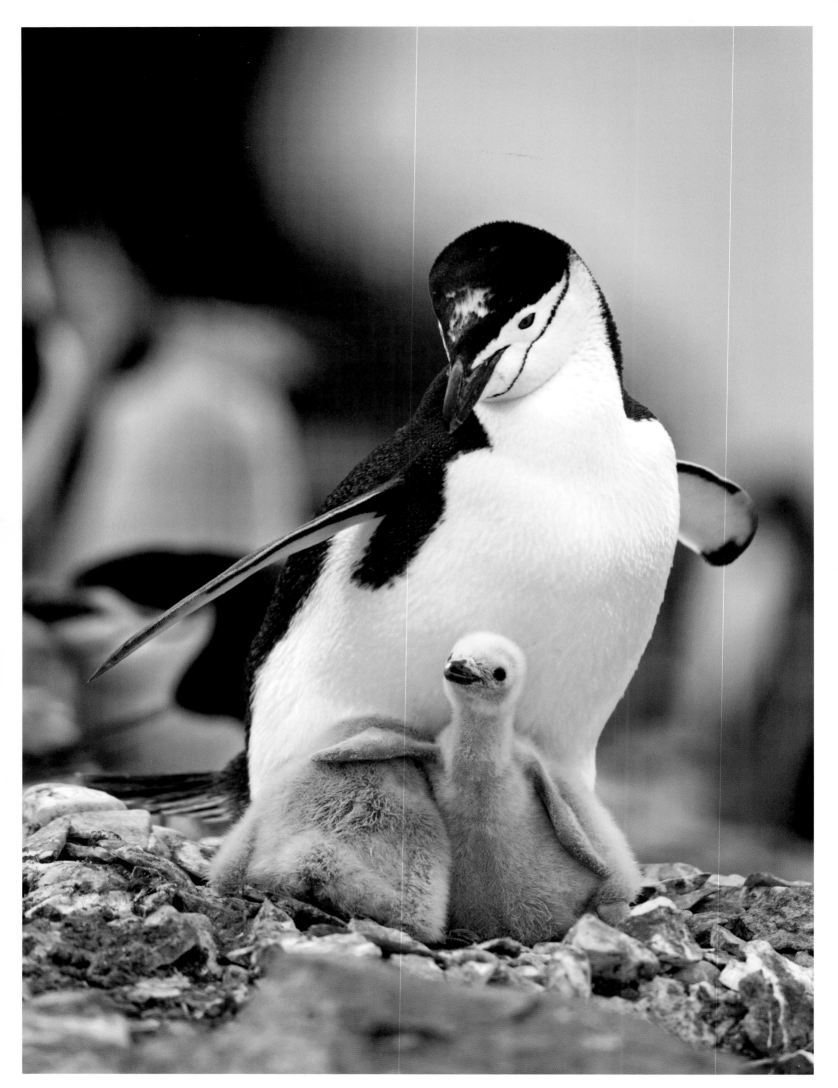

Chinstrap Penguins, Hanna Point, Antarctica, January.

The Chinstrap Penguin's bed of stones appears rather Spartan to us humans. Can a nest made out of stones really be warm and comfortable? Why do Chinstrap Penguins always fight over lumps of rock, and what is it about these stones that turn them into selfish thieves? In fact, the stones fulfill an important function, because they drastically reduce the risk of floods that could otherwise wash away the eggs or kill the young. Chinstrap Penguins cannot, however, collect stones all the time; they need to eat too. When they choose to eat, they lose stones to their neighbors, but if they prioritize the stones, they will starve. The strongest individuals can cope with this, and so their stone collections are more likely to impress presumptive partners.

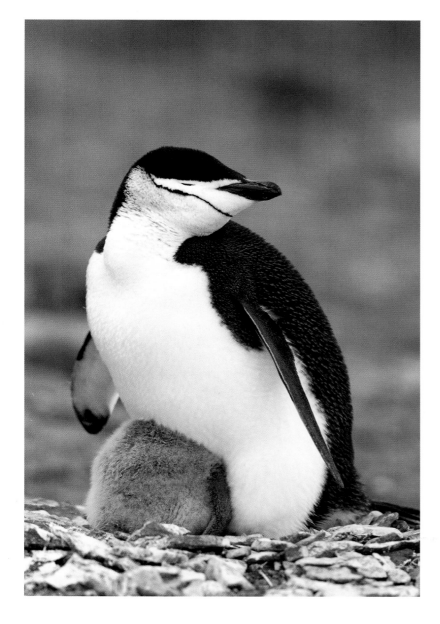

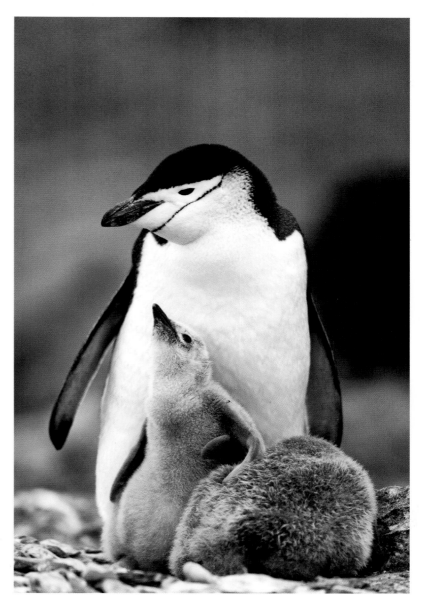

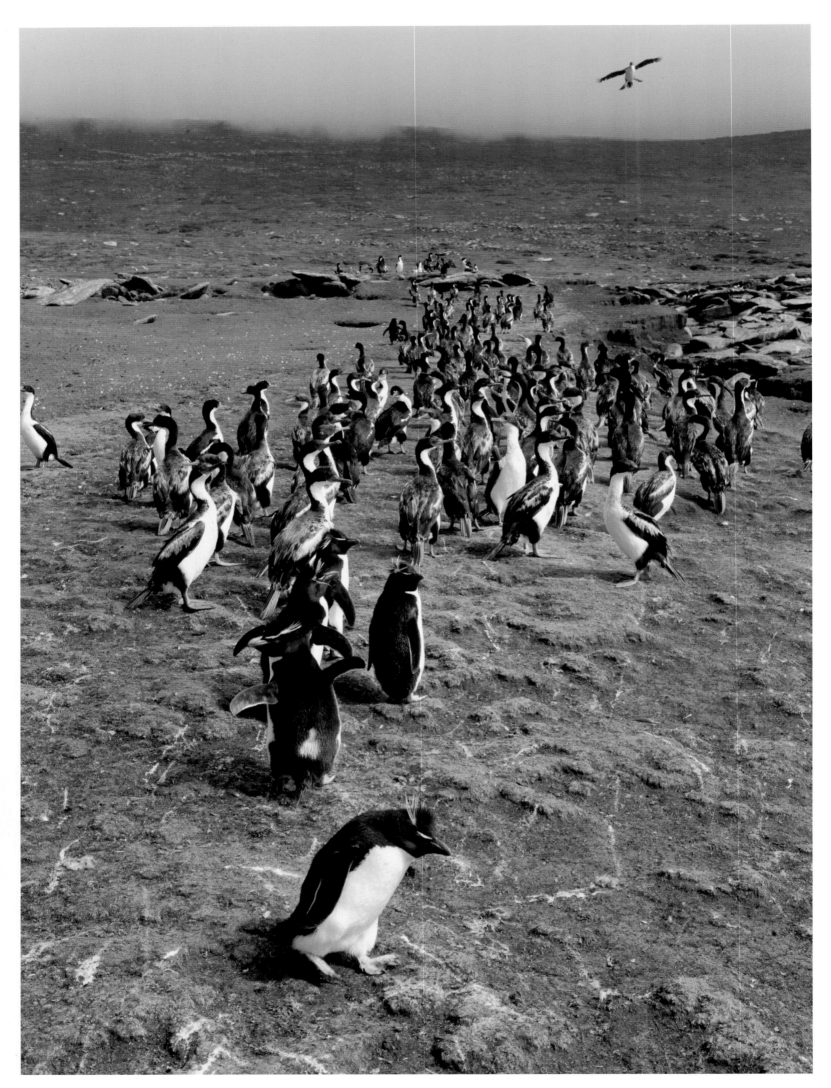

Rockhopper Penguins, Saunders Island, Falkland Islands, January.

Rockhopper Penguins on Pebbles Island in the Falklands build their nests among the rocks on the steep section of the shoreline, which means they do not need to share space with fur seals or sealions. On the other hand, the Rockhoppers live alongside Blue-eyed Cormorants. The interaction between cormorants and penguins seems to function very well on land, even though they, at least to some extent, compete for food at sea.

The Magellanic Penguins on Saunders Island seem to get along quite well with the grazing sheep. They build their nests in burrows under ground within the fenced areas and manage to raise their chicks despite the grazing animals.

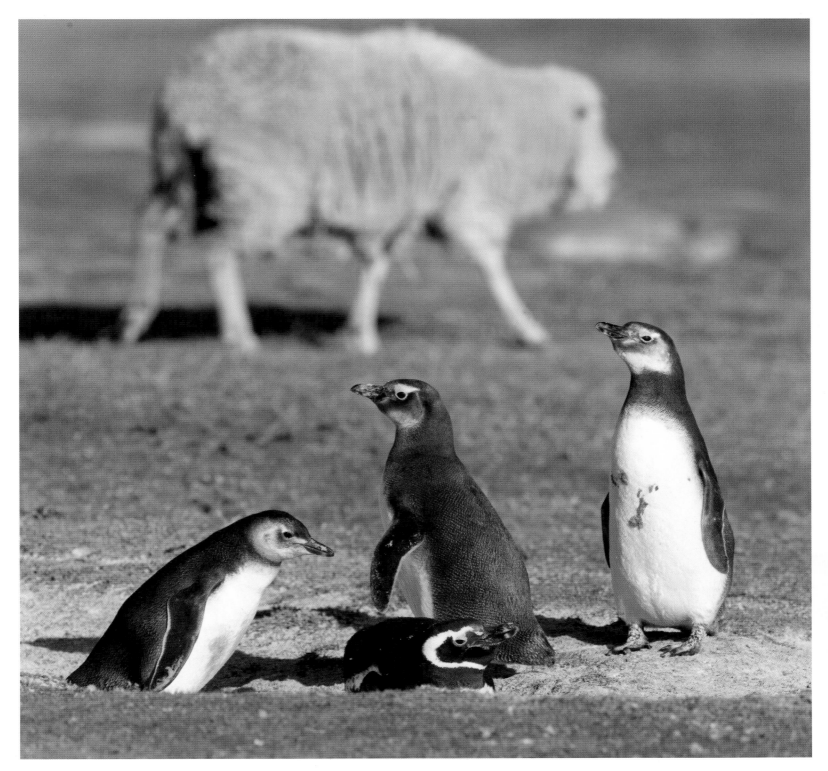

Magellanic Penguins, Saunders Island, Falkland Islands, January.

At the 2,000-strong King Penguin colony at Volunteer Point in the Falklands, individual pairs start to breed at slightly different times. Those that did well the previous year laid their eggs late in the season, while those without youngsters that are about to fledge can start early. King Penguin chicks in a colony are, therefore, often of slightly different ages.

There are many other birds that can take advantage of the abundant food and high birthrate inside a penguin colony. The Striated Caracara of the Falkland Islands, for example, prefers to build its nest in the vicinity of a colony, where it can easily find leftover food and dead chicks.

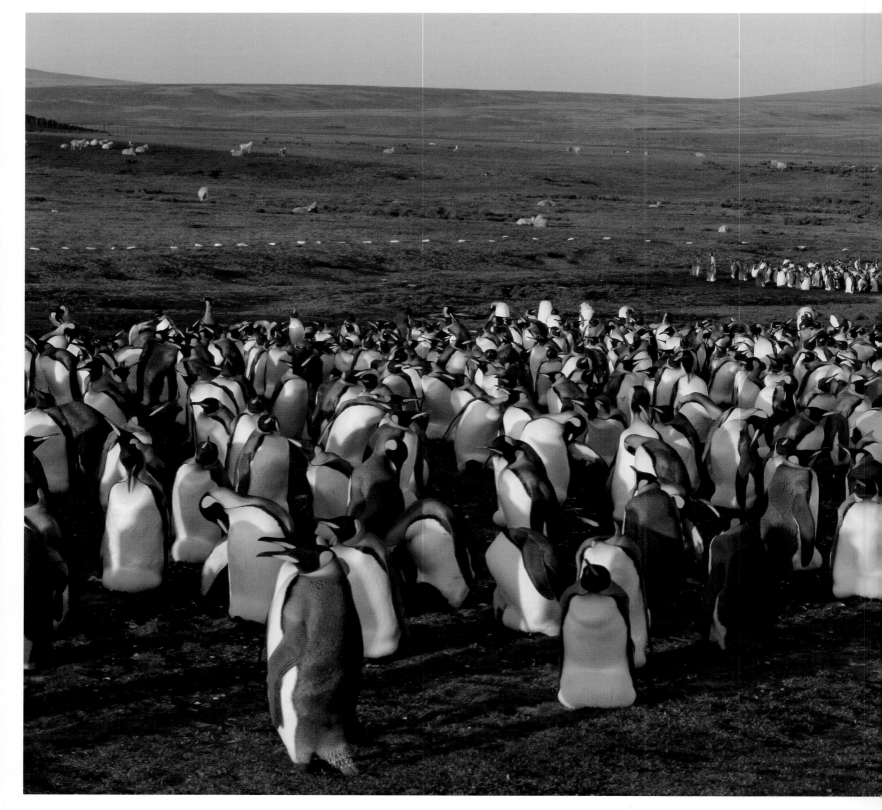

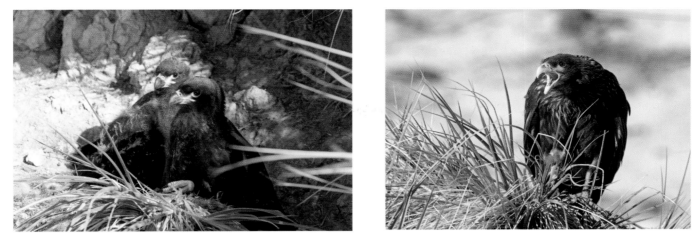

Striated Caracara adult and juveniles, Saunders Island, Falkland Islands, January.

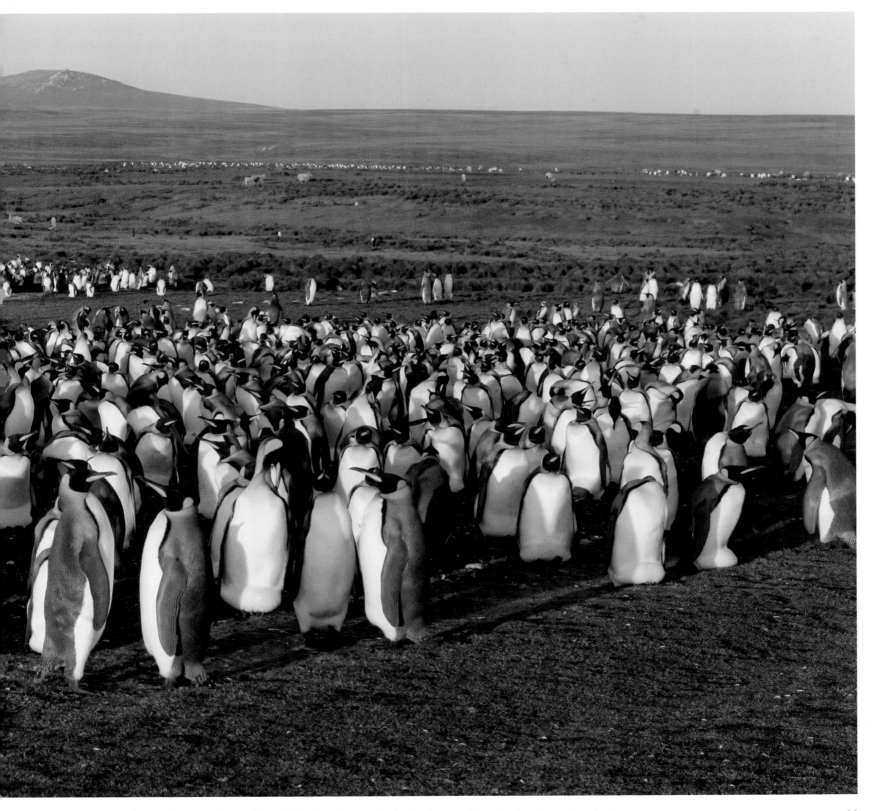

King Penguins, Volunteer Point, Falkland Islands, February. In the background are Gentoo Penguin colonies.

You often see Rockhopper Penguins preening and sorting out their feathers, keeping their plumage tidy. This is something birds do all the time in order to be able to fly or swim. A Rockhopper's feathers are essential for keeping it warm both on land and in the sea. This is why the feathers need to be cleaned frequently and lubricated with an oily secretion taken from glands situated above the rump. In addition to keeping a penguin warm, a plumage that is preened well also helps it counteract turbulence in the water.

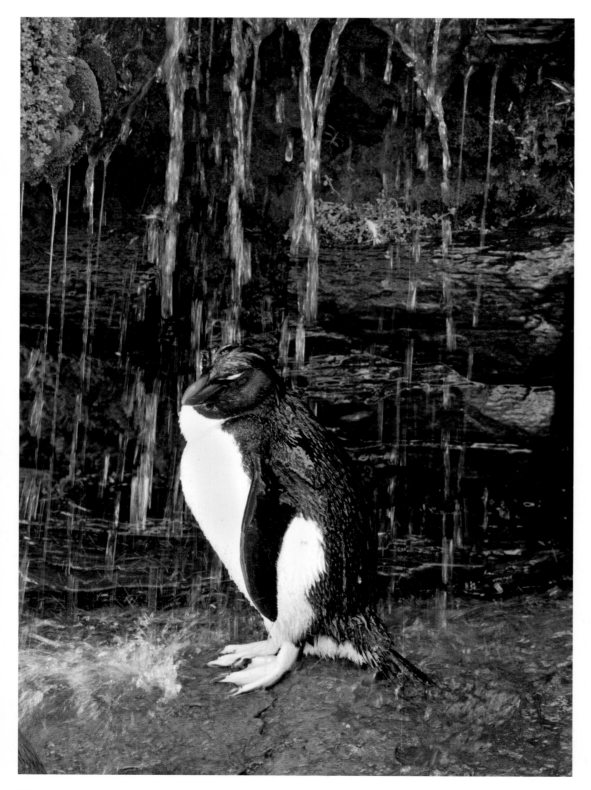
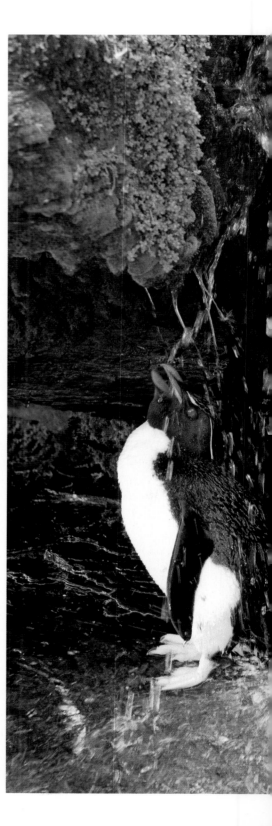

One major problem with living in a colony together with a lot of other penguins is that the soil becomes exposed and the birds' droppings are mixed with clay and rainwater. Rockhoppers sometimes have to wade around in guano and mud for long periods, such as when they are incubating their eggs, and this makes it more difficult for them to keep their plumage pristine. Rockhoppers on Saunders Island have found an excellent way of cleaning their feathers —a freshwater waterfall.

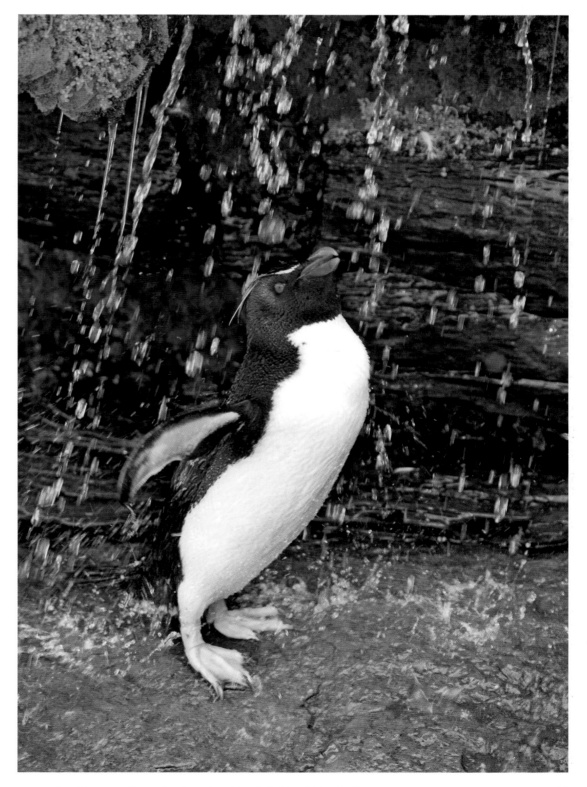

Rockhopper Penguin, Saunders Island, Falkland Islands, January.

Raising chicks

YOU MIGHT THINK that survival is of the utmost importance to penguins and other animals, but in fact their highest priority is the transmission of genes to future generations. The best way for them to do this, of course, is to bring up chicks of their own. However, an animal that shares its genetic makeup with another, such as a sibling or some other family member, may in some cases abstain from reproducing. Instead, it may help to raise other young within the family in order for these to stand a better chance of survival, so that their genes are transmitted to future generations. This system is not common among penguins, but is more often found in areas where there is fierce competition for suitable breeding sites and where different species are defending their respective territories. It is, for example, typical of the Acorn Woodpecker, the Florida Scrub-jay, and the Siberian Jay.

Most penguins defend a very small territory that literally does not reach farther than the tip of their bills. This is the case with King Penguins, for example, which breed in large, crowded colonies. To them, the spot where they stand while incubating their eggs is the only area worth worrying about. Other penguin species that burrow into the ground or nest on the ground are often not as close to their neighbors, and so they have correspondingly larger territories.

Penguins are either monogamous throughout their lives or they change partners every year. It is less common for them to change partners during the course of the breeding season, because time is short before the food runs out and the temperature turns colder. It is, however, common for them to change partners if they fail to procreate.

How do penguins become attracted to one another, and what makes them decide to enter into a partnership that will last for months or even years? To attract a mate, King Penguins perform an enticing display dance involving calls and hopping. Some species, such as Chinstrap Penguins, bear gifts of stones to their chosen partner, while others may defend an attractive nest site. Conflicts leading to aggressive behavior and fighting may arise if several individuals choose the same spot or are attracted by the same partner. During this time, it is common for birds to use their bills for stabbing and their flippers for hitting each other. If two males fight to impress a female, the female will select the winner to mate with.

As soon as the male and the female have finally found each other, a close and trusting relationship needs to develop for them to be able to raise one or several chicks. Without cooperation within the family and between different pairs in the same area, the Antarctic penguins would never be able to survive in the severe climate of the extreme south.

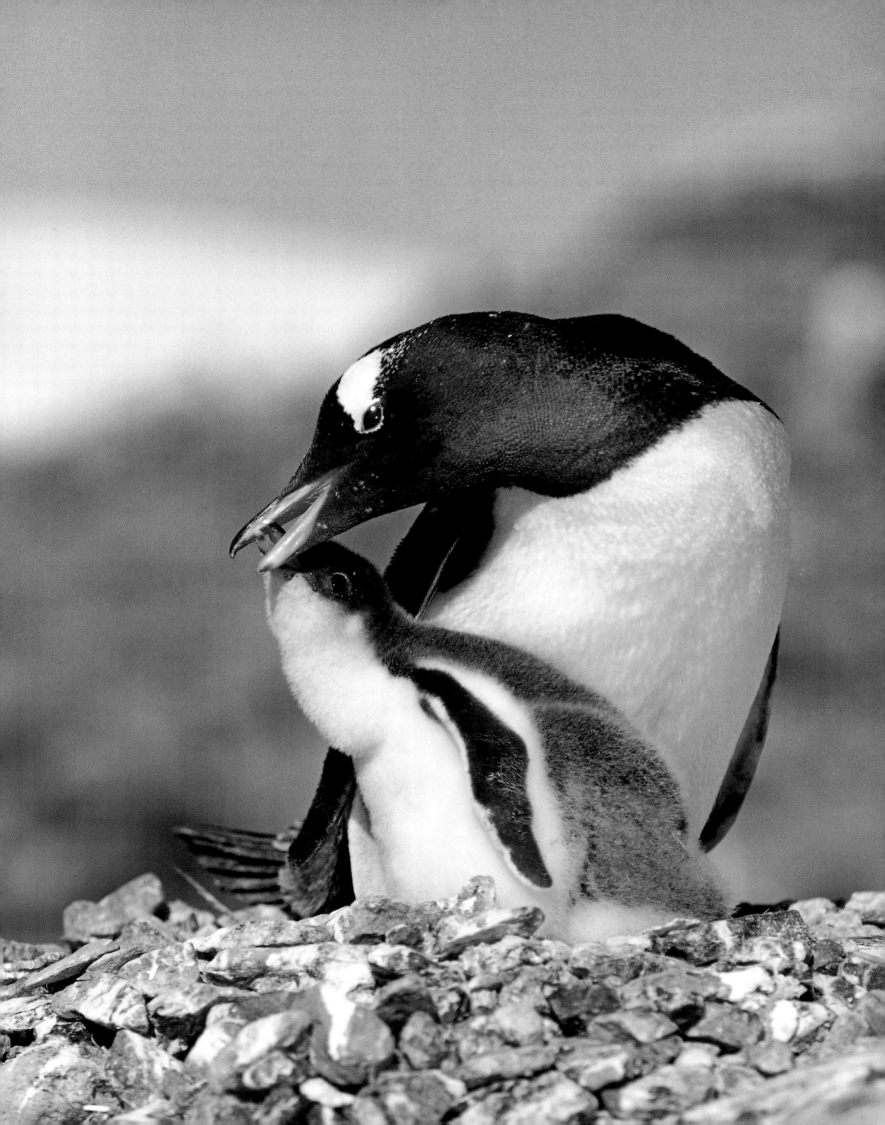

Adélie Penguins return to their colony in the spring. The male is first to arrive. If he is lucky, there will still be a pile of stones where he built his nest the previous year. The female chooses her partner according to the size of his stone collection; a large pile makes a male more attractive, prompting her to invite him to mate with her. Her interest in the size of the pile of stones is very practical. The stones prevent the nest from being flooded when the ice around the colony starts to melt in the spring.

Pairs that have bred together before tend to be more success-ful. However, because many birds do not always manage to produce an egg, they tend to change partners from one year to another. Why do they do this? It is important that foraging and incubation are well timed so that the partner responsible for the egg does not die of starvation while the other is out searching for food. If the foraging bird does not return in time, the egg is abandoned. Another reason could be that the male and female don't arrive back at the same time. Since it is important that breeding starts as soon as possible after arrival, so there is no time to lose selecting an alternative partner. Pairs that have been together for a long time are the best synchronized.

Different factors are responsible for prompting the onset of egg laying in the different penguin species. It seems that the availability of food near the colony determines when Gentoos start breeding, and as a result the date of their breeding season varies by up to three weeks from year to year. In contrast, Chinstrap Penguins, which move out of the area as soon as they have finished breeding, react to the number of hours of daylight. They synchronize this with their biological clock so they can return to their breeding grounds at exactly the same time every year.

Overleaf Scientists at the American Palmer Station on Petermann Island have noticed that the number of Adélie Penguins on nearby Torgensen Island has fallen over the past few years. The penguins are more successful in bringing up their young during years when krill is abundant, but one scientist reported another interesting behavior. If the penguins placed their nest to the left of the flag where tourists were allowed, rather than inside the protected area, they performed better. It seems that tourists do not consti-tute a threat to the Adélie Penguins; on the contrary, they keep predators away.

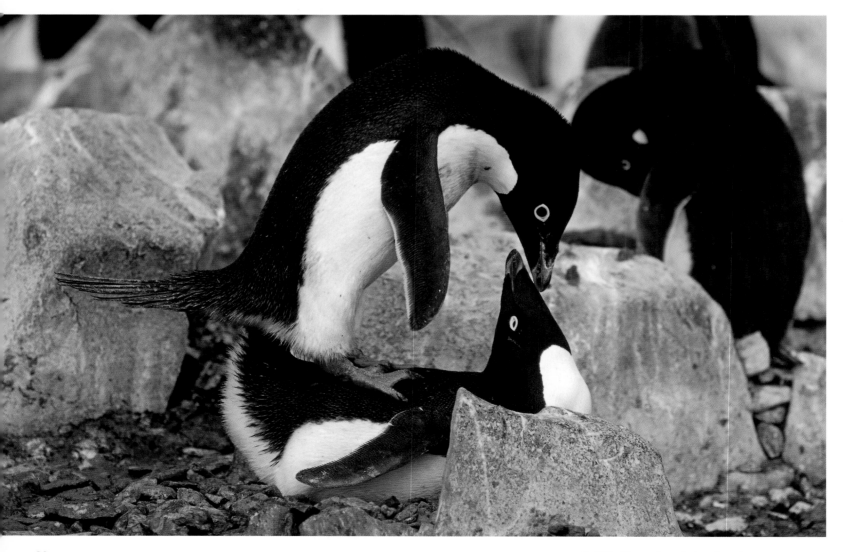

Adélie Penguins, Antarctica, January.

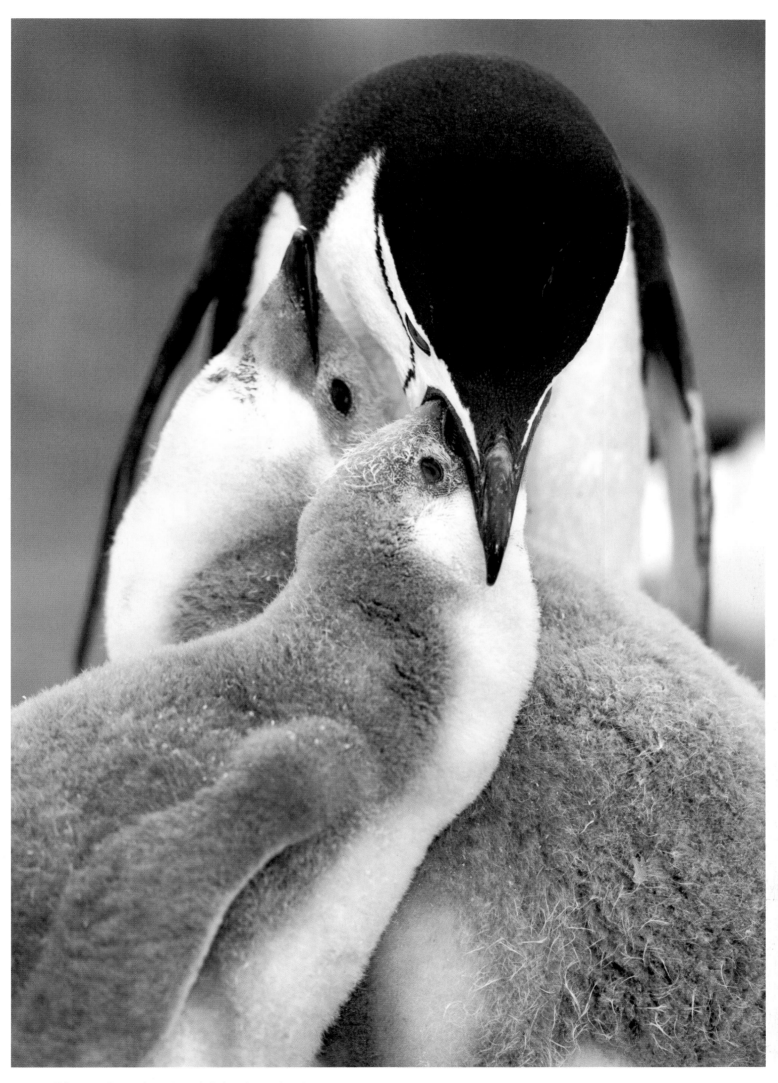

Chinstrap Penguins, Hannah Point, Antarctica, January.

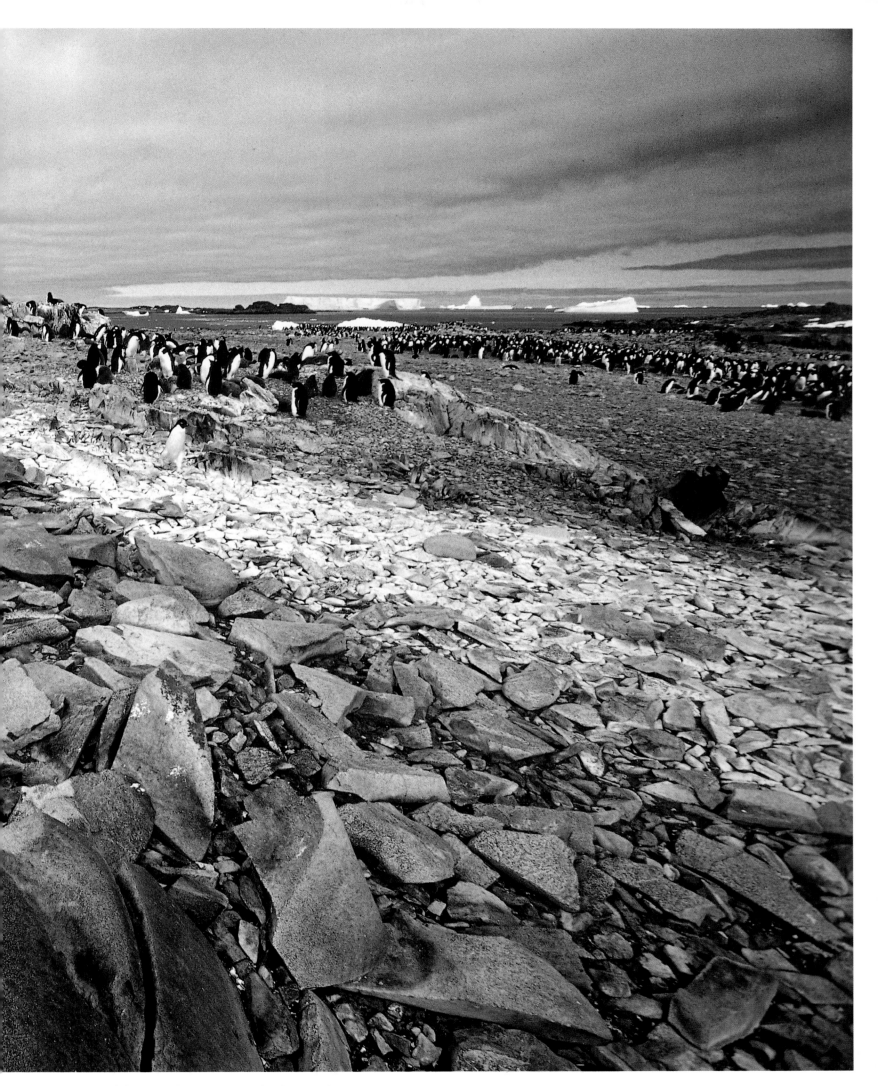

Adélie Penguins, Torgensen Island, Antarctica, January.

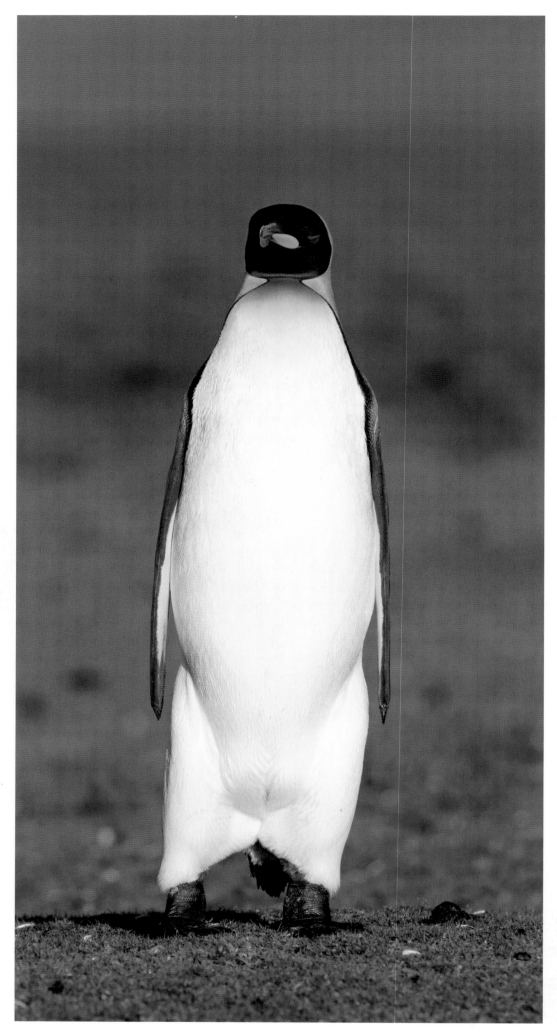

King Penguins lay only a single egg at a time, but it takes them more than a year to raise the chick. The parents take turns incubating the egg, and sometimes they have to wait for weeks before relief arrives. The two parents rarely appear on land simultaneously, and if food is scarce the female may not be able to return before the chick hatches. In order to get through such a difficult period and to guarantee the chick a regular food supply, the male stores food in his stomach, which functions as a combined fridge and heating cabinet. He can keep the food warm and fresh for up to three weeks—or until the chick has hatched—by secreting spheniscin, a substance that prevents the growth of bacteria and the formation of fungus in the stomach. During this period the male uses his own fat reserves as a source of energy.

King Penguin, Volunteer Point, Falkland Islands, February.

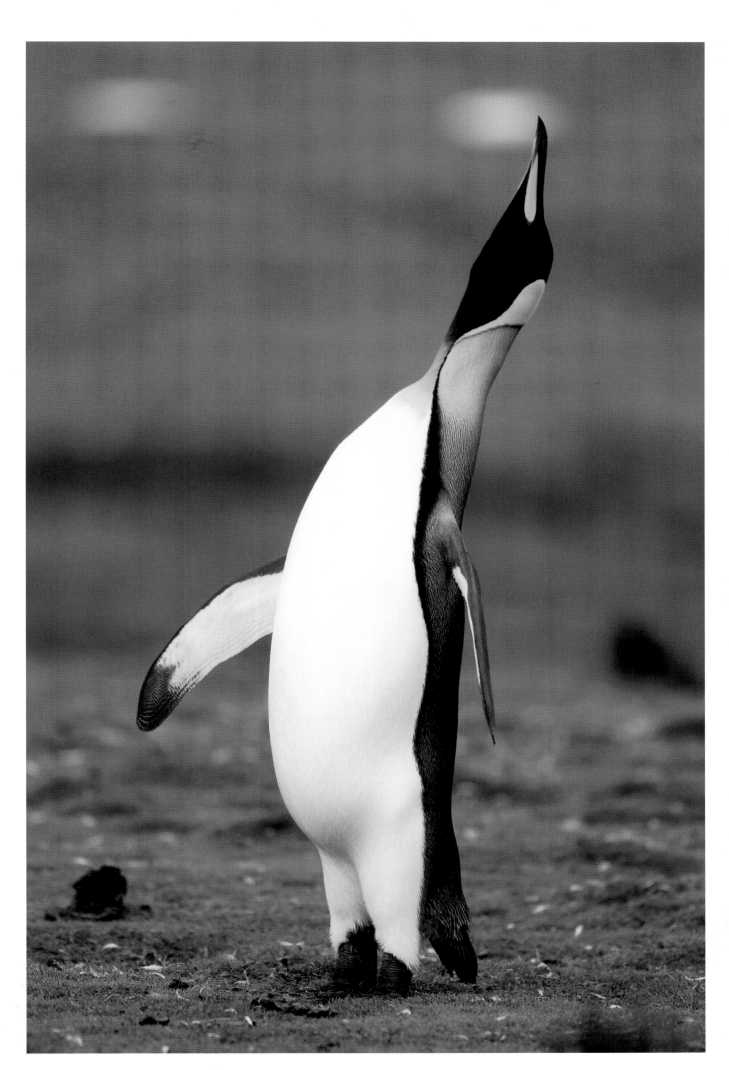

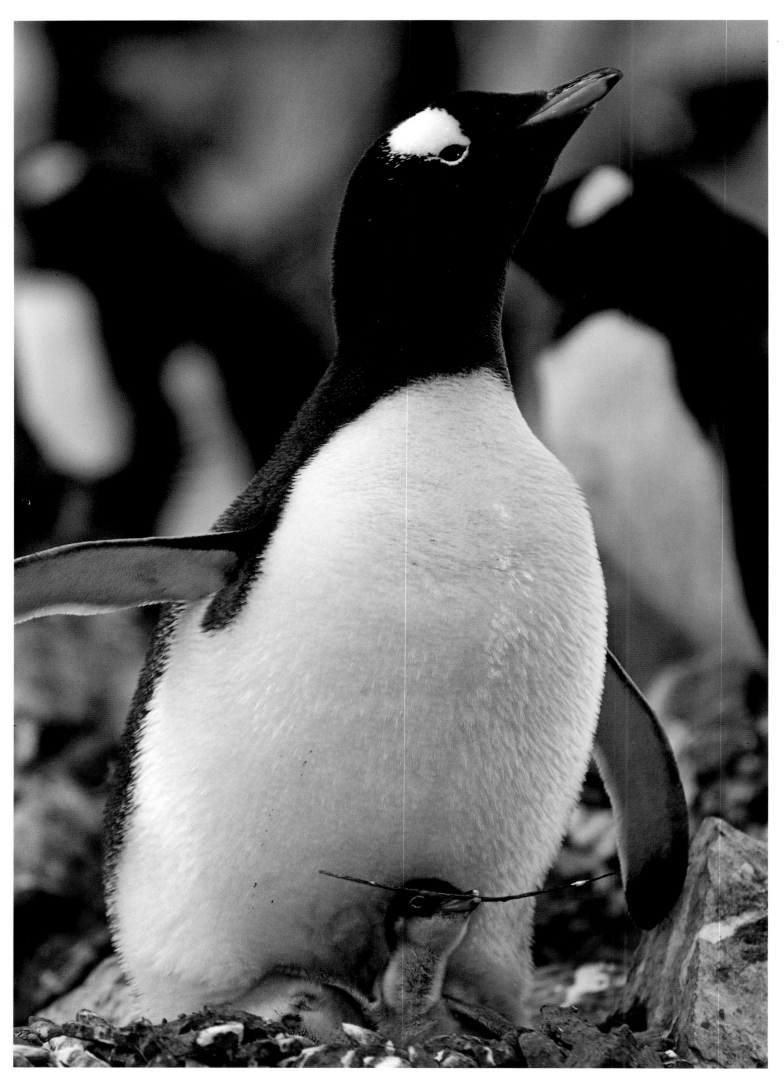

Gentoo Penguin, Antarctica, January.

Different bird species have developed very different ways of saving their young from starvation during periods when food is scarce. Some species begin incubation before all the eggs have been laid, so that the last chick to hatch will be smaller than its siblings. In other species the last egg is smaller than the rest, which will also result in a comparatively smaller chick. If there is a food shortage at a time when the young have a high intake requirement, the smallest chick will have a somewhat lower chance of survival. This may seem severe, but it is an effective strategy because it is better to sacrifice one of the chicks than all of them.

Gentoo and Snares Crested penguins both lay eggs that are hatched in reverse order—the last egg laid is the first to hatch. How does this work? Penguins can choose where they place the eggs under their skin flap; in this case, the first and smallest egg is placed near the front, where it is more difficult to keep it warm, while the second, larger egg is kept at the back, where it is warmer and so hatches sooner. In the case of Yellow-eyed Penguins, which also lay two eggs but are seldom exposed to food shortages, both eggs hatch simultaneously. The risk of losing either of the chicks is small, which is why this species has not adapted a strategy to reduce the size of the brood.

Most people are aware that we humans often catch a cold after a period of physical or mental exertion, so it makes sense that hard work also affects the immune system of birds. Equally, ill health and parasites may cause Adélie Penguins to start breeding later than normal. The timing of hatching as well as the general health of fledglings can be of vital importance for their continued survival over the next few years.

Overleaf Many young Rockhoppers spend their days in a "penguin nursery" while their parents are out foraging. When either of the parents returns, the pair listening for each other's distinctive call reunites it with its chick. There then follows a brief greeting ceremony.

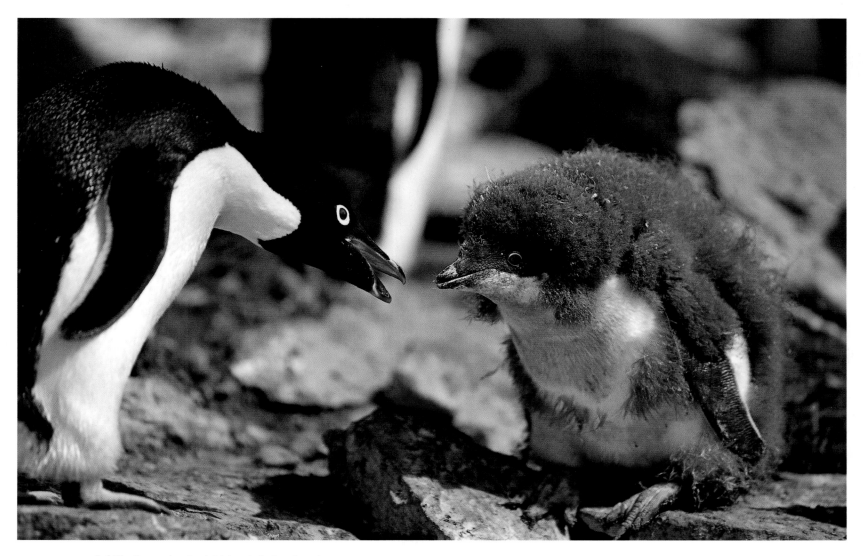

Adélie Penguin, Paulet Island, Antarctica, January.

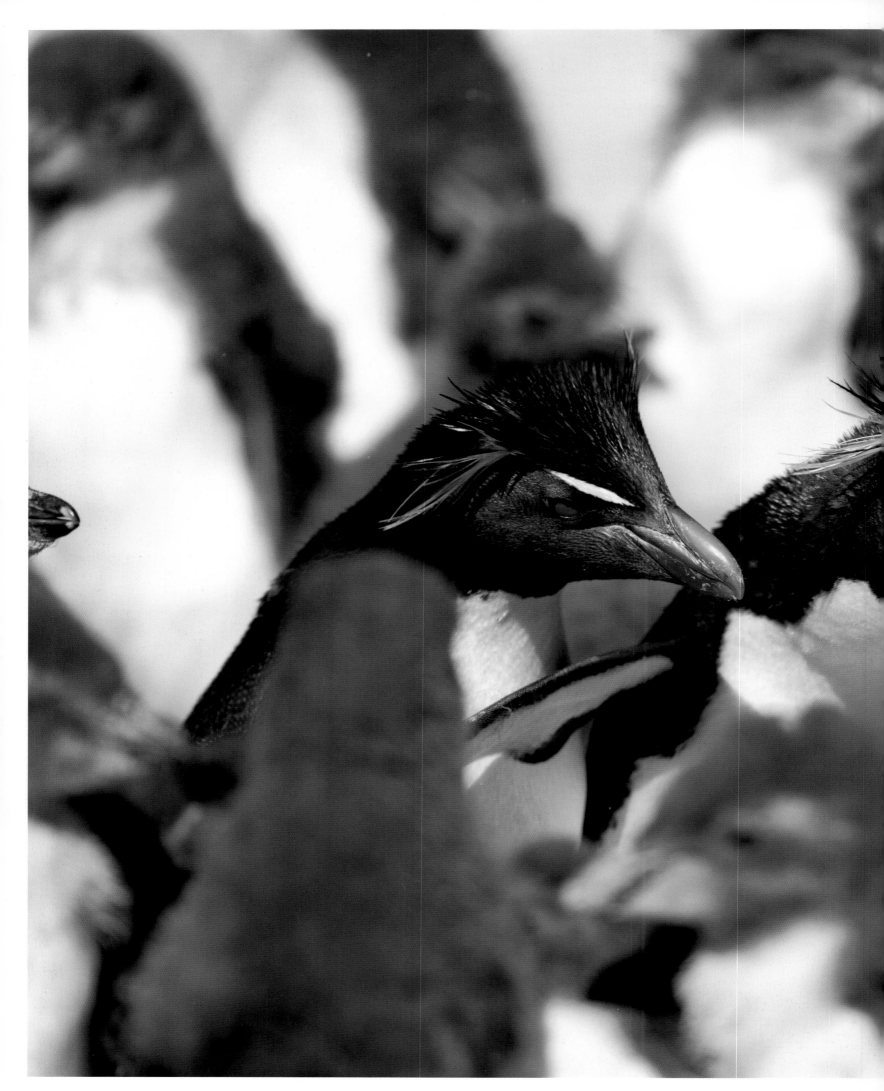

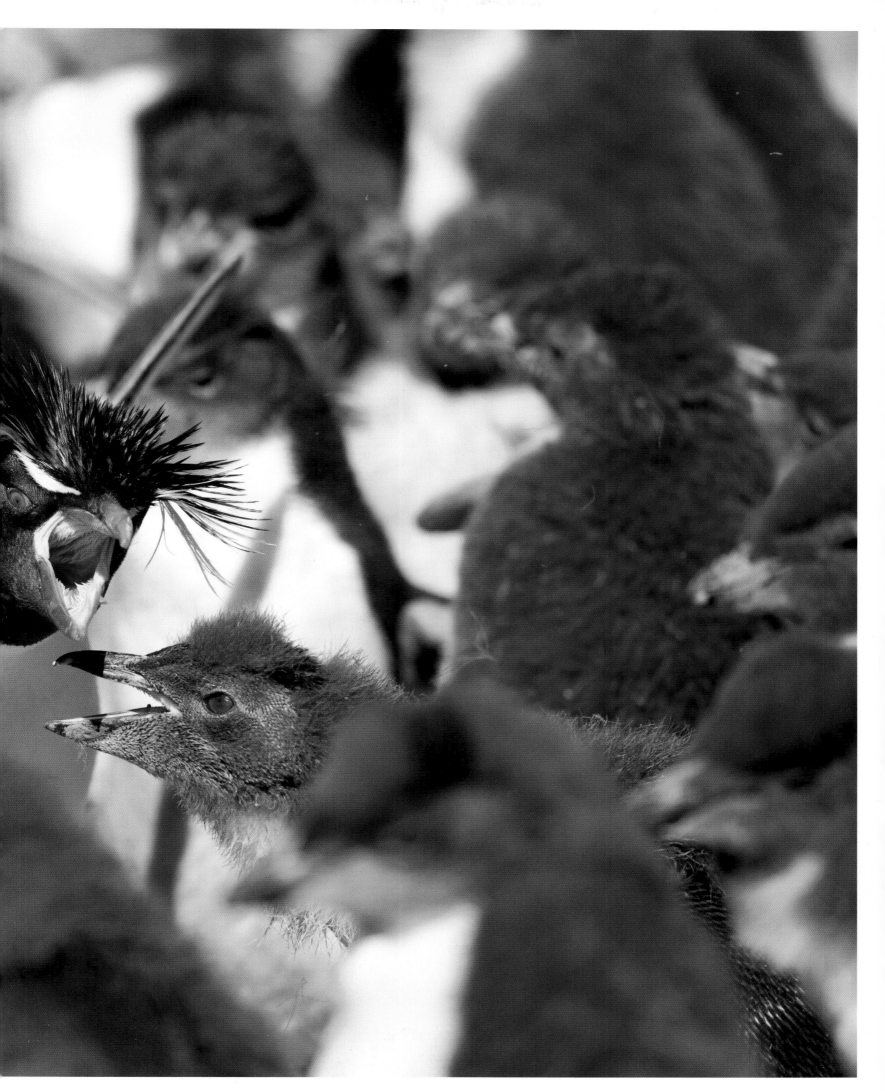

Rockhopper Penguins, Sea Lion Island, Falkland Islands, January.

It is not easy to tell which partner will produce most numerous and robust offspring. This is just as important to King Penguins as it is to most other animals. When the time comes to choose partners, every bird needs to be in peak condition to show off its excellent constitution and genetic makeup. King Penguins judge partners by the colorful pattern on their bill, head, and neck, and, in the case of females, by listening to the call of the male. Many birds have either a vibrant plumage or a complex and pleasant call with which to impress presumptive partners. To us humans it appears as if they have concentrated more on visuals than on voice, but there are some aspects we are unable to perceive. On the side of a King Penguin's bill is a multilayer photonic reflector that reflect ultraviolet light. These are surrounded by black-colored horn, creating a highlighted effect clearly visible to other penguin, but not to humans. The photoreceptors in our eyes contain only three different photopigments, none of which is sensitive to ultraviolet light, compared with the four or five pigments that appear in birds, which allow them to see ultraviolet.

Overleaf A male King Penguin uttering his mating call. Volunteer Point, Falkland Islands, February.

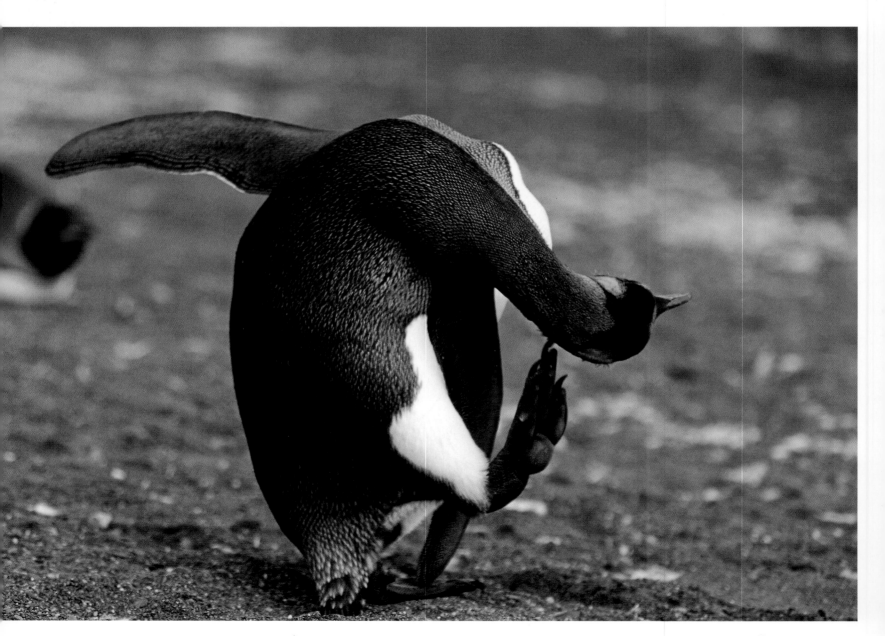

King Penguin, South Georgia, January.

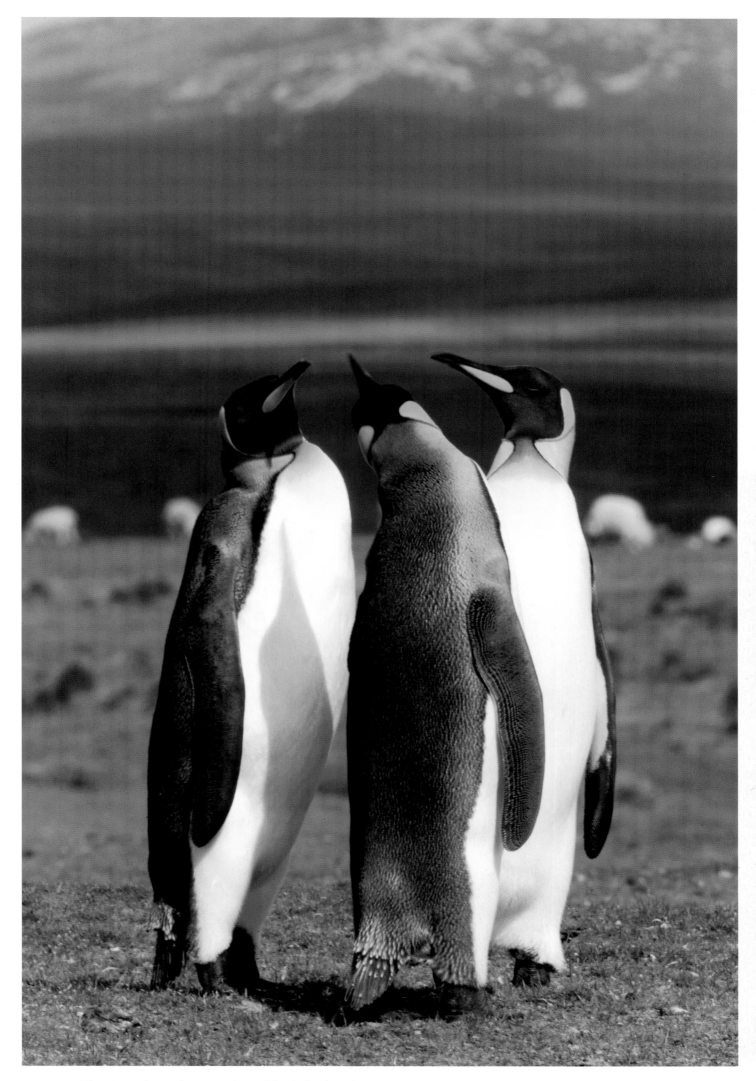

King Penguins, Volunteer Point, Falkland Islands, February.

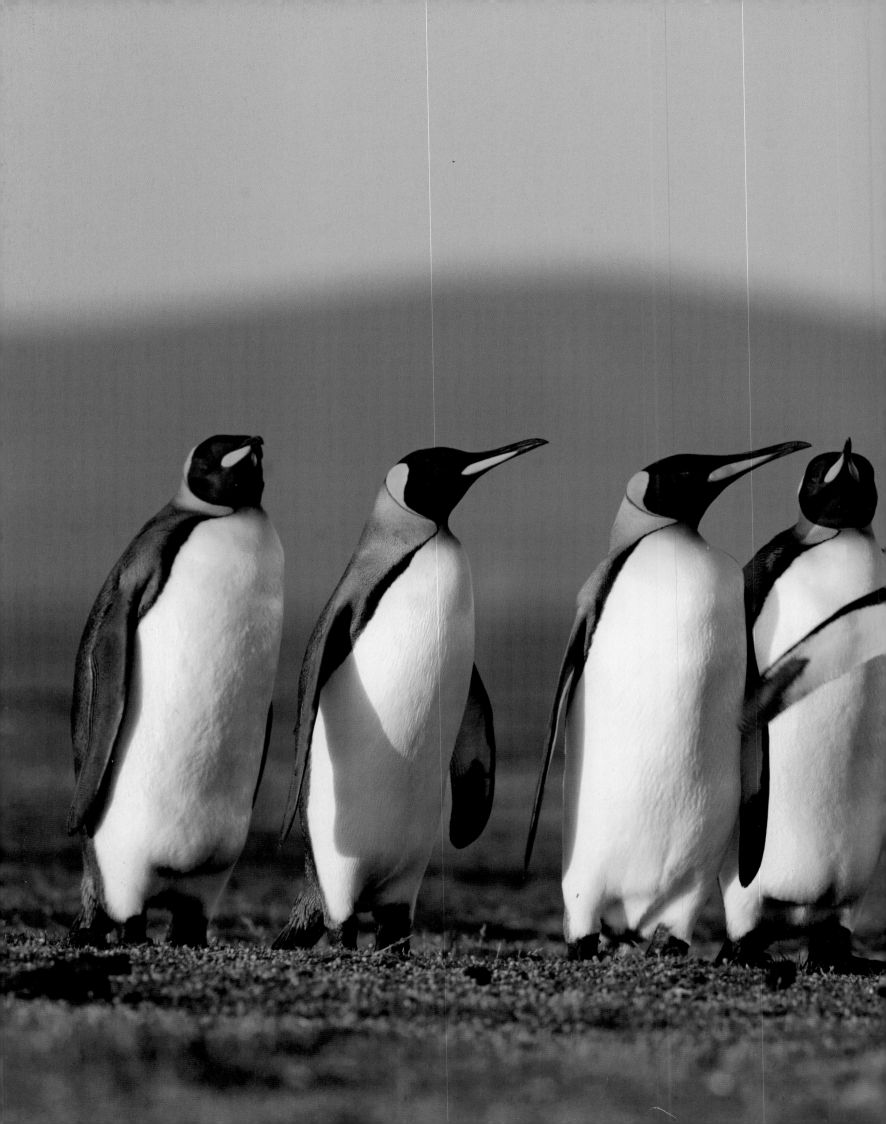

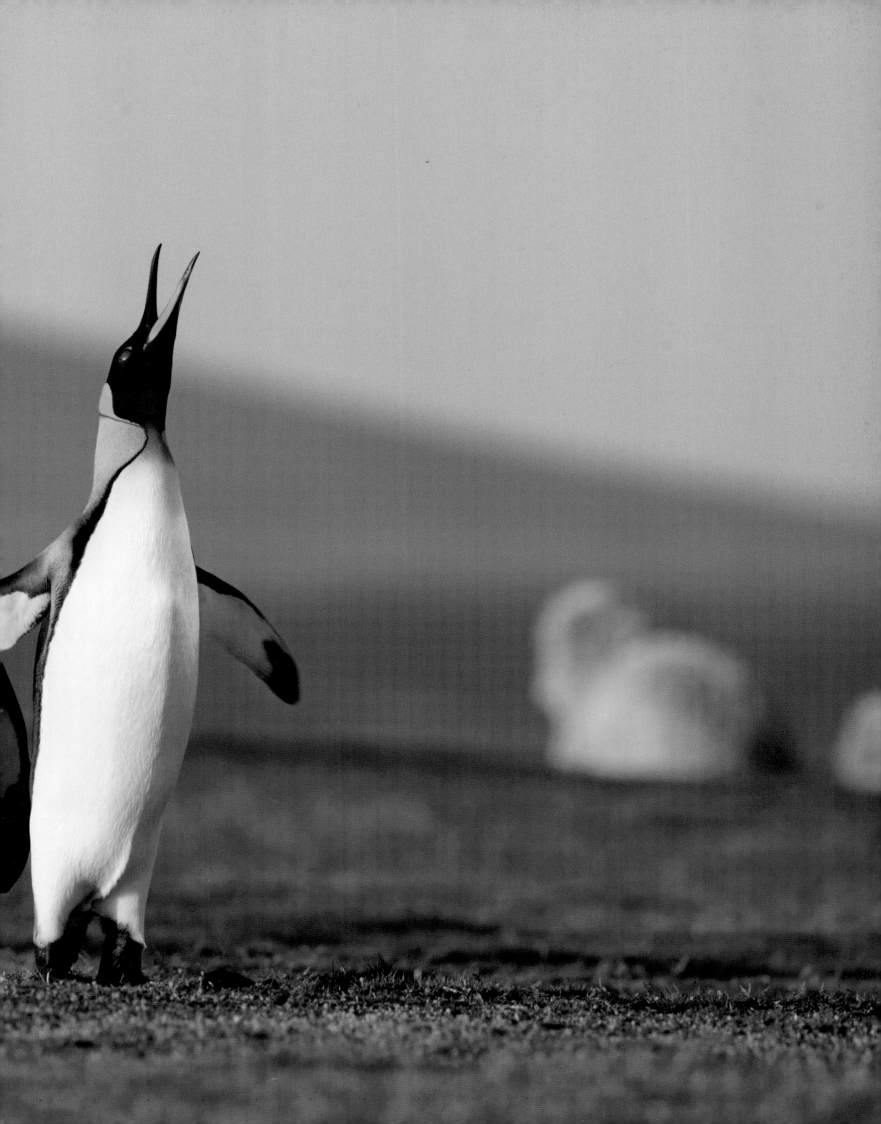

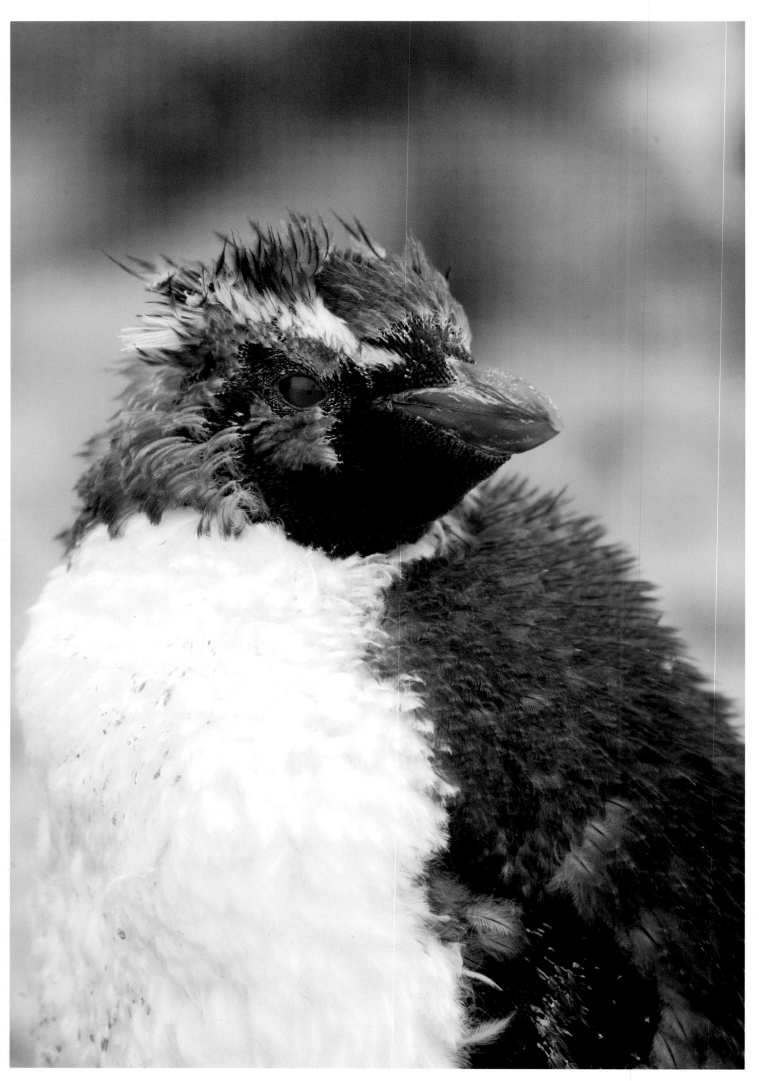

Rockhopper Penguin, Pebbles Island, Falkland Islands, February.

In their coats of furry down, Rockhopper chicks resemble little fluffy balls. The baby down remains in patches as it is gradually replaced by sub-adult plumage, which appears some time after the chick has hatched. The sub-adult plumage has excellent insulating properties and is, in fact, warmer than the plumage of adult penguins, although it is not as well able to cope with all weathers. If it is raining and the penguin becomes soaked, this plumage provides no protection whatsoever because it has none of the adult bird's oily properties. The juvenile's plumage dries quickly, but during cold, rainy periods the birds are at risk of dying from exposure.

At one time or another we have all lain down on the floor after a large meal, so it comes as no surprise that Gentoo chicks do this too. This one is busy digesting its food and needs to rest. Gentoo pairs share the incubation of the egg between them and take turns fetching food for their young. They catch fish, krill, and squid close to the coast. When the chicks are still young, the parents return with food every day, and as they get older they can go longer between meals. This presents no problem, since penguin chicks cannot eat without a break. Much of their time is spent digesting food and resting in preparation for the next meal.

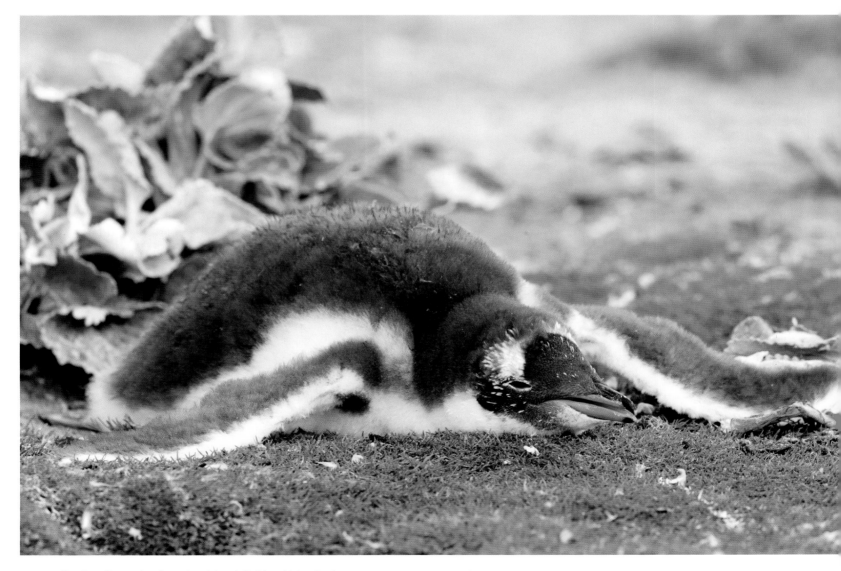

Gentoo Penguin, Saunders Island, Falkland Islands, January.

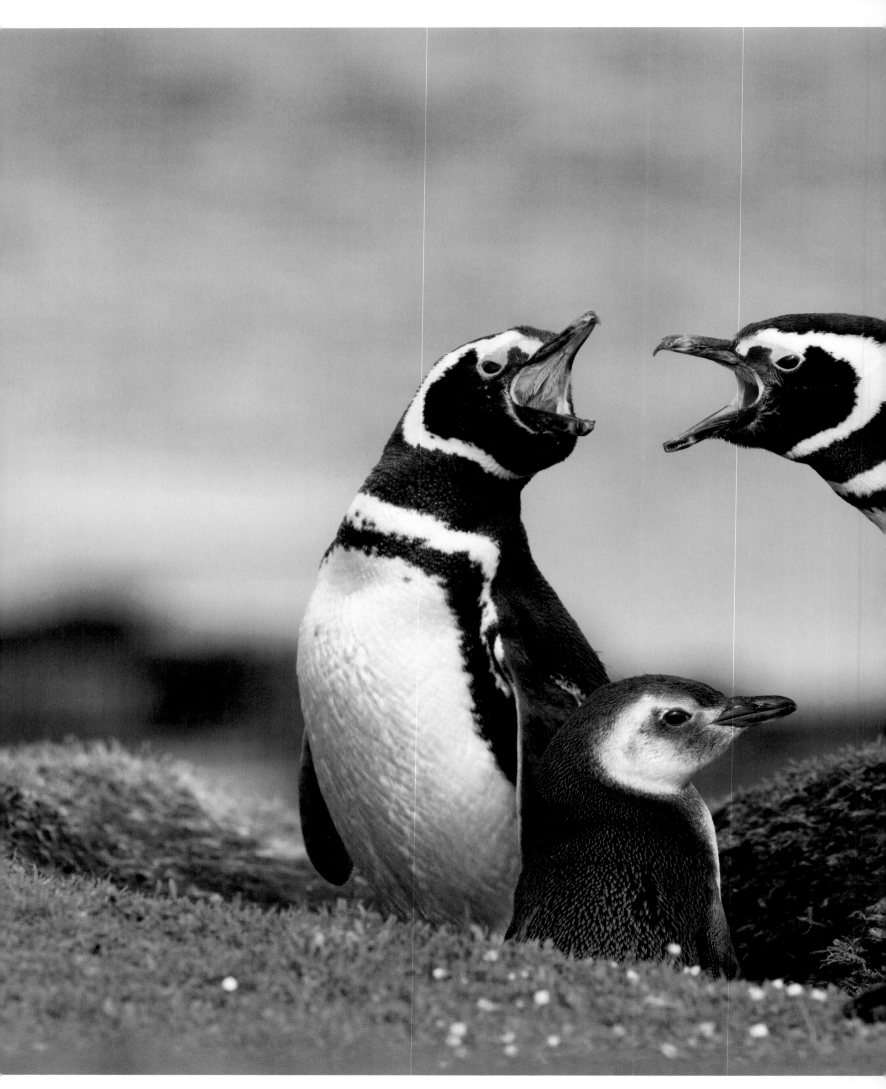

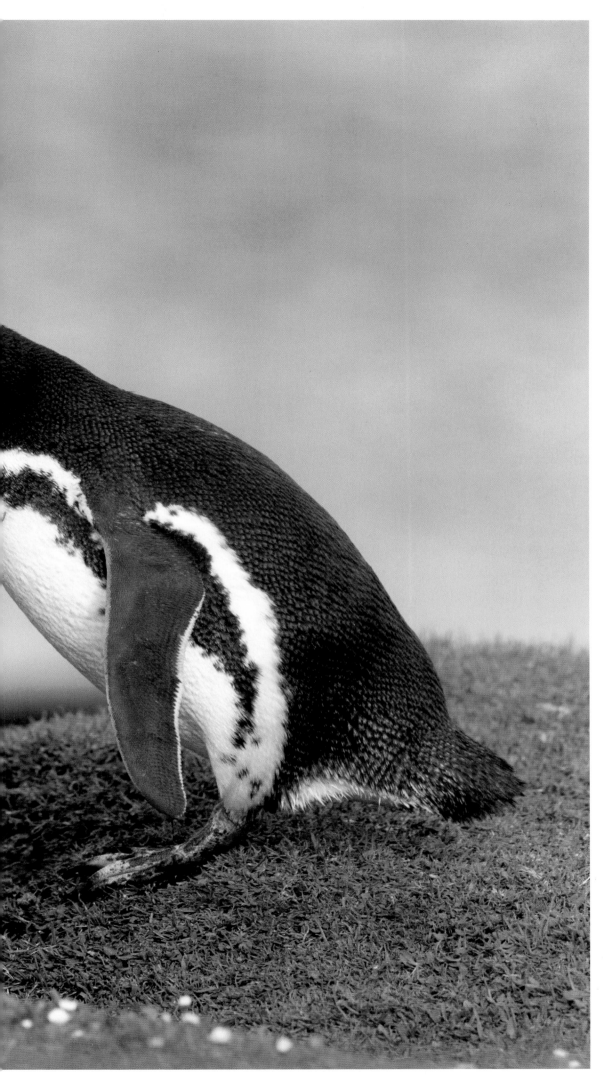

When a Magellanic male or female returns to the nest after a fishing trip, it enthusiastically greets its partner and offspring. The sound the birds make helps them recognize one another, and their voice signature keeps the family together. Adult Magellanic Penguins that move back and forth between the nest and their foraging grounds have something in common with modern full-time working human parents. The penguins have even developed a system of "nurseries," where older chicks huddle together in clusters waiting for their parents to return with food while one or two adults keep an eye on them.

Magellanic Penguins, Saunders Island airfield, Falkland Islands, January.

Young Gentoos need to spend a lot of time begging for food, because adult penguins do not regurgitate their catch until they are in no doubt that they are giving it to their own chicks. Feeding time can, therefore, end up as a protracted chase, with several other chicks joining in, but these will soon be shooed away by other adults. Feeding may take place in installments, but often the portions are quite large, the size varying with the species. The Gentoo chick does not need to go long without food, because the parents generally return within a couple of days. Consequently, it does not need to build up large fat deposits. While they wait for their next meal, Gentoo chicks metabolize approximately one-fifth of their protein supplies, the rest coming from fat. In contrast, King Penguin chicks have to fast for up to five months—longer than any other known animal of this size—and take only a small quantity of protein reserves from muscle tissue during this time. Instead, they live almost entirely off their fat reserves, which is the most efficient way of storing energy.

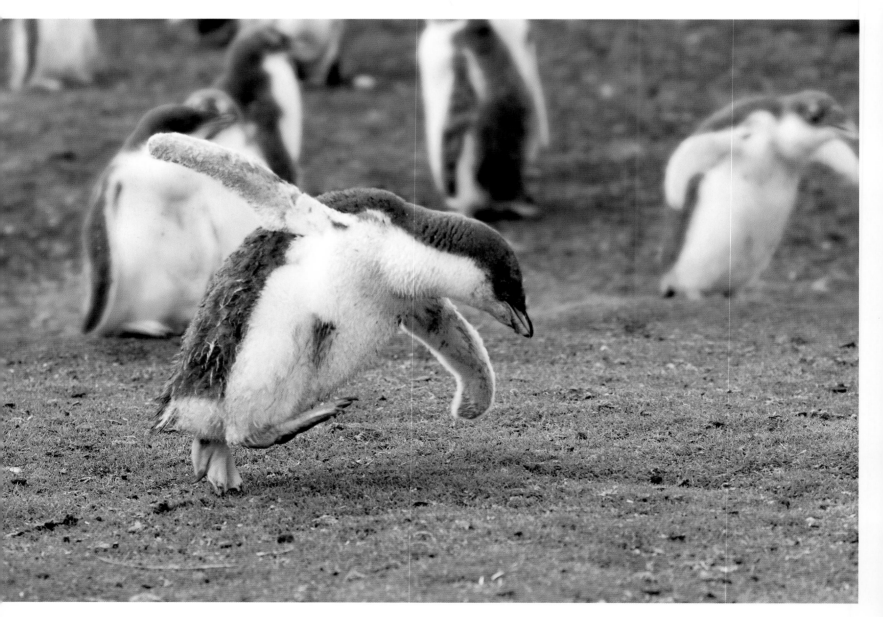

Gentoo Penguin, Saunders Island, Falkland Islands, January.

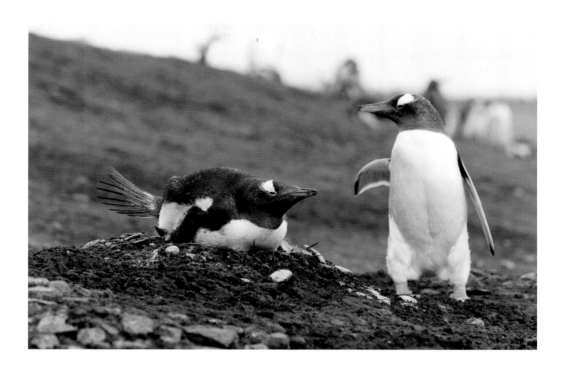

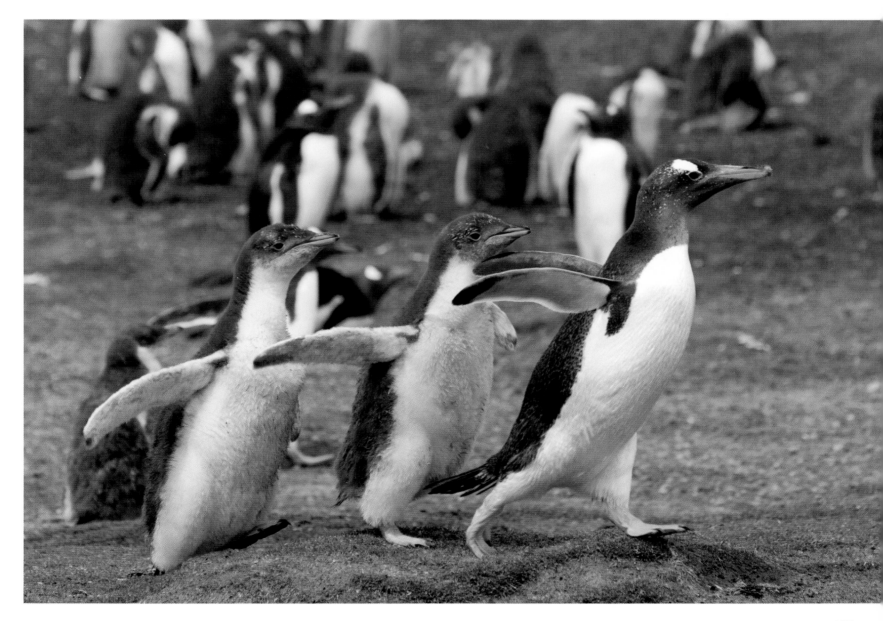

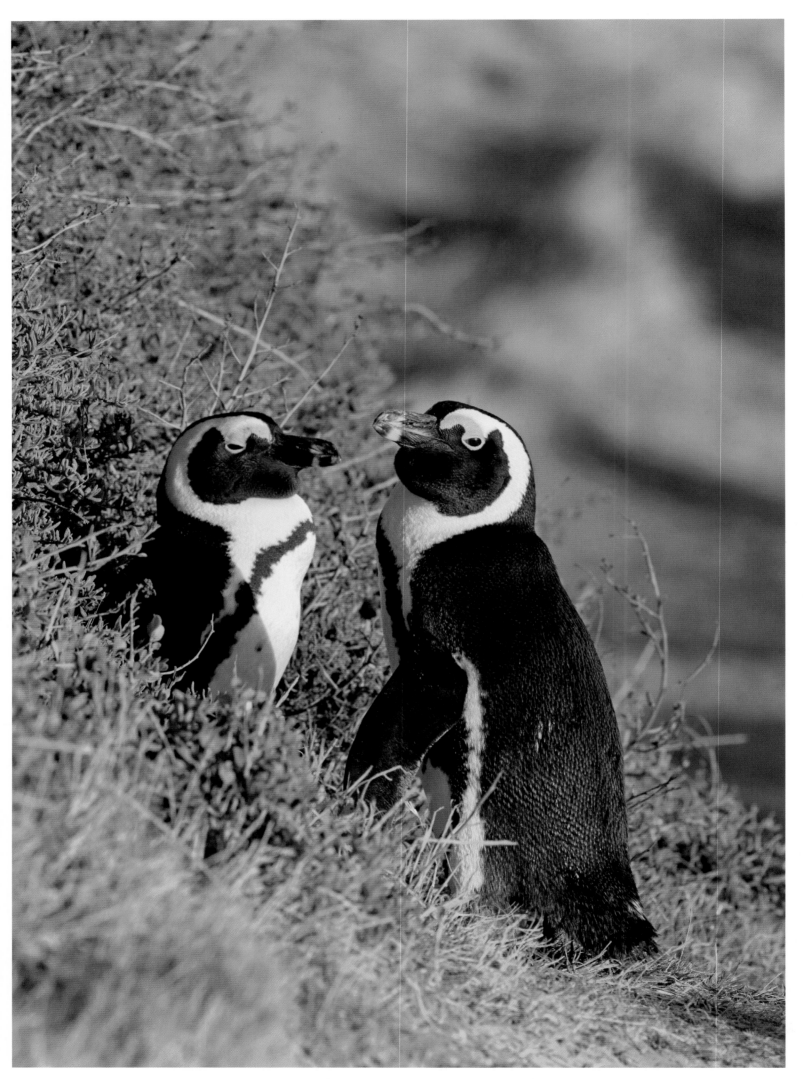

African Penguin, Simon's Town, South Africa, March.

African Penguins build burrows in order to protect their eggs from predators and the heat of the sun. Just like other penguins, the male and the female share the job of feeding the two chicks. The African Penguin stays in the same area all year round, but will spend four months at sea before the breeding season begins in January. Penguins that have already formed pairs often sit close together by the nest while the remaining birds try to impress presumptive partners with their donkey-like braying.

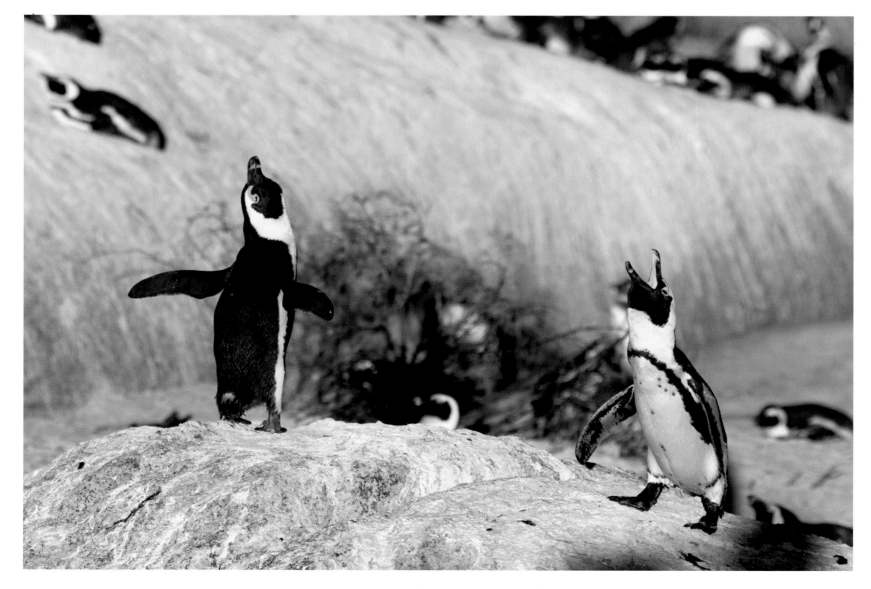

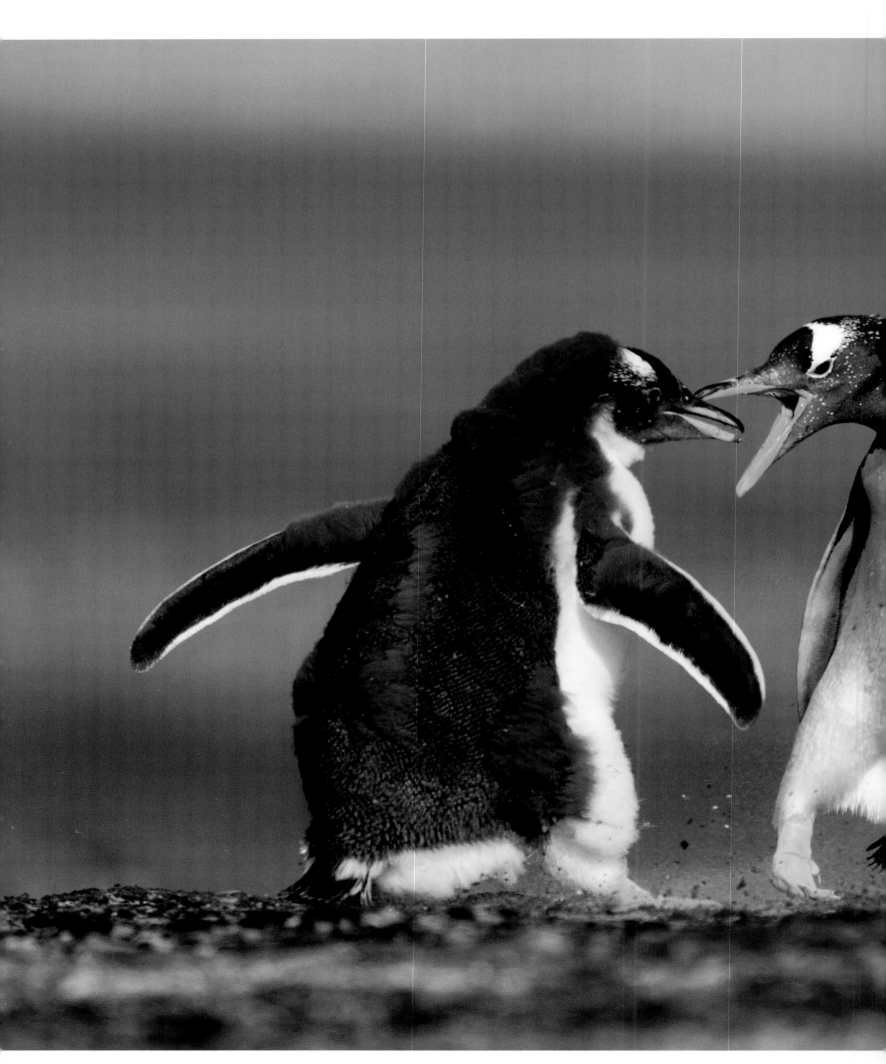

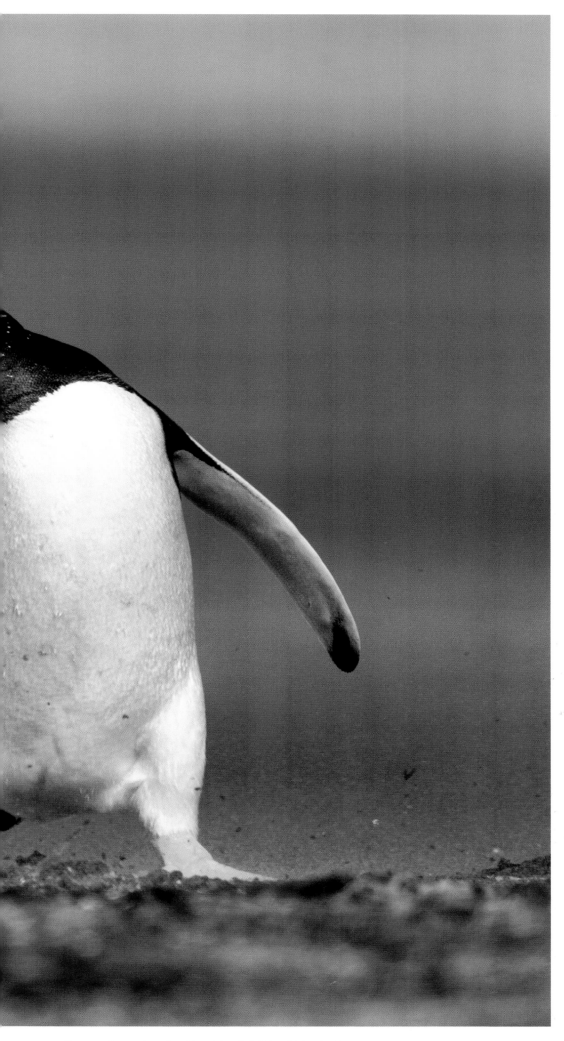

The Gentoo chick must keep begging food from the returning parent by pecking on its bill and making a special sound. Hungry chicks often try to beg food from other adults, but this is a futile, even dangerous, thing to do. The adult penguin will clearly show that it has no intention of surrendering any food by stabbing the chick with its bill.

Gentoo Penguins, Sea Lion Island, Falkland Islands, January.

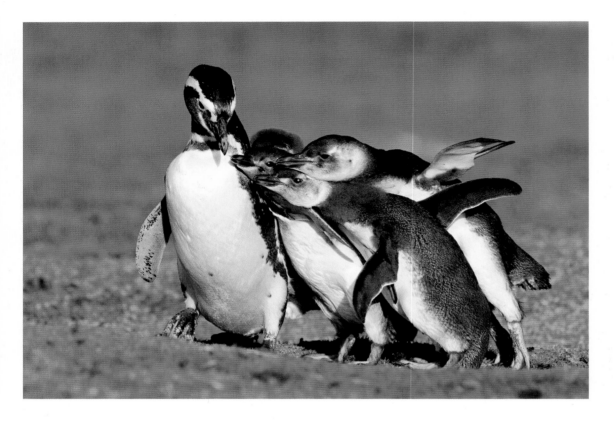

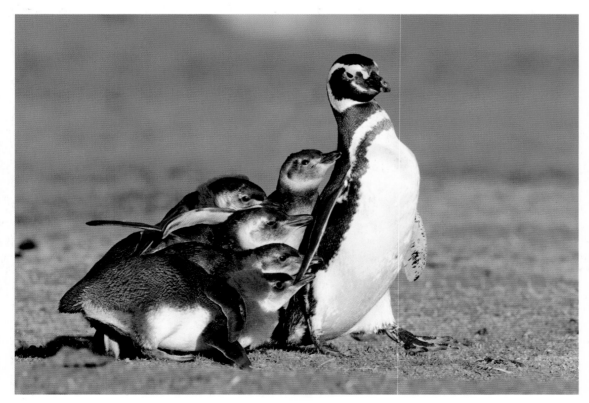

Magellanic Penguins normally lay two (occasionally three) eggs in their underground burrow, where both parents take turns incubating and bringing up the young. The main factor limiting brood size is the amount of energy the female is able to invest in egg laying, although her size also determines how many eggs she can incubate without losing any through insufficient heat production.

Magellanic parents recognize their chicks by their voices and feed only their own offspring—they may even be aggressive toward other chicks. So why does the Magellanic Penguin pictured here appear to be taking on six hungry chicks at once? Can several females have laid their eggs in the same burrow and are therefore feeding both broods? Are they related? Have they laid eggs beside each other, resulting in the eggs hatching simultaneously? If so, perhaps they have learned to recognize each other's chicks? Or is the penguin really only feeding its own two chicks? We can only speculate, but it is certainly a rare sight.

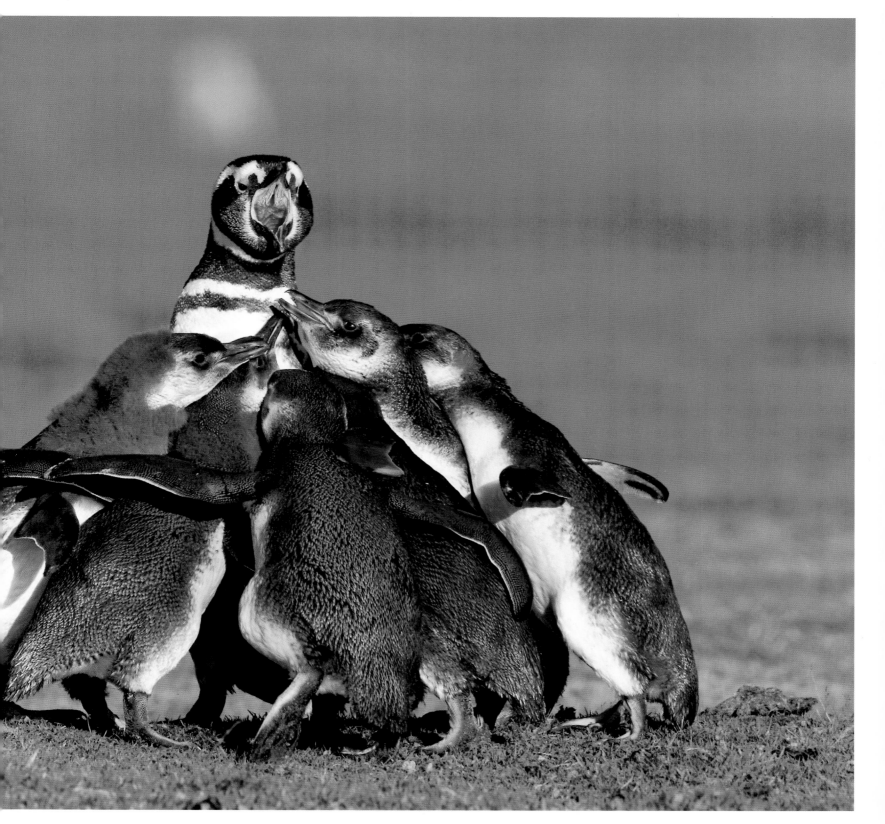

Magellanic Penguins, Volunteer Point, Falkland Islands, February.

Food from the Ocean

ANTARCTIC KRILL DOMINATES the food chains of the Southern Ocean and is the staple food of the ocean birds, seals, and whales living there. Many penguin species feed almost exclusively on krill, and you might well wonder whether there is any room for variation. Furthermore, why do these birds eat something that is in fact poisonous in such large quantities? Even though many penguins subsist exclusively on this kind of food, to which their digestive systems and entire lives are adapted, many do not, adding lanternfish, squid, and large quantities of other fish and crustaceans to their diet.

Penguins need to be able to reach depths where they can find a sufficient supply of their favorite food. Their body size determines how deeply they can dive. This is why species that eat the same food, but are different in size, can exist in the same area without competing directly with one another. If this were not the case, competition for food would constitute a major problem for penguins —after all, the resources in the sea are not inexhaustible. Fur seals, penguins, and petrels often fight over food in the water outside the penguin colonies.

Large numbers are not always a disadvantage, and penguins like to forage for food together. This probably serves as a protective measure against Leopard Seals in the water, but the birds also tend to succeed better when diving together. Penguins venturing out to sea in groups to forage for food are a common sight.

In order to be able to raise their young in isolated islands or on the ice sheet, penguins must be able to store energy and use it sparingly for long periods. The best and most efficient way of doing this is to build up fat reserves, and they are experts at this. The birds increase their body weight by 50 percent as they prepare for the breeding season, and are able to survive for months without food. Male Emperor Penguins, which stand around on the ice incubating their eggs for more than four months during the coldest part of winter, survive because they periodically huddle up together and because they shiver. When their muscles contract and relax in rapid succession during shivering, they generate heat. Huddling and shivering reduces their energy consumption by half.

One side effect of eating large amounts of food is the production of large amounts of excrement. Penguin colonies typically produce enormous amounts of penguin droppings, which the young in particular have to wade through during their months on land. The droppings generate high levels of nitrogen and carbon, as well as harmful bacteria, viruses, and parasites. Scientists still do not know how penguins handle this constant and potentially dangerous exposure to the microorganisms in their feces.

Rockhopper Penguins, Sea Lion Island, Falkland Islands, January.

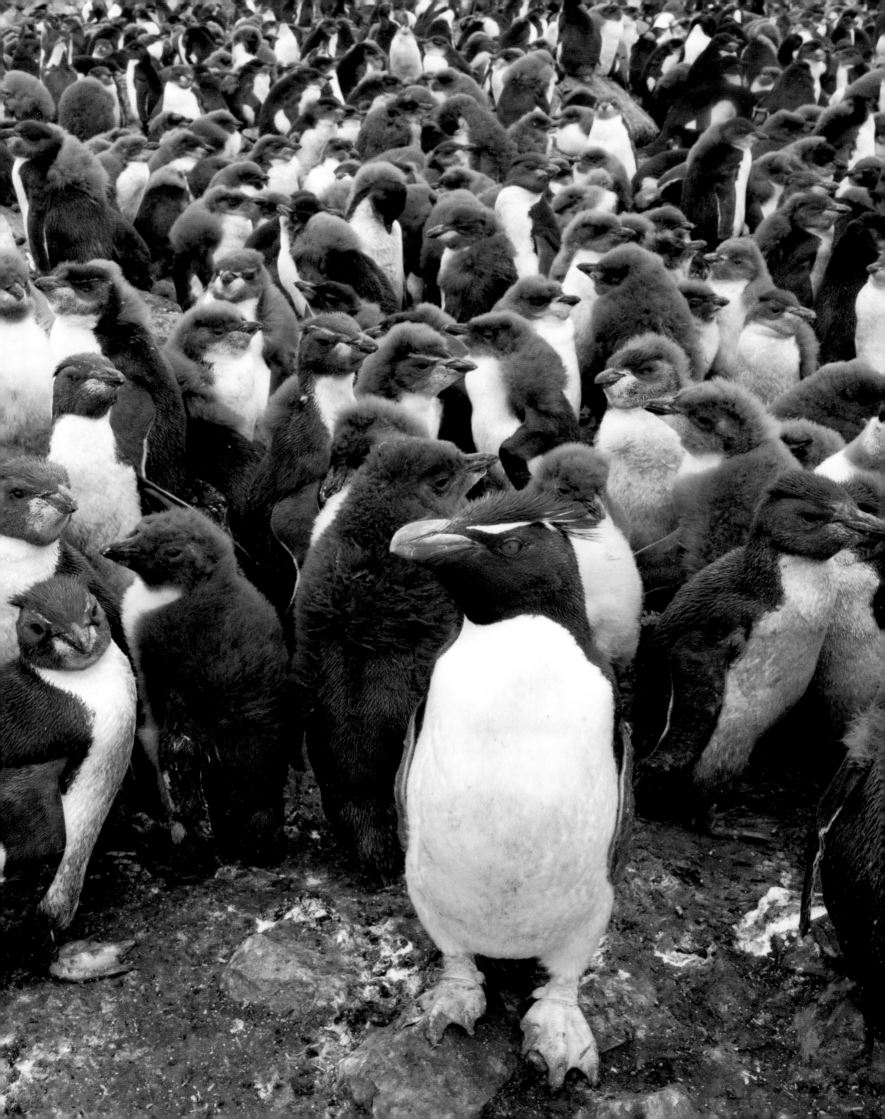

When adult Adélie Penguins on the South Orkneys venture out to sea to forage for food for their chicks, they enter the water only after some hesitation, because there is always a risk that they will meet their worst enemy, the Leopard Seal. Their return is perhaps even more frightening, since they have to negotiate the surf with bellies full of food. A meal can weigh between 7oz (200g) and 35oz (one kilo) depending on the size of the catch, and it takes the parent 10–60 hours to find enough fish and krill for each meal. The foraging time and size of the catch depend on each bird's health status. The fatter and stronger the parent, the bigger the meal, and the sooner it will reach the chick.

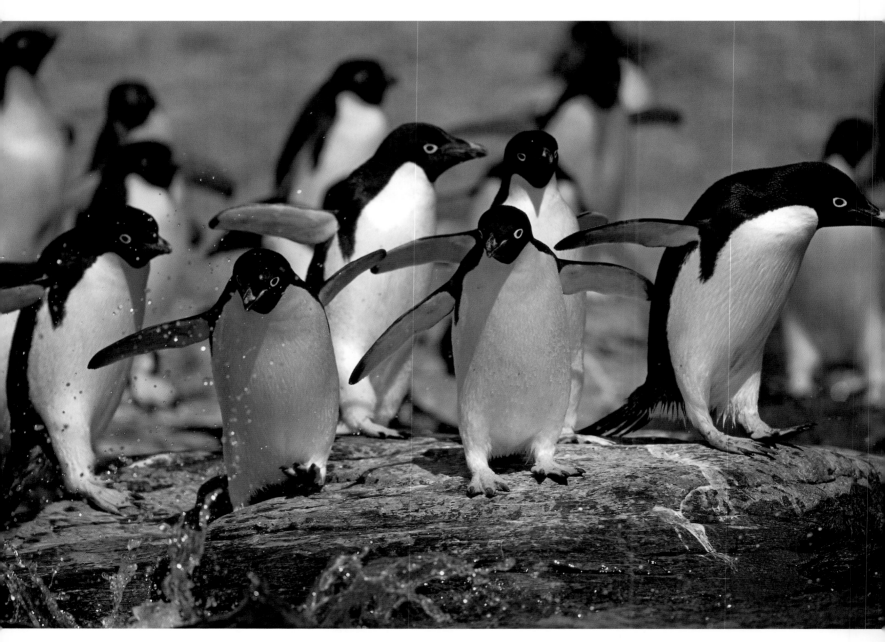

Adélie Penguins, South Orkneys, January.

Overleaf The genus Pygoscelis includes three species: the Gentoo, Adélie, and Chinstrap penguins. Together they constitute more than two-thirds of the total number of birds living in the Antarctic region. All have a circumpolar distribution, which means they can be found all over the Antarctic, and their areas of habitation partly overlap. Adélie Penguins live closer to the South Pole, while Gentoos are found farther north, and Chinstrap Penguins live in between the two.

Closely related species whose breeding grounds partly or completely overlap tend to compete for the same food and so develop their own niches. Gentoos forage for food near land and dive deeper than the other two. Adélies and Chinstraps keep relatively near to the surface, but forage farther out to sea. Competition between Adélie and Chinstrap penguins is further diminished by the fact that they breed and molt at different times of the year.

Gentoo Penguins, Volunteer Point, Falkland Islands, February.

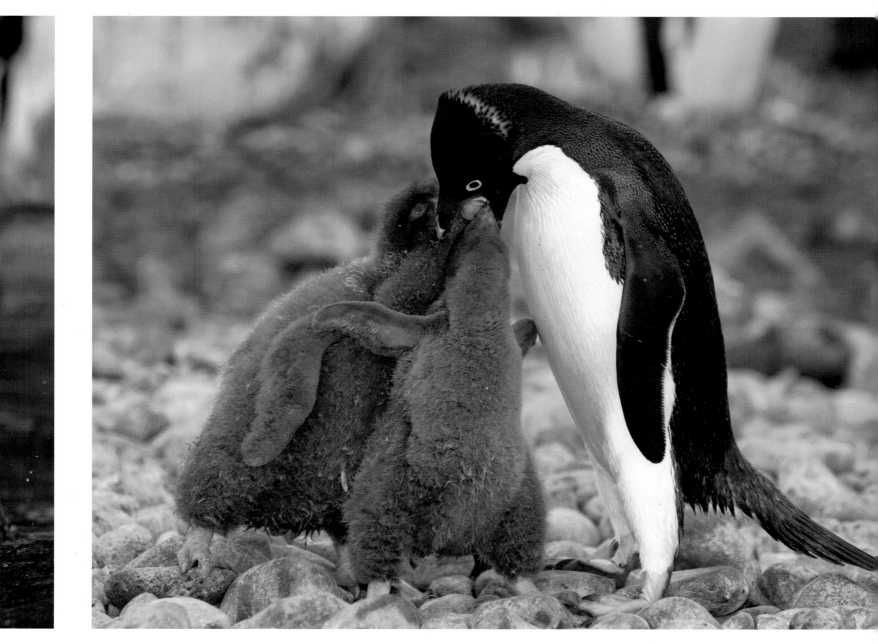

Adélie Penguins, Paulet Island, Antarctica, January.

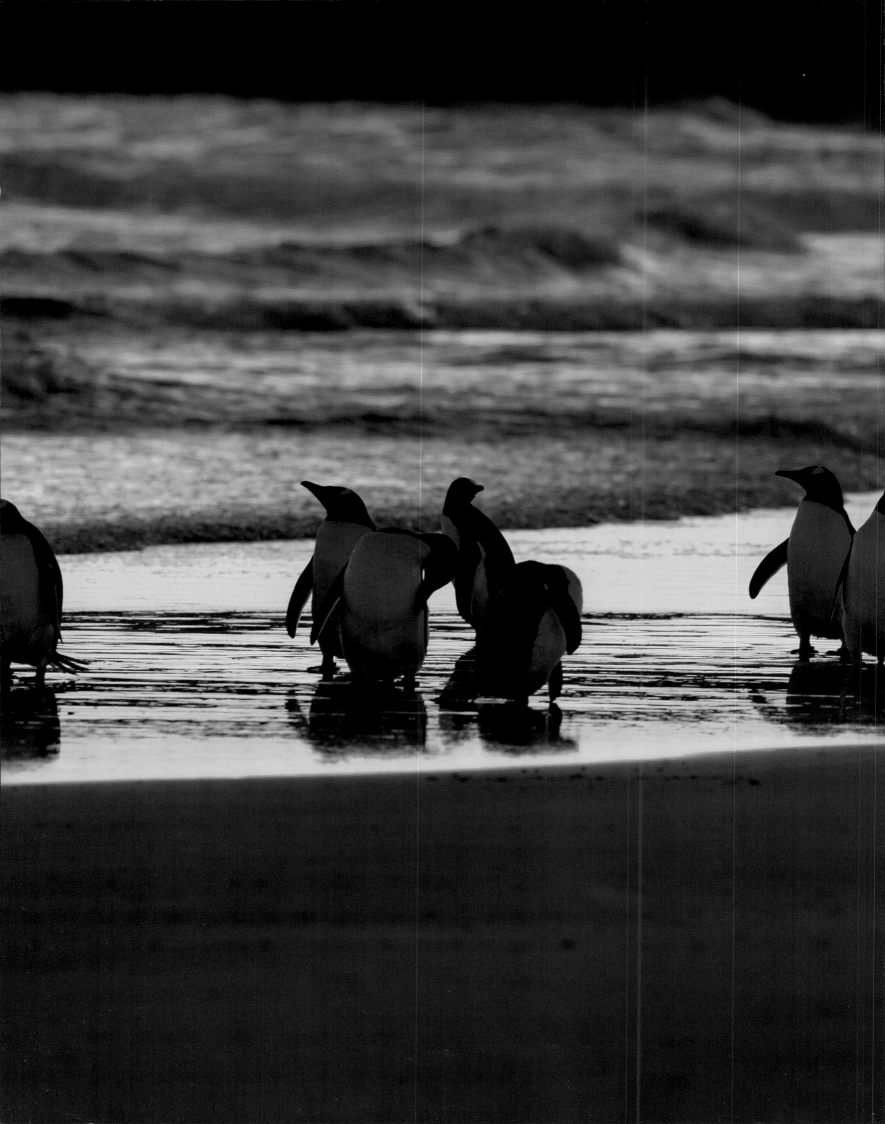

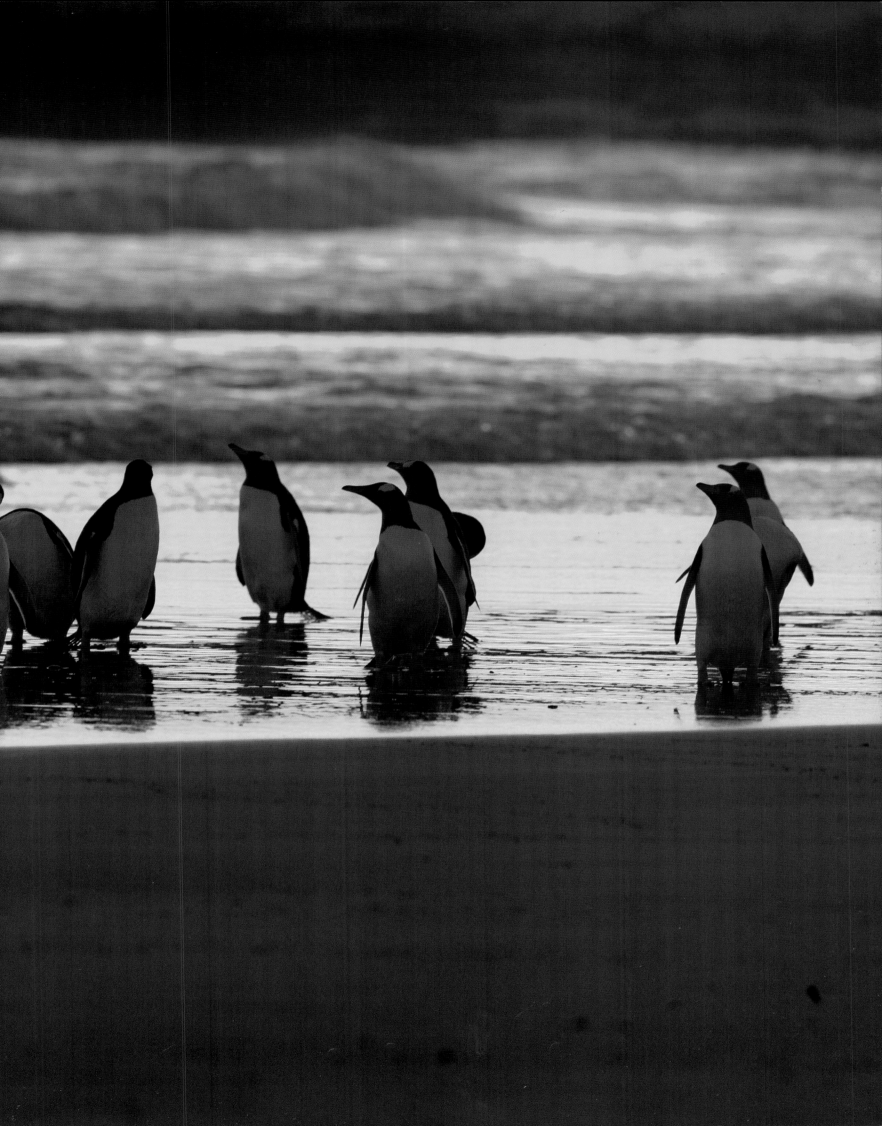

In nearly one-third of all bird species, the male feeds the female before and after she lays her eggs to build up her energy stores. This behavior is seldom seen in penguins, and seems to be restricted to African and Adélie penguins. When it comes to the African Penguin, such feeding is probably a means of strengthening the bond between the male and female while ensuring that the female has sufficient energy resources for laying high-quality eggs. Male Adélie Penguins have only ever been seen feeding their partner in an extreme emergency, such as when she is almost dying after a long period of starvation.

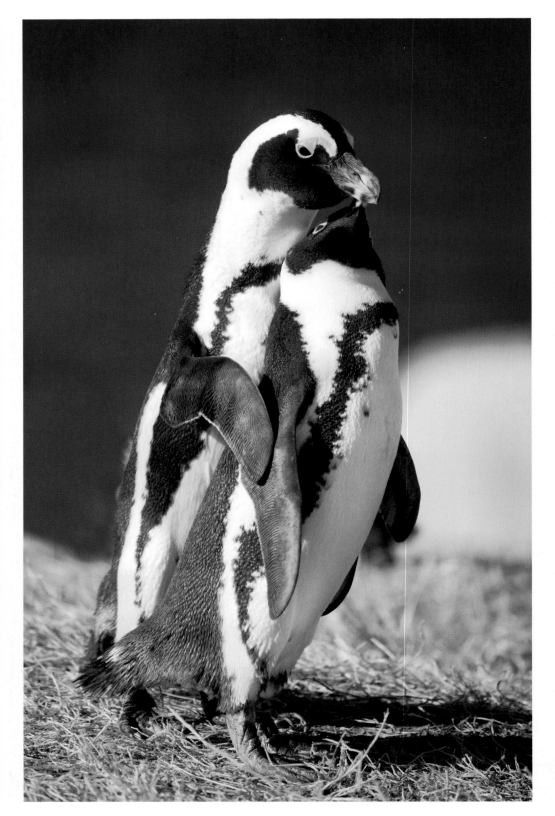

African Penguins, Simon's Town, South Africa, March.

It is not easy for the thousands of breeding Gentoos on Saunders Island to get a moment's peace, yet adult penguins will try to find a quiet spot to feed their chicks. This is a way of reducing the risk of other chicks approaching it, attempting to steal its food. The parent regurgitates a portion of food and surrenders it only after insistent begging, once it is certain that the food will end up inside the right stomach.

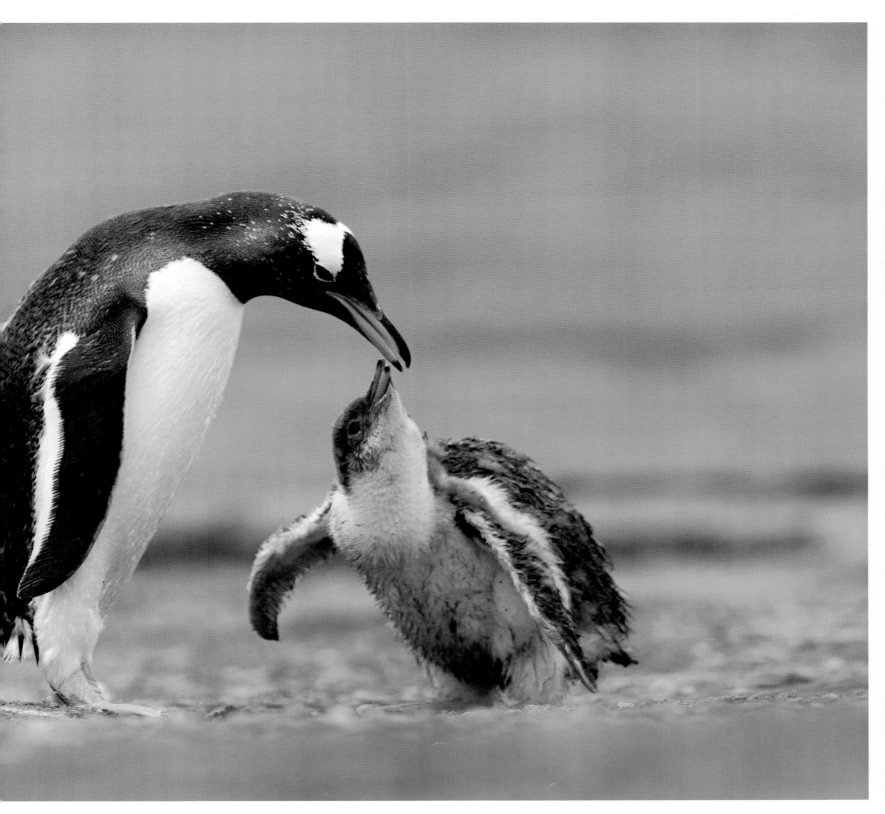

Gentoo Penguins, Saunders Island, Falkland Islands, January.

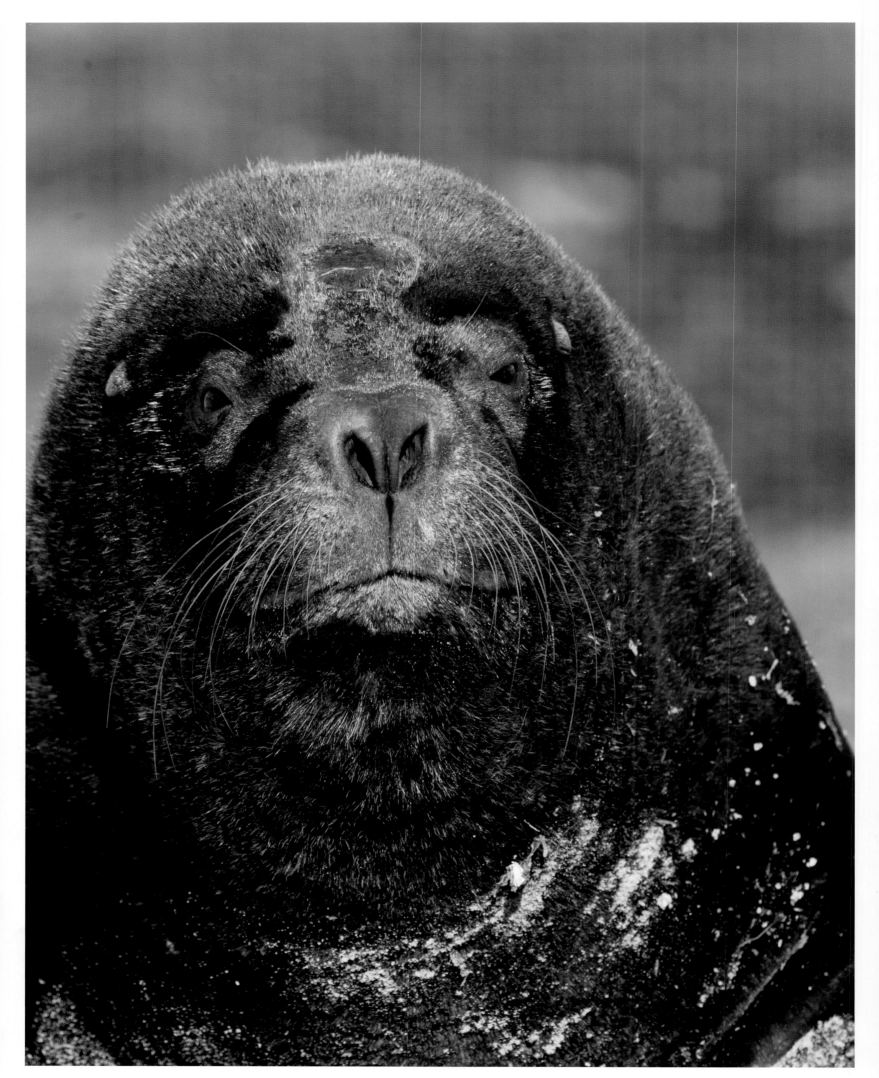

Southern Sea Lion, Sea Lion Island, Falkland Islands, January.

There is a certain amount of competition in the Falkland Islands between Southern Sea Lions and Gentoo Penguins for krill, but the occasional penguin might also slip down a sea lion's throat when the birds are in good supply. Sea lions are attracted to large penguin colonies, and in some areas they may cause problems by taking too many birds. A large male sea lion weighing 660lb (300kg) is an impressive sight to us, but even more so to the Gentoos. In comparison, a young chick is only a morsel to a sea lion.

Sea lions do take penguins on land, but it is easier for them to catch them in the water close to the shore. Many animals respond to danger instinctively, and this also applies to Gentoos, although they need to go through a learning process to find out where they are most safe and how to avoid danger. It is therefore primarily very young penguins, not yet able to swim or dive, that easily fall prey to seal lions. This is why it is so important that young penguins stay close together during this time.

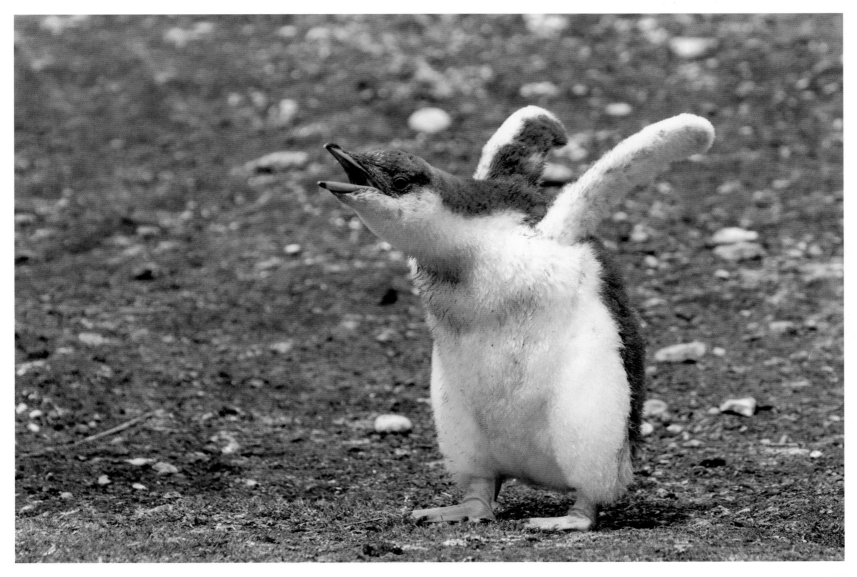

Gentoo Penguin chick, Sea Lion Island, Falkland Islands, January.

The threatened African Penguin, which lives in small colonies along the coasts of South Africa and Namibia, feeds on fish and crustaceans it catches just off the coast. The male and female take turns fetching food for their young for as long as they are still in the nest. They do not go far, but forage in close vicinity of their colonies.

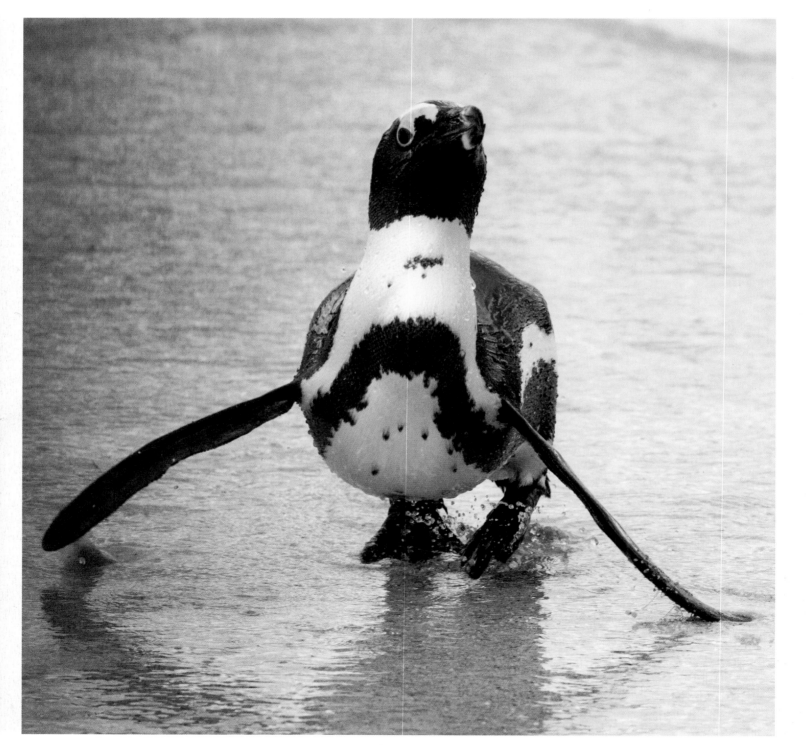

African Penguin, Boulders Beach, Simon's Town, South Africa, March.

In the morning, Rockhopper females set out from their colony to venture out to sea to forage and spend all day diving. Scientists have discovered that they make, on average, 44 dives per hour. The females return in the evening with food for the chicks, which have been looked after by the fasting males all day.

Overleaf African Penguins prefer to forage in groups, especially when diving in cloudy water where the risk of being attacked by predators is greater owing to the poor visibility. By placing transmitters on individual birds and registering their diving patterns, scientists have established that penguins that dive in groups stay close together during the entire trip.

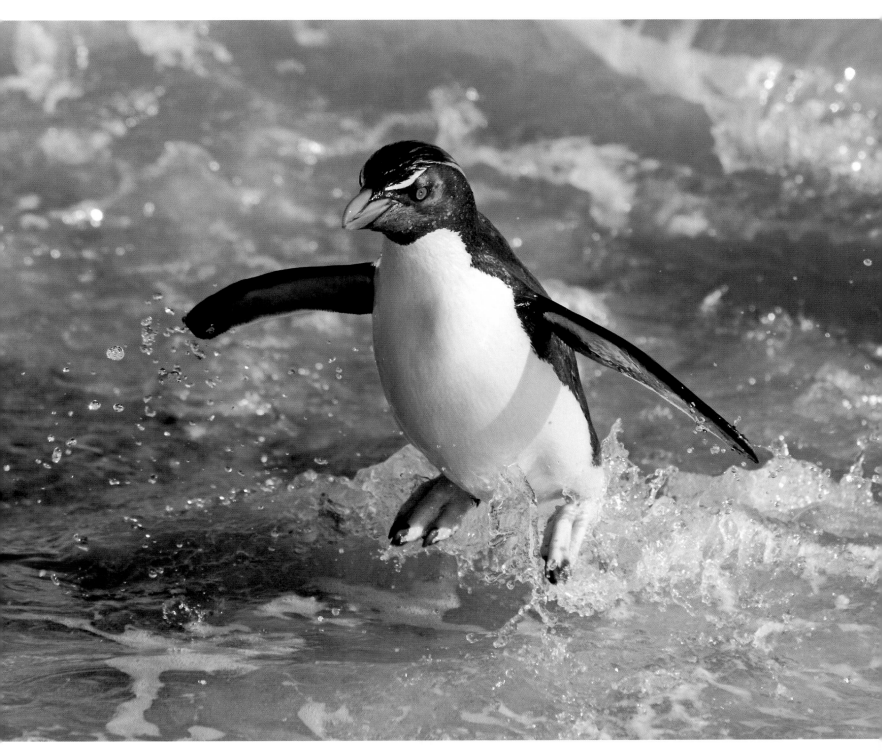

Rockhopper Penguin, Saunders Island, Falkland Islands, January.

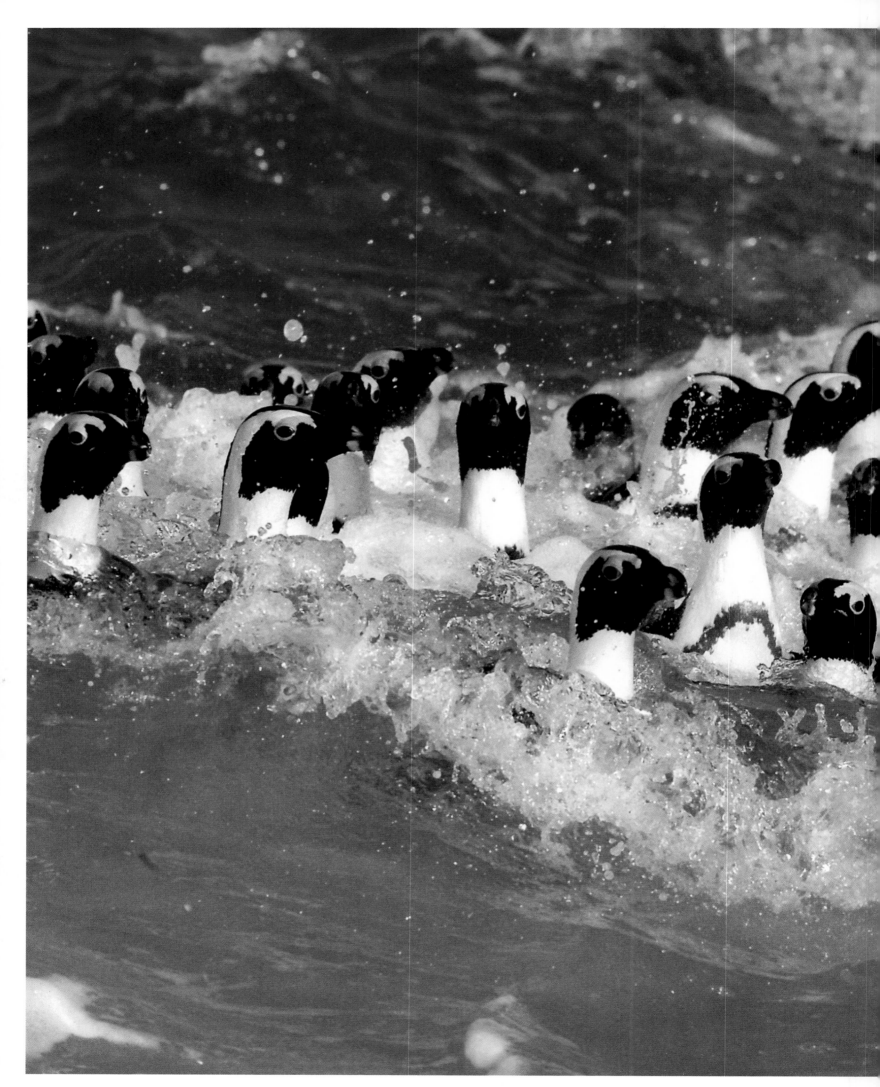

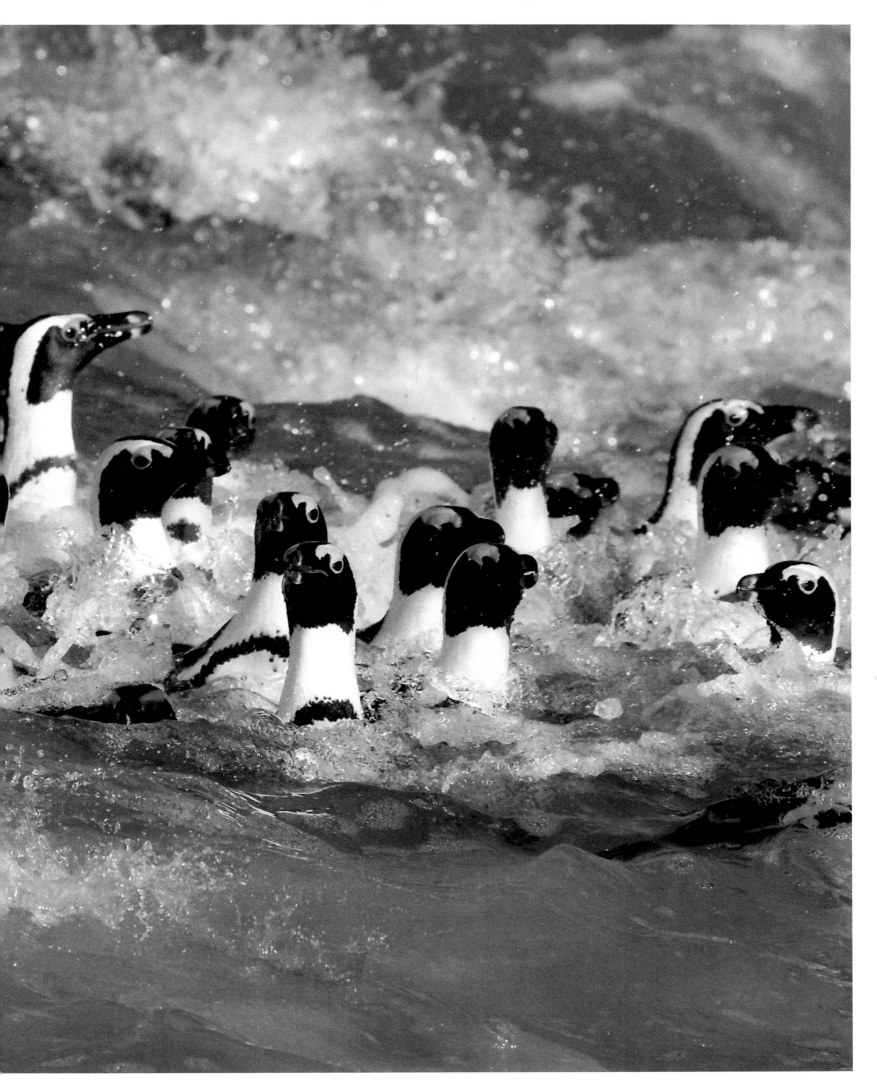

African Penguins, Boulders Beach, Simon's Town, South Africa, March.

Chinstrap Penguins are the second most common penguin species in the world, numbering more than 7.5 million breeding pairs. They live almost exclusively on Antarctic Krill and Ice Krill, which they catch in the open sea. On Signy Island in the South Atlantic, Chinstrap Penguins dive for krill 24 hours a day to a depth of 600ft (180m). Occasionally, they dive nearer the coast, aiming for large schools of krill that feed on plankton on the ocean floor.

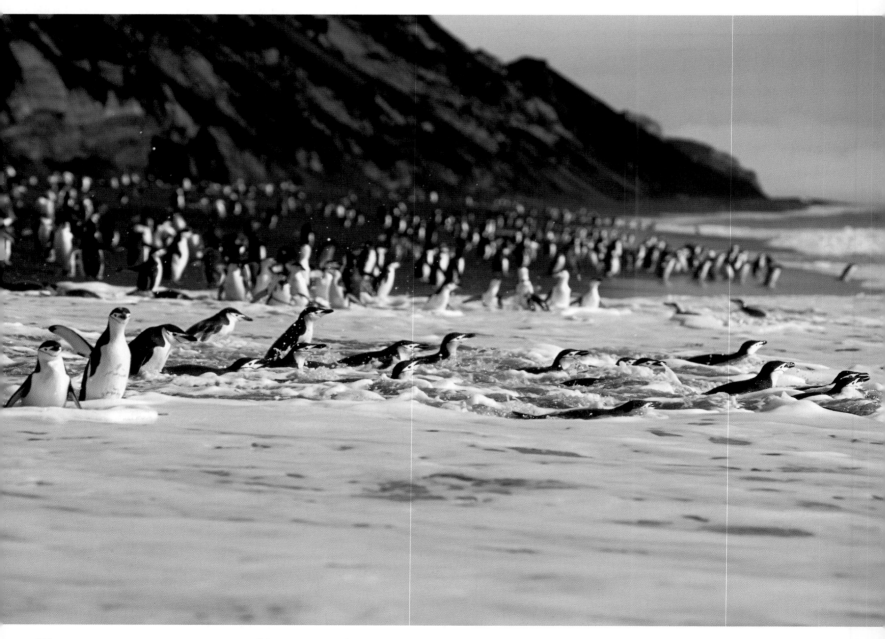

Chinstrap Penguin, Baily Head, Deception Island, Antarctica, January.

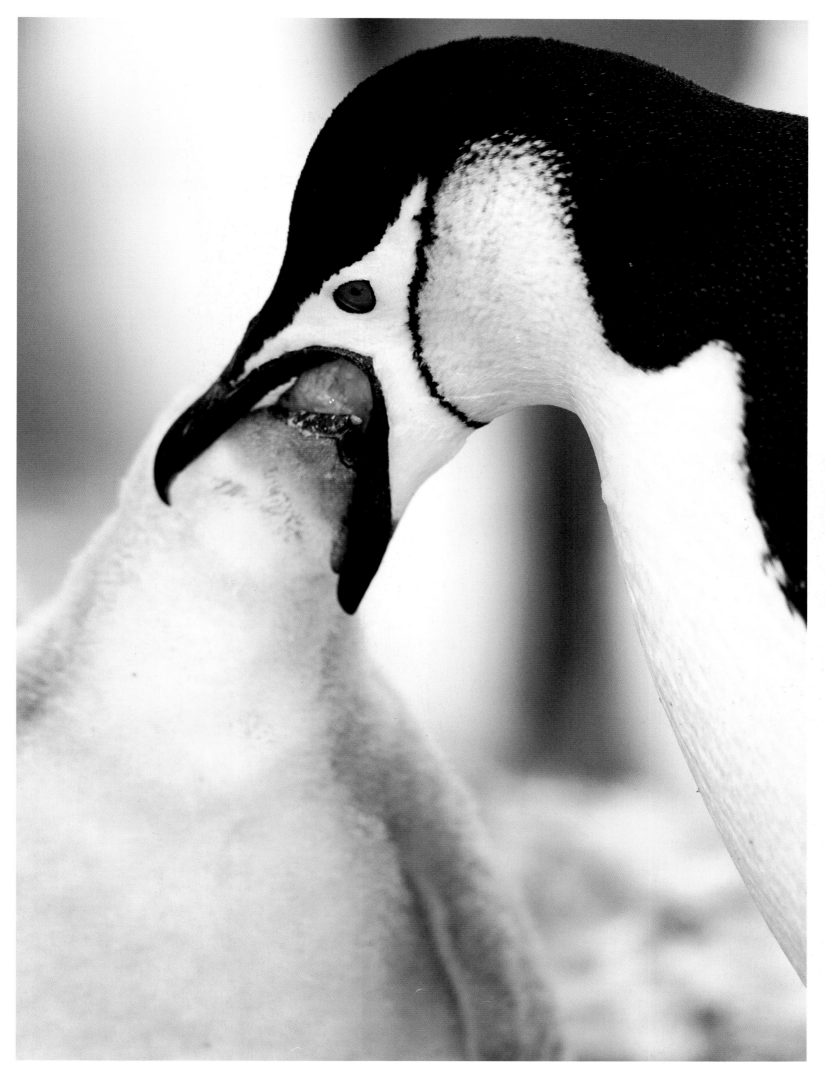

Chinstrap Penguin, Hannah Point, Antarctica, January.

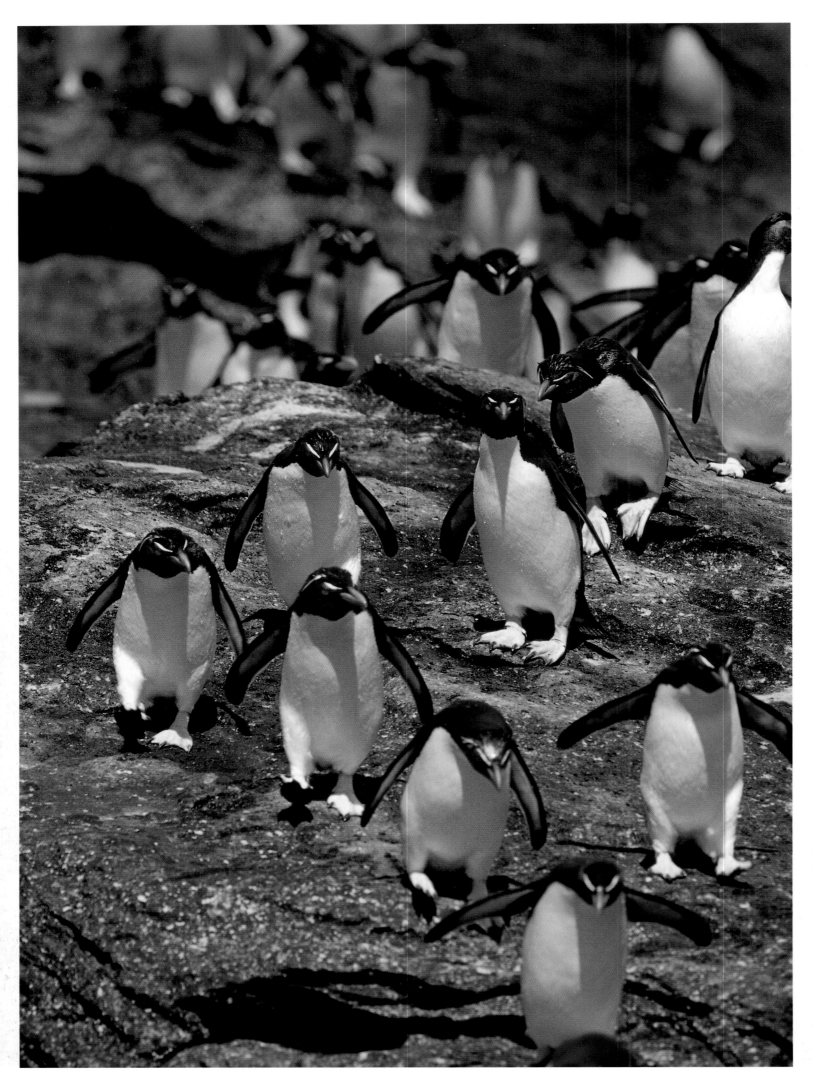

Rockhopper Penguin, West Point Island, Falkland Islands, December.

Even though Rockhoppers are well adapted to hopping around on land among large boulders, they often find it rather difficult to make an elegant landing after spending a long time in the water. The reason for this is that they often choose almost impossible landing sites in order to evade sea lions and other predators waiting on land, so they have to struggle through the surf and try to avoid being thrown against sharp rocks. Rockhoppers with particularly full bellies often need to stay in the water for a long time before they are able to get ashore, making them easy prey for the seals and sharks that regularly prowl the waters off the beaches.

Overleaf One of the distinguishing features of penguins is their ability to store large amounts of fat and then starve for long periods, such that some individuals really do look like well stuffed walking barrels. Here, young Magellanic Penguins raised in a nearby burrow are lying around on a Saunders Island beach, waiting for their next meal to be delivered by their parents. They will wait for as long as possible—they are clearly reluctant to venture out to sea by themselves. The first time the youngsters leave land, they do it with well stocked fat reserves to ensure they survive the first critical period in the sea on their own. This is when mortality is at its highest.

Magellanic Penguins, Saunders Island, Falkland Islands, January.

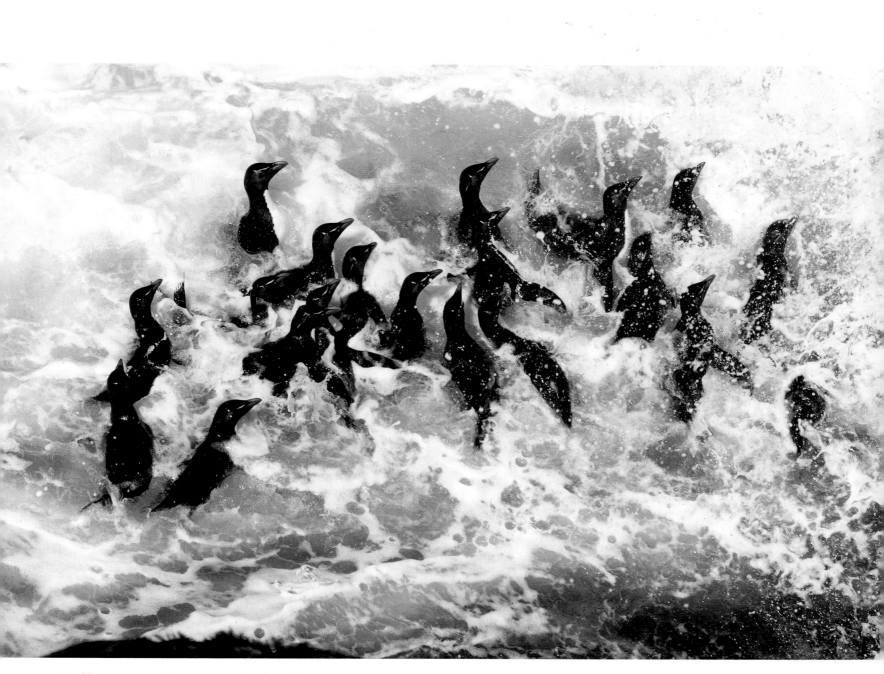

Rockhopper Penguins, Sea Lion Island, Falkland Islands, January.

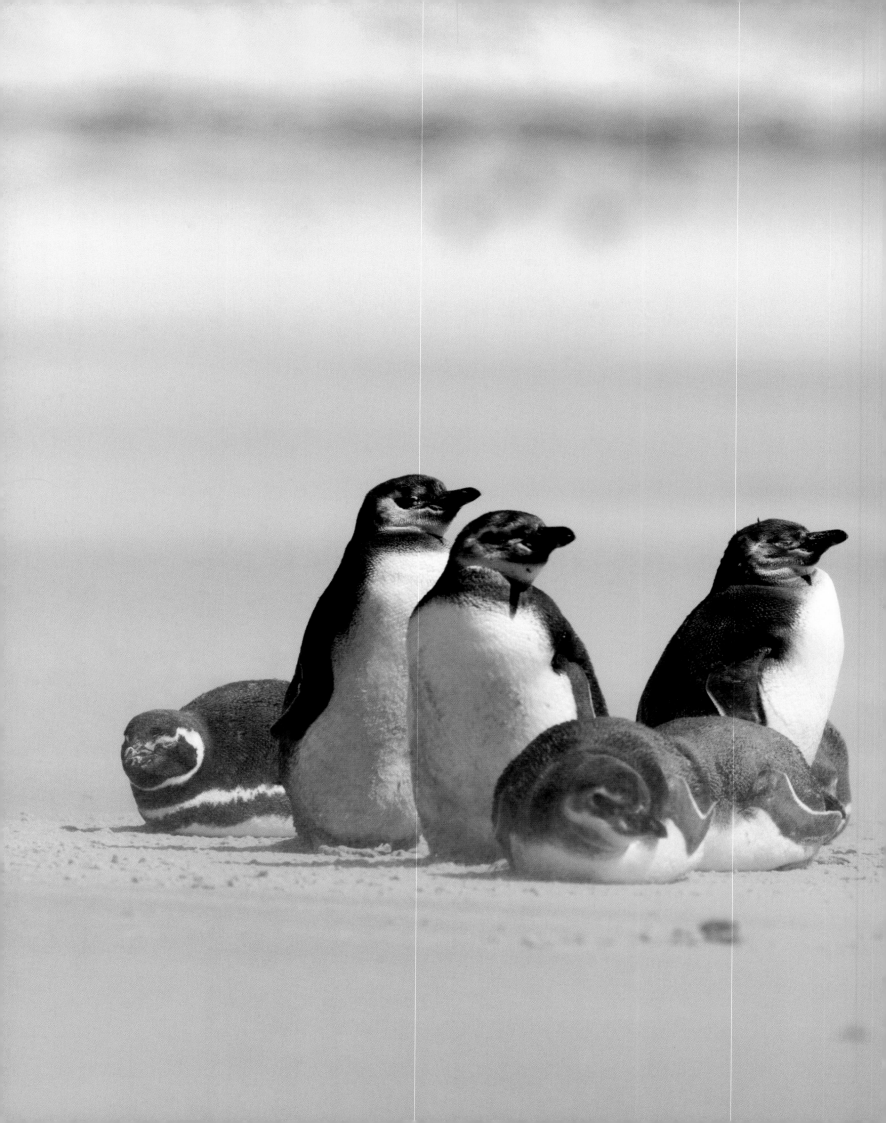

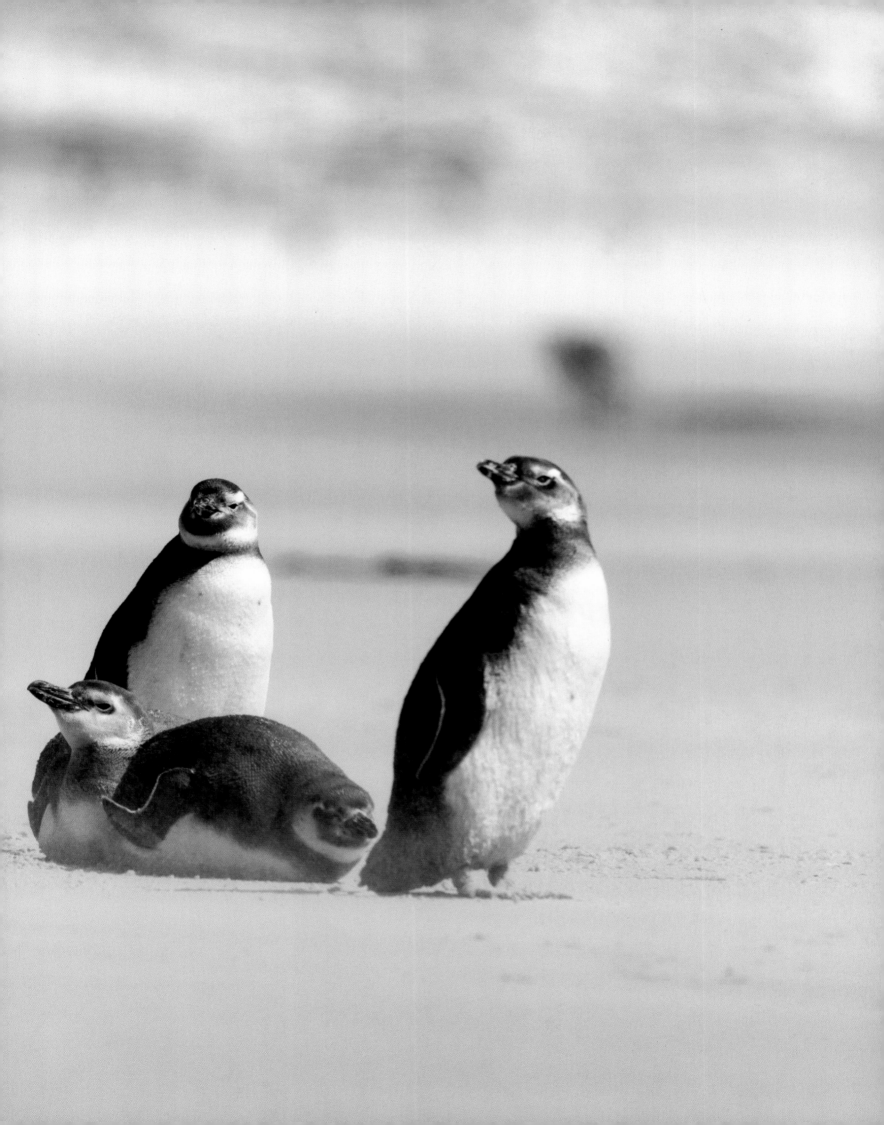

The chances that a King Penguin will survive from one year to another depends on its ability to stay clear of danger and find food, but it is also a question of size. The largest species—the King and Emperor penguins—have the greatest survival rate. Only a few percent of these birds die during the course of a year, compared to a mortality rate of 20 percent among the remaining smaller species.

The age when penguins become sexually mature does not seem to have anything to do with their size. Gentoos are ready to breed at the age of three years, while Magellanic, Adélie, and King penguins take up to six years to reach maturity, and Macaroni penguins do not become sexually mature until the age of seven.

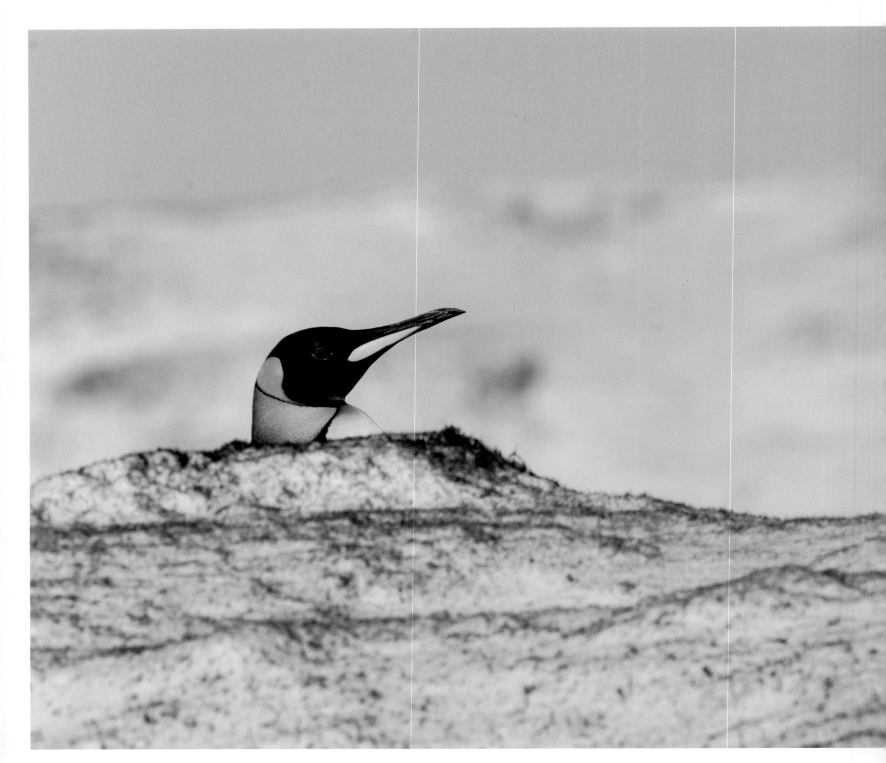

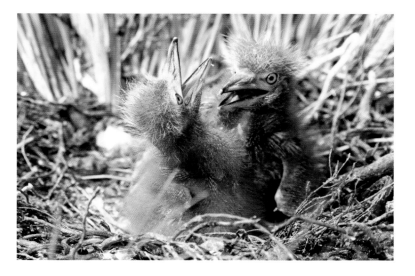

Night Heron, Pebbles Island, Falkland Islands, January.

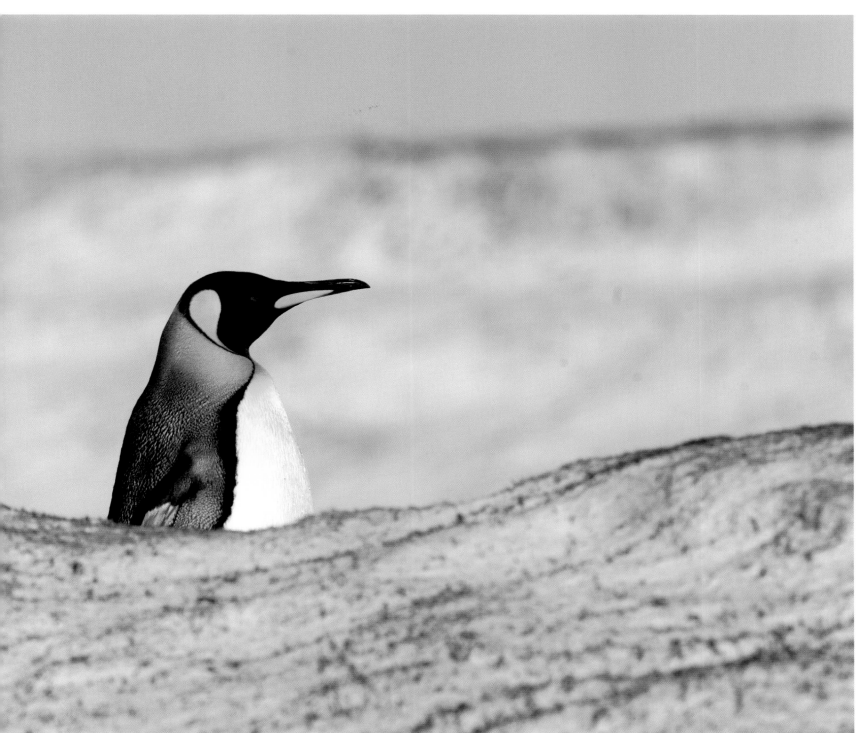

King Penguins, Volunteer Point, Falkland Islands, February.

The color of a penguin's feces reveals whether it has been eating fish (white) or krill (pink), and its diet also influences the texture of the usually more or less liquid excrement. In order to avoid soiling their nest, penguins have developed a special excretion technique: they "shoot" their feces as far away as possible at a pressure of 1,450–8,700psi (10–60kPa), depending on texture. Pressure is greatest at the beginning of the action and then rapidly diminishes, resulting in long streaks resembling paint stains around the nest. As the breeding season progresses and the young become more mobile, the feces will cover a larger area of the colony.

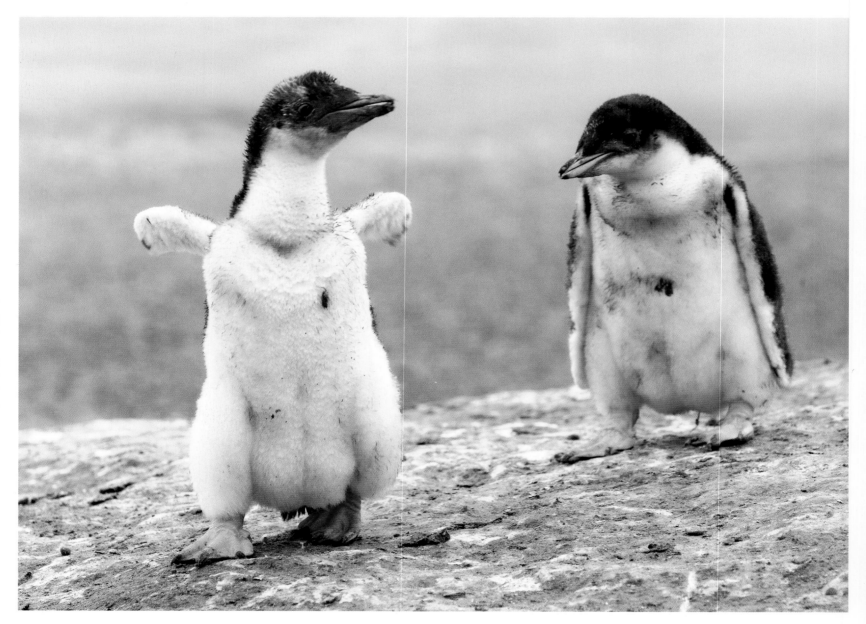

Gentoo Penguin chicks, Sea Lion Island, Falkland Islands, January.

Rock Cormorants and Rockhopper Penguins only partly share the breeding grounds situated along the rocky shores of the Falkland Islands. The Rock Cormorants place their nests on the steepest rock shelves, while the Rockhoppers prefer more easily accessible slopes that can be reached on foot, and which they share with Blue-eyed Cormorants. Both cormorants and the Rockhoppers fish at some distance offshore, but at very different depths: Rockhoppers dive to 500ft (150m), while the cormorants reach down only a few yards below the surface. Cormorants, like penguins, use their wings when diving, but their webbed feet also aid them when propelling themselves through the water. The cormorants' wings are articulated and are not as well adapted to underwater "flying" as are the penguins' more rigid flippers.

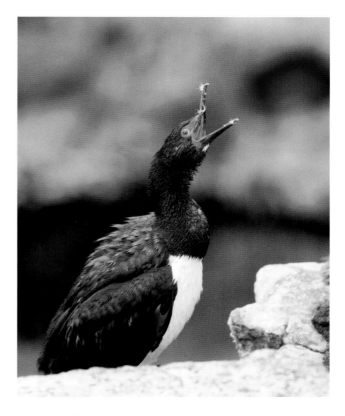

Rock Cormorant, Pebbles Island, Falkland Islands, February.

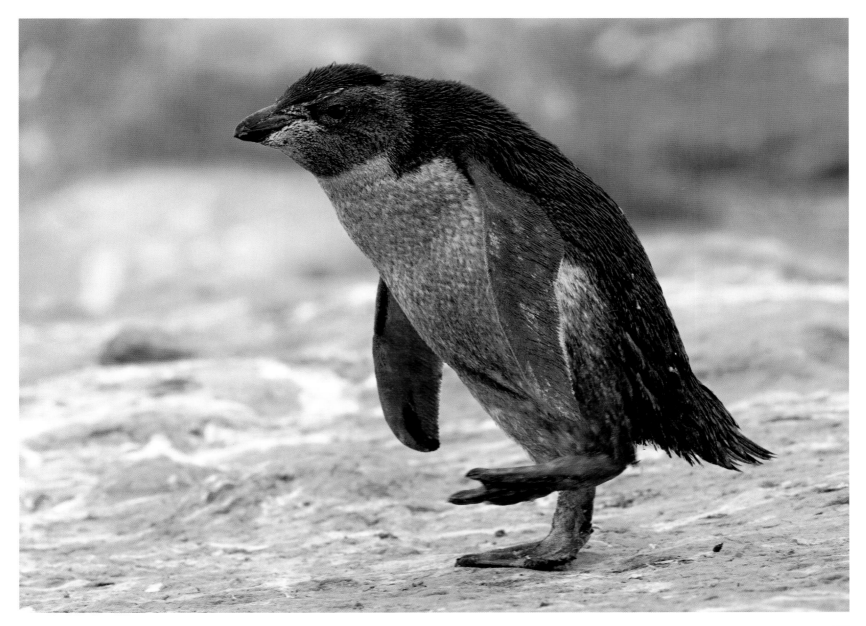

Rockhopper Penguin juvenile, Pebbles Island, Falkland Islands, January.

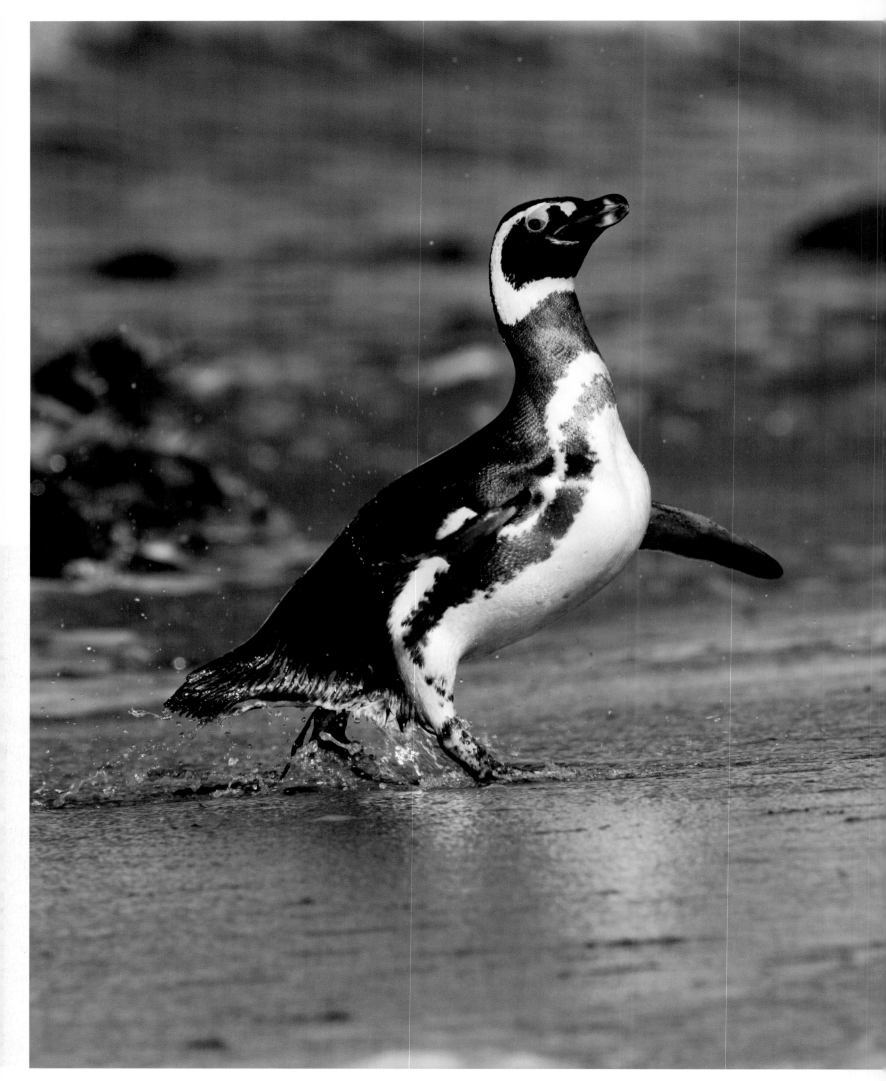

Magellanic Penguin, Sea Lion Island, Falkland Islands, January.

The Magellanic Penguins on Sea Lion Island look very similar to the African Penguins at Boulders Beach, South Africa. They are, however, adapted to very different types of environment in terms of sensitivity to heat, ability to handle cold temperatures, feeding habits, and migration throughout the year. One feature both have in common with most penguin species is their adaptation to water. Another adaptation that relates to both species, but sets them apart from others, is that they nest in burrows. This behavior protects the Magellanic Penguin chicks in the south from the cold and the African Penguins in the north from overheating.

Overleaf On Pebbles Island in the Falklands, there is a constant stream of Rockhoppers moving between the colony and the seashore during the breeding season. They all follow the easiest path to and from the sea like a column of marching soldiers. Some of them have to wait for their turn.

Rockhopper Penguins, Pebbles Island, Falkland Islands, February.

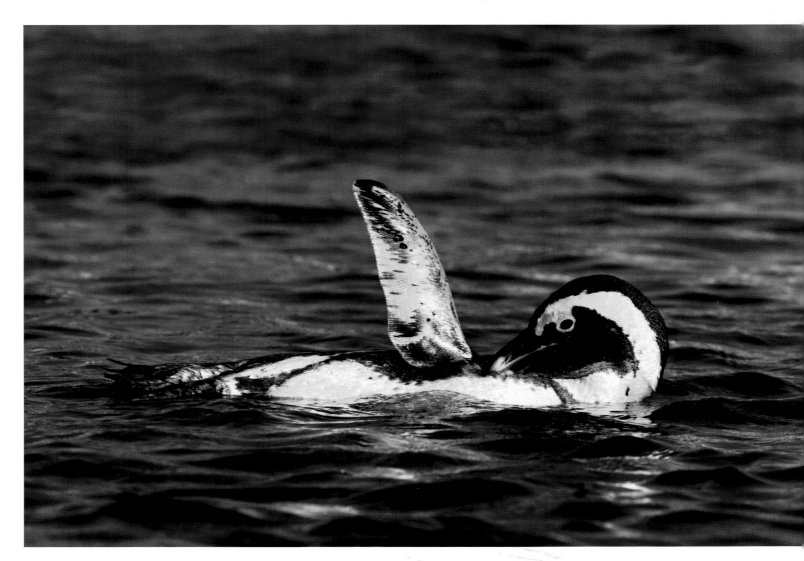

African Penguin, Simon's Town, South Africa, March.

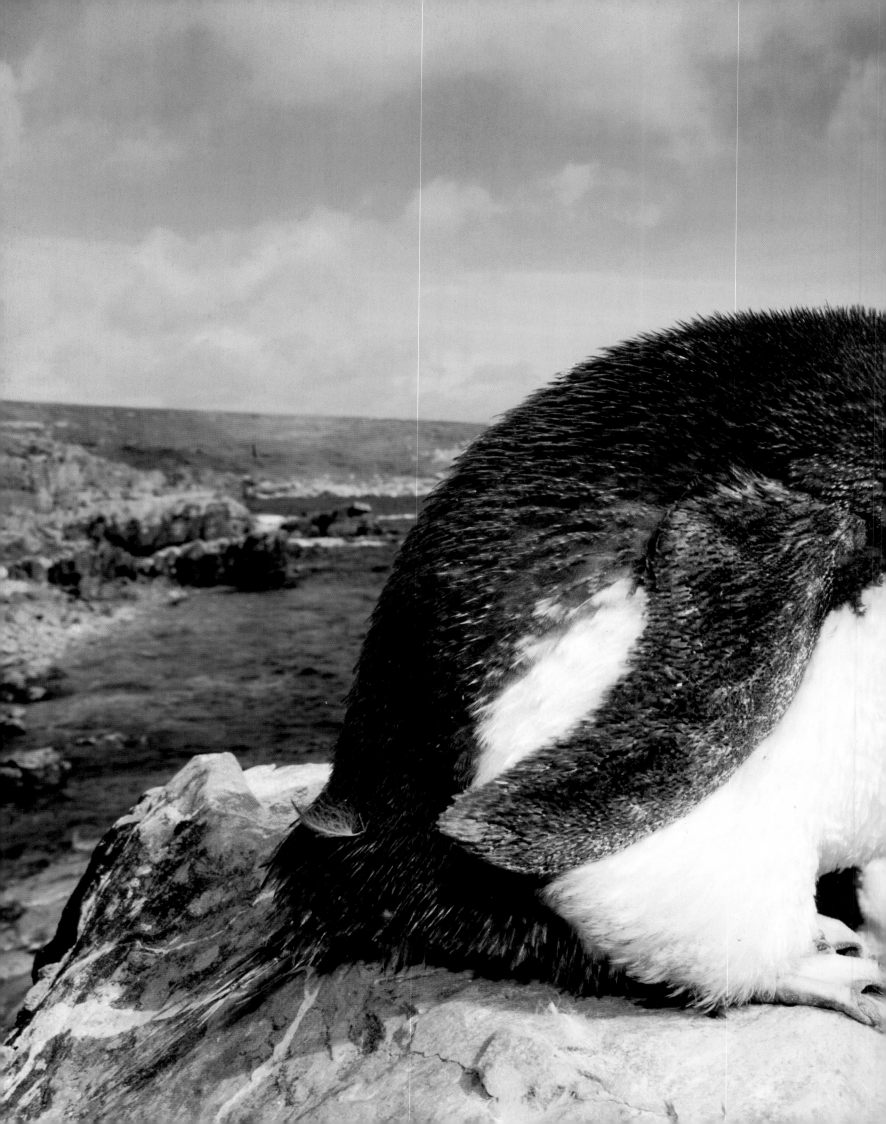

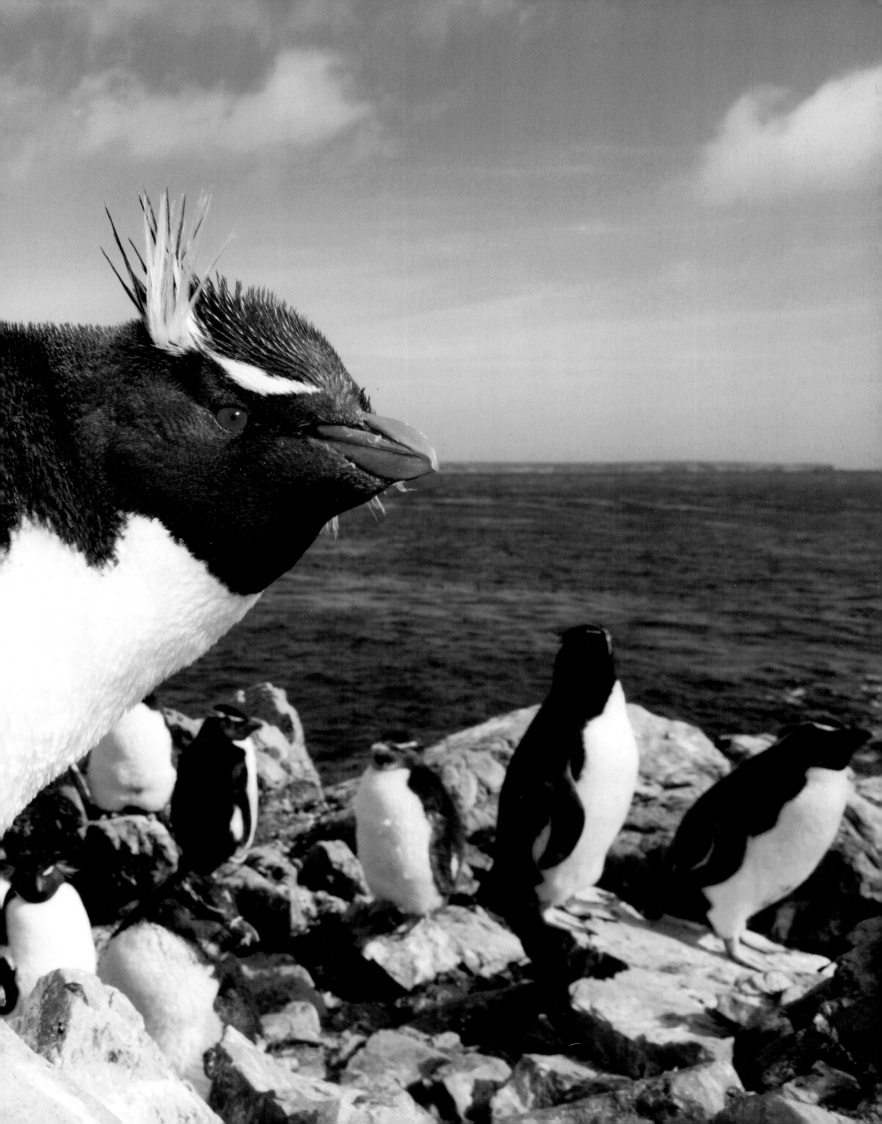

King Penguins compare the size of their bellies, but the rule among penguins is the bigger the better. A male with a large belly is a tell-tale sign to the female that the male is good at catching food and fit to cope with breeding.

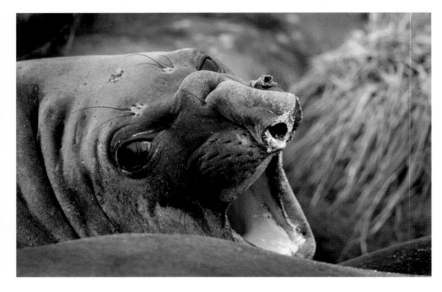

Southern Elephant Seal, South Georgia, January.

Within a few months of hatching, King Penguin chicks, like this one on Saunders Island, have grown to an impressive height. Penguin chicks grow faster than any other animal, especially when it comes to bone tissue, where the growth rate is extreme. King Penguins feed their young lanternfish, which is sometimes in good supply and sometimes scarce—there are strong variations in availability from season to season. After having stocked up on fish fat for many months, King Penguins are able to spend winters when no food is available on land, although they may lose up to two-thirds of their body weight.

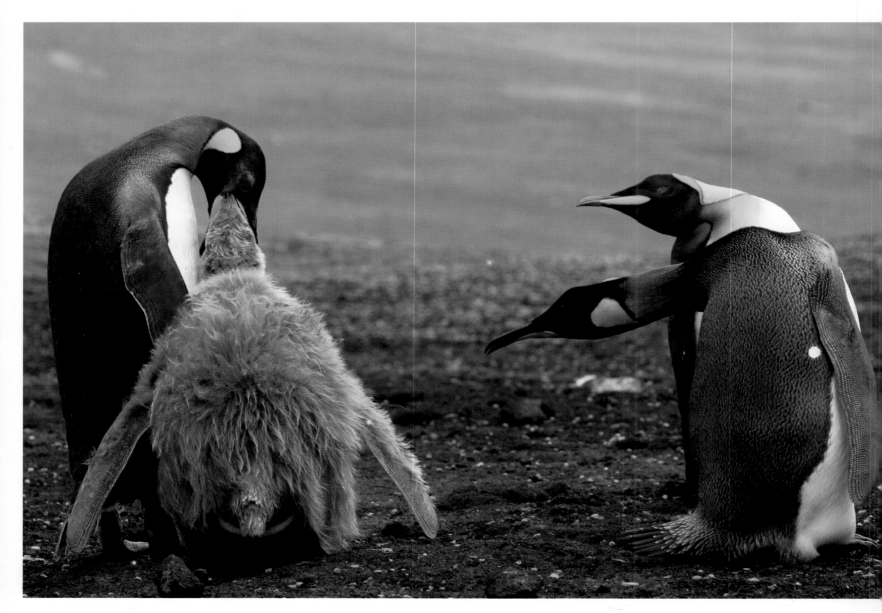

King Penguins, Saunders Island, Falkland Islands, January.

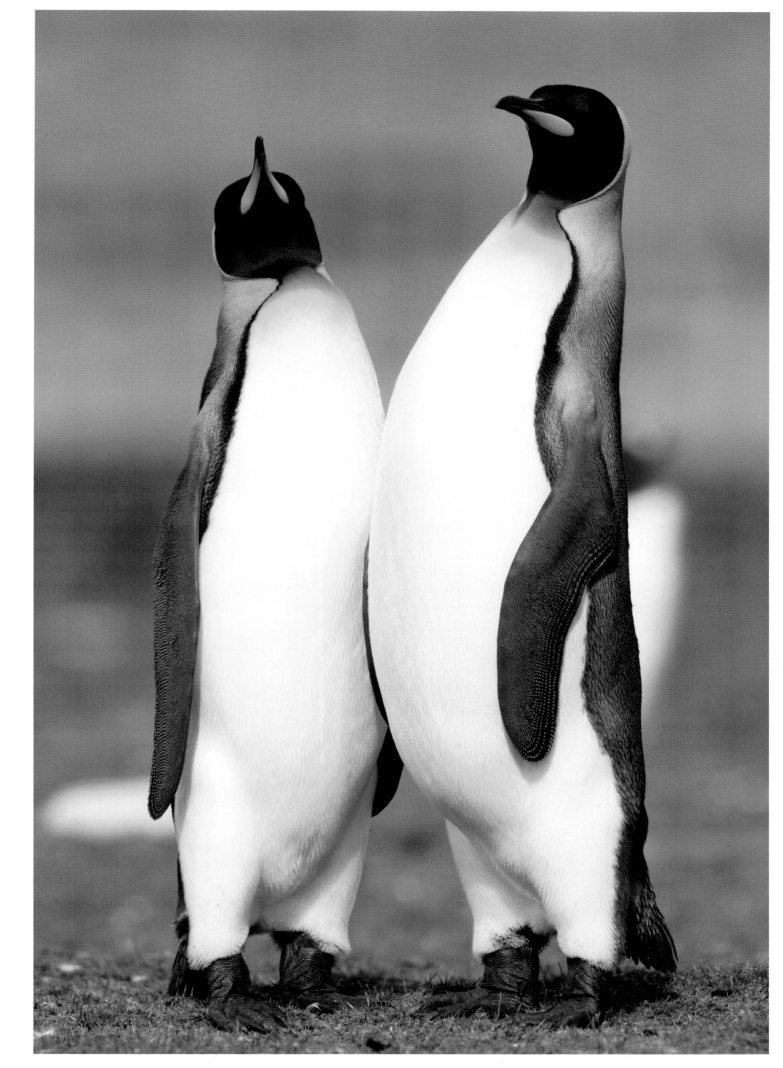

King Penguins, Volunteer Point, Falkland Islands, February. 143

Penguin Migration

MANY BIRDS NEVER migrate or change their environment, but most of those that live near the poles do not overwinter there. What is the purpose of migration, and how are birds and other animals able to travel hundreds of miles between their breeding and wintering grounds? In order to survive these long hauls, they need to build up energy, find suitable staging posts, stay clear of danger, determine the optimal time for traveling, and, most importantly, navigate.

Some penguin species are stationary (they do not migrate at all), while others are able to swim for hundreds of miles in search of well stocked foraging grounds, which will support them through the many months between breeding seasons. There are even penguins that breed during the coldest time of the year—Emperor Penguins incubate their eggs during the dark Antarctic winter.

In contrast to birds that can fly, migrating penguins must swim to their wintering grounds, which may be situated several thousand miles away from their breeding grounds. Penguins are well suited to long-distance swimming. Throughout their evolution, the birds' physiognomy has been perfected to cope with energy-efficient transportation in the water. They have a torpedo-shaped body, an insulating layer of fat, along with a cushion of warm air nearest the skin, flippers that produce propelling action, and a coloration that renders them less visible to predators.

What is perhaps most fascinating about the migration process is how animals and birds find their way. Just like other birds, penguins probably function according to a genetic code that works in synchronization with their internal clock, which determines when, for how long, and in which direction to migrate. Furthermore, because they live together in colonies, they are also able to follow others and find their way in groups. We know little about the internal compass and migration habits of penguins, and it is only recently that we have begun to understand when, how, and where they migrate. This has been possible through modern technology, such as satellite tracking and computer logging, used to follow up individual birds.

By experiencing variations in the number of daylight hours, penguins and other animals synchronize their internal clock with real time. If, however, they do not experience a clear difference between night and day, but are instead subjected to continuous daylight over a 24-hour period, their internal clock will gradually adjust its setting to a preset cycle that is less than 24 hours. It therefore seems that birds and animals need to experience variations in daylight in order to be able to keep time. It thus remains a mystery how penguins that live in the Antarctic, with 24-hour daylight in summer and 24-hour darkness in winter, manage to keep time.

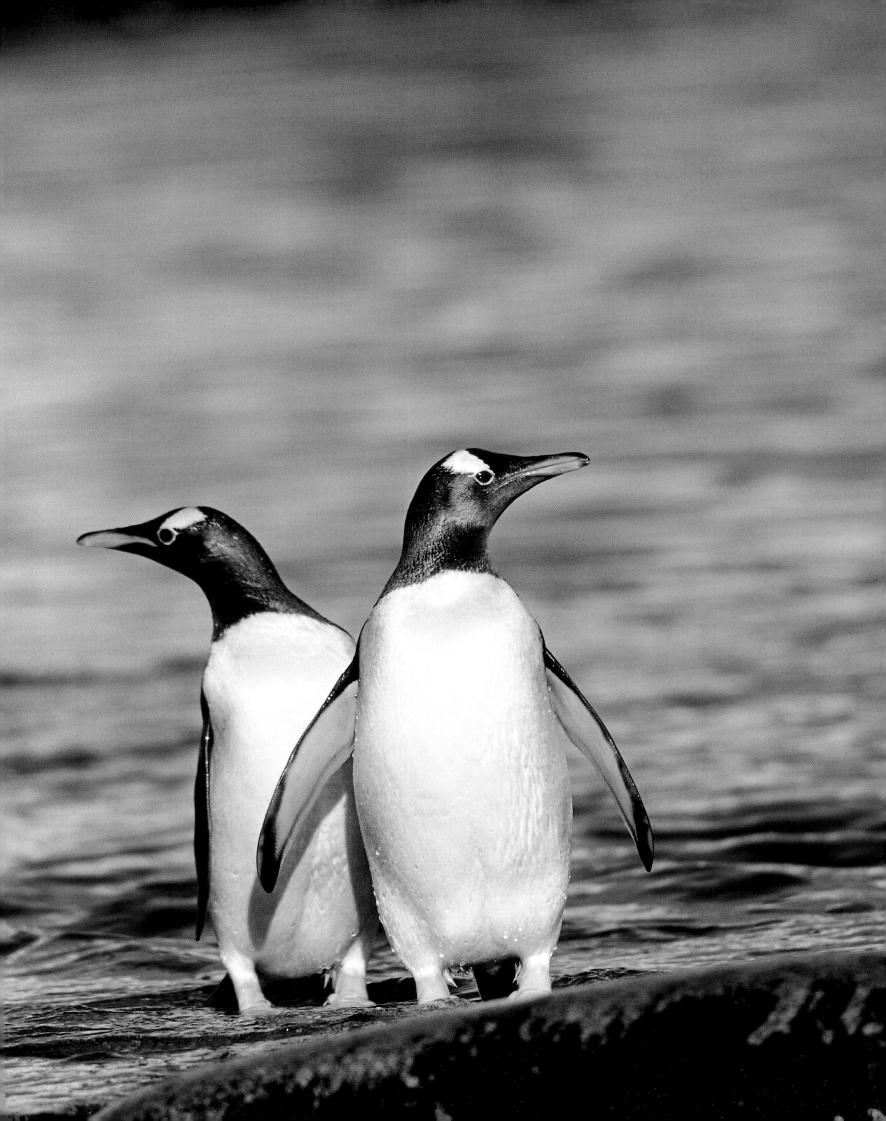

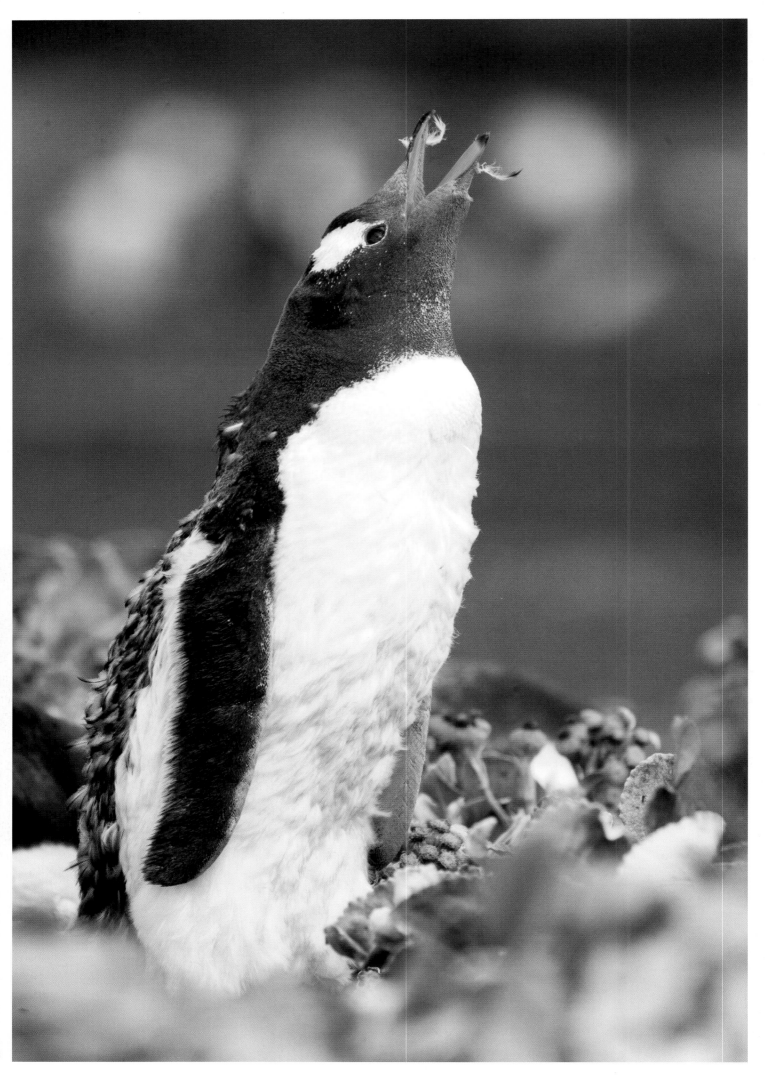

Gentoo Penguin, Saunders Island, Falkland Islands, January.

The Gentoo is the world's most widely distributed penguin species, and in order to be able to colonize new areas it needs to migrate. It was previously believed that it took hundreds of thousands of years for a bird population to establish new migration routes, but we now know that this is achieved over a much shorter time period. The Adélie Penguin's migration habits have developed over the past 6,000 years, following the end of the last Ice Age (they need ice-free ground for breeding). A more contemporary example of rapid changes in migration routes and wintering grounds is that of the Blackcap, which in the past few decades has started to overwinter in Britain.

Scientists believe that migration began as a result of strong competition for food among birds in tropical and temperate climate zones. As food shortages became imminent, a new behavior developed—birds that succeeded in moving to other areas, and bred in the less competitive environments that they found, had a better chance of survival and produced more chicks. The birds migrated greater and greater distances, probably in conjunction with the contraction of the ice sheet to the north and south following the end of the last ice age. Animals that found their way back to their original wintering areas and that managed to raise more chicks than those that stayed behind were favored, and so their genes became distributed throughout the entire population.

Overleaf Penguins that have survived for a number of years are expected to stand a better chance of surviving from one year to another, but they still face many risks and migrations are the most dangerous periods of their adult life. In some species as many as one-quarter of all adult individuals die during migration, either owing to a lack of food or as a result of falling victim to predators. It is easier for predators to catch adult animals while they are migrating, perhaps because they are moving through unknown territory and are less aware of dangers and where to find shelter. King Penguins do not migrate far, but the environments in which they live differ markedly depending on whether the birds are feeding their young or foraging at sea.

King Penguins, Volunteer Point, Falkland Islands, February.

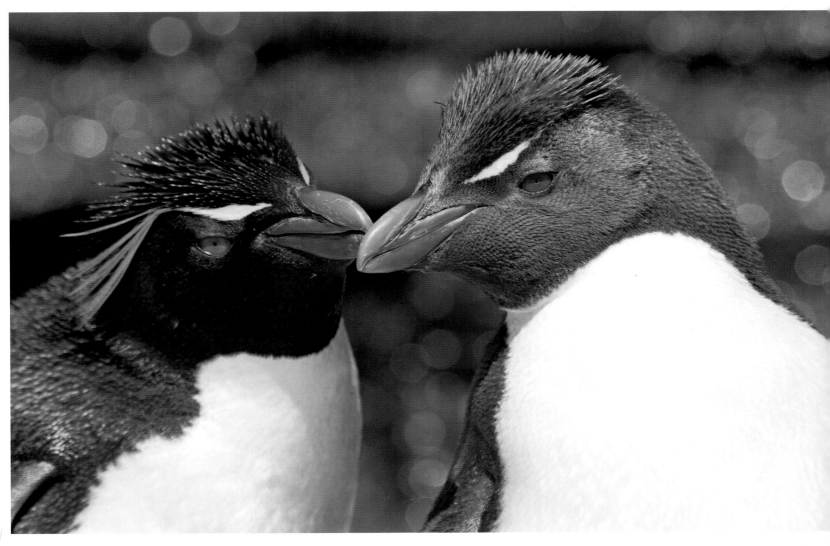

Rockhopper Penguins, Pebbles Island, Falkland Islands, February.

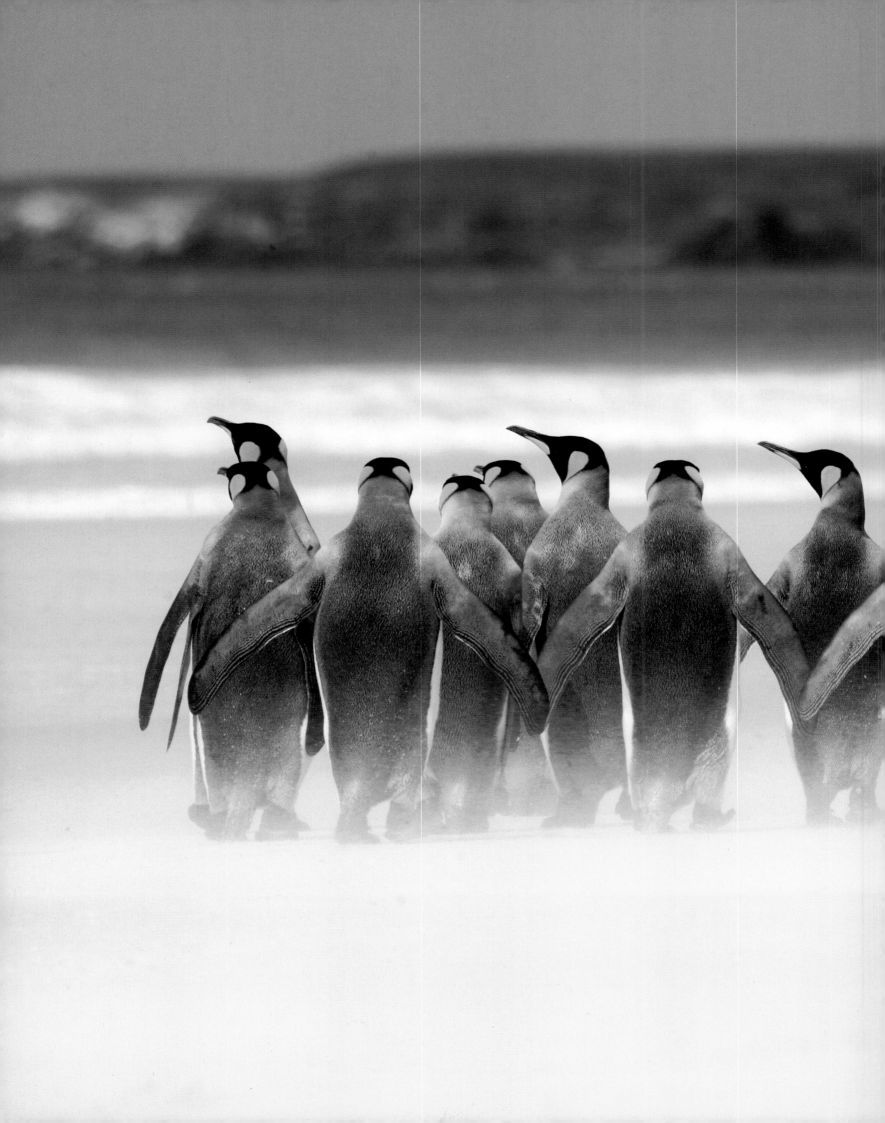

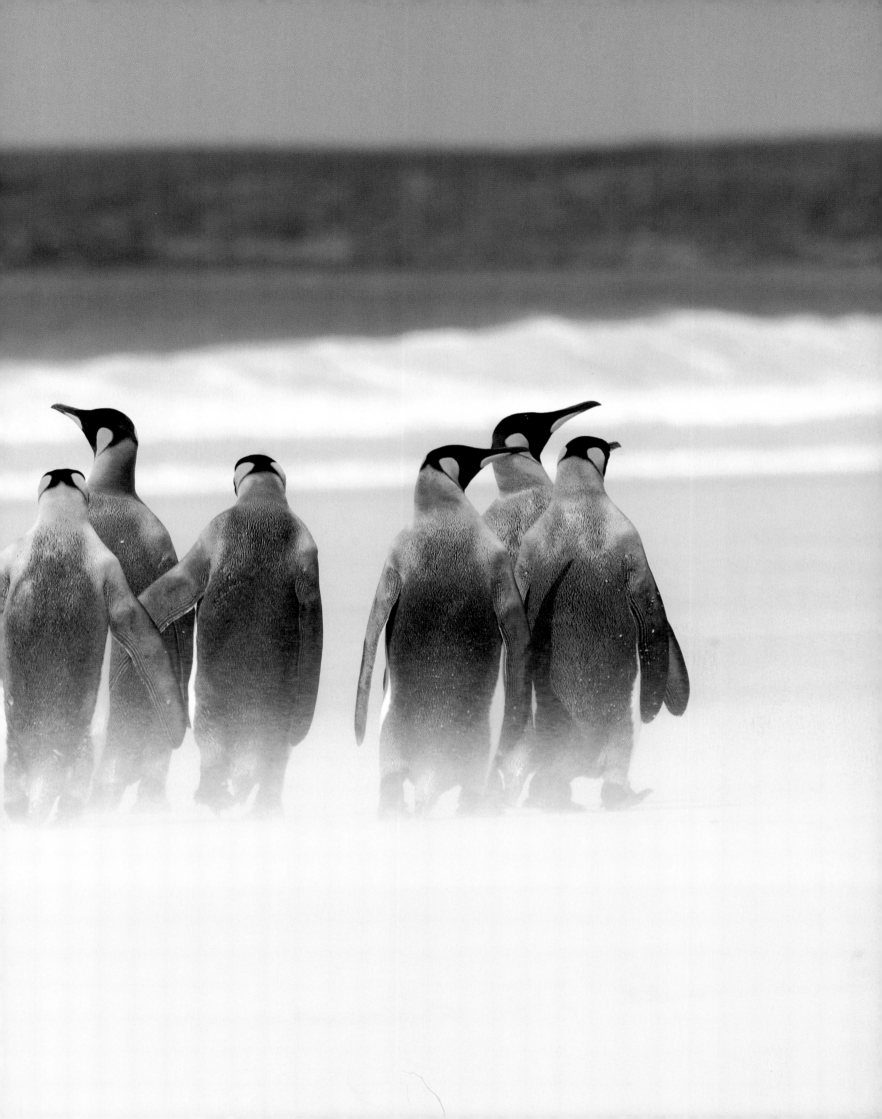

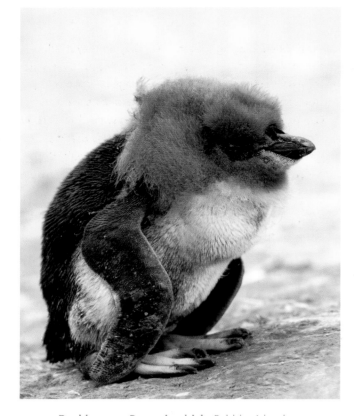

Before the young Rockhoppers migrate, it must molt its sub-adult plumage and build up its energy stores in the form of fat. During this time the adult feeds the chick.

Rockhopper and African penguins about to migrate or swim out to sea prefer to set off in groups. Being close to others is both a protective measure and an aid to navigation. The question is how they are able to stay together for months at a time, and how they avoid getting separated when they dive. It is thought that they probably use both visual and acoustic signals to keep track of one another, but that they may also have other senses to help them.

Rockhopper Penguin chick, Pebbles Island, Falkland Islands, February.

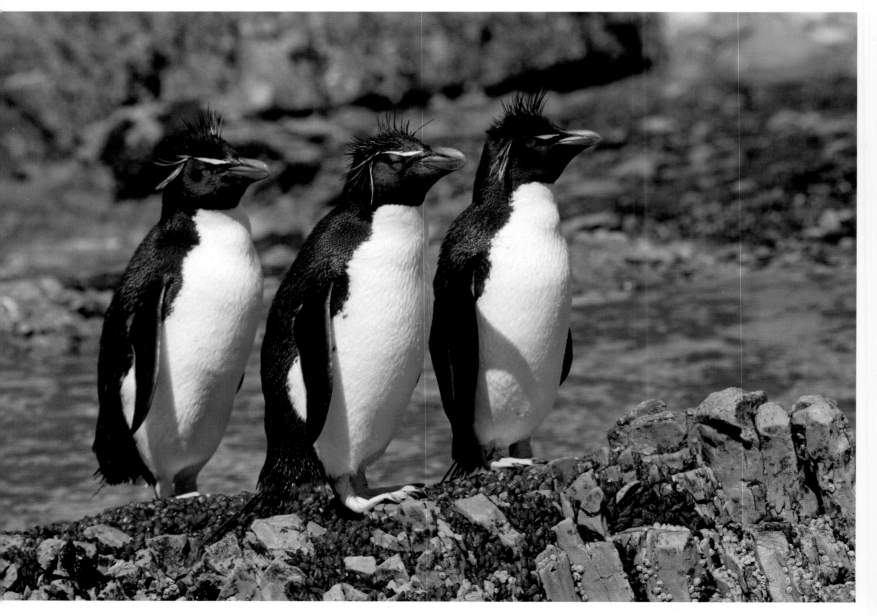

Rockhopper Penguins, Pebbles Island, Falkland Islands, February.

Overleaf Penguins are faced with a difficult task when foraging for food. Not only do they need to find their way from their breeding grounds to their foraging grounds and back, they need to navigate underwater and at great depths. This is less of a problem for Gentoos, which forage near the coast, but it is harder for Chinstrap, Adélie, and Emperor penguins, which regularly dive under the polar ice cap. Periodically, these three species are limited to diving in small expanses of open water, but nobody knows how they find their way back again. Perhaps they have developed a special sense that makes use of inertial navigation, assessing and integrating the body's acceleration in different directions through the water in much the same way that advanced navigation systems monitor the movements of aircraft through space.

Gentoo Penguins, Sea Lion Island, Falkland Islands, January.

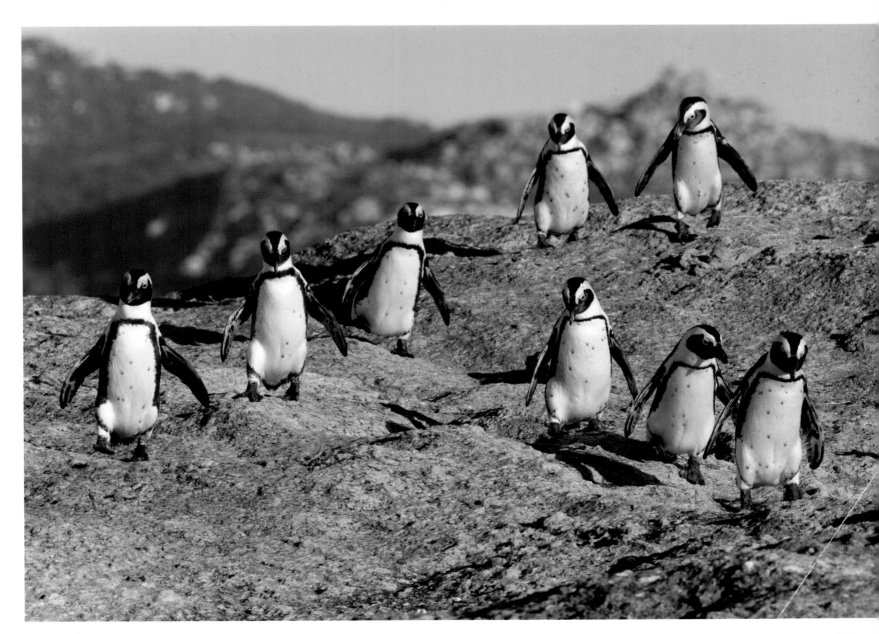

African Penguins, Boulders Beach, Simon's Town, South Africa, March.

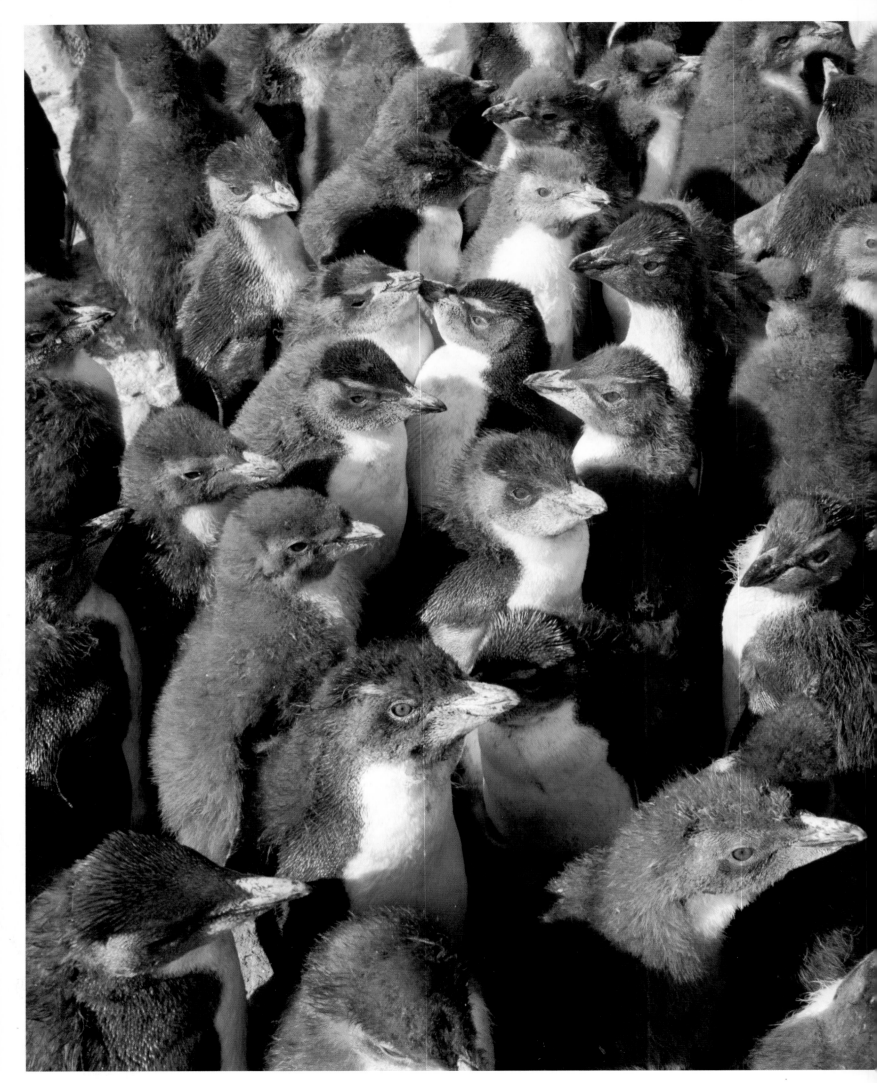

Rockhopper Penguins, Sea Lion Island, Falkland Islands, January.

Many juvenile birds are forced to migrate on their own, and this also applies to young penguins and other ocean birds whose parents abandon their chicks just before they are fully independent and ready to migrate. Young Rockhoppers that have been raised in colonies migrate in groups. The first groups to leave tend to take off in almost any direction, and only later adopt a more organized flight pattern. But how can juveniles that have never migrated before find their way, and how do they know where to go?

Research into genetic migration systems has primarily been carried out on songbirds, and many useful facts have been learned. In these birds, an individual's first migration is triggered by a genetic code, which determines the direction and length of time it needs to fly. The time of year is assessed with the help of the bird's internal clock, which determines how many days, weeks, or months it must travel in order to reach its destination. To this internal innate information concerning time and direction are added external data, possibly picked up from the Earth's magnetic field, which tells the bird when to stop or change course, together with information about the number of daylight hours. It has been established that the buildup of fat in Nightingales migrating across the Sahara is governed by geomagnetic information specific to each latitude. It is also possible that long-distance migrants, such as Rockhopper Penguins, have a similar, built-in migration program. Even though African Penguins do not travel as far as Rockhoppers, they depend on the same type of genetic programming for other season-bound activities such as breeding, molting, and foraging.

Overleaf King Penguins can be found only on certain isolated islands in the subantarctic region, while Adélie Penguins are much more widely distributed throughout the entire region and live as far north as the Kerguelen Islands. The migration paths of the two species also differ in many respects. Adult King Penguins hardly ever move outside their colony, while Adélie Penguins may migrate thousands of miles, for example, between colonies in the Ross Sea to their wintering grounds at the rim of the polar ice sheet. Adélie Penguins from neighboring colonies follow roughly the same pattern to their wintering grounds. Once there, they seek out areas where there is plenty of food and surrounding pack ice on which to stand (only one-fifth of the ocean in their overwintering areas is ice-free). King Penguins, on the other hand, never move further than about 600 miles (1,000km) from their breeding grounds.

King Penguins, Volunteer Point, Falkland Islands, February.

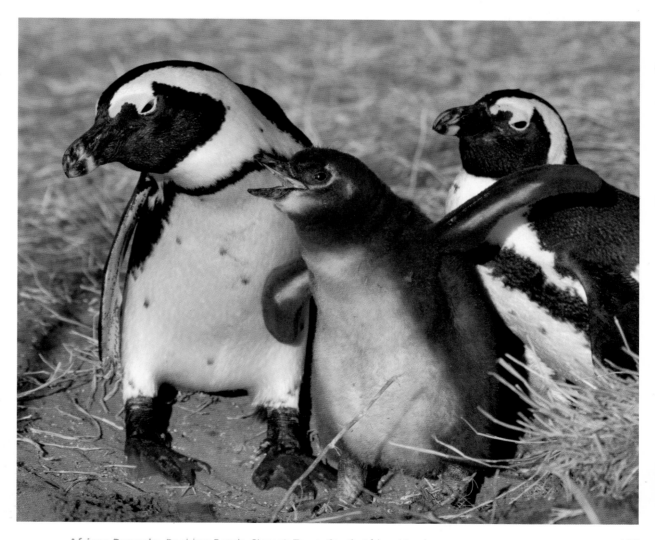

African Penguin, Boulders Beach, Simon's Town, South Africa, March.

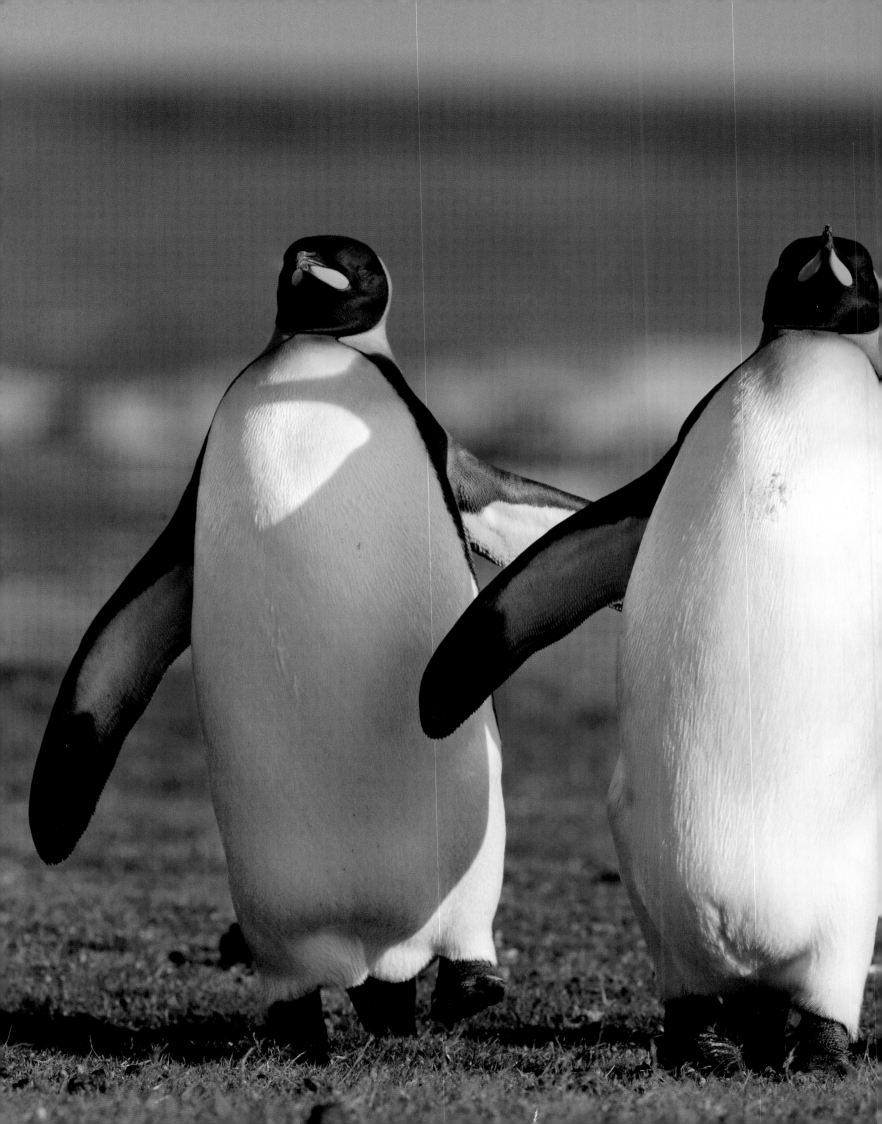

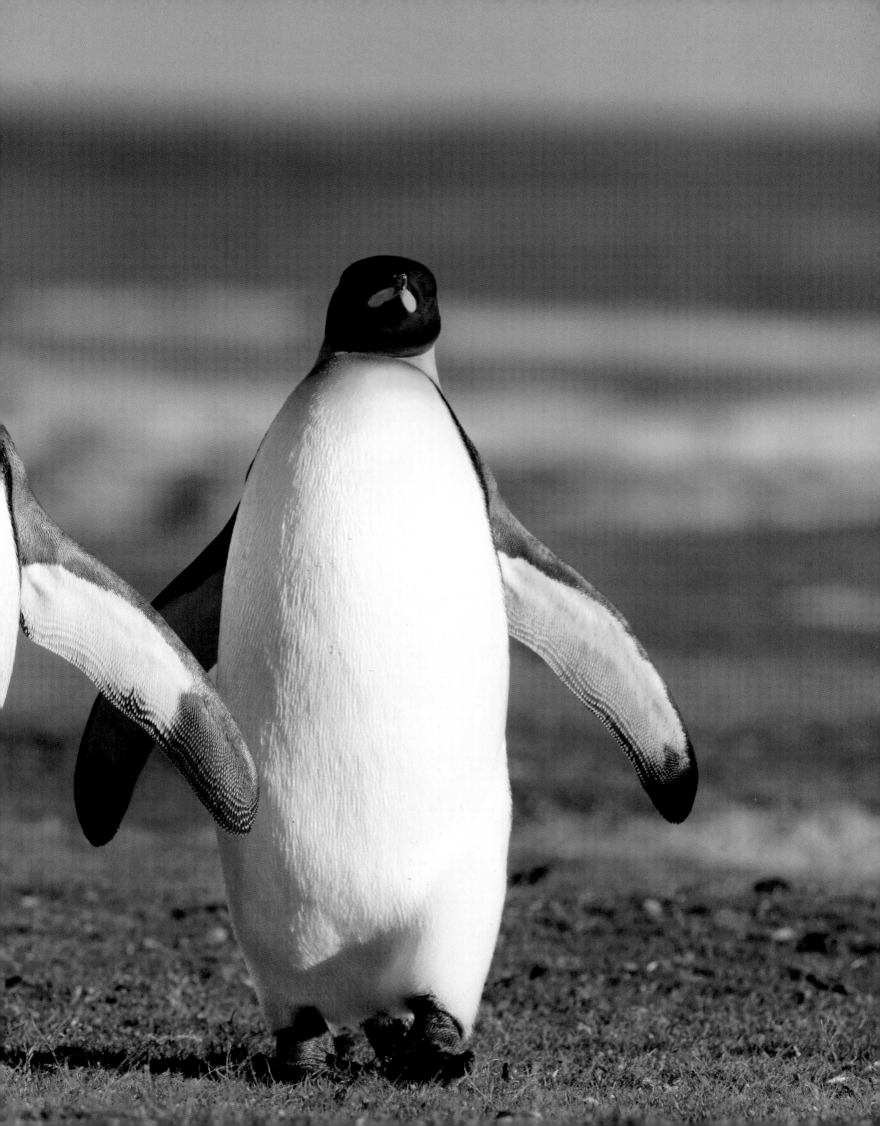

Magellanic Penguin in front of a King Penguin colony, Volunteer Point, Falkland Islands, February.

In the extreme south, penguin breeding grounds are surrounded by ice during the winter, but the islands further north are ice-free year round. This allows some species to stay put and some species to visit their colonies only during the breeding season. Species that stay put are the ones found farthest to the north, including the African, Little, Galápagos, and Yellow-eyed penguins. The Gentoo has a wide distribution, so that birds in the south do migrate whereas those in the north do not. To put it simply, penguins move north toward the equator if winters in their breeding grounds are cold because they risk running out of food at this time, but not all penguins can move away from the ice. Outside the breeding season, species that normally breed in the Antarctic need to migrate to the rim of the ice sheet in order to be able to forage in open water.

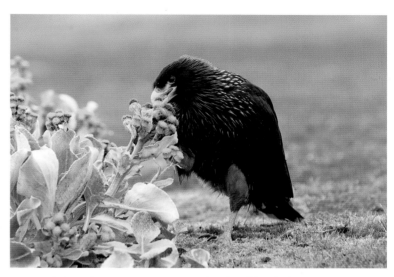

Striated Caracara, Sea Lion Island, Falkland Islands, January.

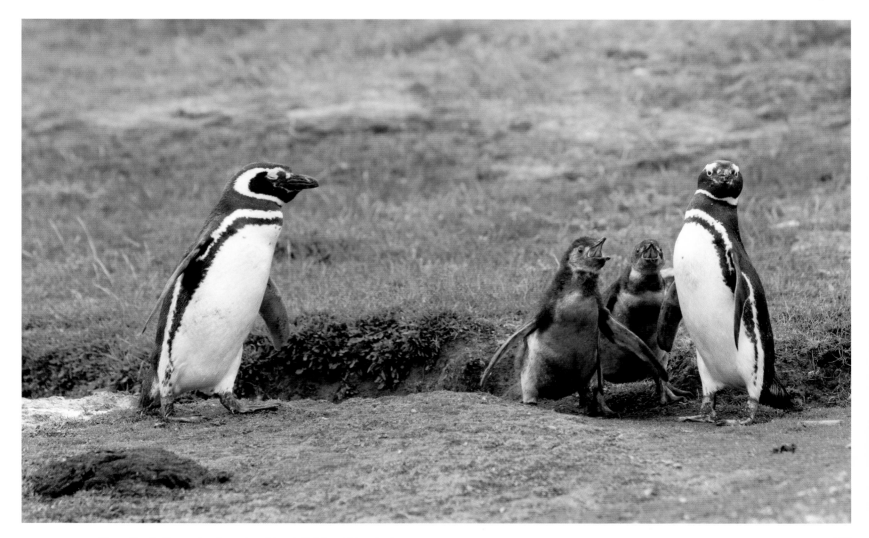

Magellanic Penguin, Saunders Island, Falkland Islands, January.

African Penguins do not migrate far, but they change their environment from land to water and stay out at sea for several months every year before the breeding season begins. Like other northern penguins, they live in a climate that allows them to stay put. Access to food is vital, but it is just as important to arrive at the breeding grounds early in the season in order to secure a nest site. If a penguin has managed to raise young in the past and has learned to recognize and protect itself against threats, it is important for it to hold onto its nest site to increase its chances of continued success. This means that penguins that are able to survive from one year to another have a constant advantage over other birds.

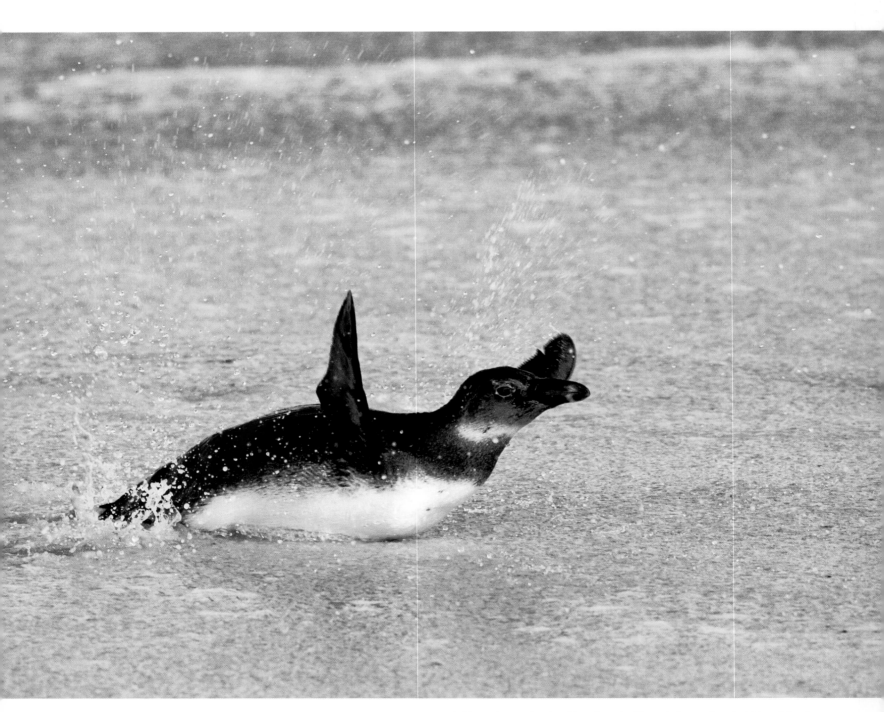

African Penguin, Boulders Beach, Simon's Town, South Africa, March.

Overleaf Navigation during long migrations in the Polar Regions is a major problem for many animals, and even humans find it problematic. One reason is that the Earth's magnetic field tilts at a sharp angle at the poles, making it difficult to plot a course. Another reason is that during polar summers the midnight sun makes celestial navigation impossible. Instead, during their long walk across the polar ice cap Adélie Penguins navigate with the aid of a solar compass. This is synchronized with their internal clock, which compensates for the sun's movement across the sky during daylight, and helps them stay on course 24 hours a day.

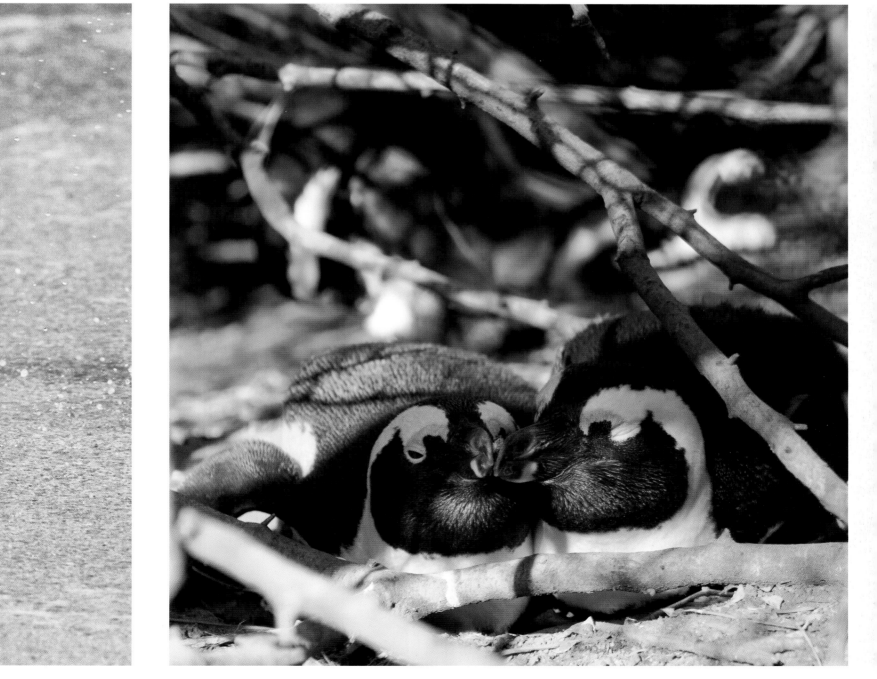

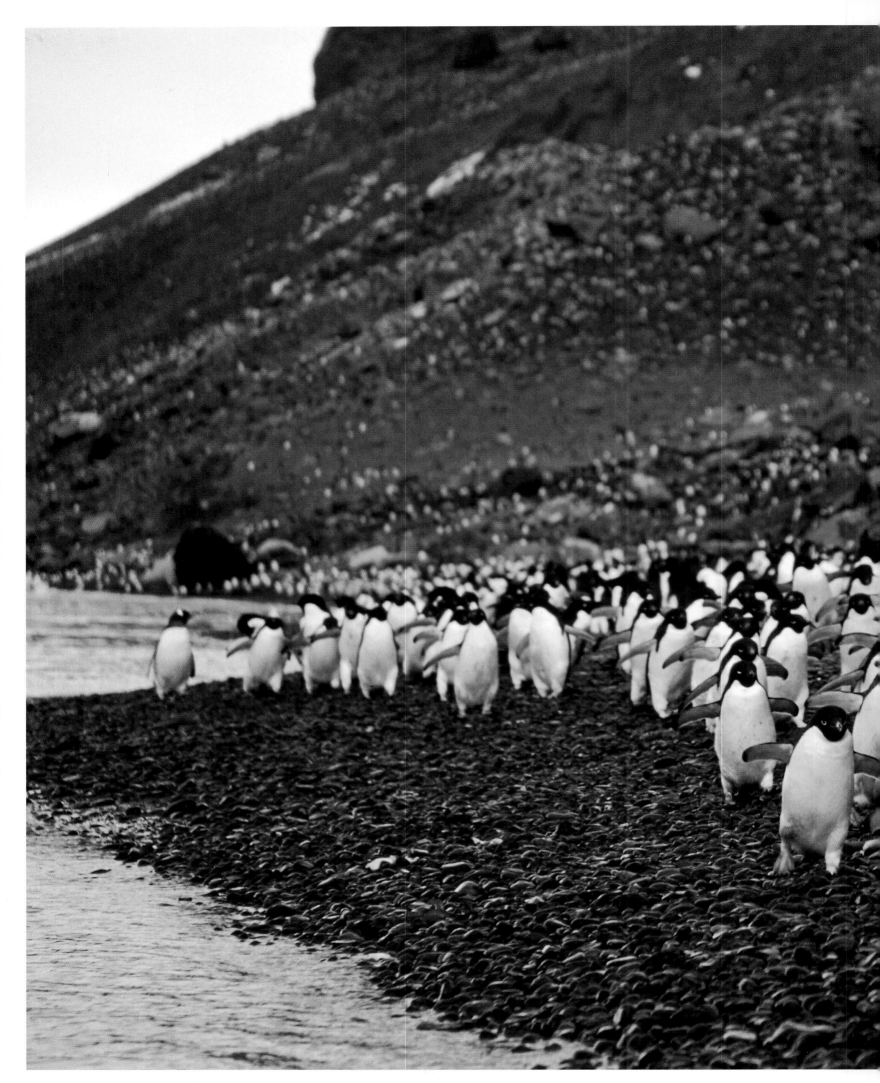

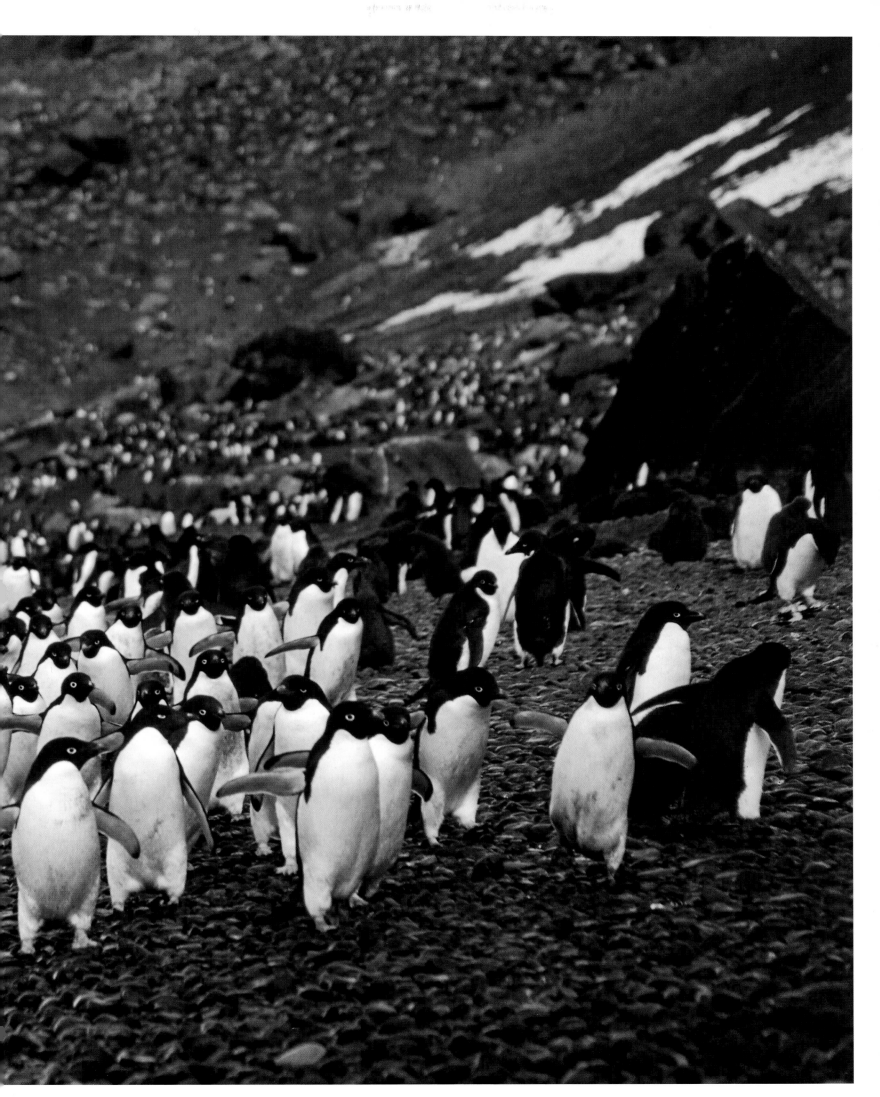

Adélie Penguins, Antarctica, January.

Unstable Populations

WHAT IS OUR responsibility towards the penguins as a whole and the Antarctic? We clearly have, and have had, a major impact on marine life in and around the Antarctic, as well as in more temperate and tropical waters. Penguins and other animals are badly affected by overfishing and oil spills. In the long term, they will also be affected by more general climate changes, possibly resulting in an alteration of the direction and strength of oceanic currents, air temperature, and precipitation.

Historically, we have exterminated many penguins for the purpose of extracting oil from their fat reserves. We have also upset the natural order in isolated islands by introducing alien species such as rats, ferrets, dogs, and pigs. And today, we are aware of only some of the effects caused by environmental pollution.

Because penguins are noticeably affected by climate change and food availability, the size of their populations has always fluctuated. In turn, their food supply is affected by the way nutrients are released and circulated in the ocean. By studying the variation of stable isotopes in soils, and hence the release of nutrients into the oceans, it is possible to chart the size of penguin populations going back thousands of years. Such research has established that penguins have been common during some periods while numbers have fallen in others.

More penguin species have been made extinct than exist today. And while some living species have populations amounting to millions of individuals, others are being reduced at a rapid rate. BirdLife International's list of endangered bird species states that ten of the world's penguin species are considered to be either endangered or vulnerable, while another two are on the verge of becoming endangered. This, in short, means that numbers have fallen rapidly during a brief period of time and that this downward trend may continue. If no measures are taken to protect the species, there is a great risk that it will be impossible to sustain healthy population levels. The majority of the most threatened penguin species are found in temperate and tropical waters, including the Gentoo and African penguins, all the crested penguins, and the Galápagos Penguin. It is only those species living farthest to the south—the King, Emperor, Adélie, and Chinstrap penguins—that still enjoy large and vital populations.

How are penguins affected by global warming? What will happen if the Antarctic ice cap melts? Will populations die off if krill or anchoveta supplies are exhausted? We must start to answer these questions and more, by improving our understanding of nature so that we can increase our awareness of the changes that may constitute a threat to penguin species. Our only hope is that we have both the ability and the desire to react before it is too late. How heartbreaking it would be not to be able to show future generations a Galápagos Penguin's nest among volcanic rocks, to share with them our fascination with the Emperor Penguin's long journey, and the cooperation of the males on the ice, to wonder why crested penguins have such bushy eyebrows, or to listen together to the braying of the Gentoo. The Southern Ocean would quite simply feel deserted if it were deprived of its penguins.

Adélie Penguin, Antarctica, January.

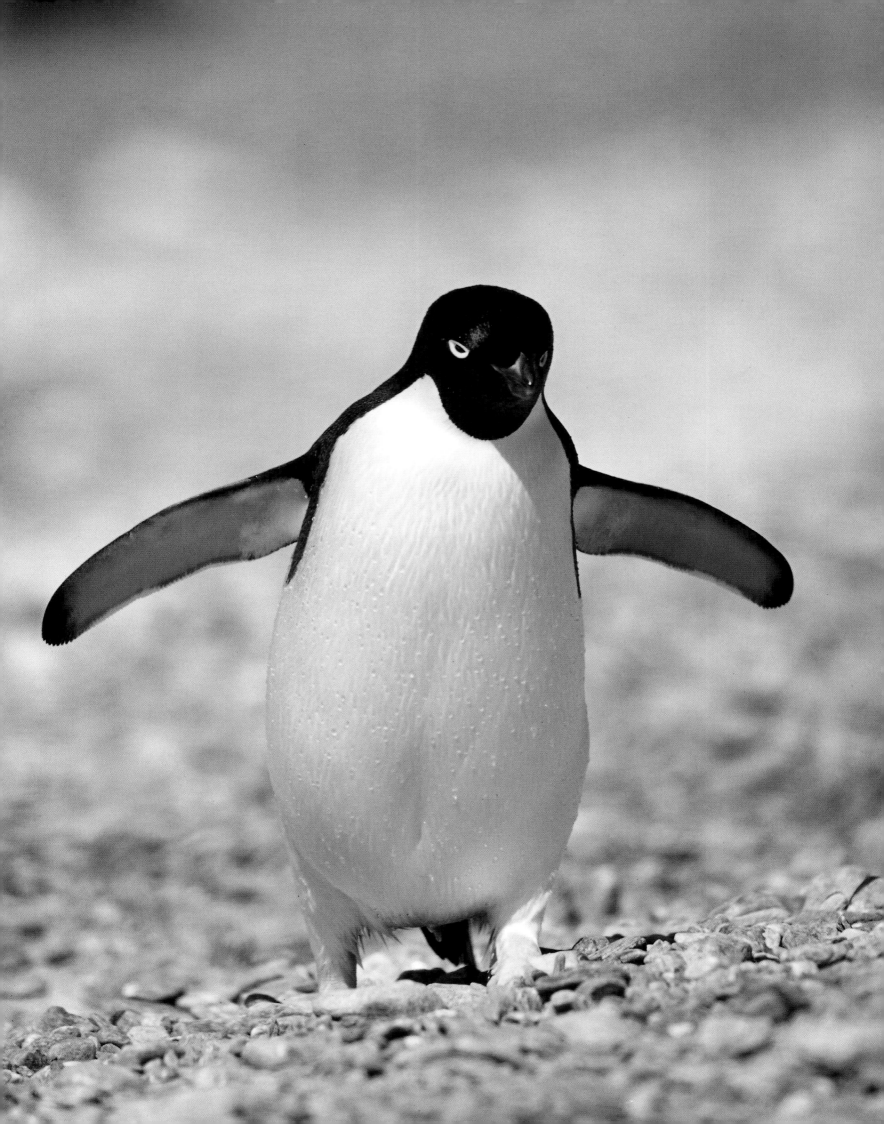

Environmental pollutants and heavy metals used near the Equator and in temperate regions are transported in the air from there to the poles. Here, they are deposited via precipitation or condensation on the land and in the water, thereby entering the food chain. Large quantities of heavy metals and other fat-soluble pollutants eventually become concentrated inside animals at the top of the food chain, which store large amounts of fat. Penguins, seals, and polar bears are examples of such animals. They are unable to excrete the toxins, which are instead deposited in the fatty tissues of their bodies. When penguins fast, these toxins are released into their bloodstream and may cause irreparable damage to their reproductive system, possibly leading to infertility. We know nothing about the effects many of the substances currently spreading across the globe to the poles have on us or on the animals that come into contact with them. It is therefore vital that we learn more about these effects and precisely what substances are disseminated in this way. The Arctic and Antarctic regions are not as clean as we may have hoped or believed. What is the penguins' current health status?

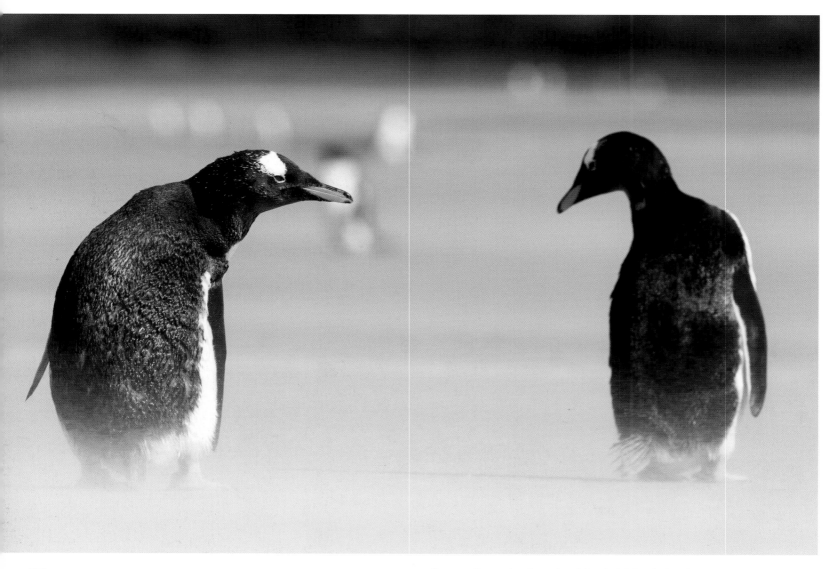

Gentoo Penguin, Saunders Island, Falkland Islands, January.

The number of African Penguins feeding on shoals of fish off the coasts of South Africa and Namibia has fallen drastically in recent years. After a dramatic decline over the past century, only one-tenth of the original population remains. This decrease has mainly been caused by food shortages, although oil spills have also had a significant effect. Oil on a penguin's plumage interferes with its heat-storing properties, so the bird is unable to keep warm in the ocean and dies. Penguins and other birds also ingest the toxic oil residues during preening. In addition, intensive fishing has interfered with the availability of food and penguins become entangled and die in the nets. Fur seals have also increased in number in southern Africa, and in some areas they are contributing significantly to the decline in penguin populations. The seals are such a problem that wildlife rangers trying to ensure the continued existence of the African Penguins actively cull seals.

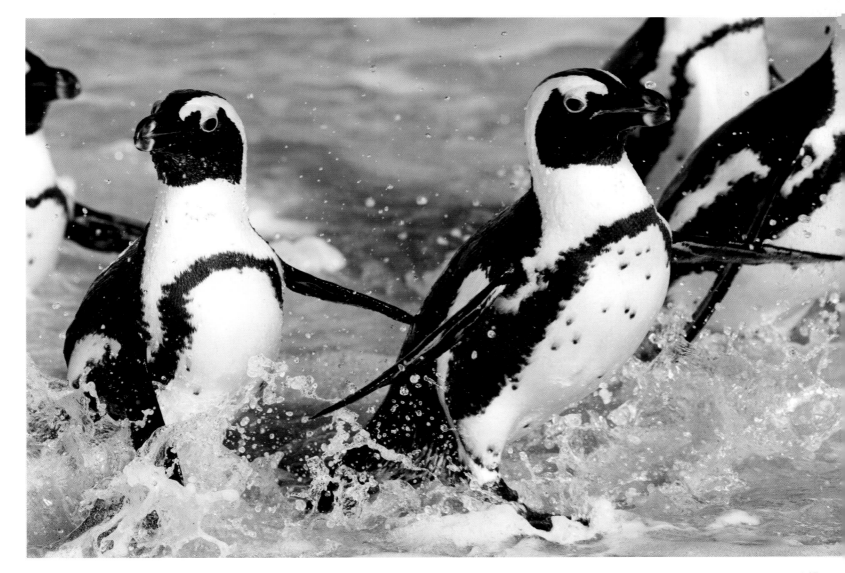

African Penguin, Boulders Beach, Simon's Town, South Africa, March.

It has been found that female Gentoos have lower levels of mercury in their feathers than males. This may be due to the fact that some of the mercury ingested with food is excreted in conjunction with laying eggs. Gentoos have relatively small mercury concentrations compared to other birds populating the same areas of the southern hemisphere. The highest concentrations are found in Gray-headed Albatrosses, Southern Giant Petrels, and Blue-eyed Cormorants, which all feed on fish and other animals near the top of the food chain. Apart from laying eggs, molting is the only way birds can rid themselves of mercury.

Measurements increase in temperature in the stomach show that penguins may expend an additional 10 percent of energy when subjected to negative stress. Such stress causes the penguin to prepare for a "flight-or-fight" response, which increases its energy expenditure. It is the type of reaction that an attacking predator, such as a giant petrel, will trigger in a chick.

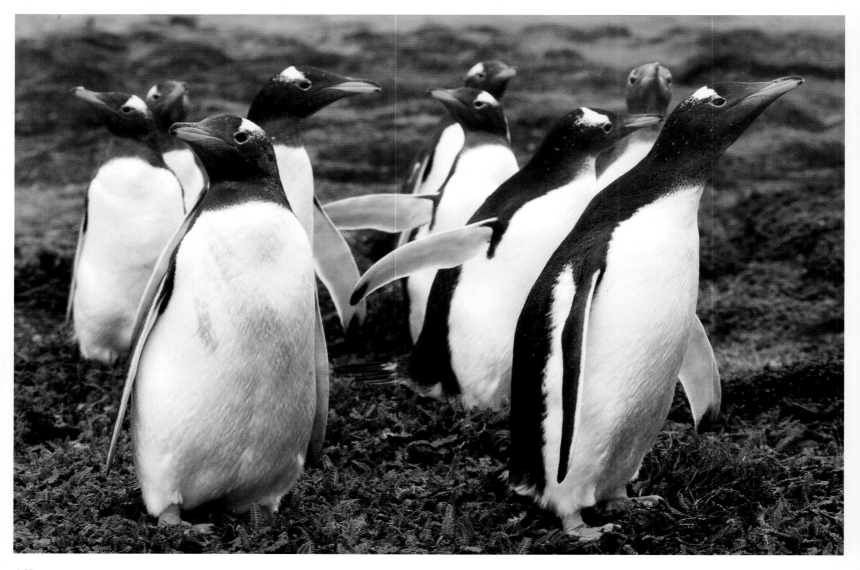

Gentoo Penguins, Pebbles Island, Falkland Islands, January.

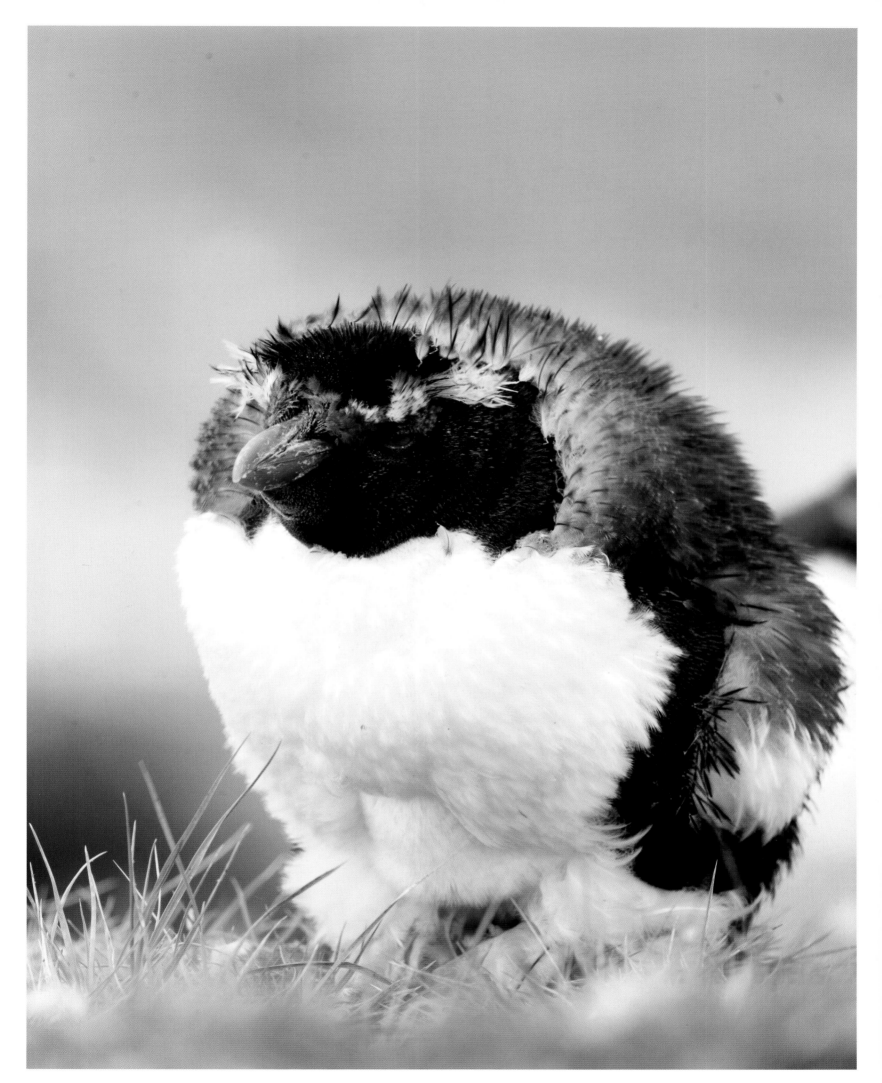

Rockhopper Penguin, Pebbles Island, Falkland Islands, January.

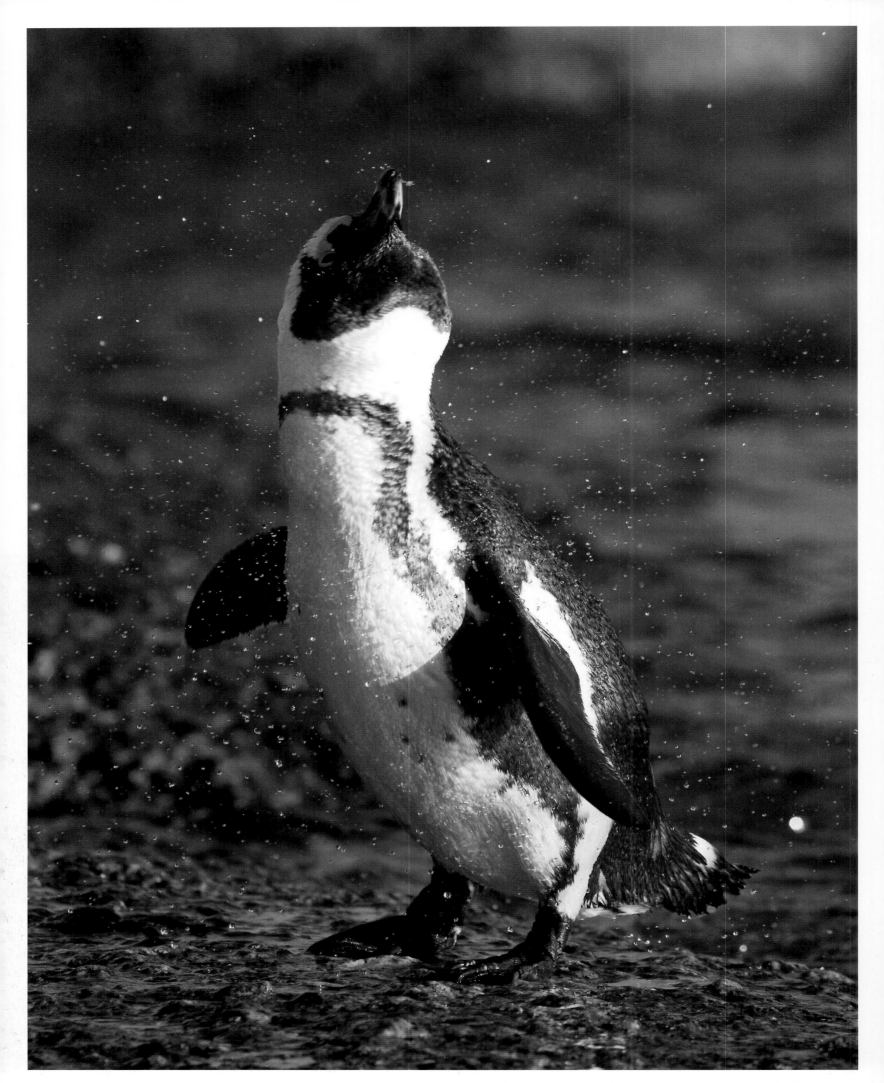

African Penguin, Boulders Beach, Simon's Town, South Africa.

Keeping clean and staying healthy is essential. Many birds are carriers of malaria and other diseases that enter their system via the bites of mosquitoes and gnats. There is no doubt that the African Penguin, for example, can fall victim to such blood parasites. *Plasmodium relictum*, *P. elongatum*, and several other blood parasites have been found in nine penguin species in captivity, although they are seldom found in wild penguins. Only in the temperate zones of South Africa, Australia, and New Zealand, and on Gough Island in the South Atlantic, have four different strains of parasites been found in five penguin species. In the Antarctic and subantarctic, meanwhile, there have been no confirmed cases. The reason for this is partly because wild penguins spend long periods at sea, which counteracts the spread of parasites between individuals, and partly because few vectors (potential carriers) can survive in very low temperatures. There are many different types of blood parasites in birds, some of them deadly.

Overleaf When the Antarctic was first explored visitors were quite careless when handling waste products and harmful substances. The worst examples of such pollution are found in areas where there has been activity for a long time, and consist of corroding ships, barrels, and other scrap. The most dangerous forms are probably bacteria associated with humans, such as Flavobacterium, *Micrococcus*, and *Streptomuces*, as well as the common gut bacteria *Escherichia coli*, which has been found on several sites. The waste problem in the Antarctic has been addressed in recent years, and as a result the rules regulating the handling of garbage and human waste have become stricter at the numerous bases.

Gentoo Penguin colonies, The Neck, Saunders Island, Falkland Islands, January.

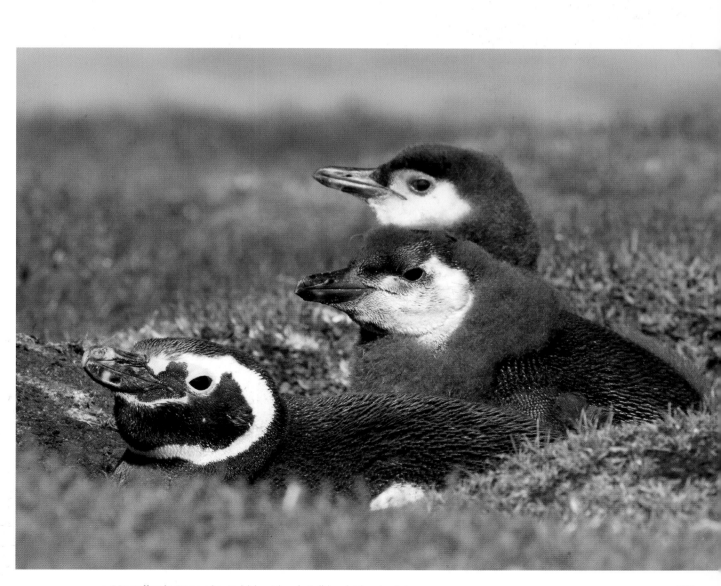

Magellanic Penguin, Pebbles Island, Falkland Islands, February.

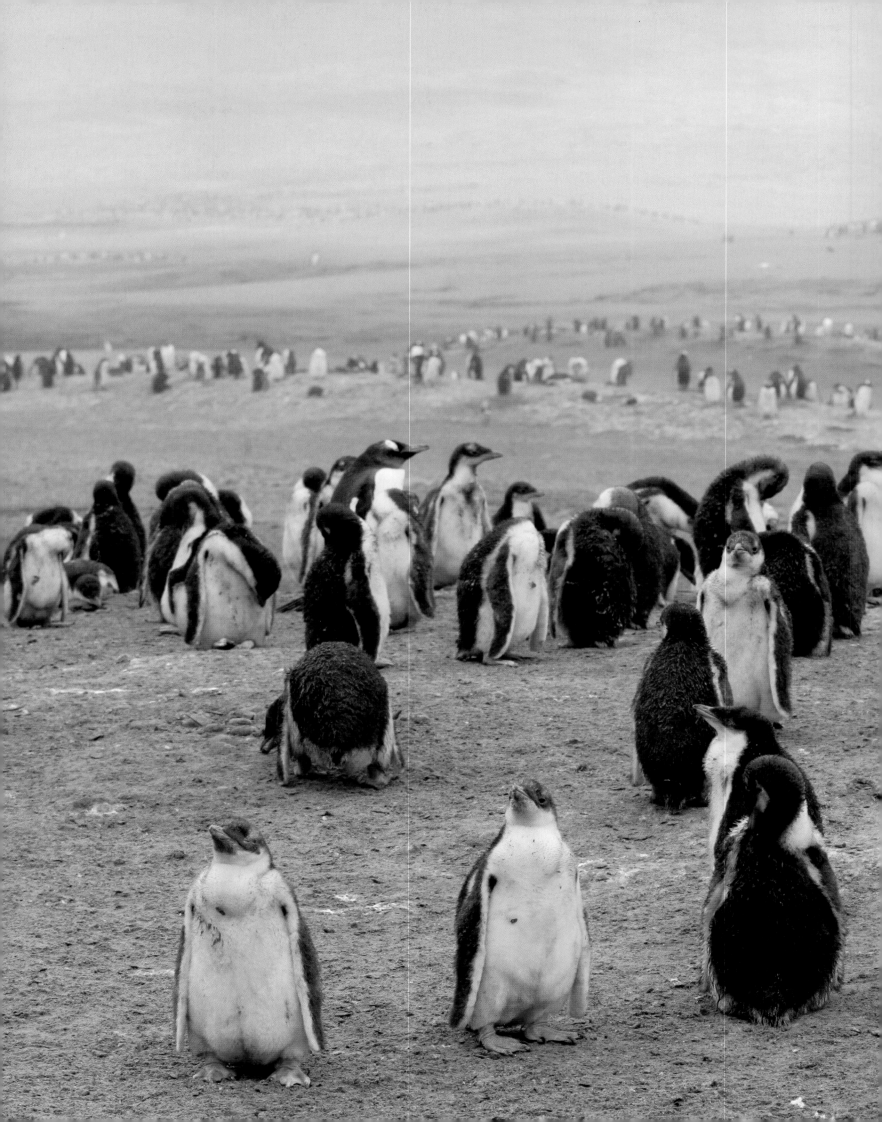

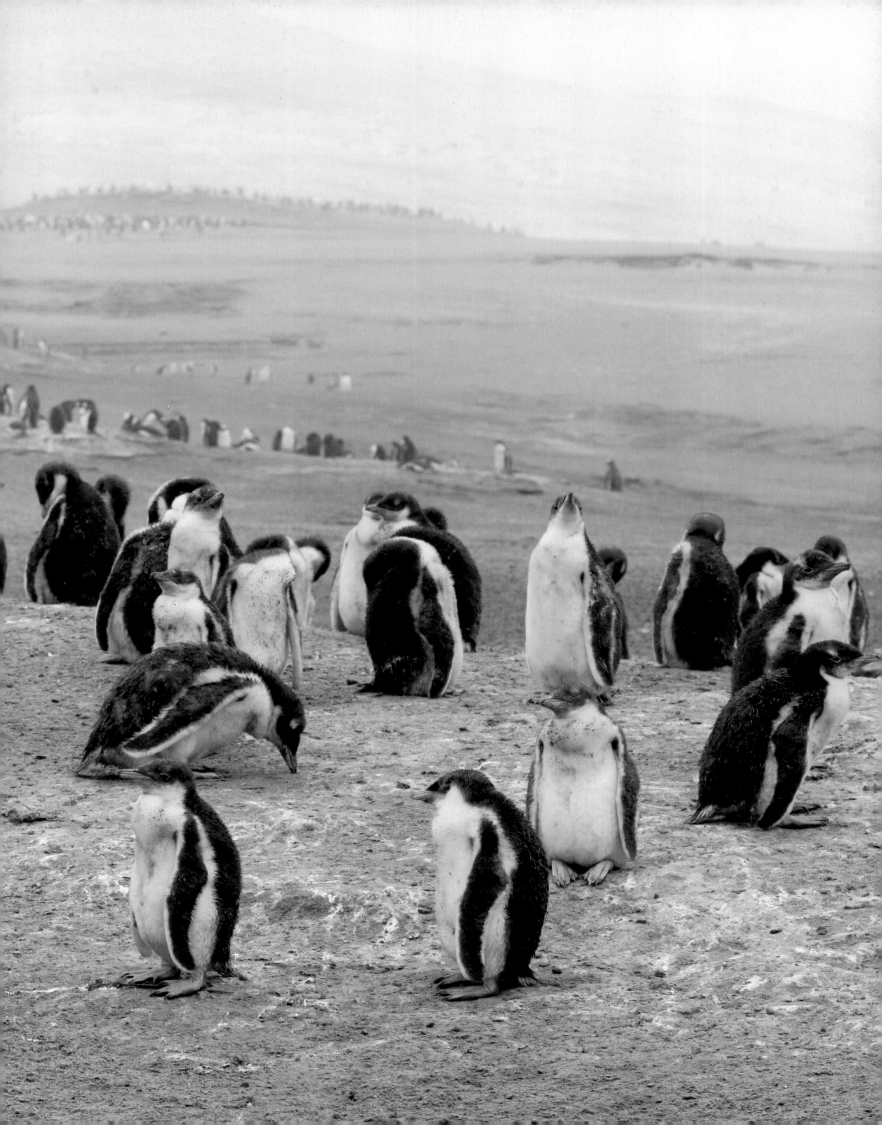

If humans compete with penguins over food resources, there is a risk that we disrupt the complex interaction between breeding birds whereby one of the two partners lives off its stored fat while the other collects food at sea. If the foraging partner takes too long in returning owing to a shortage of food, the pair will interrupt the breeding process, there will be no reproduction, and a whole year will be wasted.

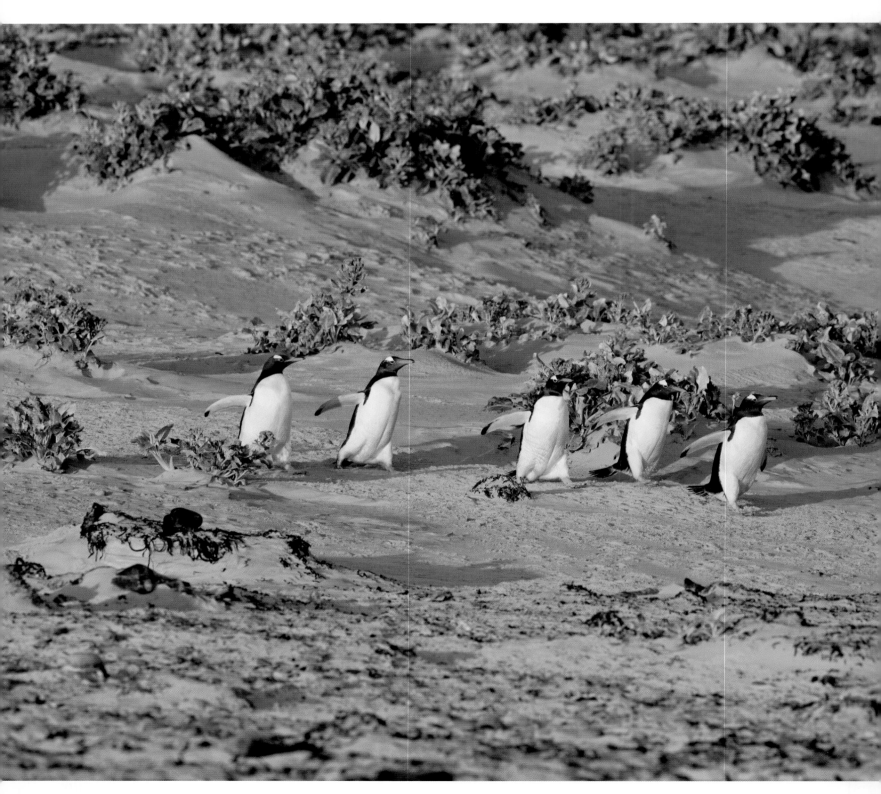

Gentoo Penguin, Volunteer Point, Falkland Islands, February.

Overleaf The number of breeding penguins and their success in raising young varies with changes in climate. By analyzing trace elements and variations in, for example, the amount of carbon, nitrogen, and strontium in sediments, it has been possible to identify periods several thousand years ago when penguins were common in certain areas and others when they were fewer in number. Series of observations have shown variations in the breeding pattern of Adélie Penguins in the Antarctic caused by climate change. Ocean currents and weather systems affect food supplies in the sea near colonies, which is of crucial importance to birds raising young chicks and having to eat themselves. If food is scarce at the egg-laying stage, the female will interrupt the whole process. Food shortages that occur during the period when the chick is still being fed by its parents will result in it being abandoned, sacrificed to promote the parents' survival.

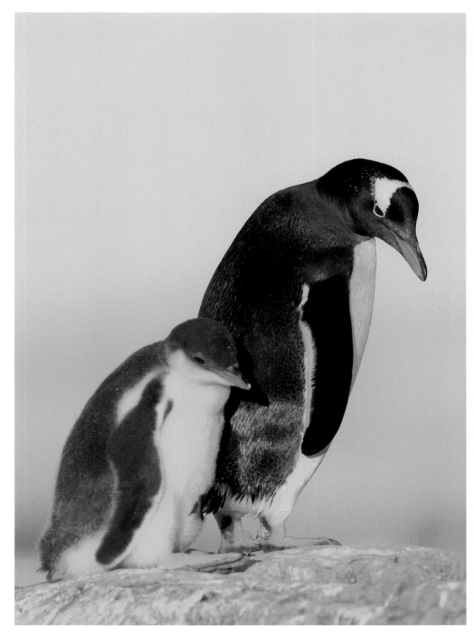

Gentoo Penguins, Petermann Island, Antarctica, January. 175

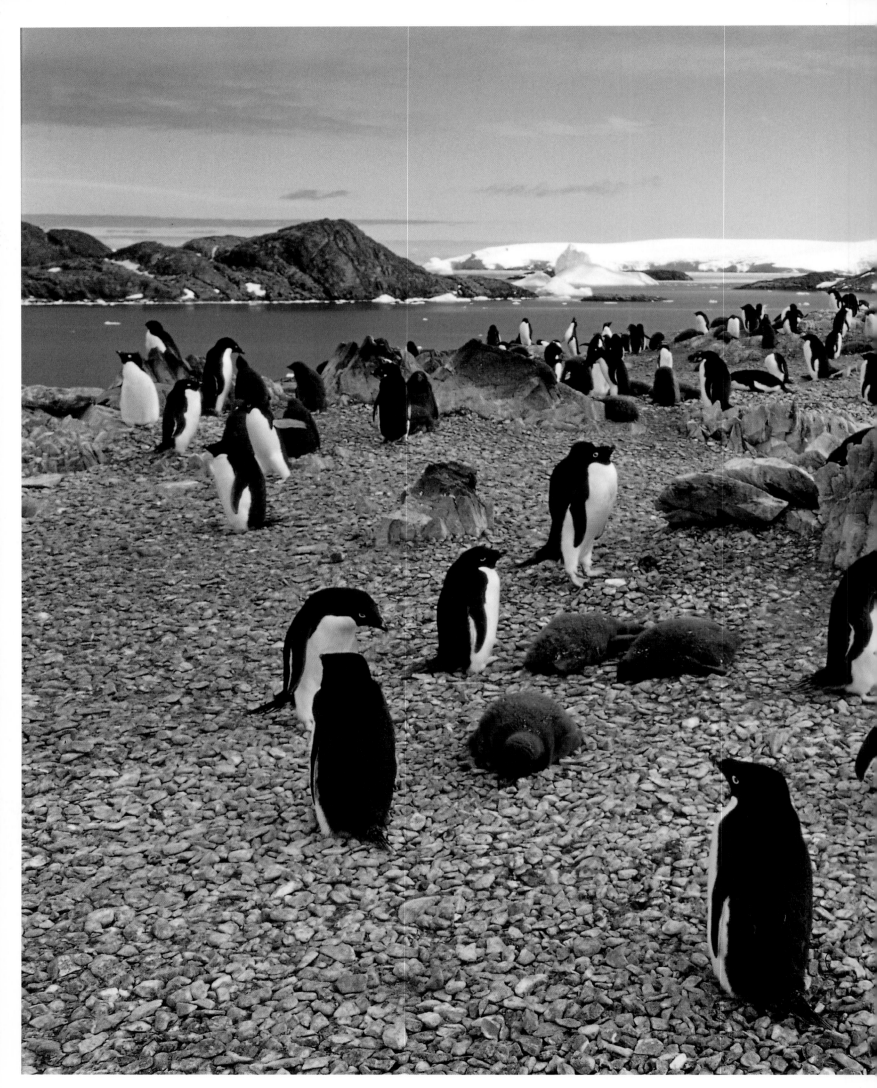

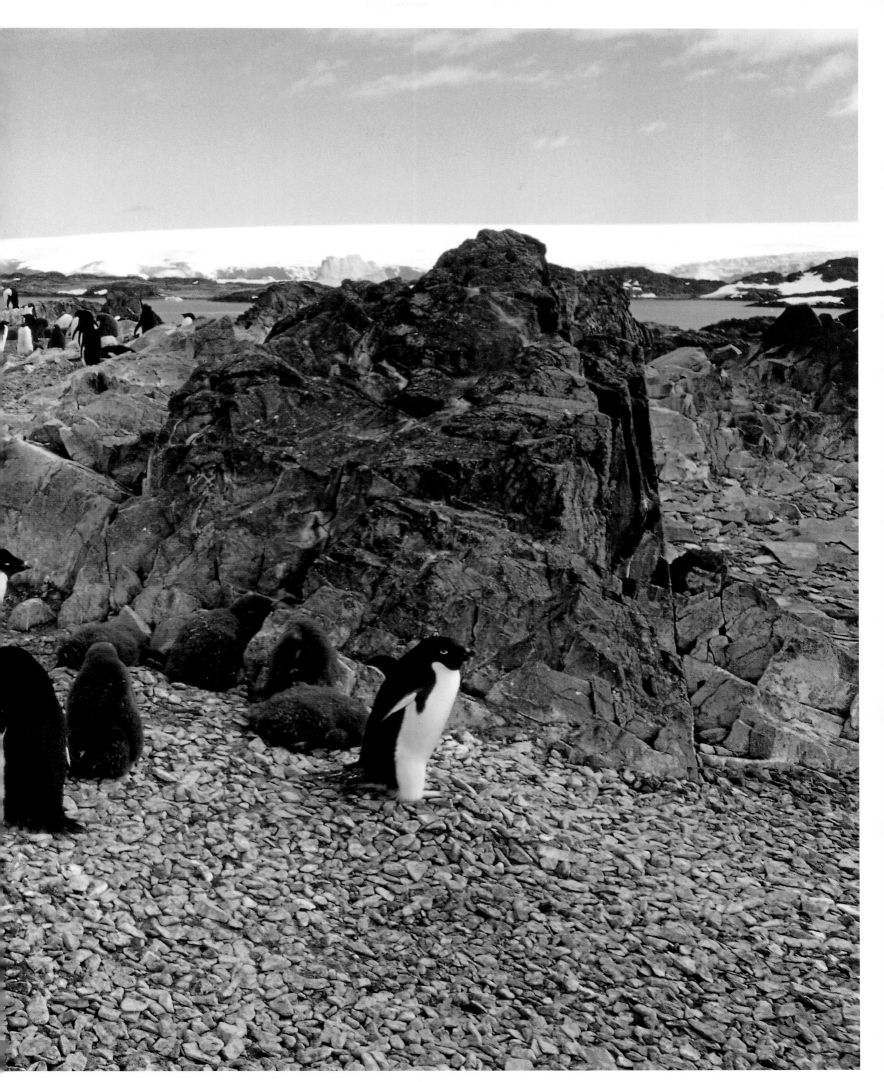

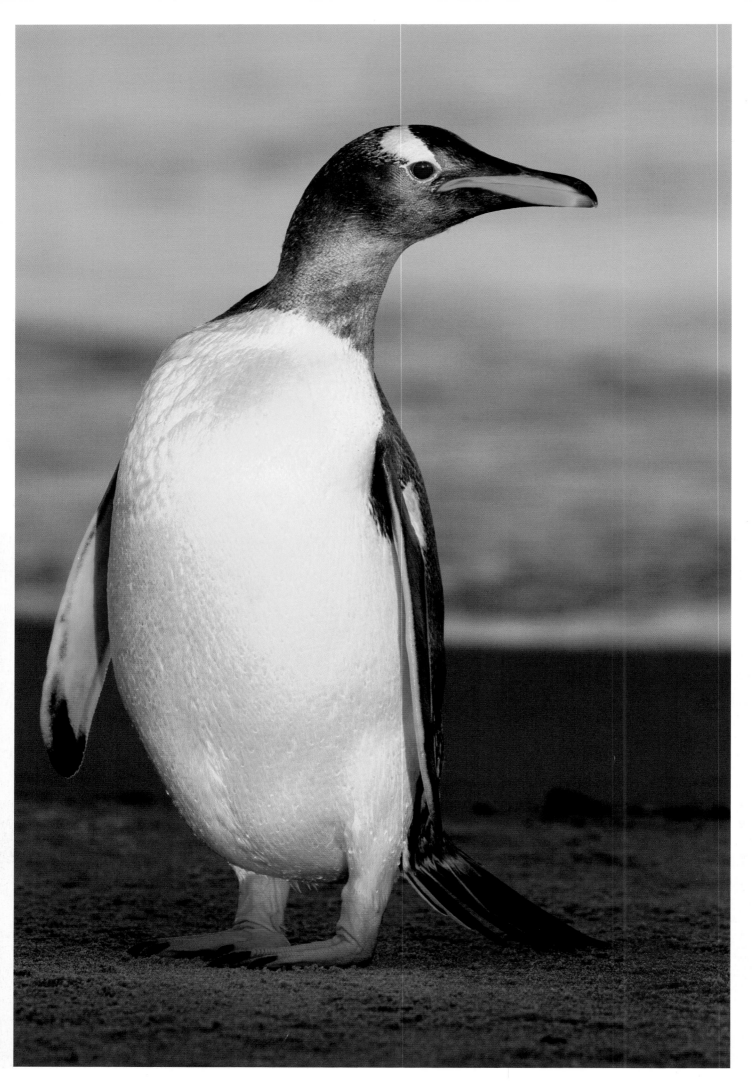

Gentoo Penguin, Sea Lion Island, Falkland Islands, January.

Whether a Gentoo Penguin is fit and healthy as an adult depends very much on how it was raised. For many birds, being born early in the year is crucial. They need to have sufficient weight both when they are born and later on, when they are abandoned by their parents. This applies to penguins as much as to any other bird. By leaving the nest early and gaining independence, young Gentoos have more time to learn to forage on their own before the arrival of winter, with its less reliable supply of food. Statistics show that individuals that are born early, and have gained more weight than those that are born late, are more likely to survive the winter. During years when food is scarce, the chances of survival are, of course, lower for all chicks. They are forced to leave the colony late, and their weight is too low when they do so. If humans compete with adult penguins by fishing for large amounts of their favorite food—krill and fish— we risk interfering with their chances of ensuring that their chicks grow rapidly and are in good health when winter sets in.

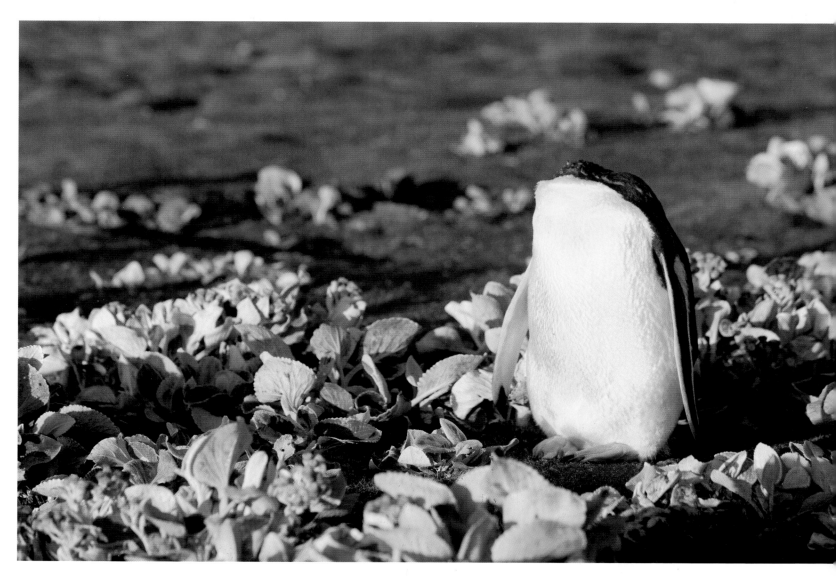

Gentoo Penguin, Saunders Island, Falkland Islands, January.

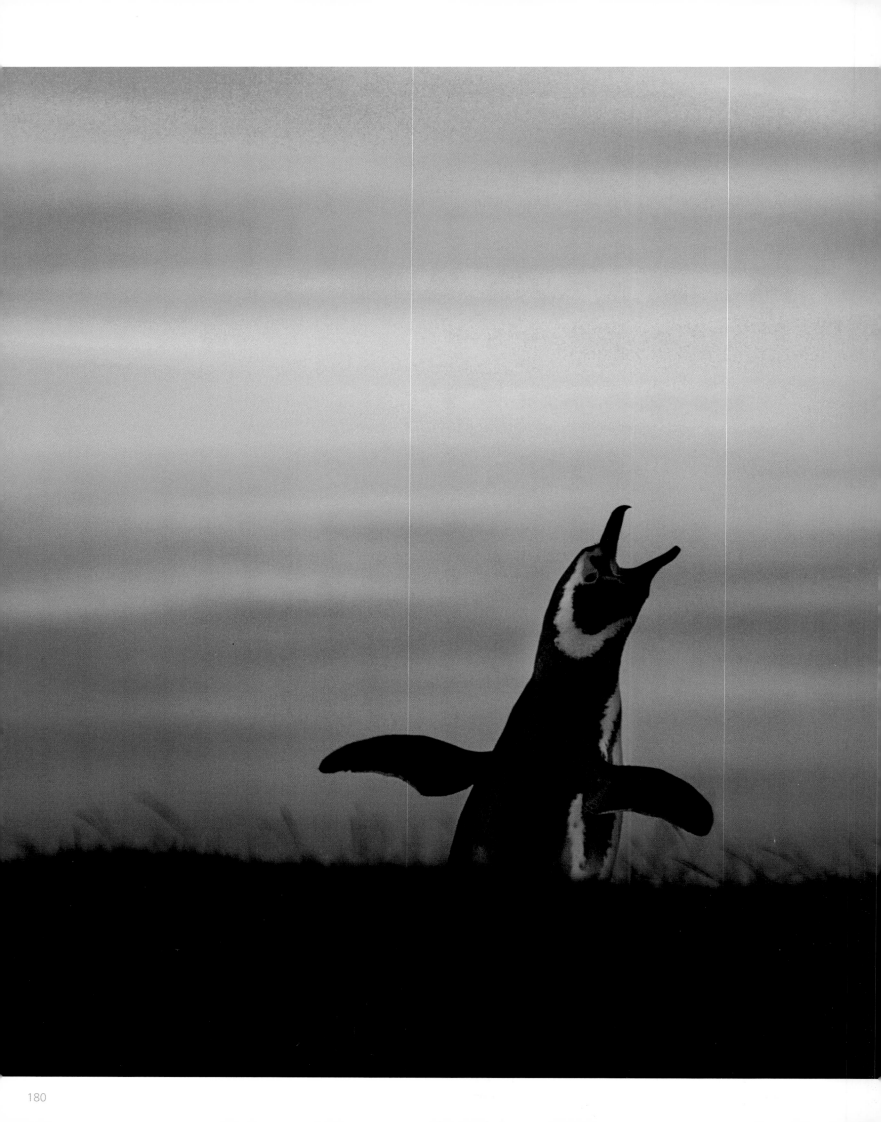

The first thing the Magellanic male does at dawn is call out for all to hear that he claims his space and that he is ready to mate. The males use their bills to fight over nest sites, and the more attractive the site (how well covered it is), the more intense the fighting. This does involve some danger, and may lead to either bird being injured. If the males are very different in size, the fighting will not go on long before the smaller bird surrenders. To be big, strong, and in good shape is therefore an advantage for Magellanic males when fighting over a suitable nest site. The odds that such a bird will find a partner increases further if he can prove that he is both a good provider and a fierce defender of the nest.

Overleaf Adult Gentoos do all they can to give their chick the best possible start in life, but they are, of course, unable to control everything that is going to affect the young chick's life in the future. It is worth considering here the state in which we want to hand over our own, and the penguins', living environment to coming generations. The question is how much we are interfering with the penguins' habitats now and what our activities will be in years to come. Responsibility for the future lies both with mankind as a whole, and with each and every one of us individually.

Magellanic Penguin, Volunteer Point, Falkland Islands, January.

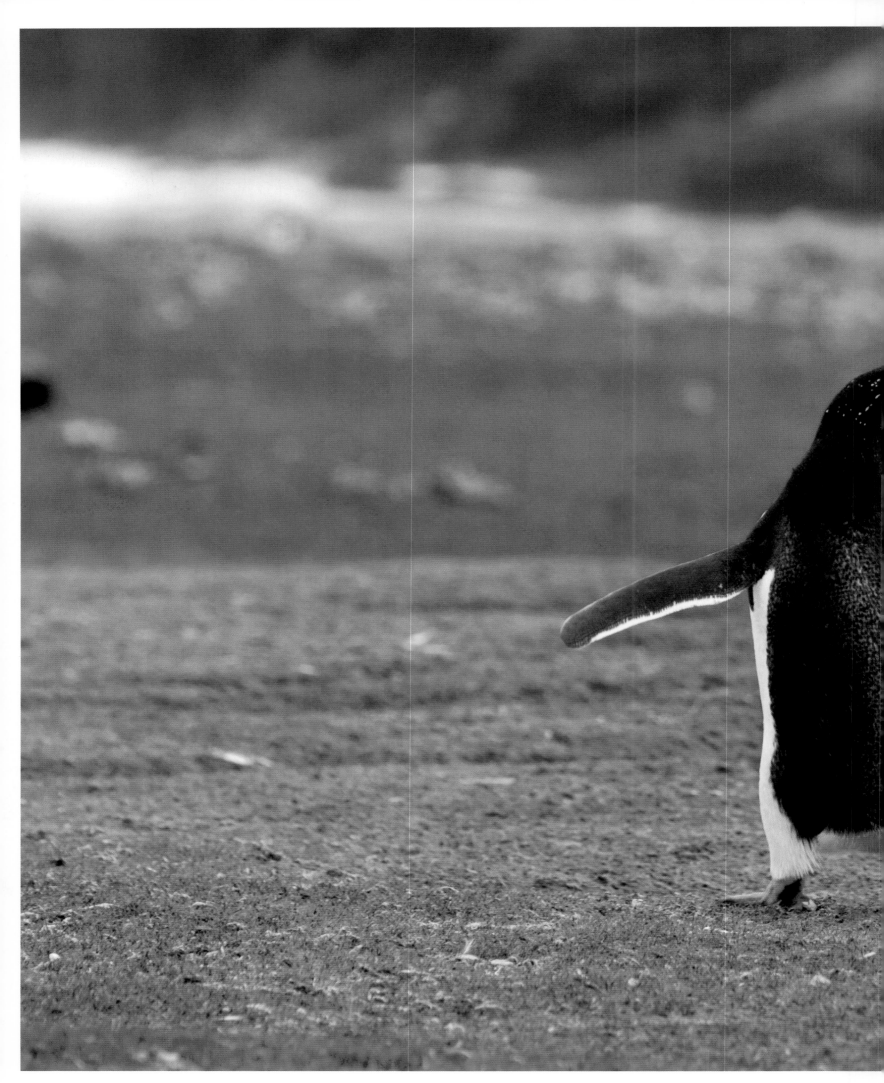

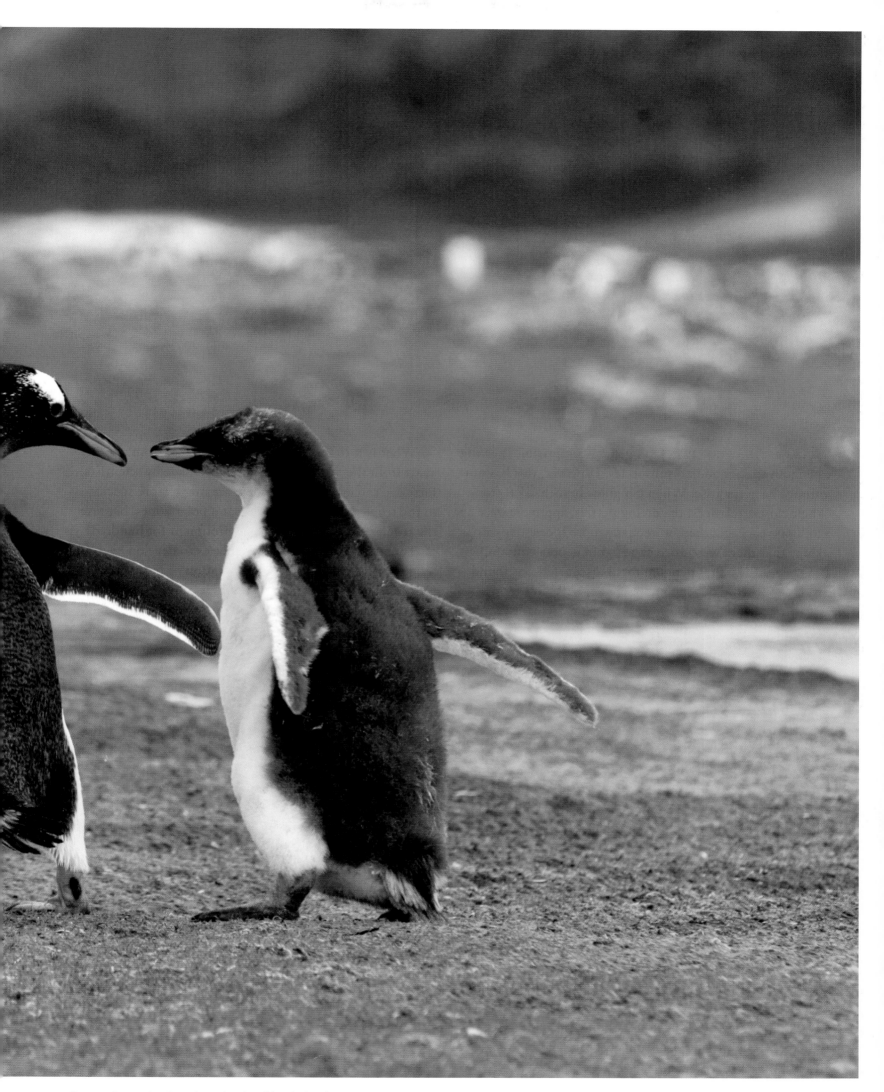

Gentoo Penguin, Saunders Island, Falkland Islands, January.

An Introduction to Penguin Species

Sphenisciformes (penguins) is the only order belonging to the class Aves that contains birds that are both flightless and adapted to a marine life. It comprises only one family, Spheniscidae.

SPHENISCIDAE CONTAINS SIX genera comprising 17 living penguin species and 26 subspecies. However, this has not always been the case. When penguins branched off from their closest relatives, the diving petrels, approximately 47 million years ago, there were many more species. Fossils show that there were once 21 penguin genera containing 32 species. The first penguin fossil discovered was found in New Zealand in 1859 and was named *Palaeeudyptes antarcticus* by the zoologist Thomas Henry Huxley. Since then, many more fossils have been found within basically the same area of distribution that we recognize from our own era—Australia, New Zealand, South Africa, South America, and various islands around the Antarctic and subantarctic. The largest penguin was the height of a human—somewhere between 5ft (152cm) and 5ft 2 in (160cm)—and weighed more than 285lb (130kg).

There is some dispute as to how many penguin species there are today, with some scientists claiming that there are more than the 17 that most seem to agree on. The method that was previously used to classify species was primarily based on morphological studies of bones and variations in plumage. It was not always easy, however, and sometimes mistakes were made, such as when a King Penguin chick, which is entirely brown, was classified as a completely different species. With the aid of modern technology it is possible to describe genetic variations between races that may prove to be more significant than can be determined from plumage and size. As a result, some scientists would like to classify Moseley's Penguin—a Rockhopper Penguin subspecies found on Tristan da Cunha, Gough Island, Amsterdam Island, and St. Paul Island—as an independent species.

What is it that distinguishes one species from another apart from the artificial classifications made by scientists? First, we can establish that there are many more species in the tropics than in temperate and polar zones, because the tropics have been a stable environment for hundreds of thousands of years, allowing species to develop over long periods, either by genetic mutation or by adaptation to a variety of environments. When it comes to polar and temperate regions, however, the species now living there did not gain access to the land until a few thousand years ago, since the past few ice ages made colonization impossible.

In theory, species may develop in a number of ways, but in nature the single most common process is when part of a population becomes isolated in a new environment and then adapts to its local conditions and food sources. This is what scientists call allopatric speciation. As individuals from these branched-off populations come into contact again, they are no longer able to reproduce. This does not necessarily mean that they can no longer exchange sex cells, but that they now look very different from each other and no longer react to the same mating signals, or that their breeding seasons occur at different times of the year.

Many of the world's penguins are found in and around islands, and it is therefore reasonable to assume that the development of individual species has been heavily dependent on geographic isolation, on how easy it has been for them to gain access to other islands and on food supply.

Emperor Penguin (*Aptenodytes forsteri*).
Size: 44–45in (112–115cm)
Weight: 60–90lb (27–41kg)
The Emperor Penguin is a circumpolar species native to the Antarctic. The female lays a single egg, which is then incubated by the male during the coldest time of the year. It takes one year to raise the chick. Emperor Penguins have no territory to defend, but during incubation the males huddle close together for warmth.
There are between 135,000 and 175,000 pairs. It is not an endangered species. (**1**)

Rockhopper Penguin (*Eudyptes chrysocome*)
Size: 21–24in (55–62cm)
Weight: 5–6lb (2.3–2.7kg)
Rockhoppers are common throughout the sub-antarctic region, where they breed on islands in the north. They live on rocky beaches and forage at sea. Different populations start breeding at different times, the ones farther to the south beginning somewhat earlier than the northern populations. The subspecies Moseley's Penguin is considered by some to be a separate species. There are approximately 3.5 million pairs. It is not an endangered species. (**2**)

Adélie Penguin (*Pygoscelis adeliae*)
Size: 28in (71cm)
Weight: 8–10lb (3.6–4.5kg)
The Adélie Penguin is a circumpolar species—it can be found throughout the southern hemisphere. It is one of the species that breeds in the Antarctic. However, Adélie Penguins can breed only on snow-free ground, using stones to build their nests. They migrate to the rim of the ice sheet during the winter and molt standing on an ice floe. They reach sexual maturity at the age of six years. There are 2–2.6 million pairs. It is not an endangered species. (**3**)

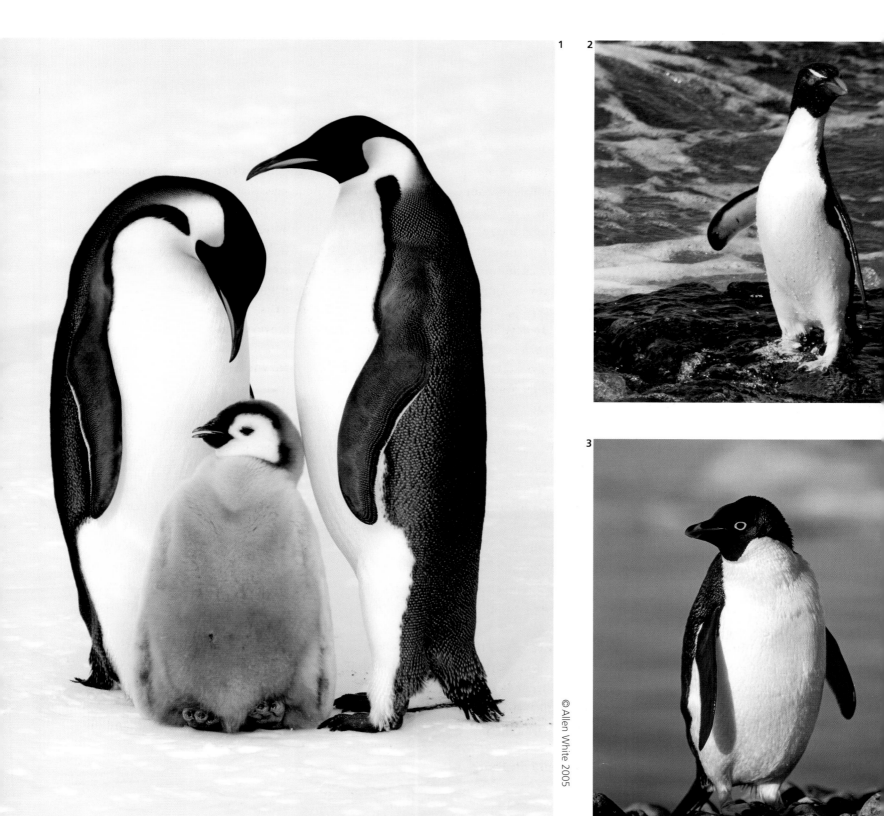

1

2

3

Humboldt Penguin (*Spheniscus humboldti*)

Size: 26–28in (65–70cm)

Weight: 9lb (4kg)

Humboldt Penguins breed in small colonies along the Peruvian and Chilean coastline affected by the Humboldt oceanic current. They nest in rock crevices and openings on rocky islands or along the coast, and forage for shoals of fish and squid close to shore. The size of the entire population is unknown, but is likely to be less than 10,000 pairs. The Humboldt Penguin is an endangered species owing to overfishing in the area. (**4**)

Snares Crested Penguin (*Eudyptes robustus*)

Size: 22–29in (56–73cm)

Weight: 6–7lb (2.7–3kg)

Snares Crested Penguins breed in colonies of a few hundred individuals within a limited area on the Snares Island, to the south of South Island, New Zealand. They lay two eggs in a nest built on muddy, forested shores or on rocky slopes. As their feces and general wear kill off vegetation, they move to new breeding grounds. During the breeding season the Snares Crested Penguin forages some distance from the coast in small groups. There are approximately 33,000 pairs. It is not an endangered species. (**5**)

African Penguin (*Spheniscus demersus*)

Size: 27–28in (68–70cm)

Weight: 7lb (3kg)

African Penguins breed on small islands and on the mainland along the south coast of Africa. The birds are stationary (do not migrate) and breed all year round, with some variation between different areas. Their diet consists of fish, which they catch from large shoals near the coast, foraging in groups. The number of individuals is unknown, but is estimated to be between 50,000 and 71,000 pairs, all within the same area. The species has suffered from oil spills, and numbers have fallen over the past few years. (**6**)

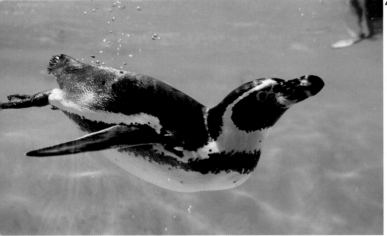

Annmarie Loubsens © Naturbild, Stockholm

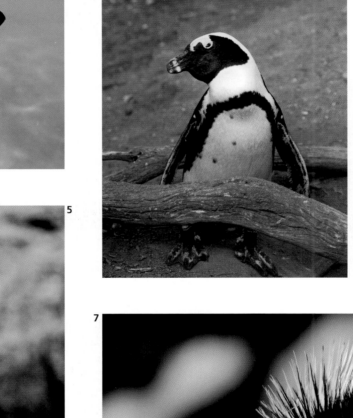

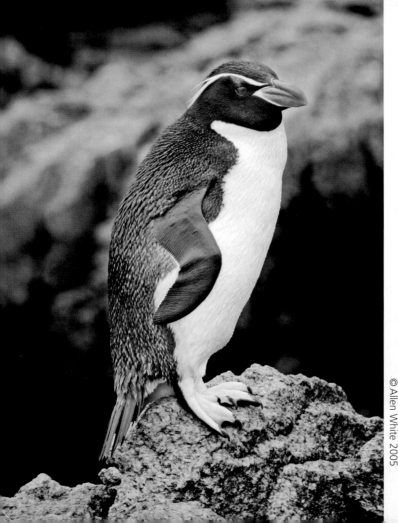

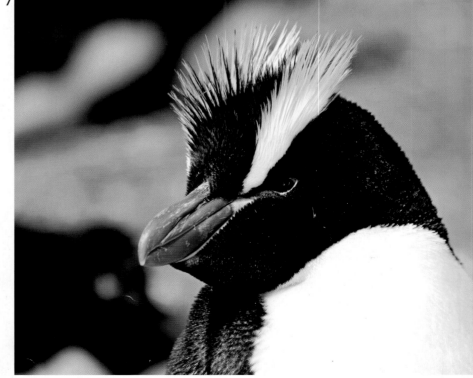

© Allen White 2005

© Allen White 2005

Erect-crested Penguin

(*Eudyptes sclateri*)
Size: 24–26in (63–68cm)
Weight: 6–8lb (2.7–3.5kg)
Erect-crested Penguins (also called Sclater's Crested Penguins) breed in large colonies on rocky shores on islands south and southeast of New Zealand, around the Bounty and Antipodes island groups. They lay two eggs in a scrape surrounded by stones. The total population is estimated at over 200,000 pairs. It is not an endangered species. (**7**)

Magellanic Penguin

(*Spheniscus magellanicus*)
Size: 27–29in (70–76cm)
Weight: 11lb (5kg)
Magellanic Penguins breed along the southern coast of South America, in the Falklands, and elsewhere in the region. They burrow on beaches, under sand or earth mounds, in forests, or on grassy slopes. Their staple diet is anchoveta. The total population is 4.5–10 million pairs, and it is not endangered. (**8**)

Chinstrap Penguin (*Pygoscelis antarctica*)

Size: 26–30in (68–77cm)
Weight: 9lb (4kg)
Chinstrap Penguins breed along coasts and on isolated islands throughout the Antarctic region, although they are most common in the South Atlantic. Their staple diet is Antarctic Krill, which the birds dive for down to 230ft (70m). Chinstraps live in large colonies of several hundred thousand pairs. Both parents incubate the two eggs for 34–60 days, and the chicks then fledge after about two months. There are at least 7.5 million pairs, and because the population has increased in recent years it is not an endangered species.(**9**)

King Penguin (*Aptenodytes patagonicus*)

Size: 37in (94–95cm)
Weight: 30–35lb (14–16kg)
The King Penguin breeds on subantarctic island groups, the largest colonies of several hundred thousand individuals being found on South Georgia in the South Atlantic. Birds lay a single egg and the breeding season lasts a whole year, so that over a period of three years King Penguins raise only two chicks. There are 2 million pairs in total. It is not an endangered species. (**10**)

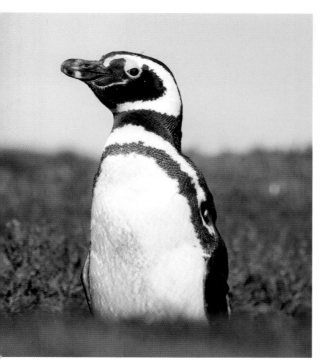

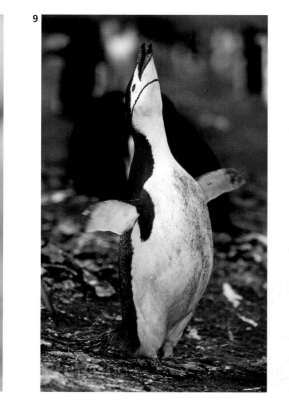

9

10

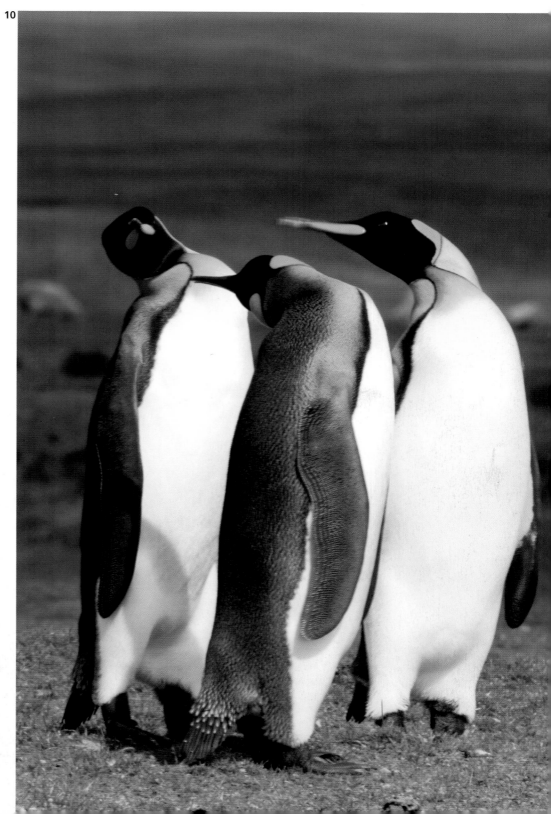

Gentoo Penguin (*Pygoscelis papua*)

Size: 30–32in (76–81cm)

Weight: 12–14lb (5.5–6.4kg)

Gentoo Penguins breed in colonies along rocky shores and on isolated islands north of Antarctica from 60ºS, north to the south-eastern coast of Argentina. They forage near the coast, but their diet differs from place to place. Gentoos build large nests of grass and pebbles and lay two eggs. The chicks hatch after 31–39 days and fledge when they are two to three months old. The parents continue to feed them for another one to 50 days. There are 260,000–300,000 pairs in total. The species is not endangered. (**11**)

Macaroni Penguin

(*Eudyptes chrysolophus*)

Size: 28in (70cm)

Weight: 6.5lb (3kg)

Macaroni Penguins breed primarily on island groups in the South Atlantic and South Pacific down to the Antarctic region. They live in crowded colonies and forage out at sea. The two eggs are placed in a nest built in the shade on grass or gravel. The Macaroni is the most numerous penguin species, with more than 11.6 million pairs, and is not endangered. (**12**)

Royal Penguin

(*Eudyptes schlegeli*)

Size: 29–30in (73–76cm)

Weight: 12lb (5.5kg)

Royal Penguins breed only on Macquarie Island and the minor islands that surround it. They nest in grass on beaches or slopes up to 1 mile (1.5km) from the water and forage at sea. There are approximately 850,000 pairs. This is not an endangered species. (**13**)

Yellow-eyed Penguin

(*Megadyptes antipodes*)

Size: 26–30in (66–76cm)

Weight: 13lb (6kg)

Yellow-eyed Penguins breed in New Zealand, on South Island, Stewart Island, and Codfish Island, and southeast of there on the Auckland and Campbell islands. Their nests are built on slopes and among rocks in forest or scrub areas near the coast, and they forage in shallow waters close to shore. There are 5,000–6,000 pairs. The species is included in the BirdLife International list of endangered species. (**14**)

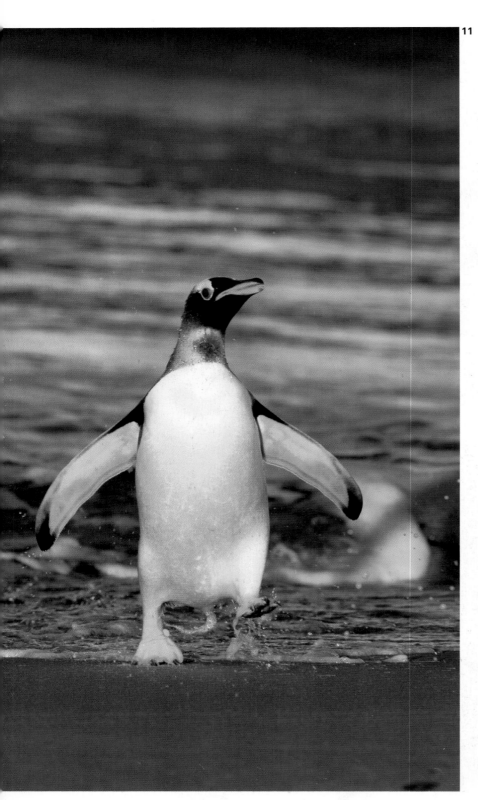

11 **12**

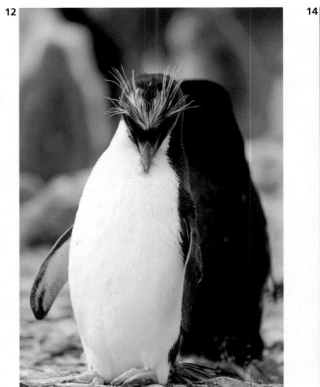

13

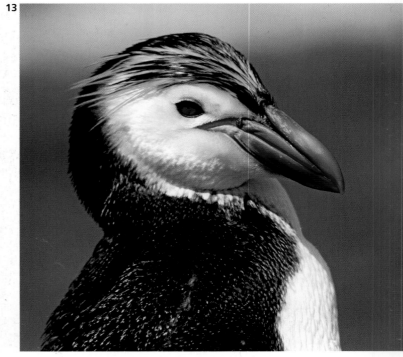

Kevin Schafer © Naturbild, Stockholm

Fiordland Crested Penguin
(*Eudyptes pachyrhynchus*)
Size: 21–30in (55–71cm)
Weight: 6.5lb (3kg)
Fiordland Crested Penguins breed on island groups around New Zealand and Tasmania. They nest in rocky crevices and among root systems in coastal rain forests and on steep rock faces. During the breeding season, they forage near the coast; during the rest of the year, they have a pelagic distribution (they live out at sea). There are between 5,000 and 10,000 pairs, and the species may be threatened with extinction sometime in the future.(**15**)

Little Penguin (*Eudyptula minor*)
Size: 16–17in (40–45cm)
Weight: 2lb (1kg)
The Little Penguin breeds from South Australia to New Zealand and comprises six subspecies. The birds are found in temperate climates and forage in shallow water near the coast. They catch fish by circling a shoal, forcing the fish together, and then they dive right through the middle of them. Little Penguins build their nests on sandy beaches, by the foot of a rock, or on the perimeter of sand dunes. It is difficult to assess the size of the Little Penguin population because the birds are nocturnal. However, it is estimated that more than a million live in Australia alone, although numbers are falling in several areas. This is not an endangered species. (**16**)

Galápagos Penguin (*Spheniscus mendiculus*)
Size: 19–21in (48–53cm)
Weight: 5.5lb (2.5kg)
Galápagos Penguins are found only on the Galápagos Islands off the coast of Ecuador. They breed all year round and nest in crevices and under volcanic rocks at sea level. The diet consists of fish, which they catch in cool, nutrient-rich current upwellings. The birds breed in loose colonies, small groups, or alone. Like most other penguins, they lay two eggs, although normally they raise only one chick. The population is estimated at 6,000–15,000 pairs, but they are very sensitive to certain weather conditions such as El Niño, which has resulted in a dramatic reduction in numbers. As a result, the Galápagos Penguin is on the verge of becoming an endangered species. (**17**)

16

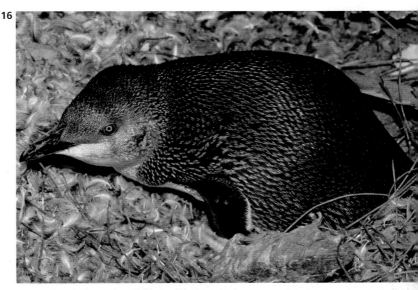

Kevin Schafer © Naturbild, Stockholm

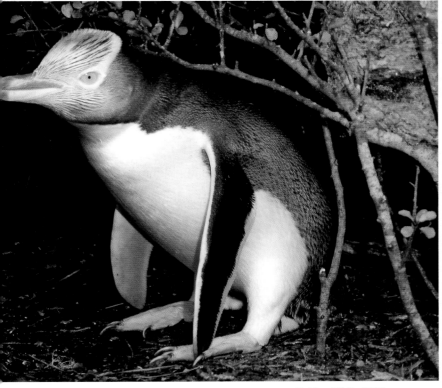

© Allen White 2005

15

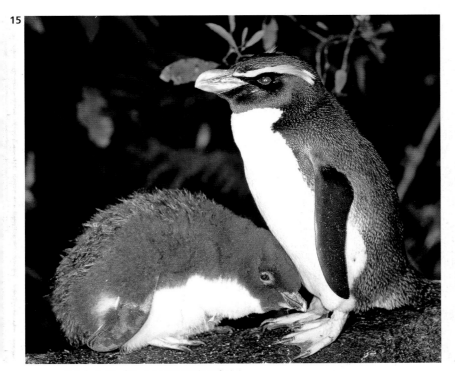

© Rob Suisted/www.naturespic.com

17

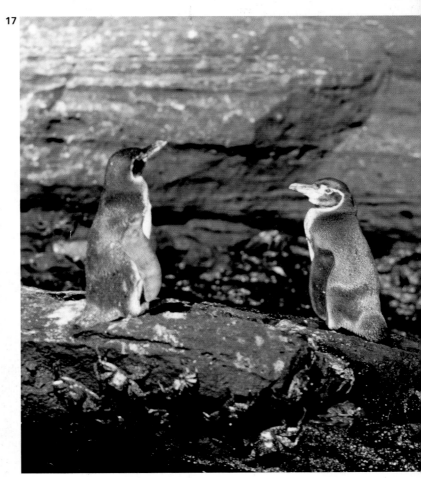

Anders Haglund © Naturbild, Stockholm

189

Photographer's Acknowledgments and Comments

The first time I saw penguins was on a three-week Cheeseman's Ecology Safari to the Falklands, South Georgia, and the Antarctic in 2002–3, but I didn't make up my mind to produce a book about them until the end of 2005. Just before the New Year, I received an email from my American agent, Peter Riva, in which he proposed making a book about penguins, as HarperCollins, who had recently bought my first book, wanted one for the American and British markets. There was only one small problem: they wanted it to be ready in just four months. A week later I was on a plane bound for the Falklands via Santiago, Chile.

Most of the pictures in this book were taken in January, February, and March of 2006, during two amazing trips to the Falklands and South Africa. The Falklands were never as wet as during January 2006, but rather than giving up and going home I was offered a unique opportunity to photograph the daily life of penguins. Falkland summers are always windy, and a couple of the featured pictures were taken on a day of force-ten storms with 60mph (100km/h) winds.

For those interested in photography, all the new pictures from the Falklands and South Africa were taken with Canon's digital SLR EOS 1 Ds Mark II and 1D Mark II. For the pictures from South Georgia and the Antarctic, I mainly used an analog Canon Eos 1V.

The picture of the adult Blue-eyed Cormorant looking into the camera on page 55 was taken with remote control. I had set up the camera at ground level, hoping to get some pictures of Rockhopper chicks, when the cormorant—whose chicks had already made their first attempts at flying—suddenly attacked it, and I had to rush forward to save it.

Because the majority of these pictures are of penguins, it is probably unnecessary to point out that none was taken in an enclosure, and we have tried to avoid all forms of editing. There are, however, two exceptions to this, where the printer's image editors removed some small but annoying details: one is an out-of-focus wing in a lower corner of the small picture of a Rockhopper chick on page 150; the same applies to the Gentoo chick on page 123. These small alterations should be mentioned, although they do not affect the image content in any way.

I would like to express my gratitude to all those who helped me make this book: Katarina Saldén and Per-Magnus Sander at PolarQuest, who assisted me with research and bookings; the amazing Allan White on Pebbles Island, who did not only guide me around, but who loaned me four of his own pictures for the "'Penguin Species'" section on pages 185–189; photo enthusiast David Pole-Evans and his wife, Suzan, on Saunders Island, who were always there for me (it was Dave who tipped me off about the showering Rockhoppers); Ted and Doug Cheeseman, who not only organized a fantastic journey around the Antarctic, but who helped me "recall" where some of the pictures from 2003 were taken; and, finally, Rod and Phyllis Tuckwood for their great hospitality at Volunteer Point.

I would also like to thank all those who were involved in producing this book in such a short time: Jens Andersson, who did the layout; and Christina Sejte, my wife of 16 years who, despite having to look after our three small children during my travels, offered invaluable comments on the layout and selection of pictures.

Brutus Östling
Stehag, April 27, 2006

Author's Acknowledgments and References

First and foremost, I would like to thank my family, Sir Colin Spedding, and Bea Uusma-Schyffert for urging me to write this book. I am also grateful to John Croxall, Anders Hedenström, Christoffer Johansson, Nils Kjellén, and Christine Phillips for taking part in discussions and for offering relevant information, as well as to Lars Hedenström and Christina Sejte for valuable criticism on parts of the manuscript.

Since I have not actively studied penguins in my research, I referred to general information on the subject in the following literature: Hagelin, J. & Cheeseman, T., "The Log of the Cheesemans' Ecology Safaris Great Southern Ocean Expedition, 2002–3"; Harrison, P.: *Havsfåglar*. Stockholm, Wahlström & Widstrand,1985; del Hoyo, J., Elliot, A. and Sargatal, J. (eds), *Handbook of the Birds of the World*. Vol. 1. Lynx Editions, Barcelona, 1992; Schreiber, E.A. and Burger, J. (eds), *Biology of Marine Birds*, New York, CRC Press, 2002. Simpson, G.G., *Penguins: Past and Present, Here and There*. New Haven, CT: Yale University Press, 1976.

In addition, I referred to specific information in, among others, the following sources: Barbraud, C. & Weimerskirch, H., "Emperor penguins and climate change", *Nature*, 411, 2001.; Becker, P.H., González-Solís, J., Behrends, B. and Croxall, J., "Feather mercury levels in seabirds at South Georgia: influence of trophic position, sex and age", *Marine Ecology Progress Series*, 244, 2002; Clark, J.A. and Boersma, P.D., "Southern elephant seal, *Mirounga leonina*, kills magellanic penguins, *Spheniscus magellanicus*, on land", *Marine Mammal Science*, 22(1), 2006; Croxall, J.P., "Southern Ocean environmental changes: effects on seabird, seal, and whale populations", *Philosophical Transactions of the Royal Society of London B*, 338, 1992; Croxall, J.P. and Davis, L.S., "Penguins: paradoxes and patterns", *Marine Ornithology*, 27, 1999; Davis, L.S., "Coordination of incubation routines and mate choice in Adélie penguins (Pygoscelis adeliae)", *Auk*, 105, 1988; Dewasmes, G. and Loos, N., "Diurnal sleep depth changes in the King Penguin (*Aptenodytes patagonicus*)", *Polar Biology*, 25(11), 2002; Dresp, B., Jouventin, P. and Langley, K., "Ultraviolet reflecting photonic microstructures in the King Penguin beak", *Biology Letters*, 1, 2004; Gauthier-Clerc, M., Le Maho, Y., Clerquin, Y., Drault, S., and Handrich, Y., "Penguin fathers preserve food for their chicks", *Nature*, 408, 2000; Griffin, T.M. and Kram, R., "Penguin waddling is not wasteful", *Nature*, 408, 2000; Jones, H.I. and Shellam, G.R., "The occurrence of blood-inhabiting protozoa in captive and free-living penguins", *Polar Biology*, 21(1), 1999. Jouventin, P., Aubin, T., and Lengagne, T., "Finding a parent in a King Penguin colony: the acoustic system of individual recognition", *Animal Behaviour*, 39, 1999; Kooyman, G.L., "Evolutionary and ecological aspects of some Antarctic and sub-Antarctic penguin distributions", *Oecologia*, 130, 2002; Le Bohec, C., Gauthier-Clerc, M., Gendner, J.-P., Chatelain, N., and Le Maho, Y., "Nocturnal predation of King Penguins by Giant Petrels on the Crozet Islands", *Polar Biology*, 28(4), 2003; de Margerie, E., Robin, J.-P., Verrier, D., Cubo, J., Groscolas, R., and Castanet, J., "Assessing a relationship between bone microstructure and growth rate: a fluorescent labeling study in the King Penguin chick (*Aptenodytes patagonicus*)", *Journal of Experimental Biology*, 207, 2004; Meyer-Rochow, V.B. and Gal, J., "Pressures produced when penguins pooh—calculations on avian defaecation", *Polar Biology*, 27(1), 2003; Noren, S.R., Williams, T.M., Pabst, D.A., McLellan, W.A. and Dearolf, J.L., "The development of diving in marine endotherms: preparing the skeletal muscles of dolphins, penguins, and seals for activity during submergence", *Journal of Comparative Physiology B*, 171, 2001; Olsson, O., "Effects of food availability on fledging condition and post-fledging survival in king penguin chicks", *Polar Biology*, 18(3), 1997; Penney, R.L. and Lowry, G., "Leopard seal predation of Adélie Penguins", *Ecology*, 48(5), 1967; Regel, J. and Pütz, K., "Effect of human disturbance on body temperature and energy expenditure in penguins", *Polar Biology*, 18(4), 1997; Shepherd, L.D., Millar, C.D., Ballard, G., Ainley, D.G., Wilson, P.R., Haynes, G.D., Baroni, C., and Lambert, D.M., "Microevolution and mega-icebergs in the Antarctic", *Proceedings of the National Academy of Sciences*, 102(46), 2005; Thouzeau, C., Le Maho, Y., Froget, G., Sabatier, L., Le Bohec, C., Hoffmann, J.A., and Bulet, P., "Spheniscins, avian ß-defensins in preserved stomach contents of the King Penguin, *Aptenodytes patagonicus*", *Journal of Biological Chemistry*, 278(51), 2003; Vleck, C.M. and Van Hook, J., "Absence of daily rhythms of prolactin and corticosterone in Adélie Penguins under continuous daylight", *Condor*, 104(3), 2002.

Susanne Åkesson
Dalby, April 27, 2006

List of species

Travel Tips

No penguin colony is easier to get to than the one at Boulders Beach near Simon's Town, half an hour's drive from Cape Town, South Africa. After that, the Falkland Islands qualify as one of the most accessible places for watching penguins. Thousands of Rockhopper, Gentoo, Magellanic, and even King penguins breed on these islands. Several tour operators specialize in the Falkland Islands, but it is also possible to directly contact, for example, Falkland International Tours and Travel in Port Stanley, who will book accommodation and air travel between the islands, either at their office or in advance. The local airline FIGAS operates small propeller aircraft holding up to seven passengers with baggage.

With regards to the Antarctic and South Georgia, you need to travel by sea. The easiest—and only—way of getting there is to book a berth on a ship or contact a travel agent specializing in the Antarctic and subantarctic to arrange it for you.

The smallest of all penguins, the Little Penguin, has a wide distribution along the Australian south coast and in New Zealand, but it is nocturnal so it is not always easy to spot. In New Zealand, you will find other interesting penguin species, such as the Erect-crested, Snares Crested, and Fiordland Crested, as well as the endangered Yellow-eye. They, too, are not easy to find, and some species breed only on remote islands.

The endangered Humboldt Penguin is found along the coasts of Argentina, Chile, and Peru. The only place to find the Galápagos Penguin, meanwhile, is on the Galápagos Islands off the coast of Ecuador.

A number of travel agents specialize in trips and cruises to the Antarctic, South Georgia, and the Falkland Islands. We would especially like to mention Cheesemans' Ecology Safaris (www.cheesemans.com) and PolarQuest (www.polar-quest.com), which are two of the most reliable tour providers in the business.

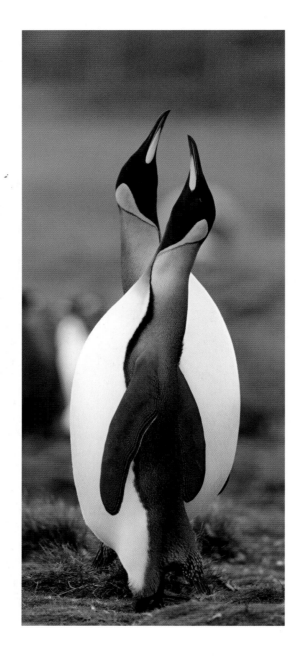